THE BACKYARD BIRDWATCHER'S BIBLE

Published in North America in 2020 by Abrams, an imprint of ABRAMS.

First published in the United Kingdom in 2020 by William Collins, an imprint of HarperCollins Publishers

Text © HarperCollinsPublishers 2020, except where otherwise specified.

Excerpts used by permission:

The New Generation Guide to Birds by Christopher Perrins

Warblers and Other Songbirds of North America by Paul Sterry

Images © individual copyright holders, see page 406 for details

Cover illustrations © Lynn Hatzius 2020

Cover photograph © Brian E. Small/Nature Photographers Limited

Written by Christopher Perrins, Sonya Patel Ellis, Paul Sterry, and Dominic Couzens

The authors assert their moral right to be identified as the authors of this work.

All rights reserved. No parts of this publication may be reproduced, stored in a retrieval system, or transmitted, in any form or by any means, electronic, mechanical, photocopying, recording, or otherwise, without the prior permission of the publishers

Library of Congress Control Number: 2020931043

ISBN 978-1-4197-5053-3

Text by Sonya Patel Ellis except where otherwise specified
Original illustrations © Lynn Hatzius, see pages 406-409 for details
Design by Eleanor Ridsdale
With design assistance from Gareth Butterworth
Picture research by Jo Carlill
Project management by Ruth Redford

All reasonable efforts have been made by the author and publishers to trace the copyright owners of the material quoted in this book and of any images reproduced in this book. In the event that the author or publishers are notified of any mistakes or omissions by copyright owners after publication, the author and publishers will endeavor to rectify the position accordingly for any subsequent printing.

All images were taken by experienced photographers and naturalists and supplied by distinguished picture image libraries with strict codes of conduct around best practice on safe and respectful bird photography.

Printed and bound in Spain by Estellaprint 10 9 8 7 6 5 4

Abrams books are available at special discounts when purchased in quantity for premiums and promotions as well as fundraising or educational use. Special editions can also be created to specification. For details, contact specialsales@abramsbooks.com or the address below.

Abrams® is a registered trademark of Harry N.Abrams, Inc.

DISCLAIMER

The publishers urge readers to be responsible birdwatchers. Please see pages 18-19 for details on safe and responsible birdwatching practice. Additionally, please familiarize yourself with local restrictions and safety measures.

MIX
Paper from
responsible sources
FSC™ C007454

This book is produced from independently certified FSC™ paper to ensure responsible forest management.

THE BACKYARD BIRDWATCHER'S BIBLE

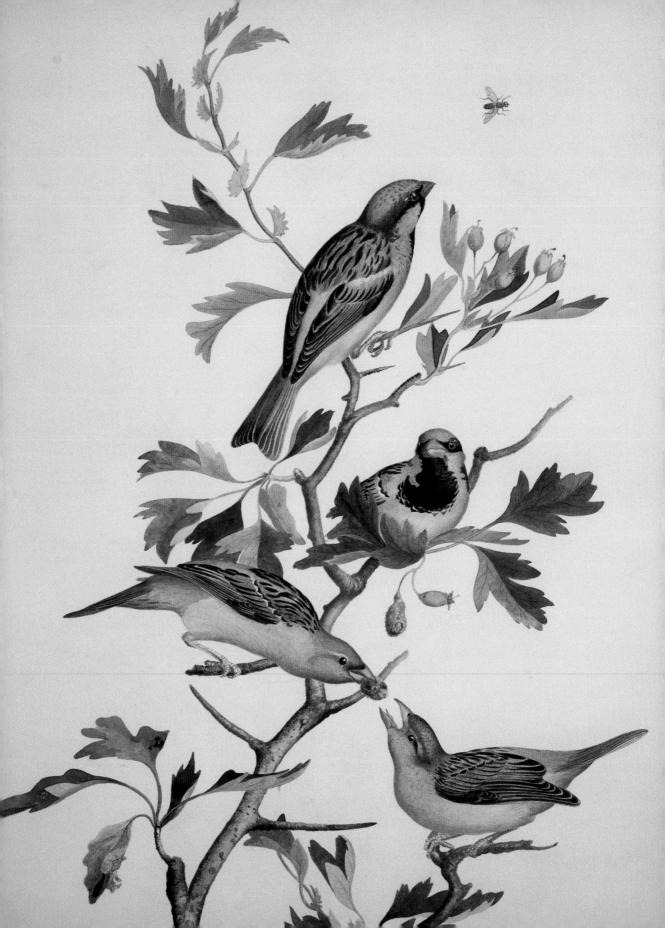

CONTENTS

7	Introduction	246	Times, weather, and seasons
10	How to use this book	250	Bird sounds
18	Safe and respectful	252	Types of birdwatchers
	birdwatching practice	256	Birdwatching equipment and outfitting
20	Bird topography and glossary		
		260	CHAPTER THREE:
24	CHAPTER ONE:		ATTRACTING BIRDS
	BACKYARD BIRD SPECIES	262	The bird-friendly backyard
26	The origins of birds	264	Foraging and feeding
28	Characteristics of birds	268	Trees and hedges
30	Feeding	272	Flowers, shrubs, and grasses
34	At-a-glance backyard birds	278	Bird tables, feeders, and baths
36	Species profiles	280	Make a bird table
		282	Make a fat ball
178	CHAPTER TWO:	283	Make a bird bath
	BIRDWATCHING FOR	285	Make a bird café
	BEGINNERS	286	Breeding and shelter
180	The study of birds		Climbers and vines
	Life of a bird	292	Woodpiles and compost heaps
183	What makes birds special?		Nest boxes and roosts
184	The hatchling	297	Make a nest box
186	Foraging behavior	302	Thinking sustainably
188	Flight		
192	Running, hopping, walking,	306	CHAPTER FOUR:
	and perching		BIRDS IN ART
194	Bird song	308	The art of birds
196	Territories	318	Ornithological art and illustration
198	Nests	330	Painting and sculpture
202	Eggs	340	Photography and film
204	Incubation	356	Design, craft, and style
206	Parental care	372	Swan song for the birds
210	Migration		
	Population	376	Additional resources
222	Protection and conservation	378	Dedication
228	The changing scene	383	Acknowledgements
236	History of birdwatching	386	Further reading and resources
240	Introduction to birdwatching	392	Index
242	Immersion	406	Picture credits
244	Bird habitats	413	Contributor biographies

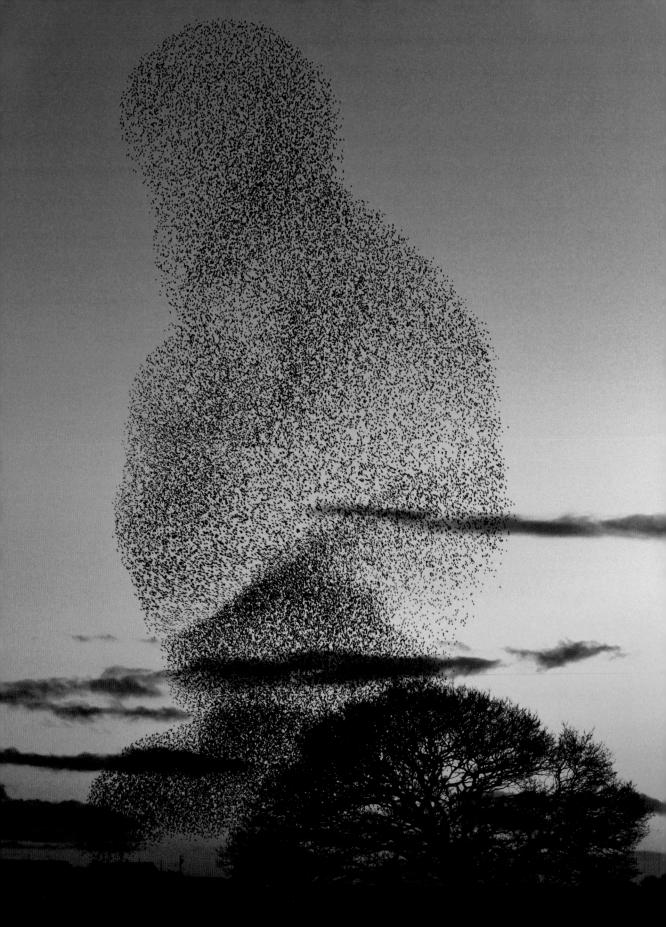

INTRODUCTION

Imagine there was a pastime that was fun, absorbing for all ages, easily accessible to anyone, proven to be good for your mental and physical health, remarkably inexpensive, ethically sound, and a gateway to a richer life—a pastime good for both the anguished soul and the anguished world. Now imagine you could undertake this pastime with no preparation, anywhere you live, and at any time of year, dipping in from time to time or immersing yourself completely.

Welcome to birdwatching, or birding, a hobby that is exploding worldwide. Astoundingly, about 50 million Americans regularly go out looking for birds. The birding community was once skewed toward the middle-aged and retirees, but its appeal has broadened enormously in recent years, attracting huge numbers of younger participants. Birdwatching is now mainstream; but more than that, it is trendy, and a trend that is here to stay. It ticks the boxes for wellness of soul and environment.

For millennia, humans have looked at birds at a basic level. People still watch, but the possibilities have expanded. Now we can take part in citizen science, photograph birds through telescopes using smartphones, communicate sightings through internet forums, use identification apps; many of us can even travel abroad to enjoy seeing different species. Birdwatching is the perfect hobby for the twenty-first century.

This book is the ideal companion to this perfect pastime. It is largely aimed at those who might not have tried birdwatching before, but it also provides a rich source of information for those further along the birdwatching journey. It is a handbook for the backyard and the backwoods, helping you identify the more familiar species, but also providing a mine of information about birds in general.

The handy At-a-Glance provides thumbnail illustrations of a selection of 96 familiar species, followed by a stunning profile of each one, with photographs, distribution map, and a factfile of details on

Opposite A murmuration of Starlings fills the evening sky

characteristics, location, food sources, and more. The species featured have been carefully chosen to be representative of those seen around houses and backyards across the country. As North America is a large area, the selection also illustrates those found commonly but which are specific to particular regions, such as along the East and West Coasts, and toward the Deep South. With so many possible species, we have decided to omit waterbirds, since these will mainly be seen on field visits and away from backyards.

Birds are remarkable creatures, from their powers of flight to their remarkable sense and astounding transcontinental migrations. Their origin is a shock, too; we now know that birds are the only surviving dinosaurs! This book has the whole story of a bird, from egg to chick to fledged juvenile, to adult fighting for survival. It covers reproduction, territory, song, parental care, and navigation, and presents amazing facts all along the way. It examines how the birds of North America and Europe came to be where they are, takes stock of their fortunes and discusses what might happen to them in the future. Part of that, of course, is down to us, and the last part describes how to start birdwatching so that you can best appreciate the birds around you. This includes information on societies to join and other ways to immerse yourself in this amazing hobby.

There is helpful information for the birdwatcher, providing fun and practical guidance about how you might help the birds of your backyard and beyond.

Millions of people across the world, in many

countries and in all climates, enjoy providing food and water for their backyard visitors, from Robins and Blackbirds to Hummingbirds and colorful Finches. The sheer delight of attracting something new and different is a feeling few of us ever forget, and it is a special pleasure simply to revel in the hive of activity that we have caused. Birds benefit enormously from our provision, and some species have changed their habits and distribution as a result. In this section we provide tips for what food to provide and how to provide it, as well as practical craft ideas for how to make your own bird feeders, bird boxes, and baths. Another great way to benefit birds is to plant your backyard with suitable plants that will keep providing the insect life, seeds, and fruits that they need, and this section provides advice and recommendations.

Birds have informed and instigated countless artforms over the centuries. It is therefore important to be able to present a celebration of birds in art, sculpture, photography, craft, and style. This book is illustrated with copious examples of the multitude of ways in which birds can be depicted, together with short profiles of a wide and eclectic range of contributors.

There are examples from around the world, and across a range of media, from the illustrations of John James Audubon to the paintings of Frida Kahlo, and from Bird Photographer of the Year to the designs of Charley Harper.

Birdwatching, indeed, has a worldwide reach. No human being is ever far from a bird, and this is one of the many reasons why looking for birds is so satisfying; some of the greatest experiences are on everyone's doorstep, wherever that doorstep may be. Birdwatching is also a hobby that brings people together, from birding buddies who go out each weekend to their local patch, to people using local guides abroad to discover new species. Social media ensures that no birdwatcher ever need feel isolated.

The world we know is a troubled place. We are recovering from a worldwide epidemic, and people seem to be polarized as never before. But beyond the human sphere, nature remains. It is bruised and battered, but still awesome and wonderful; we have a responsibility to protect it. One key, both to help ourselves and the world, is to look outside ourselves and wonder at the extraordinary creatures with which we share the planet.

HOW TO USE THIS BOOK

The Backyard Birdwatcher's Bible is a collective and connective celebration of some of the Earth's most beautiful creatures, from how our feathered friends evolved, appear, and function, to how to identify them and attract a range of common, backyard, or woodland species to visit us, to the story of birds in art.

Birds are endlessly fascinating creatures, particularly when you delve into their ancestry, their ability to fly, the science behind their coats of many colors or the symbolism attached to species such as Eagles, Doves, or Goldfinches in literature and art. There are also endless ways to appreciate them, whether that's through intellectual pursuit of what makes a bird, helping to conserve the myriad species still present on this Earth, providing food or nesting sites to help attract them to your backyard, or via the rewarding pastime or dedicated career of birdwatching or birding—or we may just stare in wonder at their beauty, quirks, or characteristics which are the focus of the ornithological art, illustration, and photography found throughout this book.

To help navigate such flights of knowledge and fancy, The Backyard Birdwatcher's Bible is divided into four chapters which explore all of these elements. There is also a guide to Safe and Respectful Birdwatching Practice (see pages 18-19), Bird Topography and Glossary (see pages 20-21) and suggestions for Further Reading and Resources (see pages 386-389).

The book opens with Chapter 1: Backyard Bird Species—a narrative that traverses millions of years, from the first identifiable birds to the avian world of the present day. The story opens with a brief history of the Origins of Birds (see page 26),

hurtling back in time some 140 million years to the reptilian yet feathered "missing link" known as Archaeopteryx lithographica, to the flight-capable seabird-like creature known as Ichthyornis, the ancient forerunner of familiar species such as Geese, Partridges, and Flamingos. By the end of the Eocene era, birds had most definitely arrived and with them came a flight-path of evolutionary adaptations concerning aerodynamic and postural skeletal and muscular aspects of bird anatomy (see page 28), the process of feeding (see page 30), the reproductive life cycle (see page 33), and ultimately birds' ability to survive.

Segueing into an introductory guide to backyard bird species (see page 34) The Backyard Birdwatcher's Bible lists ninety-six of the most easily identifiable backyard or woodland birds, from Wrens, Robins, Starlings, Waxwings, Blackbirds, Warblers, and Finches to Doves, Owls, Woodpeckers, Swallows, Swifts, and Kingfishers. Each illustrated entry comes with a short description and fact file pertaining to the species' typical size, markings, habitat, food preference, voice, and distribution to help you spot the difference between families of birds such as the Chickadees, or to help you become familiar with brightly colored national treasures such as Northern Cardinals and Evening Grosbeaks.

Each **species** is introduced by its most commonly used English name followed by its scientific name. In the main these names are those recommended and used by major birdwatching organizations.

The main text for each species provides detailed information on appearance and plumage for all relevant ages and sexes. In addition, behavioral habits and background information are described where it helps the reader gain an insight into the bird in question.

A though introduced little more than a century ago, the European Starling is now an abundant bird in North America. The saxes are suitedy dissimilar in summer Soutmers adult rudles have duch planning that shows a green and purple manable of the otherwise yellow bill. Summer adult fermles are similar but have some pale spots on the undergrant. In without pale starting adorted with numerous white spots, and the bill is distributed with numerous white spots, and the bill and rudlergrant. In without planning adorted with numerous white spots, and the bill and rudlergrant for which with spots, but the beds and nock remain buff. The large are reddish in all birds. The Burguess Burdling is present year consent populations more could in winter. Is forms lugge thecks in winter, which range widely in search of food.

FACTFILE
Length 'bin (ZScm)
Habitata Wide range of habitats, from farmland to towns and cities
Food Opportunistic enumiver
Status Wideopread and abundant resident, and partial migrant
Woler Song includes various chatters, favoral whisted, pilos ministry of other binks and manusake sounds. Calls include chatters and drawn-out whisted.

The maps depict geographical ranges, a species' seasonal occurence being represented by different colors:

- indicates a species' presence year-round;
- indicates a species' presence during spring and summer;
- indicates a species' presence from late autumn and throughout winter;
- III indicates a species' presence on migration.

The Factfile section provides an easy reference to important information about each species: Length; Habitat; Food; Status; Voice; and Song.

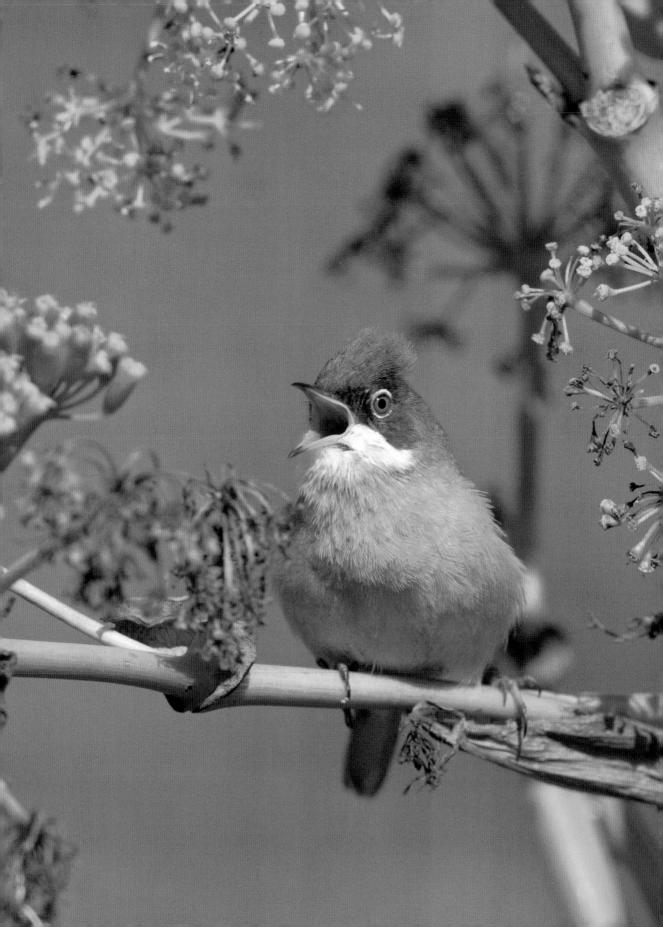

Written in the era of Coronavirus, with locked-down streets free of cars and skies devoid of airplanes, birds are particularly symbolic of the daily freedoms that we may have taken for granted in our former lives. Watching birds go about their daily lives—foraging and feeding, making nests and mating, fluttering and flying-can also be incredibly uplifting, especially when accompanied by an amplified soundtrack of chirping, tweeting, and bird song. Delve into Chapter 2: Birdwatching for Beginners and you'll find an ideal introductory or refresher course on avian habits and habitats that make such observations even more poignant.

Life of a Bird (see page 182) provides a fascinating insight into avian life followed by a foray into the differences between birding and birdwatching (see page 252) and some of the key figures and moments in the history of ornithology. While it's not necessary to own all the latest bird books, binoculars, high-tech camera attachments, or specialist clothing to enjoy the company of birds, some basic Equipment and Outfitting (see page 256) can make even an everyday experience much more rewarding, and there are tips and advice on optional extras for if you want to turn a hobby into something more serious.

Go behind the scenes of the life of a Hatchling (see page 184)—a bird's-eye view of what it takes to hatch, often naked, from an egg and survive those first few crucial hours or days relying completely on parental care. Explore the nature of Eggs (see page 203)—how they are formed, their size and shape, variations in color, and the contents that, after Incubation (see page 204), give life to a baby bird. In order to lay such eggs, birds must first make a home in the form of a Nest (see page 198)—high in the trees, deep within bushes, among reeds, in the eaves or houses, or in burrows or caves. Young birds are very much reliant on Parental Care (see page 207) until finally

Opposite A young male Spectacled Warbler (Sylvia conspicillatus orbitalis) in song

able to fend for themselves as fully fledged juveniles, able to practice skilled Foraging Behavior (see page 187), Running, Hopping, Walking, and Perching (see page 192), and Flight (see page 188).

Flight is one of the most enthralling lines of enquiry when it comes to birds, as they are the only vertebrates with this ability apart from bats. The anatomy and skill that enables the wonder of taking-off, fluttering, soaring, gliding, and turning has fascinated humans for tens of thousands of years. The endurance required to journey across wide oceans and land masses during Migration (see page 210) is truly awe-inspiring to behold. Bird communication is another marvel, most especially the world-enhancing gift of Bird Song (see page 194) with a vast repertoire of calls and mimicking abilities.

Flight and communication—through visual displays and voice—are also paramount when it comes to staking out territory. Territories on page 196 provides an enlightening guide to the lengths birds will go to in order to attract a mate and defend vital resources and their young, helping to reduce disease, predation, aggression, and over-population at the same time. Chapter 2 explains the ecology of birds, how they fit into the environment in which they live and how they co-exist with other organisms, including humans. Find out about birds' strategies for survival, how they live, feed, and breed.

Birds account for over 11,000 of all known creatures on Earth-although some scientists estimate that there may be nearly twice as many due to the "hidden" diversity of species that look to us to be similar to one another. However, over 150 birds are known to have become extinct over the past few hundred years and over 400 avian species are currently listed as endangered. With threats including human-made habitat loss and climate change, consider the effects on bird Population (see page 217). There are lots of things that we can do to turn the tide for birds with dwindling numbers, through Protection and Conservation (see page 222)

of natural habitats. For a list of national and international organizations that undertake and promote critical work in the wild, turn to Useful Resources on page 389.

Addressing these issues at ground level, Chapter 3: Attracting Birds provides a hands-on introduction to the Bird-Friendly Backyard (see page 266) starting with an overview of Foraging and Feeding habits (see page 268) according to species preference and season. Packed with planting tips and advice for all kinds of spaces, from large landscapes and backyards to small balconies or backyards, it's easier than you think to incorporate at least some of what birds need or love.

Trees and Hedges (see page 272) such as hawthorn, mountain ash, firethorn, and holly provide fruits, nesting sites, shelter, refuge, and perches, for example. While Flowers, Shrubs, and Grasses (see page 277) such as sunflower, coneflower, and panic grass attract bird-tempting insects and bugs, and provide nutritionally important seeds through fall and winter. It's also possible to put out supplementary food in the form of seeds, nuts, fat balls, or grubs, especially welcome in breeding season or winter. Read all about Bird Tables, Feeders, and Baths on page 282, including step-by-step guides on how to make a bird table (see page 284), a fat ball (see page 286) or a bird café (see page 289). Birds need water too, so there's also a guide to crafting a simple bird bath (see page 287) and advice on how to keep feeding and water stations clean.

Breeding and Shelter (see page 290) are also key factors in a bird-friendly backyard. Climbers and Vines (see page 292), for example, often provide delicious and nutritious berries or seeds but also ideal foliage, branches, or hidey-holes for nests, roosts, or shelter from predators. Plants such as ivy or clematis can also be grown in relatively small spaces, up a trellis, wall, or fence. Less ornamental features such as Woodpiles and Compost Heaps (see page

Opposite A Barn Owl (Tyto alba) perches on a fence

296) harbor an abundance of food, shelter, and nesting places for birds, with extra support from bird-friendly plants such as nettles, borage, cleavers, dandelions, elderberry, and yarrow. Bolstering plant diversity, providing seasonal food, and leaving corners of the garden to go wild is also part of Thinking Sustainably (see page 306), a crucial mind set in terms of bird protection and conservation, but also one that can bring huge rewards in terms of bird watching and song.

Celebrating birds in all their glory and diversity is the main theme of Chapter 4: Birds in Art with The Art of Birds (see page 310) setting the scene with a soaring guide to over 40,000 years of bird-themed or inspired art. From the first fledgling impressions of birds in Palaeolithic cave art, through symbolic paintings, ornithological illustrations, and decorative displays, to today's intimate high-tech photography of avian life, it's clear that birds have always held a huge power to intrigue, uplift, and teach us much about the natural world and the role that we play in it.

Explore the world of Ornithological Art and Illustration (see page 320), celebrating the works of master bird artists and observers past and present from John and Elizabeth Gould and James Audubon to Roger Tory Peterson, David Sibley, Matt Sewell, and Jane Kim. From beautiful paintings to painstakingly produced prints, to huge murals expressing the evolution of birds, what flocks these works together is the scientific study of birds through time, place, and classification as well as the exquisite portrayal of them.

The twentieth century not only saw advances in modern art but also major technological change, including the invention of the first portable cameras. From early black-and-white snapshots of birdlife by Eric Hosking to high-resolution portraits or cinematic documentaries by Bence Máté or David Attenborough, Photography and Film of birds (see page 342) now allow us to get closer to avian life than ever before,

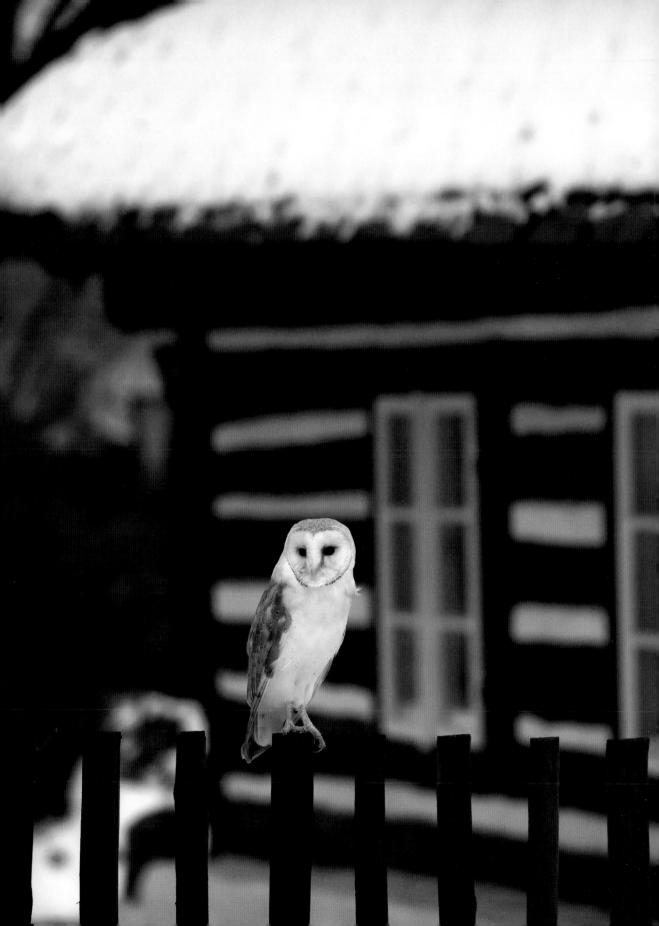

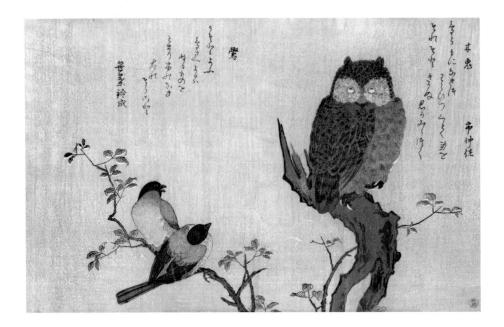

including rare or typically shy species. Zoom, macro, and studio photography also facilitate detailed portraits of birds' physical or habitual features by artists such as Thomas Lohr or Leila Jeffreys. There is also some background on the internationally renowned Bird Photographer of the Year (BPOTY) competition for those interested in capturing birds on film.

Our metaphysical relationship with birds is perhaps best expressed through the Painting and Sculpture they have inspired (see page 332). From spiritually invested bird-and-flower paintings exemplified via the Japanese art of *Kacho-e* and iconic dove drawings by Pablo Picasso, to Constantin Brancusi's soulful *Bird in Space* sculpture or Frida Kahlo's self portraits with her pet parrots, the bird as muse is a timeless theme. We seek to capture their richly colored plumage or their soaring flight, but we also see birds as symbols of peace, hope, power, familiarity, and joy.

Some of the most memorable or charming images of birds, however, have been created in the disciplines of Design, Craft, and Style (see page 358), from bird-inspired, ancient textiles and ceramics and the Arts and Crafts motifs of artists

William Morris and C.F.A. Voysey to the beautiful stylized or illustrative prints of Charley Harper or Robert Gillmor. While some of these works are incredibly detailed or decorative, others, such as Edward Lear's "colored birds," sum up the defining characteristics of our feathered friends in a few allegorical lines and words, the mark of an ornithological illustrator as well as a humorous artist and poet.

Last but not least, Swan Song for the Birds (see page 374) pays homage to the birds that, although preserved for posterity in galleries and museums, sadly didn't make it to the present day: the Dodos, Passenger Pigeons, Labrador Ducks, Carolina Parakeets, and Great Auks. Art provides a vital visual reminder to celebrate the true wonder and diversity of today's avian world by observing and representing birds, but also by conserving them and their habitats for millennia to come.

Above An Owl and Two Eastern Bullfinches from Kitagawa Utamaro's Birds Compared in Humorous Songs (1791) **Opposite** Bullfinch and Weeping Cherry Tree (1834) by Katsushika Hokusai

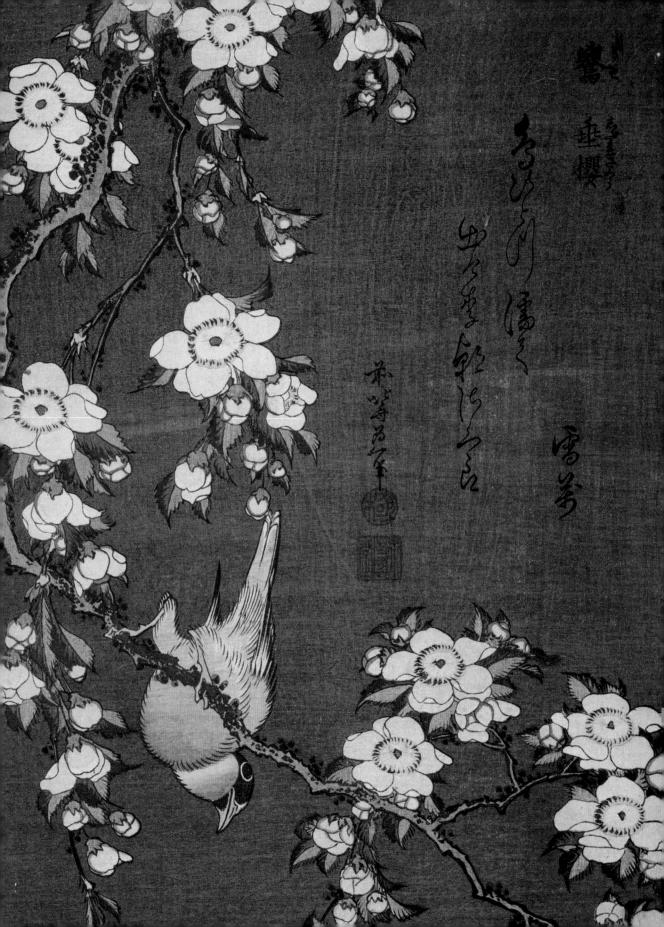

SAFE AND RESPECTFUL BIRDWATCHING PRACTICE

Whether you're new to birdwatching or a fully fledged birder, following a widely agreed birdwatchers' code of conduct helps protect birds while allowing everybody to enjoy the wonders of the avian world, now and for years to come.

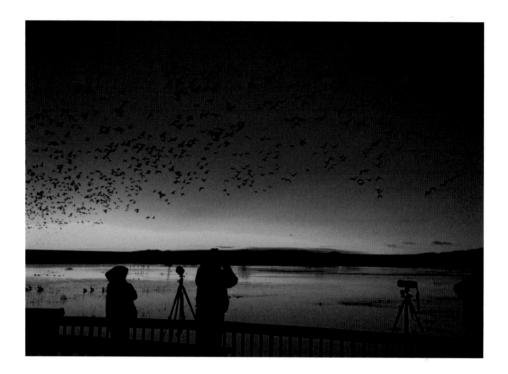

Millions of people take part in birdwatching or birding activities each year around the globe—forty-seven million in the US—supported by ornithological societies such as the American Birding Association (ABA), the National Audubon Society, and the international partnership known as BirdLife. This is great news on two counts: one, you're part of a huge and growing community of like-minded souls, and two, there's plenty of great official advice out there on how to observe birds respectfully and safely, including the widely adopted birdwatchers' code.

Gear up

Sport dark, easily camouflaged clothing to help keep a low profile and prevent birds seeing you coming. Check the weather and bring appropriate gear for rain showers, wind, or strong sunshine: invest in a good waterproof/windproof jacket, hiking shoes (and comfortable socks), sunblock, and hats for winter and summer. Seasoned birdwatchers also never leave the house without a pair of binoculars, a pen and paper to record sightings, a bird guide, a map (if you're in unfamiliar territory), and some drinks and snacks. A smartphone can also be handy for taking snaps or notes as well as helping with navigation and communication, including emergency calls.

Avoid disturbing birds

If birds are disturbed during the breeding season they may keep away from their nests, leaving chicks hungry or enabling predators to take their eggs or young. It is also illegal to ever remove or harbor wild bird eggs, or to disturb nests in the breeding season. In cold weather or just after migrants have made a long flight, repeatedly disturbing birds can significantly impact on vital energy needed for breeding or foraging in order to survive the winter. If a bird makes repeated alarm calls, flushes—flies or runs away—or appears to freeze, you're too close. Staying on roads and paths where they exist can help to avoid disturbing habitats used by birds, as can becoming more familiar with flock or species behavior.

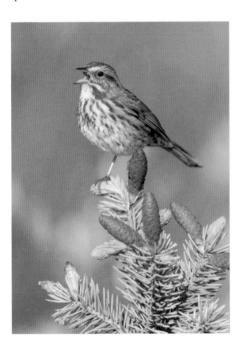

Opposite Birdwatchers observing flocks of Snow Geese taking off in the Bosque del Apache National Wildlife Refuge, New Mexico, USA Above A Song Sparrow (Melospiza melodia) in song

Use equipment wisely

Camera flashes should be turned off, or a filtered flash, at most, used for night photography. If you're serious about getting the ultimate photographic bird shot, consider using a telephoto lens or a bird hide where you can get a great view of birds without making your presence known—see Bence Máté's photography in Chapter 4: Birds in Art (see page 356) for inspiration. Making sound recordings of birds can be wonderfully rewarding, but playing songs to attract birds is controversial, so limit its use, obey local restrictions, keep quiet around rare birds, ask permission if you are in a group, and take care to avoid invading a bird's territory or confusing birds during the breeding season.

Be an ambassador for birdwatching

This means being kind, considerate, and friendly to birds, fellow birdwatchers, and birders as well as those not interested in birds at all. Remember to follow the laws of the countryside at home and abroad, including closing gates, never trespassing on private land, and "leaving no trace" of litter, trampled vegetation, or disturbance to any wildlife. It's also helpful to report findings to bird conservation organizations, but think twice about passing on information about rare species to fellow birders or birdwatchers too quickly. Consider the potential impact to the birds and their habitats, plus the people or communities who live nearby. Last but not least, enjoy yourself. There's no rule that says you can't inspire others to observe, conserve, and protect birds via the example you set and the enthusiasm you bring.

BIRD TOPOGRAPHY AND GLOSSARY

Ornithologists give precise names to distinct parts of a bird's body, both to the bare parts (legs and bill, for example) and areas of feathering (wing coverts, primaries, and the like). These terms have been used throughout the book to ensure precision and to avoid ambiguity about what is being described or discussed. As a reader, an understanding of this terminology helps with interpretation of the descriptive text in the book. It is also helps when talking about bird identification with other birdwatchers, and is useful in the process of identification in the field. On the following pages, a glossary of terms helps with the learning process, and annotated photographs show the important anatomical and topographical features for a range of common bird species.

Adult A fully mature bird.

Axillaries The area of feathers that cover the "armpit" of the bird; this is only visible on stretched wings or in flight.

Bill The beak.

Carpal The "wrist" of a bird, formed at the bend of the wing.

Coverts Areas of contour feathers found on the upperwing, underwing, uppertail, and undertail.

Culmen The upper ridge of the bill.

Eye-ring A ring of feathers, often colorful, that surrounds the eye.

First-winter A bird's plumage in its first winter after hatching. (1st Basic Plumage)

Forewing The leading edge of the upperwing. **Gorget** A patch of color on the throat of a bird—especially Hummingbirds.

Immature A bird that is any age younger than an adult.

Juvenal A young bird with its first set of full feathers. **Lek** A communal display.

Lores The area between the eye and the bill. **Malar** A band or stripe of feathers on the side of the throat, in front of and below the submoustachial stripe.

Mandibles The two parts of a bird's bill: upper and lower.

Mantle Feathers covering the back.

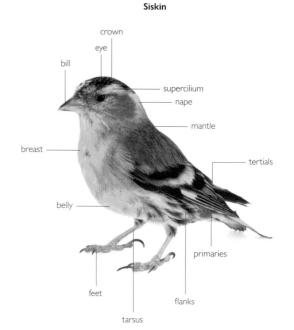

Eastern Bluebird

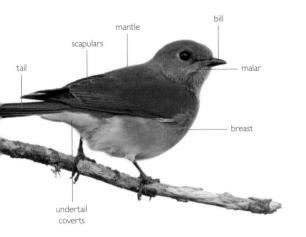

Migrants Birds that have geographically separate breeding grounds and winter quarters. Many birds of the region are breeding visitors, present here in spring and summer but wintering as far away as Africa. A few species use Central America, South America, and the Carribean as their wintering grounds.

Moustachial stripe A stripe that runs from the bill to below the eye, fancifully resembling a moustache. Nape The hind neck.

Nidifugous Born or hatched in an advanced state. Nidicolous Born or hatched in an undeveloped state. Orbital ring Ring of bare skin around the eye, often brightly colored.

Pelagic Associated with or living in the open ocean. Primaries The main flight feathers found on the outer half of the wing.

Primary projection The visible extent of the primary feathers beyond the tertials on the folded wing.

Rufous Reddish-brown in color. **Scapulars** A group of feathers that form the "shoulder" of the bird between the back and folded wing.

House Sparrow

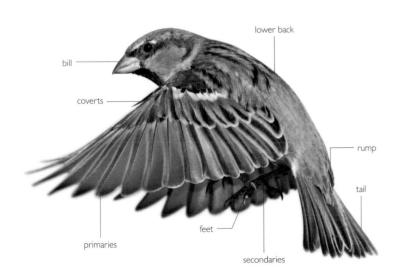

Seabird A species that, outside the breeding season, spends its life at sea.

Second-winter A bird's plumage in its second calendar winter after hatching. (2nd Basic Plumage) **Secondaries** A group of relatively large flight feathers that form the inner part of the wing.

Species A taxonomic description relating to a population, members of which breed with one another but not with others. A species' scientific name is binomial, comprising the genus name first followed by the specific name; taken together the name is unique.

Supercilium A stripe that runs above the eye. **Tarsus** The obvious main section of a bird's leg, below the "knee."

Tertials The innermost flight feathers.

Third-winter A bird's plumage in its third calendar winter after hatching. (3rd Basic Plumage)

Tibia The area of the leg above the "knee."

Vent The area underneath the tail, covered by the undertail coverts.

Wingbar A bar or band on the wings, created by aligned pale feather tips, often those of the wing coverts.

Black-headed Gull

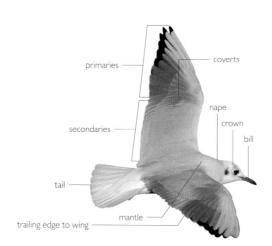

American Goldfinch

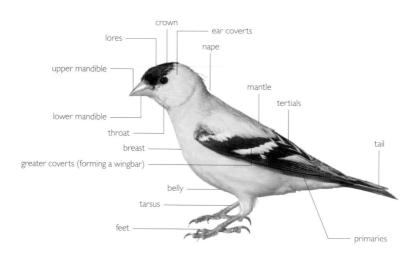

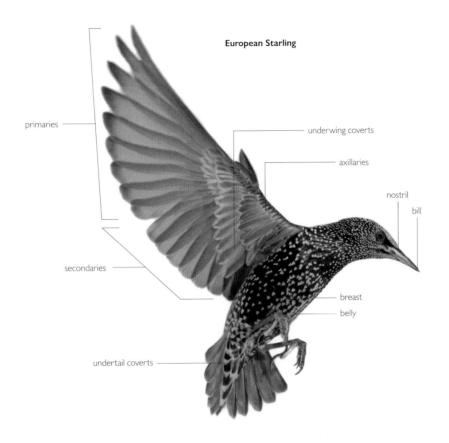

Common Grackle

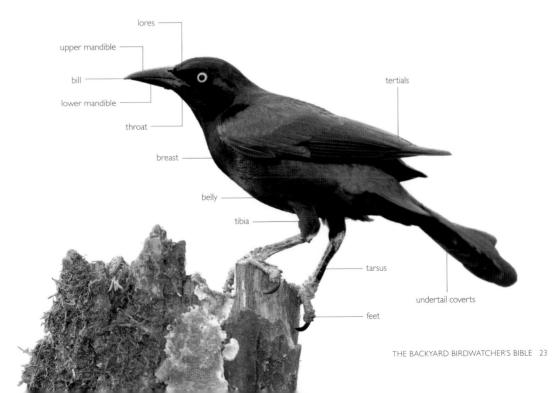

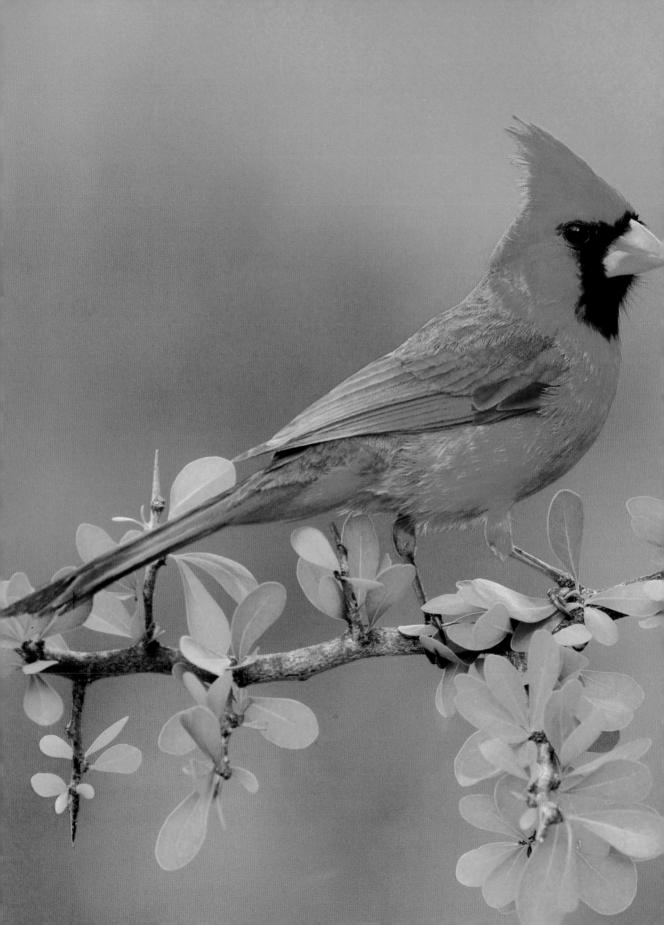

CHAPTER ONE

BACKYARD BIRD SPECIES

The Place of Birds in the Animal Kingdom

THE ORIGINS OF BIRDS

Traces of animals and plants—fossils —exist in rocks that were formed many millions of years ago. Initially animals evolved in the sea; but later the early lung-fish and amphibians conquered the land to be followed by the reptiles. Two branches of reptiles played very important parts in the history of animals; these are the synapsids, which eventually gave rise to the mammals; and the sauropsids, which evolved into modern reptiles and birds. Between 240 and 65 million years ago, a branch of the sauropsids, the dinosaurs, became the dominant group of land animals; these included most of the largest that have ever existed, such as the famous Tyrannosaurus rex.

Living alongside these huge animals were many smaller sauropsids, which evolved into an extensive range of small, agile, and fast-moving creatures, some of which ran on two feet and sometimes climbed using their forelimbs. Being smaller and more fragile than the larger dinosaurs, there are fewer fossil remains and for a long time they were less well known.

In 1861, workers in a slate quarry in Bavaria, Germany, discovered what at first seemed to be just another one of these small sauropsid fossils. But beautifully preserved in the fine slate were feathers on the wings and tail! Archaeopteryx lithographica (literally "ancient-wing in picture stone") became one of the world's most famous fossils: it caused a sensation because it looked like a "missing link" between reptiles and birds -among other features it had a long, bony tail and reptile-like teeth. Recent finds, especially from China, have unveiled a great radiation of forms from the beginning of the Cretaceous (145-65 million years ago). While Archaeopteryx is a striking fossil, there are many other small dinosaurs, some anatomically so similar to birds that they blur the traditional distinction between birds and

reptiles. One widespread feature is some sort of feather-like structures covering the body. These could not have been used for flight, but may have been used for camouflage or display. Another likely function was for insulation, and the probable reason for this was that these animals were warm-blooded and needed a coat in order to be able to maintain their body temperature.

By some 70 million years ago many lines of these smaller dinosaurs existed alongside their vastly larger cousins. Then, a little over 66 million years ago, came the single most important happening in the history of birds: a massive earthquake. The Chicxulub Eruption occurred in the Caribbean Sea off the coast of Honduras. Its immediate impacts—tsunamis across the whole of the Caribbean, forest-felling gales, and fallout of volcanic debris across the whole of North America—were almost minor compared with the global effects. For several years clouds of dust, hanging in the atmosphere, cut out the light and killed off most of the vegetation and the animals dependent on it; some 70 percent of the plant and animal species, including all of the big dinosaurs, both on land and in the sea, went extinct.

This episode is known as the Cretaceous–Paleogene (K–Pg) boundary and had important outcomes. With the stage lacking its major players, there was scope for a cast of smaller players. Some of those who had survived were able to move centerstage and become the major players. And they did! Many groups of both mammals and birds first appear in the fossil record at this time.

The story that the dinosaurs became extinct at this time is not quite true; one small and insignificant group survived and flourished: birds *are* dinosaurs!

Previous page Male Northern Cardinal perched in a tree Opposite page Archaeopteryx lithographica, considered to be the earliest-known bird

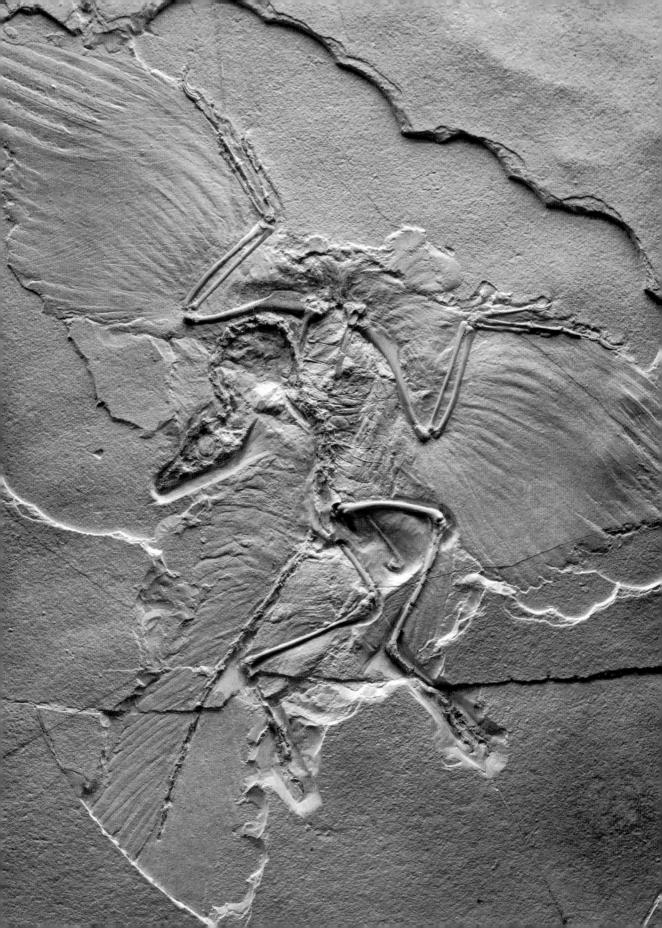

CHARACTERISTICS OF BIRDS

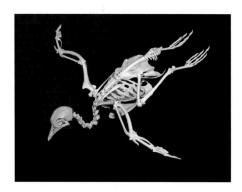

In general form all birds are very similar to one another. Birds have such a constant form because of the need to be able to fly efficiently. Flight is one of the most useful, and one of the most energy-demanding, methods of locomotion. In order to make it as economical as possible—indeed in many species to make flight possible at all—birds cannot deviate from sound aerodynamic design. Only in a few species, such as the ostriches and the penguins, which have abandoned flight, has it been possible to alter greatly the basic size and shape.

It is possible to see adaptations for flight in virtually every aspect of a bird's anatomy; evolution has made birds as light as possible, and as maneuverable as possible. However, since there is also a great need of power for flight, some parts, such as the flight muscles, could not be greatly reduced.

The skeleton

The skeleton of a bird shows a number of marked adaptations for efficient flight, all of which can be looked on as helping to reduce weight or to make the bird as compact and maneuverable as possible.

The weight of the bird's skeleton has been reduced in a number of ways. Some parts have been greatly reduced and many of those bones that remain have been considerably lightened. In areas such as the spine and synsacrum, bones have fused together, reducing the need for muscles and other

tissues to hold them together. The skeleton of a pigeon is only 4.5 percent of the bird's total body weight. Many bird bones are hollow tubes instead of being almost solid like those of mammals; the outer surface of the bone remains big enough to provide adequate attachment for muscles, but its weight is much reduced.

The limbs and the muscles

All terrestrial animals use one or both pairs of limbs for locomotion. Most use both pairs of limbs simultaneously and these are positioned so that the animal's center of gravity falls between the limbs. Birds, however, have two quite different modes of locomotion—flying, and walking or swimming. In order to do both efficiently, they must have the center of gravity close to the base of both sets of limbs, and this has led to certain modifications.

When in flight, a bird's body hangs from the shoulder joints and the center of gravity lies just beneath the shoulders. However, this means that the center of gravity is well forward of the hip joint; so a perched or standing bird balanced at its hips would be in danger of falling forwards when it walked. The bird's skeleton has adapted to deal with this problem. The top section of the leg, the femur, is tightly held along the sides of the body by muscles. The lower end of the femur then performs as if it were the hip joint; because this is nearer to the center of gravity, the bird has less of a problem balancing when it is walking.

In order to power its wings, a bird needs a massive power source, and this is provided by great flight muscles. In most species the weight of these muscles is about 15 percent of the bird's total weight, but in hummingbirds this may be as high as 30 percent.

Above Skeleton of a pigeon **Opposite** A Ringneck Dove rises into the air

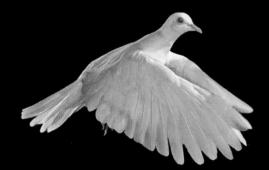

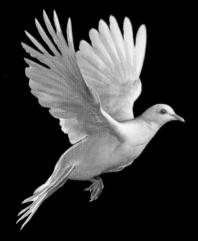

FEEDING

Although the weight of a bird's head has been reduced by the loss of the heavy jaws and teeth of its reptilian ancestors, food still has to be collected, caught, or torn up, and birds need to use some sort of tool for this. Beaks vary in design in order to deal with a wide variety of foods. A good clue to a bird's food can be found in the sort of beak it has.

Despite the wide range of forms, the basic design of the *beak is* similar in all birds. The upper mandible is firmly attached to the skull, though in many species there is a small amount of articulation between the mandible and the skull. The lower mandible, like the human one, is much freer, articulating at its base with and held to the skull only by muscles.

The horny outer surface of the bill is, like scales and fingernails, made of keratin. This wears away and is replaced.

Natural selection has resulted in a great diversity of bills, each enabling its owner to cope with a specific diet. The most generalized bill, such as those of warblers and thrushes, is a pointed one of medium length; this can be used for collecting a wide variety of foods from insects to fruits. Warblers do little more than stab their insect prey to kill it; Song Thrushes hold prey such as snails, then beat them on a rock; both swallow their prey whole, as do many other birds. Although the bill of the Starling is similar, it has much more powerful muscles for opening the bill; it probes into soil and forces the bill open so as to enlarge the hole to enable it to withdraw any prev that it finds.

The master hammerers are, of course, the woodpeckers; the Great Spotted Woodpecker often makes a small hole in a tree branch in which to wedge nuts or seeds while it hammers them open. At other times a

Right A Hawfinch Opposite The digestive system of a bird

woodpecker uses its bill for opening up wood to get at burrowing insects. They may even take the young of hole-nesting birds such as chickadees and titmice. They have very long tongues with which to reach and grasp the prey, and special adaptations of the skull that reduce the shock of the hammering to the brain. The Green Woodpecker can extend its tongue four times the length of its bill, the Wryneck five times.

The bills of finches have evolved specializations for opening seeds. The upper mandible has a groove in which the seed can be held by the tongue while it is split by the cutting edge of the lower mandible. The extreme development of this type of bill is found in the Hawfinch, which has the largest beak of any European finch; the jaw musculature is also exceptionally large. The Hawfinch is able to split open the stones of cherries and olives, a feat requiring a crushing force of 8.8 pounds (4 kilograms) per square centimeter or more. The crossbills

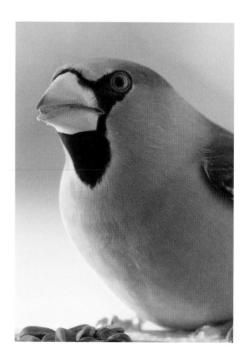

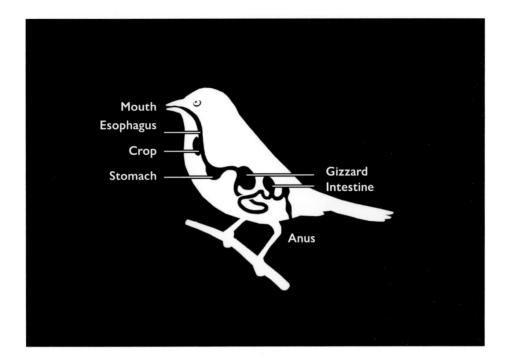

have unusual beaks which enable them to twist open the scales of conifer cones and scoop out the seeds with their tongues.

The jaw muscles of birds of prey are also powerful; many of these birds use their bill for tearing large prey into pieces small enough to swallow. They may also actually use the bill to kill their prey. The owls do not normally tear up their prey, but swallow it whole; their bill and jaw muscles are less powerful.

The weakest bills are found in many of the insectivores, such as the flycatchers, swallows, swifts, and nightjars. These species mostly catch flying insects and rely on a very wide gape to give them the best chance of doing this.

The Crop

Many birds accumulate their food, initially, in a thin-walled extension of the esophagus—the crop. No digestion takes place here. It is simply a temporary storage area and allows a finch, for example, to alight, swallow a large number of small seeds in a short space of time, and then retire to the safety of a bush to digest them. The bird can also take a large quantity of seeds to

roost with it and digest them during the night, so shortening the period over which it has to go without food. Many birds, such as some seabirds and pigeons, carry food long distances in their crops to their young. In pigeons and flamingos, the crop wall becomes thickened during the nesting period and the cells from these thickened areas are sloughed off to provide a milk-like substance for the chicks.

The Gizzard

Because birds no longer have sets of teeth with which to grind up their food, this treatment has to be carried out elsewhere. Birds that eat insects, fish, or meat do not have a great problem since their stomachs have strong juices and their food is easily digested. This is not so true of the birds, such as finches, that eat vegetable matter. They need to be able to grind up their food into fine particles to digest it properly. They do this in the gizzard, the muscular forepart of the stomach; hard material to serve as teeth is needed for the grinding process, so these birds take in grit and mix it with the food.

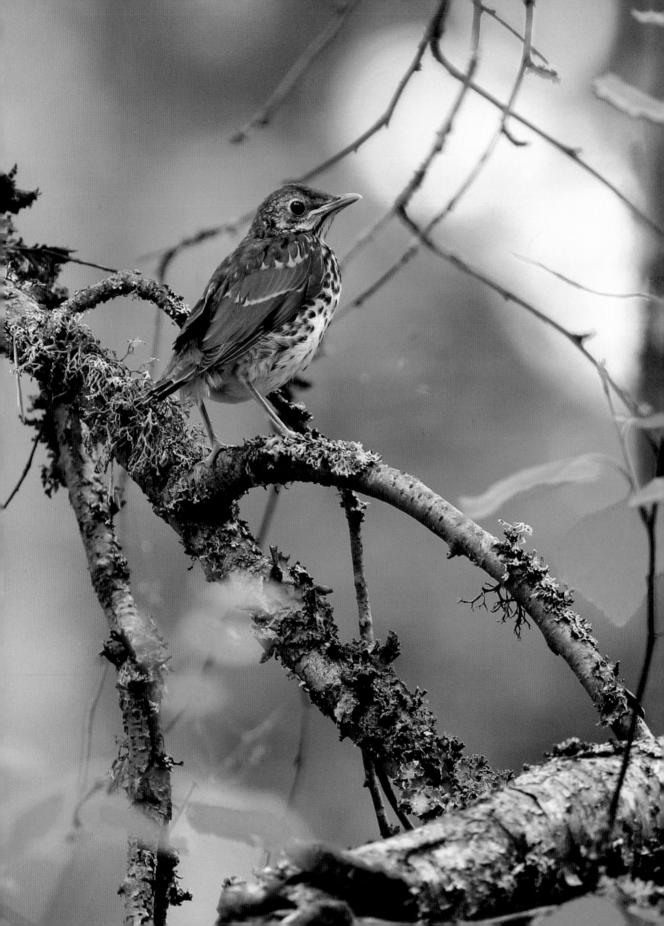

THE LIFE CYCLE OF A BIRD

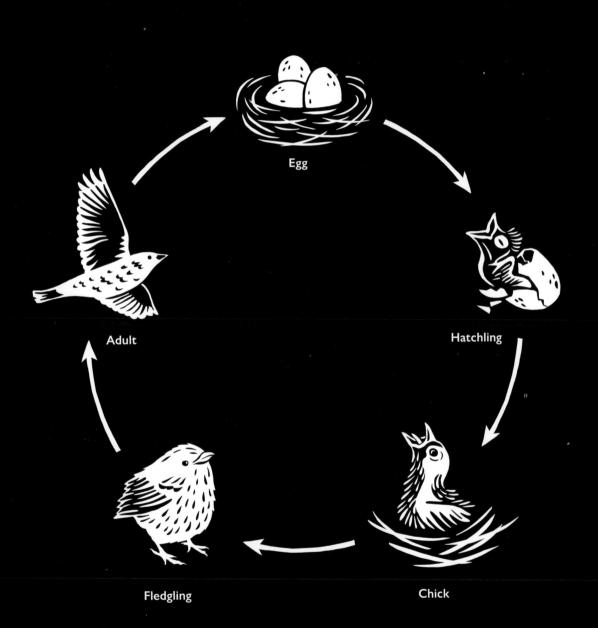

Opposite A Song Thrush chick perches on a branch **This page** The life cycle of a bird

AT-A-GLANCE BACKYARD BIRDS

Sharp-shinned Hawk Accipiter striatus page 38

Cooper's Hawk Accipiter cooperii page 38

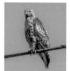

Red-tailed Hawk Buteo jamaicensis page 40

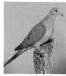

Mourning Dove Zenaida macroura page 42

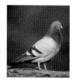

Rock Pigeon/Rock Dove Columba livia page 43

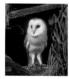

Barn Owl Tyto alba page 46

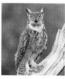

Great Horned Owl Bubo virginianus page 47

Eastern Screech Owl Megascops asio page 48

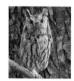

Western Screech Owl Megascops kennicottii page 49

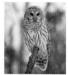

Barred Owl Strix varia page 50

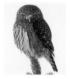

Northern Pygmy Owl Glaucidium gnoma page 51

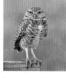

Burrowing Owl Athene cunicularia page 52

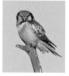

Northern Hawk Owl Surnia ulula page 53

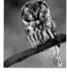

Boreal Owl Aegolius funereus page 54

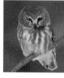

Northern Sawwhet Owl Aegolius acadicus page 55

Eastern Whip-poor-will Antrostomus vociferus page 58

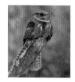

Chuck-will'swidow Antrostomus carolinensis page 59

Common Nighthawk Chordeiles minor page 60

Common Poorwill Phalaenoptilus nuttallii page 61

Chimney Swift Chaetura pelagica page 62

Calliope Hummingbird Selasphorus calliope page 66

Broad-tailed Hummingbird Selasphorus platycercus page 67

Ruby-throated Hummingbird Archilochus colubris page 68

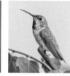

Allen's Hummingbird Selasphorus sasin page 69

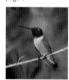

Black-chinned Hummingbird Archilochus alexandri page 70

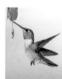

Rufous Hummingbird Selasphorus rufus page 71

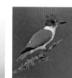

Belted Kingfisher Megaceryle alcyon page 72

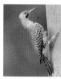

Northern Flicker Colaptes auratus page 76

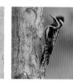

Yellow-bellied Sapsucker Sphyrapicus varius page 78

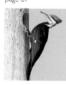

Pileated Woodpecker Dryocopus pileatus page 79

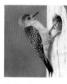

Red-bellied Woodpecker Melanerpes carolinus page 80

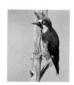

Acorn Woodpecker Melanerpes formicivorus page 81

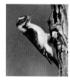

Woodpecker Dryobates pubescens page 82

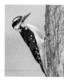

Woodpecker page 83

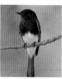

Black Phoebe Sayornis nigricans page 86

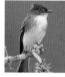

Eastern Phoebe Savornis phoebe page 87

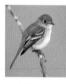

Least Flycatcher Empidonax minimus page 88

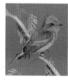

Vermilion Flycatcher Pyrocephalus rubinus page 89

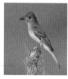

Great Crested Flycatcher Mviarchus crinitus page 90

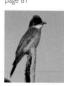

Eastern Kingbird Tyrannus tyrannus page 91

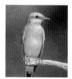

Western Kingbird Tyrannus verticalis page 92

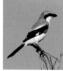

Northern Shrike Lanius excubitor page 93

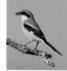

Loggerhead Shrike Red-eyed Vireo Lanius Iudovicianus page 94

Vireo olivaceus page 95

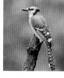

Blue Jay Cyanocitta cristata page 96

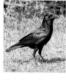

American Crow brachyrhynchos page 98

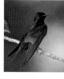

Purple Martin page 100

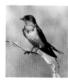

Barn Swallow Hirundo rustica page 102

Tufted Titmouse Baeolophus bicolor page 106

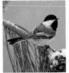

Black-capped Chickadee Poecile atricapillus page 107

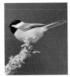

Carolina Chickadee Poecile carolinensis page 108

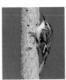

Brown Creeper Certhia americana page 109

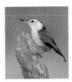

White-breasted Nuthatch Sitta carolinensis page 110

Red-breasted Nuthatch Sitta canadensis page | | |

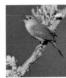

House Wren Troglodytes aedon page 112

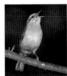

Carolina Wren Thryothorus Iudovicianus page 114

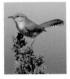

Bewick's Wren Thryomanes bewickii page 115

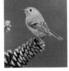

Ruby-crowned Kinglet Regulus calendula page | | 6

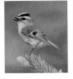

Golden-crowned Kinglet Regulus satrapa page 117

Eastern Bluebird Sialia sialis page 118

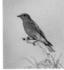

Western Bluebird Sialia mexicana page 120

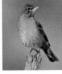

American Robin Turdus migratorius page 122

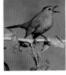

Gray Catbird Dumetella carolinensis page 124

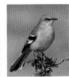

Northern Mockingbird Mimus polyglottos page 126

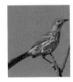

Brown Thrasher Toxostoma rufum page 128

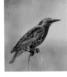

European Starling Sturnus vulgaris page 130

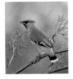

Bohemian Waxwing Bombycilla garrulus page 132

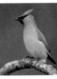

Cedar Waxwing Bombycilla cedrorum page 133

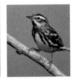

Black-and-white Warbler Mniotilta varia page 136

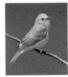

Yellow Warbler Setophaga petechia page 137

Northern Parula Setophaga americana page 138

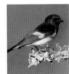

American Redstart Setophaga ruticilla page 140

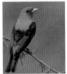

Scarlet Tanager Piranga olivacea page 142

Western Tanager Piranga ludoviciana page 143

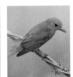

Summer Tanager Piranga rubra page 144

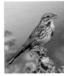

Song Sparrow Melospiza melodia page 146

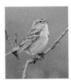

American Tree Sparrow Spizelloides arborea page 148

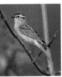

Chipping Sparrow Spizella passerina page 149

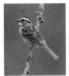

White-throated Sparrow Zonotrichia albicollis page 150

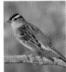

White-crowned Sparrow Zonotrichia leucophrys page 151

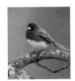

Dark-eyed Junco Junco hyemalis page 152

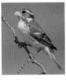

Rose-breasted Grosbeak Pheucticus Iudovicianus page 154

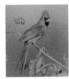

Northern Cardinal Cardinalis cardinalis page 156

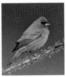

Indigo Bunting Passerina cyanea page 158

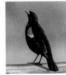

Red-winged Blackbird Agelaius phoeniceus page 160

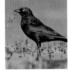

Brewer's Blackbird Euphagus cyanocephalus page 161

Common Grackle Quiscalus quiscula page 162

Orchard Oriole Icterus spurius page 164

Baltimore Oriole Icterus galbula page 165

American Goldfinch Spinus tristis page 166

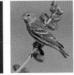

Pine Siskin Spinus pinus page 168

Common Redpoll Acanthis flammea page 170

Purple Finch Haemorhous purpureus page 172

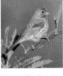

House Finch Haemorhous mexicanus page 173

Evening Grosbeak Coccothraustes vespertinus page 174

House Sparrow Passer domesticus page 176

Birds of Prey

epending on where you are in North America, it may be possible to see a dozen or more different species of birds of prey sailing high in the sky above you. But which one is it? A bird of prey in flight presents a number of problems for the observer: it is hard to judge how far away it is and hence its size, which varies markedly with species; the wing shape varies depending on whether the bird is flapping, diving, or gliding; females and males may be very different in size (the females being the larger); plumage color varies with age (individuals may take four or more years to reach full adult plumage); and many species have light and dark forms which they retain throughout their lives.

Birds of prey belong to one of three families: Accipitridae: the harriers, kites, hawks, and eagles; Pandionidae: the Osprey (in a family of its own); and the Falconidae: the caracaras and the falcons. The large and, in summer, widespread Turkey Vulture is not a close relative of any of these, but is put in a separate family: Cathartidae. Recently, detailed studies of the DNA of these groups have caused us to rethink these relationships. The New World vultures are more closely related to the storks, the Old World vultures are eagles, and the falcons are not at all closely related to the other birds of prey: they are relatives of the parrots.

One reason why ornithologists failed to recognize these newly understood relationships is that all these birds, apart from the vultures, have very similar ecologies: they all hunt live prey, and this has resulted in them evolving many similar adaptations for catching it, with some specializing in avian prey, others mammals, and some taking both.

Hawks Accipiter

Three species of Accipiter occur in North America, the Northern Goshawk being the largest and least common. All three are widespread, though the Northern Goshawk, as its name suggests, is scarcer in the south, and largely present only at higher elevations in the southwest. All three are predominantly predators of birds in forested areas. Their short wings and long tails make them adept at quick turns when in pursuit of prey. Often, they sit silently watching the local bird population until the prey is close enough to strike. Alternatively, they may skim low along hedgerows hoping to disturb a small group of birds and use the element of surprise to catch them in an unguarded moment. The female Goshawk, though, is more interested in substantial prey, including grouse and mammals as large as hares.

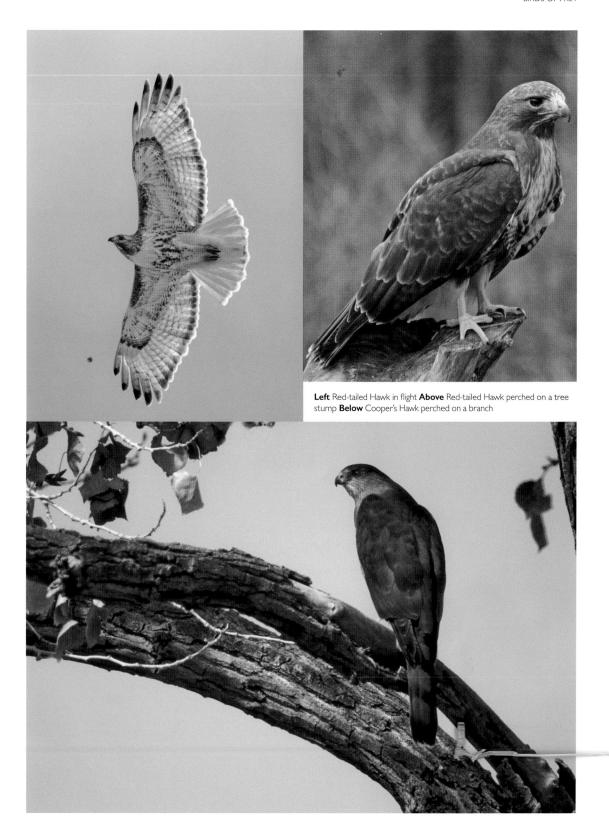

Sharp-shinned Hawk

Accipiter striatus

and Cooper's Hawk

Accipiter cooperii

Sharp-shinned and Cooper's Hawks are remarkably similar in all plumages but are markedly different in size, with Sharp-shinned Hawks being much smaller. Pronounced sexual dimorphism in both species means there are effectively four different-sized hawks. At a distance, difficulty judging size may make distinguishing them difficult.

Adults of both species have slate-gray backs and three dark bars on their tails. They have fine rust-colored barring across white underparts, and red eyes. The Cooper's Hawk has a longer tail. Juveniles of both species have brown backs, four tail bars, and coarse brown streaks on their undersides. Their yellow eyes darken through orange to red as they mature.

The prey of these birds is closely related to their body size so each hunts prey of a different size. Both species may hunt around bird feeders: the Sharp-shinned Hawk chooses the smaller warblers and chickadees; the Cooper's Hawk takes starlings, pigeons, and jays. Cooper's Hawks, particularly those in western areas, also prey on mammals such as squirrels. Both species tend to be ambush predators, but Sharp-shinned Hawks may also catch insects in flight.

Cooper's Hawks are resident in much of the U.S.A., but birds nesting in the northern central states and southern Canada migrate. Sharp-shinned Hawks are resident in wooded areas associated with more mountainous areas in the east and west; those nesting in Canada mostly migrate.

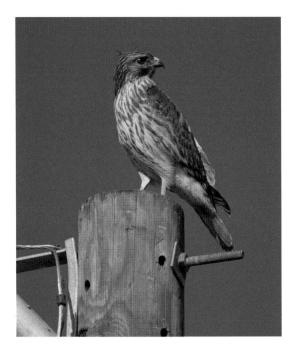

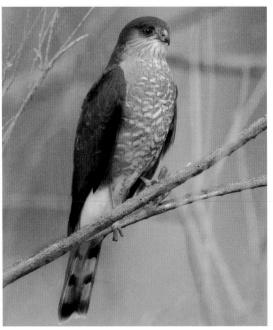

Above Cooper's Hawk perched on a post **Below** Sharp-shinned Hawk perched on a branch

FACTFILE

Length Male: 10in (25cm) Female: 14in (35cm)

Habitat Widespread in forest

Food Mostly birds; on average small thrush

or smaller

Status Largely resident; most northerly populations move south for winter **Voice** Series of high-pitched calls

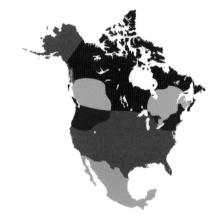

FACTFILE

Length Male: 14in (35cm) Female: 20in (50cm)

Habitat Widespread in forest

Food Mainly birds; commonest are thrush-size

to small dove

Status Largely resident

Voice Series of calls; lower pitched than

Sharp-shinned Hawk

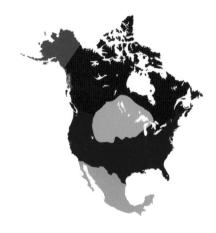

The map key is included in the How to use this book section on page 11

Red-tailed Hawk

Buteo jamaicensis

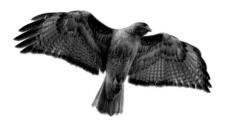

Red-tailed Hawks are stocky, with short fan-shaped tails and broad wings. In most populations, adults display the red tails for which they are known, but there is a dark morph which lacks it, and pale morph for which only the tips of the tail feathers are red. Most have brown backs and show pale underwings when flying; some morphs have pale underwing coverts, too. Juveniles lack the red tail but some have pale bases to their tails. Red-tailed Hawks are very variable and nine subspecies are recognized within North America.

The commonest large bird of prey over much of North America, Red-tailed Hawks are resident across most of the U.S.A., but those breeding in Canada migrate. They are found in almost all habitats, especially open areas where there are trees for nesting. They also occur in some treeless, rocky areas.

Red-tailed Hawks take a wide range of prey, including mammals ranging from mice and voles up to size of hares, birds up to the size of grouse, and also snakes and lizards. They frequently scavenge, especially at road kills. They are not usually seen in backyards but may often be seen close to human habitation, sitting on poles and fenceposts or soaring overhead.

FACTFILE

Length 19in (48cm)

Habitat Widespread

Food Wide range of prey; commonly scavenges **Status** Occurs across North America, including much of Canada; populations north of Great Lakes migrate south for winter

Voice Loud peeeuuw, fading away

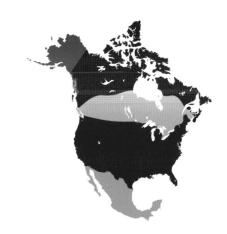

Above Red-tailed Hawk in flight **Below** Red-tailed Hawk perched on a wire

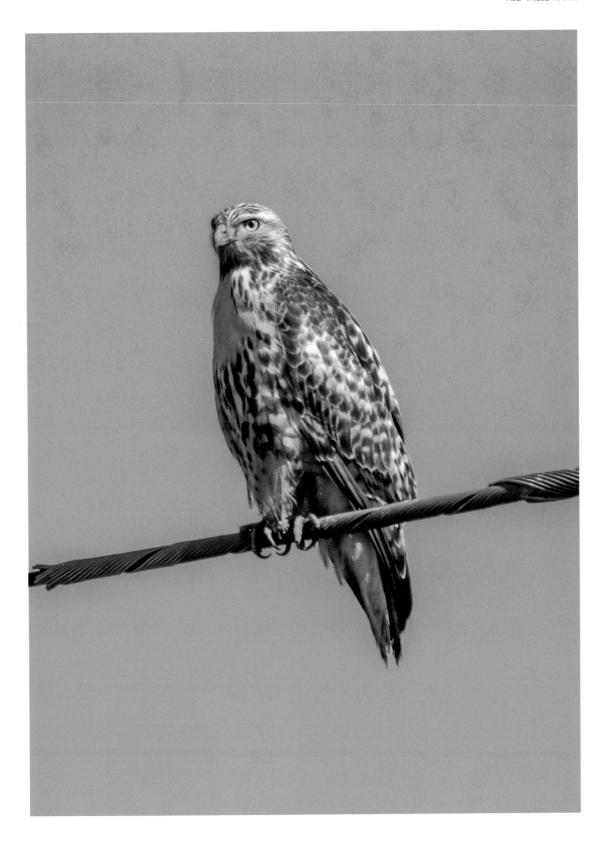

Mourning Dove

Zenaida macroura

slightly built, grayish-brown dove with black Λ dots clearly visible in the closed wings. Close up, a light blue orbital ring is visible. In flight, its narrow wings can be seen, and the long, tapering tail with white tips to the feathers is distinctive. The sexes are similar.

One of the commonest birds in North America, Mourning Doves occur where there is open ground and shrub cover. They spend a lot of time foraging for seeds on the ground and frequently visit backyards where they will use bird feeders.

This species occurs throughout most of North America, apart from far north; in winter the Canadian birds and some of the populations in the more central parts of the U.S.A. move south. They occur in considerable numbers on agricultural land, especially after harvest.

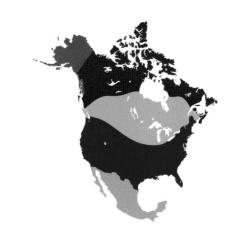

FACTFILE

Length 12in (30cm)

Habitat Almost everywhere

Food Seeds and grain

Status Common and widespread, occurs across North America; populations in Canada and central U.S.A. move south

Voice Owl-like series of hoots; wheeoo-coo-coo of variable length

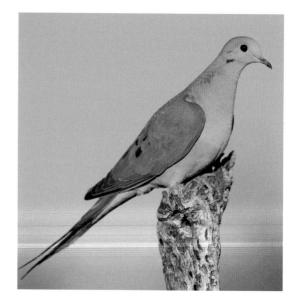

Above Mourning Dove perched on a post

Rock Pigeon/Rock Dove

Columba livia

The wild Rock Pigeon, or Rock Dove, is a shy bird of wild and inaccessible rocky coasts and cliffs. The sexes are similar. Much smaller than the Woodpigeon, the adult Rock Dove has overall blue-gray plumage, palest on the upperwings and back, the breast flushed with pinkish-maroon. The upperwings are marked with two well-defined dark wingbars, obvious both in flight and in standing birds. In flight, note the small white rump patch, the dark trailing edge to the upperwings, dark terminal bar to the tail and white underwings. The juvenile is similar to the adult. The Rock Pigeon is the urbanized descendant of the Rock Dove. Its plumage is widely variable, from pure white to almost black, and many combinations between.

The species forms flocks and, in the case of Rock Pigeon, these can number many hundreds of birds. The Rock Dove is a fast-flying and rather timid bird which nests on rocky ledges and can be tricky to observe. The Rock Pigeon has adapted well to urban areas and is now abundant in many towns and cities, generally being extremely tame.

FACTFILE

Length 12–13in (31–34cm)

Habitat Not found everywhere, completely absent from less-disturbed regions such as forests, mountains, and deserts; mainly found around towns and cities, also agricultural areas Food A variety of plant seeds, grains, other vegetation, and invertebrates.

Status Introduced to North America from Europe in 1603-7, has since spread to towns and cities all over the continent. Often abundant where it occurs

Voice A variety of cooing calls

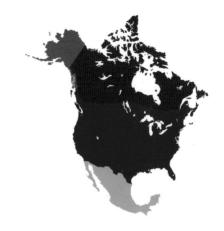

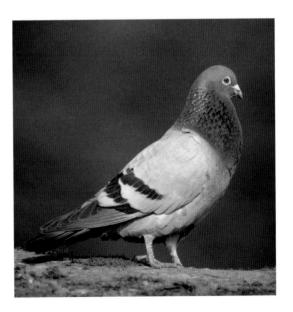

Owls

Strigiformes

Ineteen species of owls occur in North America, though Whiskered Screech Owls and Ferruginous Pygmy Owls are Central American species whose ranges only just extend into North America. All owls are in the family Strigidae except for the Barn Owl, which differs in a number of ways from the others and is placed in the family Tytonidae.

Most owls are nocturnal hunters and rarely seen, though many have a range of vocalizations which make their presence known. At lower latitudes only the Short-eared and Burrowing Owls, and to some extent Barn Owls, hunt a lot during daylight hours. Farther north, so does the Northern Hawk Owl and the Arctic-breeding Snowy Owl. (There is no darkness in mid-summer where this species breeds.) In almost all owls, the males are significantly smaller than the females and tend to take slightly smaller prey than their mates. Their prey varies with owl species. Some take insects, most prey on mammals, from small mice and voles to hares. Others will also catch bats or amphibians.

Many species start to breed early in the season, raising only a single brood, though a number will make a second attempt if the first brood is lost. Some, such as the Short-eared Owl, show marked variation in breeding according to the food supply: in years

when there are vole "plagues" the owls will lay more eggs and raise more young (they may even go on to have a second brood) than in years when there are fewer voles. Some owls may not breed at all if food is scarce.

Owl nesting behavior is fairly similar across species. They do not build nests, and all except the largest nest in tree-holes; smaller species often use those made by woodpeckers. The eggs are white and only the female incubates them, starting before she has finished laying and they hatch asynchronously. This helps ensure that some chicks survive in years when food is scarce.

Only the female broods the young, relying on the male to catch all the food for himself, his mate, and the growing brood; only when the young are well grown does the female stop guarding them and help to catch prey. The young leave the nest about a month after hatching, but this is variable. In suitable conditions chicks may clamber out of the nest and sit around nearby for some days before venturing further. In general, owls have an unusually long period of parental care, with most chicks receiving food from their parents until the end of the summer when they are starting to look for territories of their own. During this time many make distinctive begging calls so that their parents can locate them.

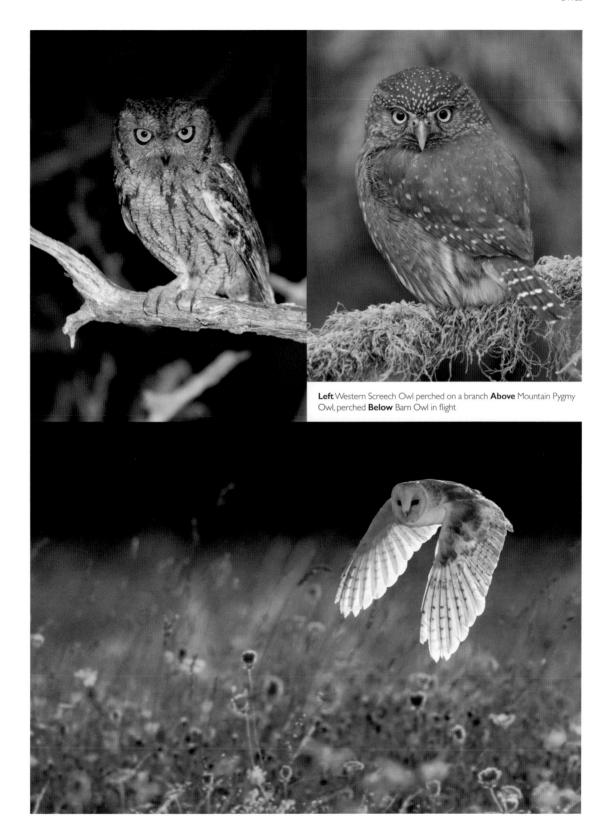

Barn Owl

Tyto alba

The Barn Owl is a medium-sized, long-legged owl. Typically, it has sand-and-gray upperparts with speckles, and white or buffy underparts. It has a white heart-shaped face and dark eyes. Long, rounded wings and slow wing-beats give it a characteristic flight style. As they hunt on the wing, mostly at night, that is when they are most seen, often appearing white and ghostly. They may also be seen sitting at openings into buildings where they roost and nest.

Like other night-hunting owls, Barn Owls have asymmetrical ear openings, slightly different structures in each ear; this is thought to enable them to identify the origin of sounds more accurately. Captive Barn Owls have been shown to be able to locate the sound of a mouse with pin-point accuracy, even in total darkness.

Barn Owls are resident in the southern half and coastal regions of the U.S.A. They are one of the most commonly seen owls because they live and nest around farms—hence the name—and abandoned or undisturbed buildings. They rely on open permanent habitats, including grasslands and wetlands, supporting large populations of small rodents, which are their main prey.

Length 16in (41cm)

Habitat Open country, especially grassland; farms

Food Small mammals, up to rat size

Status Widespread; avoids regions with very

harsh winters

Voice Drawn-out hissing shriek

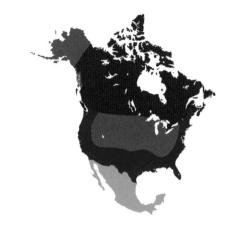

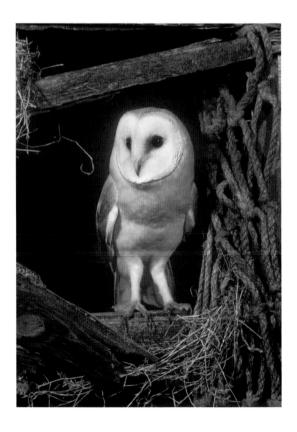

Above Barn Owl perched in a barn

Great Horned Owl

Bubo virginianus

There are three large owls in North America of which only the Great Horned Owl has "ears," and they are very conspicuous, as their name suggests. They are large, solid owls with gray-brown mottled uppersides, barred undersides, and a white patch on their necks. The color of the facial disk is often reddish. It is variable and about seven subspecies occur in North America; the birds in the northwest tend to be the largest and the darkest. Birds in the far north may be very pale.

The Great Horned Owl is resident over almost all of North America, except for Arctic Canada, in a wide range of habitats from open desert to forest, preferring areas with open land where it can hunt. It may occur in heavily wooded suburbia, but at lower densities.

Great Horned Owls take a wide range of prey, including many voles in years when these are plentiful, but they are powerful enough to take larger prey such as hares or feral cats. Studies show that 90 percent of their prey is mammals, and most of the remaining 10 percent is birds, especially waterbirds, some as large as herons.

Length 22in (56cm)

Habitat Wide range, from open desert to forest **Food** Mammals and birds up to size of a hare or heron

Status Resident, widespread

Voice Deep woo often starts with double note

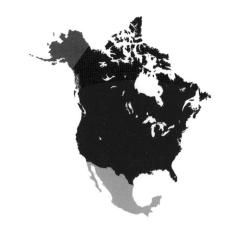

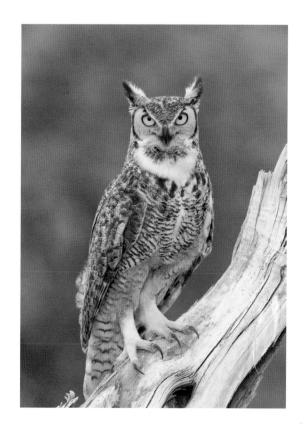

Above Great Horned Owl perched on a branch

Screech Owls

The two species of Screech Owls are very similar—small and compact, with small ear tufts and yellow eyes. They have strongly streaked upperparts, and finely barred and streaked underparts, providing exceptional camouflage, particularly for individuals with gray plumage.

Size varies markedly according to sex, with some smaller males much smaller than larger females. The two species largely occur in different regions and can also be distinguished by beak color and call. There is considerable regional variation in both size and coloration.

Both species have a screeching call, hence their name. They are noisiest in early spring, particularly as the time for breeding approaches.

Eastern Screech Owl Megascops asio

Eastern Screech Owls can be distinguished by their yellowish-green beaks. They are variable and up to five subspecies have been proposed. There are two color forms: the normal gray and a rarer rufous bird, which is commoner in the northeastern U.S.A. Northern birds tend to be larger and grayer than southern ones, and some intermediate brown birds also occur. Eastern screech owls have a monotonic trill and descending "whinny" that's somewhat reminiscent of a horse.

The Eastern Screech Owl occurs through most of the U.S.A., east of the Rockies, only just getting into Canada. They are widespread in a range of deciduous and coniferous wooded habitats below about 5,000 feet (1,500 meters), as well as wooded suburbia, which means that they are the owl most commonly seen and heard. Because old, dead, or dying trees—the trees most likely to have nesting holes—are often removed from gardens, they are sometimes short of nest-sites and will make use of nestboxes.

They feed on a wide range of prey, including worms, insects, amphibians, small mammals, and birds. They are often the most common avian predator in wooded suburban and urban habitats.

Above Eastern Screech Owl perched on a tree stump

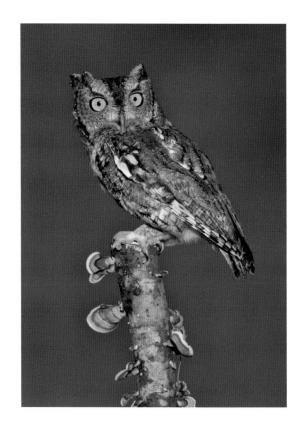

FACTFILE

Length 8.5in (22cm)

Habitat Woodland, including wooded suburbia **Food** Varied, including small mammals and birds

Status Widespread, often common

Voice Monotonic trill

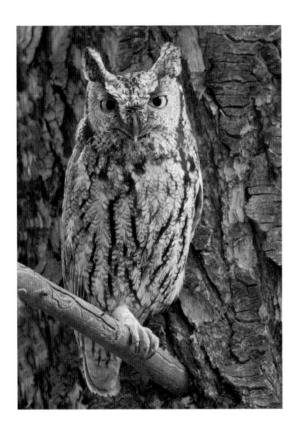

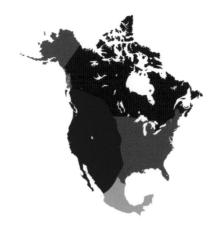

FACTFILE

Length 8.5in (22cm) Habitat Woodland, including wooded suburbia Food Varied, including small mammals and birds

Status Widespread, often common

Voice Trill, often sped up-likened to a bouncing ball

Western Screech Owl Megascops kennicottii Predominantly grayish, like the Eastern Screech Owl, but some brown forms (though not rufous) occur. It can be distinguished by its dark beak, and the streaks on its underside may be weaker, while the horizontal barring is stronger.

Its range is from west Texas extending westwards up the Pacific slope as far as northern British Columbia. There is considerable geographic variation in both size and plumage; nine subspecies have been named. The darkest birds are in coastal British Columbia and the Queen Charlotte Islands, as well as central Mexico; the palest are on the Baja California peninsula and western Great Plains. The largest birds are in the Pacific Northwest, the smallest in southern Baja California.

They are found in a wide range of conifer and deciduous forests, particularly on stream-sides. They are tolerant of humans and often live and hunt in residential areas and if suitable trees for roosting are available. They eat a diverse range of prey: primarily small rodents, but also birds, amphibians, reptiles, bats, and invertebrates.

Above Western Screech Owl perched on a branch

Barred Owl

Strix varia

A medium-large, stocky, brown owl with white mottling on its upperparts and a rounded tail. It is creamy or buff below with dark streaks. Barred Owls lack ear tufts, and have distinctive orange beaks and dark eyes. Four subspecies are recognized.

Barred Owls are resident in eastern U.S.A., across Canada, and in the Pacific Northwest.

They favor continuous, mature forest with many old trees and are more commonly found in mixed deciduous and conifer forest than in pure conifers. They hunt from perches and feed on a wide range of small mammals, birds, amphibians, and reptiles. Unusually, they may hunt fish from a perch over water.

They are hole-nesters and may use nestboxes in mature forests if natural nesting sites are in short supply.

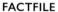

Length 21in (53cm)

Habitat Dense mature forest

Food Predominantly small mammals up to the size of squirrels

Status Resident

Voice Short series of grunting notes followed by one longer, descending

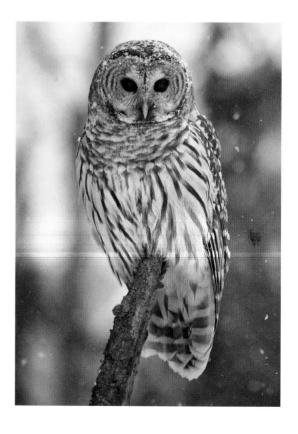

Above Barred Owl perched on a branch in the snow

Northern Pygmy Owl

Glaucidium gnoma

The Northern Pygmy Owl is, as its name ■ suggests, a small owl—about the size of a robin. It has a compact shape, rounded wings, and a long, barred tail. Its upperparts are brown and slightly mottled, and the underparts are pale and strongly streaked. The head is spotted, and the beak and eyes are vellow.

The Northern Pygmy Owl has a westerly distribution and extends from Mexico into the Pacific Northwest. It varies markedly over its range, with seven subspecies being recognized.

It is resident in a wide range of habitats, but is less common in dense forest, preferring open woodland and scrub. The distinctive flight style is undulating: a series of quick wing beats, then a glide. As it is active during the day hunting small songbirds, it is most often seen when a flock noisily mobs it until it moves off. It also feeds on insects, small mammals, and it may take small birds from bird tables. It is a major predator of Black-capped Chickadees.

They nest in holes in trees, often those made by woodpeckers, but do not use nestboxes.

Length 6.75in (17cm)

Habitat Open woodland Food Varied diet, mainly insects, but also small mammals and small birds Status Widespread in western areas from Mexico to British Columbia. Resident **Voice** A single *poop* given at intervals of about five seconds

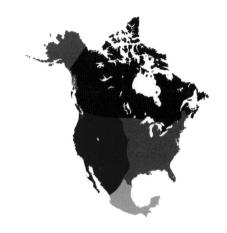

Above Northern Pygmy Owl, perched

Burrowing Owl

Athene cunicularia

This small, long-legged owl is brown with a white-spotted upperside, and varying definition to its barred underparts. The Burrowing Owl does not have ear tufts and the facial disk is less pronounced than in many owls, with distinctive white "eyebrows" contributing to more of a "binocular look." It has a yellow beak and yellow eyes. A smaller, darker subspecies is confined mostly to Florida.

They are found mainly in the grasslands of the prairie states through much of the western half of the U.S.A., just reaching Canada. All but those living along the southern border of the U.S.A. migrate south for the winter.

As its name suggests, it lives in burrows in open grassy country. Historically, and still in some areas today, quite large colonies were associated with "towns" of prairie dogs or ground squirrels, nesting down their holes. Burrowing Owls may use holes in a range of open land, including road banks and industrial sites. They feed on invertebrates, and a variety of small animals including mammals, lizards, songbirds, and bats. They may be active during the day, seen perched on the ground or a fence post.

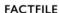

Length 9.5in (24cm)

Habitat Open, grassy country

Food Mainly small mammals and invertebrates

Status Migrant over most of North America

Voice Two notes, the second drawn out

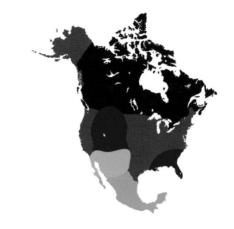

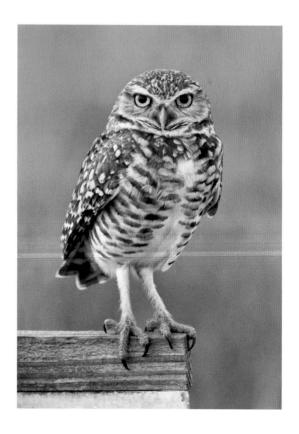

Above Burrowing Owl perched on a ledge

Northern Hawk Owl

Surnia ulula

This is a medium-sized owl, easily distinguished by its long tail. In flight this, together with its rather pointed wings and rapid flight, makes this bird reminiscent of a hawk, hence its name. Its back is brown with white spots and it has a strongly barred underside. It has a pale face, darkly outlined, and a speckled crown; its beak and eyes are yellow.

Northern Hawk Owls are resident at low densities in the northern boreal forests of Canada and Alaska. They are rare elsewhere but may be seen further south in occasional irruption years, probably brought on by a shortage of food in the north.

They hunt by sight during the day, mainly on small mammals, but may take birds as large as grouse and ptarmigan. They may be seen perched prominently in the tops of trees.

Length 16in (41cm)
Habitat Boreal forests
Food Mainly small mammals; also birds
Status Resident
Voice Long trill, starting soft, getting louder

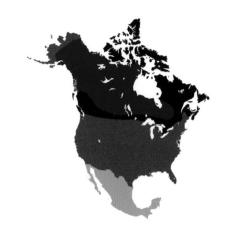

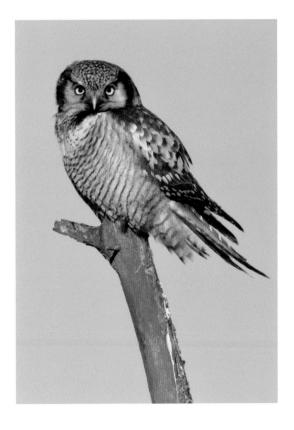

Above Northern Hawk Owl perched on a branch

Boreal Owl

Aegolius funereus

A small, compact brown owl with white spots on its back, and brown streaks on its underside. It has a large head, spotted crown, lacks ear tufts, and the pale face is darkly outlined. The yellow eyes have a dark "v" shape through them, with the point at the beak.

As its name suggests, this bird is resident in boreal forests across Canada and Alaska. It is rarely seen in the U.S.A. and then only in the northernmost states in some winters.

Unlike the Northern Hawk Owl, which hunts by day and night, the Boreal Owl is strictly a nocturnal hunter, searching from a perch for small mammals in the darkest parts of the night. It takes relatively few birds.

It nests in cavities, usually in holes made by birds such as the Pileated Woodpecker, and it will use nestboxes where natural holes are in short supply.

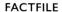

Length 10in (25cm)
Habitat Northern forests
Food Small mammals
Status Mostly resident

Voice Rapid series of quiet whistled hoots

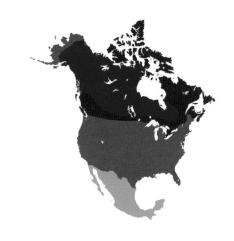

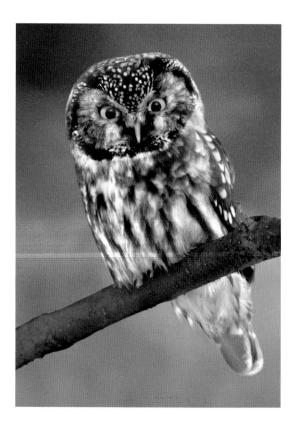

Above Boreal Owl perched on a branch

Northern Saw-whet Owl

Aegolius acadicus

Torthern Saw-whet Owls are small, about the size of a robin. Adults are chocolate-brown with lines of white spots along their closed wings and are heavily streaked below. They lack ear tufts, and have white-flecked crowns, and yellow eyes with a strong white "v" from their "eyebrows" to the dark beak. Juveniles are less spotted, a rich buff below and the facial "v" is prominent in a dark face.

They are quite secretive, so their range is not well known, but they are believed to be widespread. They are more local in the southern U.S.A., and absent from northern areas apart from a narrow coastal strip in the Pacific Northwest. They are commoner on both sides of the continent, where they are more likely to be resident, than in the central regions. Some of those breeding at higher latitudes and altitudes may move south or lower for the winter. Their habitat is both coniferous and deciduous forest, particularly where the understory is open.

Their main prey is small mammals, especially mice, taken at night. They nest in holes in trees, especially those made by woodpeckers, and readily take to nestboxes in very wooded locations.

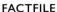

Length 8in (20cm) Habitat Mixed forests Food Small mammals Status Largely resident; some breeding at higher latitudes and higher altitudes; may move south or lower for winter Voice Loud single note, repeated

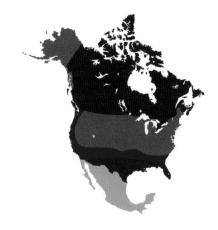

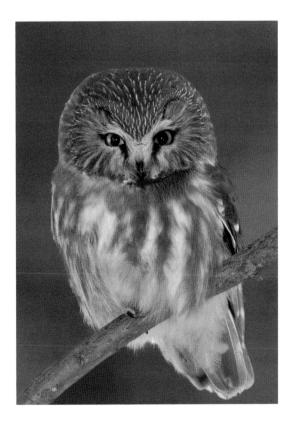

Above Northern Saw-whet Owl perched on a branch

Nightjars Caprimulgidae

Nighthawks—are secretive nocturnal birds whose presence is often only detected because of their loud, distinctive calls. As a result, most are poorly known.

At all stages—eggs, chicks, and adults—they are exceptionally well camouflaged. Adults remain motionless on the nest or roost site during daylight hours and become active only at dusk. Nightjars are similar in size to blackbirds, and have large, flattened heads that allow space for the enormous gape used for catching insects in flight. They have large eyes, a small bill bordered by long rictal bristles, and small feet. Their plumage is a complex pattern of browns and grays, resulting in the most cryptic plumage blending easily with a background of leaf litter when sitting; even when perched on a branch they are hard to see. Nightjars are best detected by their distinctive calls.

There are some ninety-eight species worldwide, mostly in the tropics; eight species have been recorded in North America, of which the Antillean Nighthawk is normally found only on the tip of Florida. In North America most live in forests with much open ground. The Common Nighthawk comes into towns where it hunts moths attracted to streetlights.

They are entirely insectivorous, using vision to detect and catch their prey; even so, they hunt mainly around dawn and dusk and are thought to catch their prey when it is silhouetted against the sky. As they can only feed when insects are flying, nightjars are very sensitive to prolonged cold, wet weather. Although poorly known, it seems that many can become torpid under such conditions, particularly the Common Poorwill.

Nightjars lay one or two eggs on the bare ground; both sexes incubate the eggs and raise the chicks, but in some species the female leaves when the chicks are about half grown to start a second brood. The timing of egg-laying seems to be closely related to the phases of the moon, so that they can optimize hunting during a full moon for when the chicks need the most food.

Nightjars were once also called "goatsuckers" because they were encountered at night near flocks of sheep and goats, and it was thought that they used their large mouths to suck milk from goats. Equivalent words in many European languages attest to the widespread nature of this myth; it is also the basis for the family's scientific name.

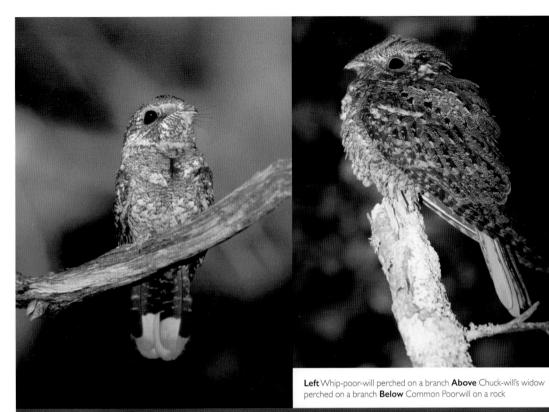

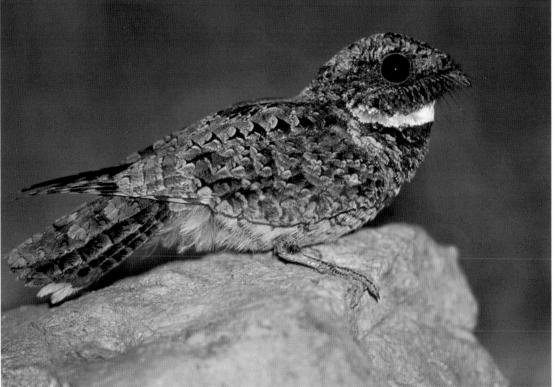

Eastern Whip-poor-will

Antrostomus vociferus

This is a beautifully cryptic medium-sized bird, similar in size to a blackbird. Both male and female birds have mottled plumage in brown or gray, heavily spotted in tawny and black on the wings. Some have more rusty coloring. They are perfectly camouflaged in leaflitter on the ground. Males have very broad white tips on their outer tail feathers, while females have narrower, buffy tips.

Widespread in the eastern half of the U.S.A., except in the south, Eastern Whip-poor-wills migrate south to Mexico and Central America for winter.

They occupy large territories in forest habitats where the forest floor is open. They hunt night-flying insects, sallying out from ground perches to catch them, around dusk and dawn and sometimes in the middle of night when the moon is bright, and not at all in heavy rain.

Length 9.75in (25cm)
Habitat Open woodland
Food Night-flying insects
Status Summer visitor to eastern U.S.A.
Voice Loud whip-poor-will

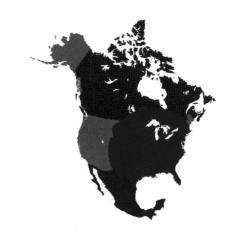

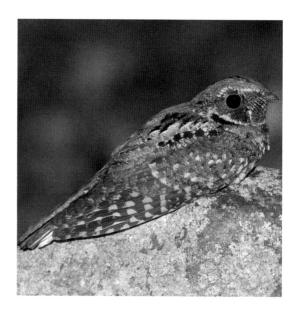

Above Eastern Whip-poor-will on a rock

Chuck-will's-widow

Antrostomus carolinensis

A large nightjar, Chuck-will's-widow is about the size of a jay. Like other nightjars it has cryptic plumage in mottled brown, gray, black, and buff to camouflage against the leaflitter. Both sexes have rufous and gray forms. This bird has a very large, flat-topped head.

Although the males have white in the outer tail feathers (the tails of females are brownish throughout), this is less pronounced than in the Eastern Whip-poor-will, helping to distinguish between the two.

These birds are migrants to the southeastern quarter of the U.S.A., moving to Mexico for the winter. They mainly inhabit open, dry woodland, preferring areas with extensive forest gaps.

Chuck-will's-widows hunt at night on the wing, low to the ground, in contrast to other nightjars, which dart out from a perch. Their diet includes more large items than the other North American nightjars: mostly larger insects, but also small birds, frogs, and bats.

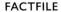

Length 12in (30cm) **Habitat** Open woodland

Food Large insects, small frogs, and birds

Status Summer visitor

Voice CHIP-wido-WIDO; series of short barks

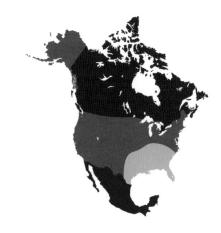

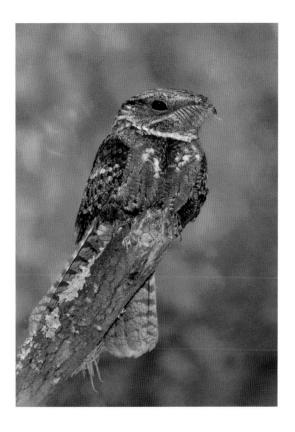

Above Chuck-will's-widow perched on a branch

Common Nighthawk

Chordeiles minor

This is a medium-sized nightjar with typically cryptic mottled brown, gray, and buff plumage. Only the tip of its beak can be seen; in contrast it has very large eyes. Its long wings give it a hawk-like look, hence its name, and it has a distinctive white patch that is visible on the undersides. The male has a white tail band and a distinct white throat patch, which in adult females is usually indistinct and buffy-white. There is considerable regional variation in color, and eight subspecies occur in North America.

Common Nighthawks are summer migrants throughout most of North America, except the far north. They spend the winter in South America.

While most species of nightjars are poorly known and seldom seen, many people are familiar with the Common Nighthawk, which inhabits cities, hunting insects at night around streetlights with a looping series of flaps and glides. They hunt on the wing, opening the gape to snap up larger insects, including beetles and moths. They sometimes nest on flat, gravel-covered rooftops.

FACTFILE

Length 9.5in (24cm)
Habitat Wide range, including towns; not thick forest
Food Insects
Status Widespread summer visitor
Voice Nasal peet given in flight; spectacular booming courtship dives

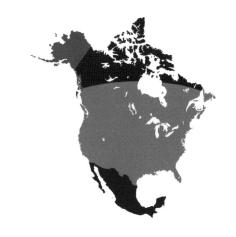

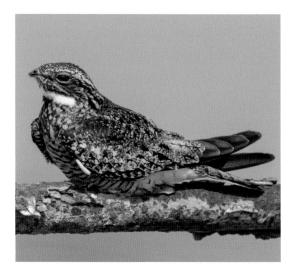

Above Common Nighthawk perched on a branch

Common Poorwill

Phalaenoptilus nuttallii

The Common Poorwill is a small, short-tailed, short-winged nightjar with mottled gray, brown, and buff plumage. Its wings show rufous color in flight. The corners of their tails are white in males, and buff in females. There is considerable geographic variation with five subspecies recognized, based on distribution and color. Though hard to see, they can be heard at night calling repeatedly.

In the breeding season the Common Poorwill is found in the western half of the U.S.A., in arid or semi-arid regions in open habitats, including some that are semi-urban, such as golf courses. In winter most migrate south into Mexico, but some stay at lower elevations in southern U.S.A.

Like other nightjars, this species feeds primarily on flying insects, mostly moths and beetles. They usually hunt around sunset and sunrise, making brief sallies from a perch or from the ground to catch prey.

The most extraordinary feature of this species is its ability to go torpid in cold conditions. It is the only bird that is known to remain in torpor for long periods.

FACTFILE

Length 11in (28cm)
Habitat Open dryish country
Food Insects caught on the wing
Status Migrant to western U.S.A.; some overwinter in south
Voice A soft, whistled *poor-will* repeated at regular intervals

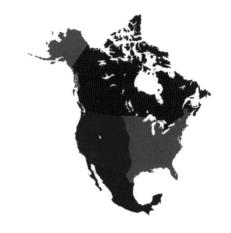

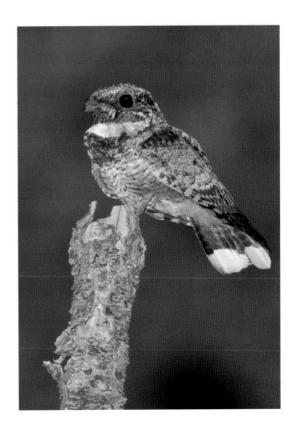

Above Common Poorwill perched on a branch

Chimney Swift

Chaetura pelagica

In flight, this small, short-tailed, near-black bird Llooks like a cigar with wings. It is a dark grayishbrown with a paler throat. The wings are long and narrow, and slightly curved; the short tail is quite tapered. Chimney Swifts fly rapidly, often twisting and swooping, and may give a chattering call in flight. The sexes are similar.

They are one of only four swifts to occur in North America and the only one in the east, where they are summer migrants as far as southeastern Canada; their winter quarters are in Amazonia. The Chimney Swift does indeed nest in chimneys. and other human-made structures. Sometimes spectacular flocks are seen gathering for or during migration.

Chimney Swifts feed on the wing, catching flies, beetles, and other insects. They often feed over urban areas, also farmlands, woodland, and wetlands. They may snatch insects from tree branches, and in urban areas may hunt at night around streetlights.

Chimney Swifts are associated with human habitation and may be seen hunting over backvards and wider urban areas. They may take up residence in nesting towers built specially for them.

FACTFILE

Length 5.25in (13cm)

Habitat Widespread; nest in tree-holes and chimneys

Food Small insects caught on the wing Status Summer visitor to eastern U.S.A., north into southeastern Canada Voice High-pitched twittering trill

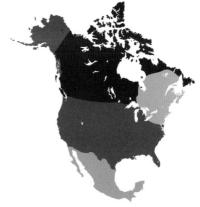

Above Chimney Swift in flight Opposite Chimney Swift in its distinctive nest—a bowl-like shape of woven twigs, attached to a chimney wall by the bird's saliva

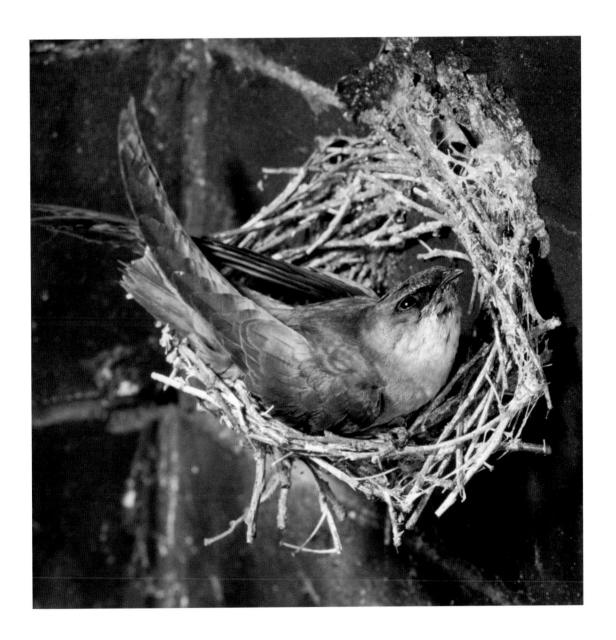

Hummingbirds

Trochilidae

E ven a quick glance—sometimes all one gets as the bird shoots past—is usually enough to recognize a hummingbird. Only a large hawk-moth is similar (some of the larger hawk-moths are larger than the smallest hummingbirds), but most of these fly at night, whereas hummingbirds rarely do.

Hummingbirds are placed in the family Trochilidae, their closest relatives being the Swifts. Some 349 species are known and they only occur in the New World; many are poorly known and some have very restricted ranges. Hummingbirds occur almost wherever there are flowers, from sea-level to 15,000 feet (4,500 meters) elevation; other than in the Pacific Northwest, they are absent from northern parts of Canada. Eighteen species occur in North America.

They vary in size from the smallest bird in the world—the male Bee Hummingbird from Cuba weighs less than 0.01oz—to the Giant Hummingbird, which occurs in the Andes.

Most have a very fine beak, usually straight, though most Hermit Hummingbirds have decurved bills and some, such as that of the White-tipped Sicklebill, are strongly so. The Sword Bearer has an extraordinarily long beak, the total length of the bird is about 8in (22cm), almost exactly half of which is beak. All have very short legs and small feet.

Most female and juvenile hummingbirds are green, though they may show a slight metallic sheen. The males, however, showcase a dizzying array of plumages, almost all of which rely on strikingly extended tail plumes or the iridescence of patches of feathers, often on the throat and breast, for their effect. Many have narrowed wing feathers with which they can produce sounds while displaying.

They can beat their wings at great speed, above eighty beats per second, some attaining 200 beats per second when displaying. This produces a whirring noise which is the origin of their name.

Hummingbirds' main food is nectar, some showing a marked preference for red flowers and those with a tubular structure. Most get their food by hovering (which they can do better than any other bird) in front of the flower and extending their long tongues to extract nectar. Some also take many small insects and spiders.

Hummingbirds are notoriously territorial and may challenge other species many times their size. They defend the food resources in their territories vigorously. But not all use this strategy, or not all of the time. Some species use a feeding strategy called "trap-lining," regularly following a set route to known flower resources spread over a wider area.

Being very small and warm-blooded means that they have high energy needs because a small body has a relatively larger surface area to body mass so heat loss is relatively higher. Being very active also requires a lot of food. In many places in North America hummingbirds burn so much energy so fast during the day that they could not make it through the night without reducing their energy consumption. They do this by going into torpor every night.

Only the female builds the nest, incubates the eggs, and rears the young. Male hummingbirds are often polygamous and do not take part in nesting. Nests are tiny, often only a few inches in diameter. They are constructed of gossamer and spider webs, covered with lichens, bark fragments, and moss. Different species build their nests in different habitats and heights, but usually in sheltered places; they are very hard to find.

Clutches usually have two eggs. Incubation and duration of the nesting period varies with species. Eggs are incubated for around 15–20 days; the young leave the nest around 18–26 days after hatching. Some species have multiple broods if the season is long enough.

Many hummingbirds come readily to artificial feeders supplied with sugar solution, where they can be observed at close quarters. (Use sugar solutions with care; in hot weather the sugar ferments and may poison birds that take it.) Alternatively, plant a range of flowers suitable for the species that occur in your area to encourage them to visit.

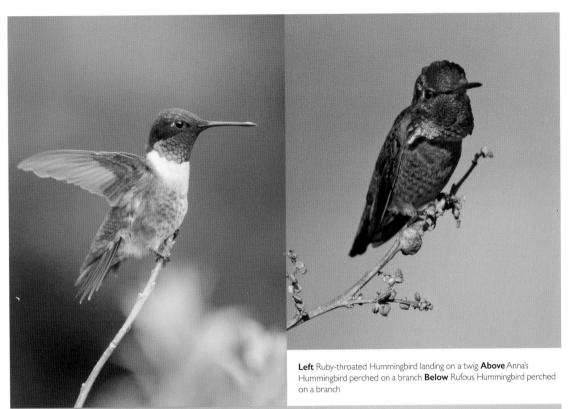

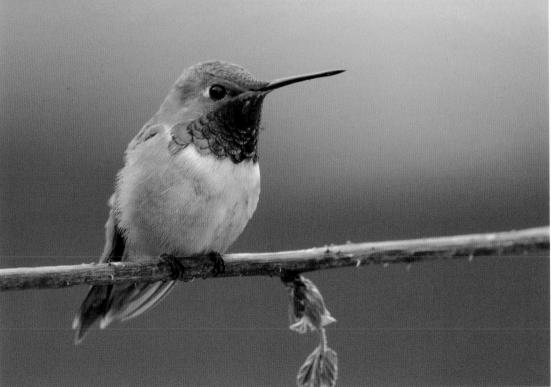

Calliope Hummingbird

Selasphorus calliope

The Calliope Hummingbird is tiny. It has a short, straight beak and shortish tail. The male can be recognized by his striking rose-red throat, which looks streaky; good views show this to be because the individual feathers of the gorget are elongated. The females and juveniles are metallic green with a pale buff tinge to their underparts, which are a cleaner white in males. Their calls are a range of chips and thin whistles.

They mainly occur in the mountains of western North America, reaching as far north as British Columbia. They breed above from about 4,000 feet (1,250 meters) elevation up to the timberline.

Calliope Hummingbirds are territorial and feed on nectar and small insects, which they catch by hawking—perching on branches' tips and darting out like a flycatcher.

The Calliope Hummingbird is the smallest species of bird in North America and is thought to be the smallest bird in the world to undertake a long migration. They migrate south to Mexico, for some individuals this is a journey in excess of 2,000 miles (3,200 kilometers) each way.

FACTFILE

Length 3.25in (8cm)
Habitat Cool montane forests of northwestern
U.S.A. and British Columbia
Food Nectar; small insects
Status Summer visitor
Voice Twittering notes

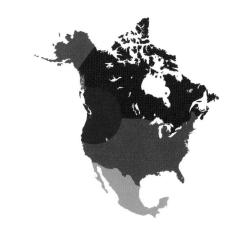

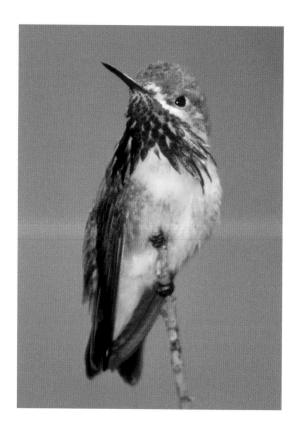

Above Calliope Hummingbird perched on a branch

Broad-tailed Hummingbird

Selasphorus platycercus

Broad-tailed Hummingbirds are medium-sized by North American hummingbird standards. Adult males have a dark-red gorget and chin, green-and-brown back, wings, and tail, with white underparts and a white chest. Females and juveniles have a metallic green back, brown flanks and wings, a spotted throat, buffy underside, and rufous sides to the base of the tail.

They breed in the southern and central Rocky Mountains and eastern California, at higher elevations, up to 10,000 feet (3,000 meters); they are most abundant in subalpine meadows and surrounding forest edges. They overwinter in Mexico.

They are territorial and feed on a range of flowers. They also glean insects from leaves or take them from the air, and also visit sap wells, and may visit sugar feeders where they are available. They become torpid at night when temperatures drop.

FACTFILE Length 4in (10cm) Habitat Subalpine meadows Food Nectar and small insects Status Summer visitor Voice High *chip*

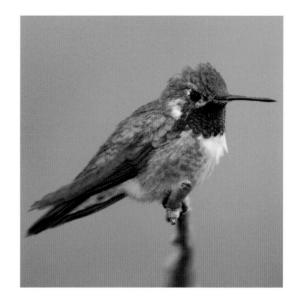

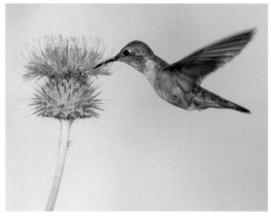

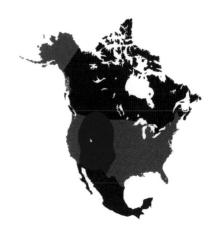

Above Male Broad-tailed Hummingbird, identified by his dark-red gorget and chin, perched on a branch **Below** Female Broad-tailed Hummingbird feeding on nectar

Ruby-throated Hummingbird

Archilochus colubris

Ruby-throated Hummingbirds are very small with long wings and beak. Female Ruby-throated Hummingbirds are bright golden-green above and pale below. They have black tails with white tips on the outer feathers, a darkish mask on the face, and dark spots on the throat. In the right light, the males have a brilliant rose-red throat, but in other lights it appears black. The male's back is emerald green, they are white below the throat and tail, but otherwise have greenish undersides. They have a dark facemask and a short, black, forked tail.

This is the only species of hummingbird that people living in the eastern half of North America can expect to see, though this species does spread further west in Canada, just reaching British Columbia. Like all hummingbirds in North America, it is a migrant. They may double their weight before migrating to Mexico or Central America for the winter.

They feed on nectar from flowers, especially red, trumpet-shaped flowers, tree sap, and they readily take small insects and spiders. They may have difficulty getting enough food to maintain body temperature in cold weather and go into torpor at night.

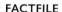

Length 3.75in (10cm)
Habitat Open woodland and gardens
Food Nectar and small insects
Status Summer visitor; tiny number may overwinter in Florida
Voice Slightly drawn-out *chip*, repeated rapidly

Above Male Ruby-throated Hummingbird, identified by his ruby-red throat, perched on a branch **Below** Female Ruby-throated Hummingbird perched on a branch

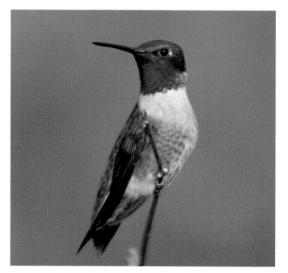

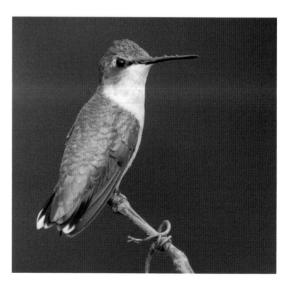

Allen's Hummingbird

Selasphorus sasin

Allen's Hummingbird is small and compact with a long beak. Males have bronze-green upperparts, and are coppery below with a copper-colored tail. Females have dull green-and-gray backs, a broad white collar, and buffy underparts; they have some muted copper along their sides. Males are very similar to male Rufous Hummingbirds that have green backs, as some do, although the latter's range is largely further north.

Males may be identified by their elaborate display flights and the bumblebee-like sounds they make.

Allen's Hummingbirds breed in a narrow, moist, coastal strip only about 20 miles (30 kilometers) wide, from southern Oregon southward to southern California. They are territorial and feed on nectar in coastal scrub vegetation or riparian shrubs; they also glean insects and catch them in mid-air.

They migrate south to a similar narrow coastal strip in Mexico. The timing of migration northward in spring is dependent on rainfall.

FACTFILE

Length 3.75in (9.6cm)
Habitat Coastal scrub
Food Nectar and small insects
Status Short distance migrant
Voice Soft, quiet rattle followed by a buzz

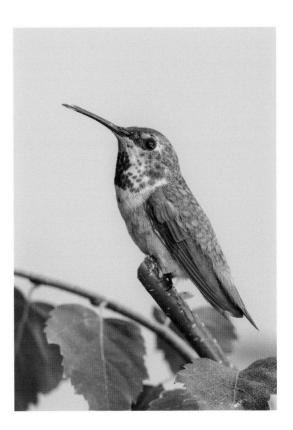

Above Allen's Hummingbird perched on a branch

Black-chinned Hummingbird

Archilochus alexandri

Black-chinned Hummingbirds are relatively slender with long, black beaks. Both sexes have dull, metallic, green backs, grayish-white undersides, and green flanks. Both have a white spot behind the eye, more visible against the male's dark head. His black throat merges with a narrow purple gorget. The female has white tips to her outer tail feathers.

They occur through much of western North America as far north as the southern edge of British Columbia, though they are more common in the south. Most spend the winter in Mexico.

They are territorial and frequent a wide range of habitats, preferring riparian edges, feeding on flower nectar and small invertebrates. They pump their tails continuously while hovering at flowers or sugar feeders. They are one of the North American species most easily seen by backyard birdwatchers, since they may nest in large yards, especially those containing large trees and water.

FACTFILE

Length 3.75in (10cm)

Habitat Wide range including orchards and backyards; stream-sides

Food Nectar and small insects

Status Migrant. Breeds across much of southwestern North America

Voice High-pitched buzz followed by tseep

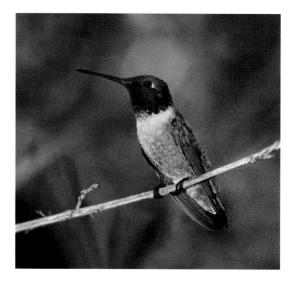

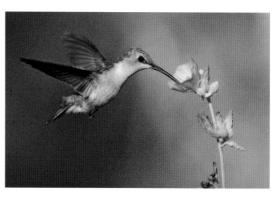

Above Male Black-chinned Hummingbird, identified by his narrow purple gorget, perched on a branch **Below** Female Black-chinned Hummingbird in mid-air

Rufous Hummingbird

Selasphorus rufus

An aptly named species: all Rufous
Hummingbirds, including the females and
juveniles, have at least a tinge of rufous color on
their flanks and tails. All have a white bib. The males
have bright, rufous flanks and are usually strongly
rufous on their backs, though some show green.
Males have a bright orange-red gorget, females a
small spot of orange-red on their gorgets.

The breeding range of the Rufous Hummingbird is the Pacific Northwest of America, from the northernmost tips of California and Idaho north to Anchorage. They migrate to the far south of the U.S.A. and Mexico to overwinter.

They breed in open woodland, shrubby areas, parks, and yards where they feed on colorful tubular flowers. They will also catch insects in the air and take aphids from plants. They are particularly aggressive territorial feeders and may chase other hummingbirds away from sugar feeders.

FACTFILE

Length 3.75in (10cm)

Habitat Wide range; breeds up to almost 6,500 feet (2,000 meters)

Food Nectar and small insects

Status Migrant. Breeds primarily northwestern coastal areas

Voice Very rapid rattle followed by a longer note

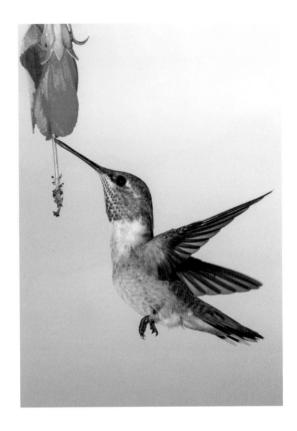

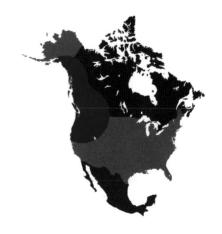

Above Rufous Hummingbird in flight

Belted Kingfisher

Megaceryle alcyon

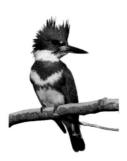

With a large head and a long powerful beak, the Belted Kingfisher is unmistakable. It has a dark-gray head, dark gray across the chest and back, and a white collar and underparts. Females have chestnut on their flanks and on a belt across the belly. Belted Kingfishers can often be located by their loud, rattling calls.

In summer the Belted Kingfisher occurs over most of North America, including much of Canada and Alaska; in winter it migrates south to Central and South America, though small numbers overwinter in southwestern U.S.A. and Florida, where they can continue to fish in unfrozen waters.

They occur in a range of wetland habitats and can usually be seen perched over the water, diving in vertically to catch prey. They also feed on crustaceans, amphibians, invertebrates, and even small birds and mammals.

They may visit backyards that contain ponds in order to hunt, but may not be welcome.

FACTFILE

Length 13in (33cm)

Habitat Wide variety of watersides; leaves if water freezes over

Food Fish, crayfish

Status Migrant; some winter in southernmost U.S.A.

Voice Rattling call

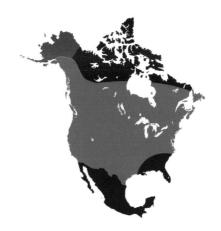

Above Male Belted Kingfisher perched on a branch Opposite Female Belted Kingfisher, identified by the chestnut belt on her belly

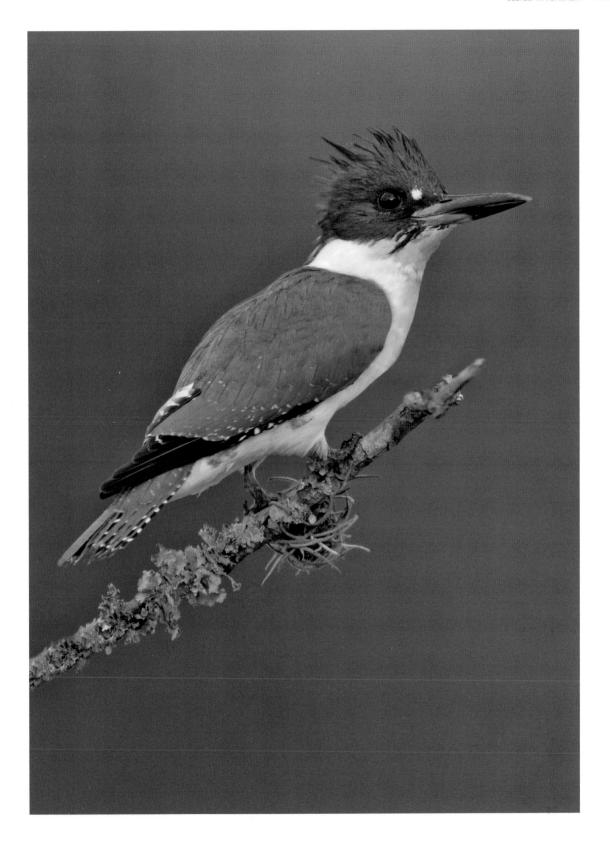

Woodpeckers

Picidae

Almost all woodpeckers are instantly recognizable as woodpeckers—either while they are climbing up a tree trunk or by their undulating flight; even if out of sight many make their presence felt by clearly audible drumming.

There are some 234 species of woodpeckers in the world; they inhabit almost every wooded area of the world except for Antarctica, Madagascar, and Australasia. There are 22 species in North America. They vary in size from chickadee to large crow.

All have a relatively powerful, dagger-like beak which they use to make holes or lever off bark. They move up tree trunks by use of two structures: powerful zygodactyl feet for gripping the trunk, and specially stiffened, wedge-shaped tail feathers which they use as props to support them against the tree trunk.

The skulls of woodpeckers have two major adaptations to their way of life. First, the skull is reinforced around the base of the bill; this cushions the brain from injury from the repeated blows as they hammer open wood either for nesting or in search of prey, or while drumming to attract attention of a possible mate. Second, they have a tongue which extends a long way beyond the tip of the beak (about

4in/10cm in a Northern Flicker) and when withdrawn the tongue and associated muscles are pulled back around the back of the skull into one of the eye sockets or nostrils. The tip of the tongue is covered with tiny spines with which the birds can spear any prey it reaches to pull them out.

Woodpeckers nest in holes in trees, which they make themselves, usually drilling new ones each year. Most use their beaks against the trunk (drumming) to establish their territory and attract a mate, in order to maximize the sounds they select pieces of timber with strong resonance; the frequency and pattern of the sounds can be used to identify the species.

They feed on a wide range of animals, from tiny ants, which they gather in large mouthfuls, through to large beetle grubs and, occasionally, baby birds taken from their nests. Sapsuckers drill horizontal rows of holes in trunks (called ringing) and revisit them to collect the sap and the insects attracted to the sap. Many also take seeds and nuts; they may drill holes in branches into which they place the nuts to hammer them open. This is taken to the extreme in the Acorn Woodpecker, which makes huge numbers of holes and stores nuts there for long periods.

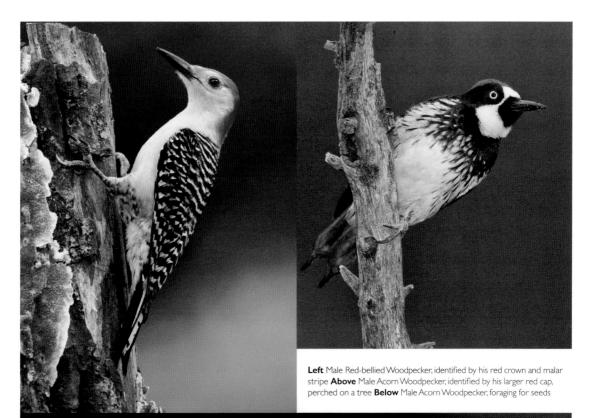

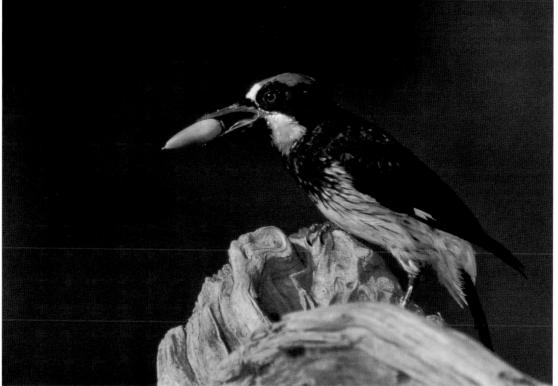

Northern Flicker

Colaptes auratus

The Northern Flicker is a conspicuous woodpecker with barred beige-and-black back and wings, and a white rump which is particularly visible in flight. It has a black bib and prominently large-spotted underparts. There are two subspecies which can be distinguished by the color of the underside of their wings and tail. Eastern birds are bright yellow (Yellow-shafted Flicker), and western birds bright red (Red-shafted Flicker), on the undersides of their wings and tails. Eastern birds have pinkish faces, a small red patch on the nape, and males have a prominent mustache. Western birds have gray faces; the male has a red malar.

Northern Flickers occur over most of North America, though in the fall those north of the Canadian border mostly fly south for the winter.

They favor open wooded country where they mainly forage on the ground for prey such as ants and beetles. They eat seeds and fruit, too, and are well-adapted to colonize habitats altered by humans. Provided there are enough trees they may be seen in more open, urban, and suburban environments. It visits backyard bird baths and, as a hole-nester, may use nestboxes in suitably wooded locations.

FACTFILE

Length 12.5in (32cm)

Habitat Open wooded country and farmland with enough trees

Food Ground-feeders; ants, ground beetles, and other insects

Status Resident across U.S.A.; mostly migrant in Canada

Voice Pulse of high-pitched chips

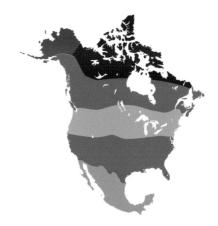

Above Female Northern Flicker, western subspecies (Red-shafted), perched on a tree **Opposite** Male Northern Flicker, eastern subspecies (Yellow-shafted)

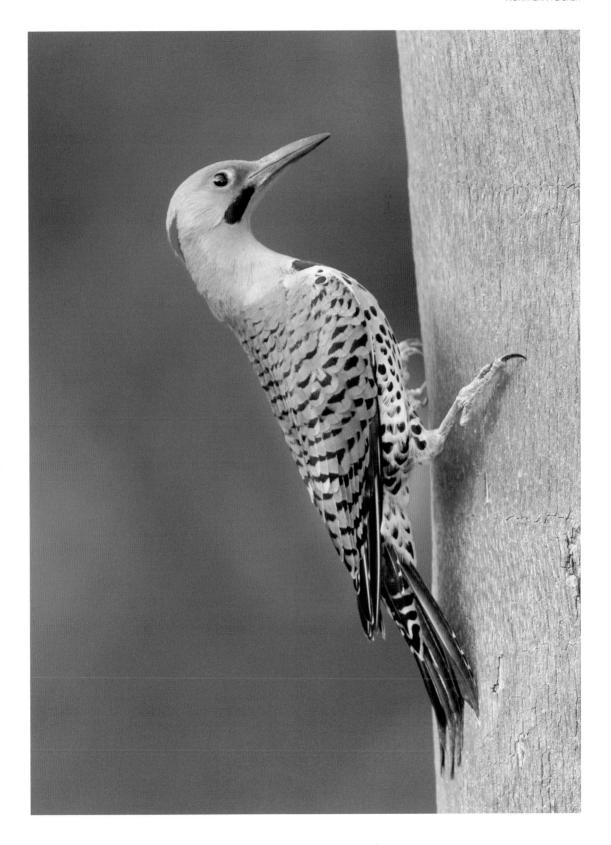

Yellow-bellied Sapsucker

Sphyrapicus varius

The Yellow-bellied Sapsucker is a fairly small black-and-white woodpecker with a bright red forehead and crown. The underparts are buff or yellow-tinged; a yellow belly is seldom apparent. There is a strong white patch on the wing. The most striking difference between the sexes is females have white chins while those of the males are bright red.

They breed in northeastern U.S.A. and widely across Canada. In winter these birds migrate to southeastern U.S.A. and Mexico.

They feed on insects and sap and are noted for the habit of drilling horizontal rows of small holes into the bark of trees (called rings) to induce the tree to bleed sap (hence its name). They visit these rings regularly, drinking the sap and taking insects attracted to it. In summer they are found most commonly in areas with small, often relatively young trees containing high sugar content in the sap, especially aspen, maple, and birch; they are most likely to visit backyards in their range that contain these trees.

Length 8.5in (22cm)

Habitat Forests, most commonly those with stands including young trees

Food Wide range of insects; sap important at some times of year

Status Migrant. Breeds Canada and northeastern U.S.A.; winters southeastern U.S.A. **Voice** Wide range from single notes repeated rapidly, to loud trills

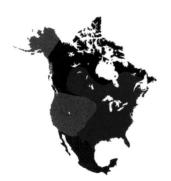

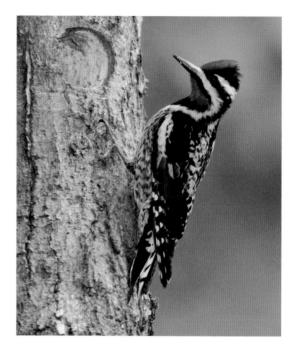

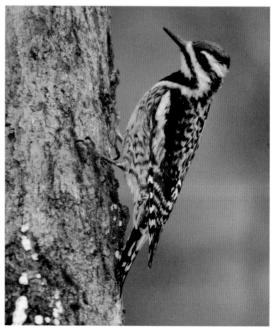

Above Male Yellow-bellied Sapsucker, identified by his red chin **Below** Female Yellow-bellied Sapsucker, identified by her white chin, perched on a tree

Pileated Woodpecker

Dryocopus pileatus

The size of a crow, the Pileated Woodpecker is largely black but with white stripes on the face and neck. Both sexes have blazing red crests; the male has a red crown and malar stripe, while the female's crown and malar stripe are black. Their flight is less undulating than that of other woodpeckers. They are unmistakable and the largest woodpecker in North America.

They are resident in almost all of eastern U.S.A. and across southern Canada, extending down the west coast to northern California. They are found in forests with large trees, including old ones that are dead or dying. They cannot persist in areas where logging results in even-aged stands of younger trees.

They feed mainly on insects, especially carpenter ants and wood-boring beetle larvae, plus berries and seeds in season. Leaving dead or dying trees in your yard, where safety allows, may bring them closer to you; they may use nestboxes or take suet from bird feeders.

The Pileated Woodpecker has been described as a "keystone species" because their holes provide nesting or roosting sites for many other species; no fewer than thirty-eight species of animals have been recorded as using their chambers.

FACTFILE

Length 16.5in (42cm)

Habitat Forests with large old trees

Food Ants, wood-boring beetle larvae, fruits in season

Status Largely resident

Voice Long series of shrill notes

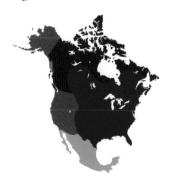

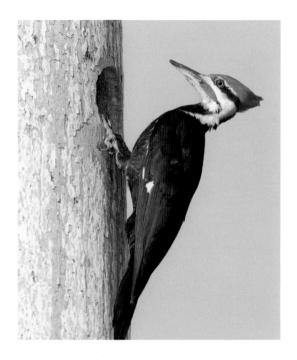

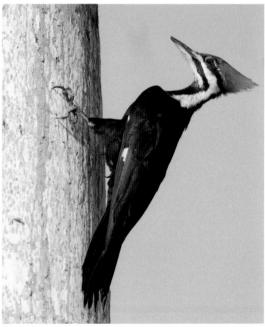

Above Male Pileated Woodpecker, identified by his red crown and malar stripe **Below** Female Pileated Woodpecker perched on a tree

Red-bellied Woodpecker

Melanerpes carolinus

This is a medium-sized woodpecker with 🗘 a finely barred upperside that can appear gray at a distance, its most conspicuous feature is its bright red nape. In the male this extends to the crown, but in the female the crown is pale gray. The face and undersides are white, often with a reddish tinge. Its red belly is restricted to a small area between its legs, often pale and not visible. White wing flashes are visible in flight.

The Red-bellied Woodpecker is largely resident throughout the eastern half of the U.S.A. and has been expanding its range northwards and westwards.

One of the least specialized woodpeckers in North America and found in almost all habitats, it is an opportunistic feeder, taking a wide range of invertebrates, seeds, and nuts, also fruits (it drinks from oranges) and sap. They commonly take the eggs and nestlings of small birds. They frequently visit bird feeders, where they may be aggressive.

Length 9.25in (23cm)

Habitat Occurs in almost all wooded habitats Food Opportunistic, taking a wide range of insects, seeds, and nuts, even eggs and chicks of small birds

Status Widespread resident of eastern U.S.A. Voice Very rapid chatter or fast trill

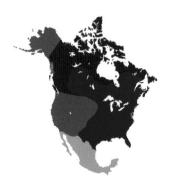

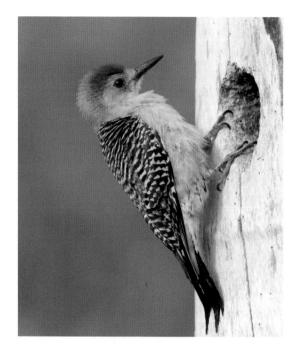

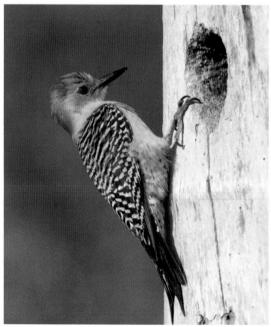

Above Male Red-bellied Woodpecker, identified by his bright red nape, extending to the crown **Below** Female Red-bellied Woodpecker perched

Acorn Woodpecker

Melanerpes formicivorus

This is a conspicuous, medium-sized, black-L backed woodpecker, with yellow eyes set off by a black mask. It has a sharply defined white forehead, malar and chin, though black around the beak. Sexes are similar but the male has a larger red cap. They have black bibs, black-streaked white undersides; small patches of white are visible on the wing and rump.

They are resident in lower-elevation and low-montane woodlands in western North America from southern Washington to Mexico, where their key habitat requirement is the presence of oak trees.

As its name suggests, this species eats acorns. Acorn Woodpeckers are usually in groups, sometimes of ten or more, with a territory centered around one or several large oaks, called storage trees or granaries. They drill holes in dead branches or thick trunk bark, without damaging the tree, to store acorns. A large storage tree may contain 50,000 or more holes, drilled over a number of years. Acorns are stored in season to be eaten at other times of year. They vigorously defend their trees, especially from other Acorn Woodpeckers, staying with them all year round. They also eat insects, seeds, and "sapsuck" from different, smaller holes than those dug for acorn storage.

FACTFILE

Length 9in (23cm)

Habitat Open country with large oaks Food Acorns, but also seeds, fruits, and insects Status Largely resident, remaining close to their storage trees

Voice Harsh two-note call repeated

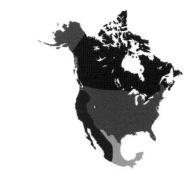

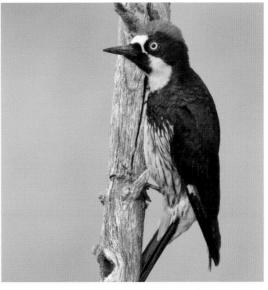

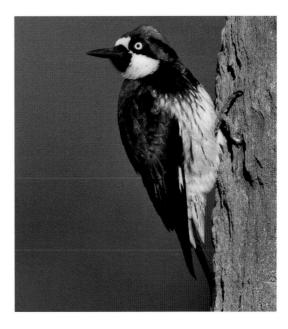

Above Male Acorn Woodpecker, identified by his larger red cap, perched on branch Below Female Acorn Woodpecker perched on tree

Downy Woodpecker

Dryobates pubescens

The Downy Woodpecker is unmistakable. It is a tiny black-and-white woodpecker, not much larger than a Tufted Titmouse. The head is striped and the black wings show lines of white spots when closed. There is a large white patch on the back, and the underparts are white. The beak is short. In males the hind-crown end of the white head stripe is red, while it is white in females. Juveniles of both sexes have a red crown until they molt in the fall. The Downy Woodpecker shows geographical variation; seven subspecies have been recognized.

The Downy Woodpecker is a year-round resident coast to coast, from the tree line in Canada and Alaska to south Florida and southern California. It occurs everywhere from the more extensive forests to urban woodlots, where it is readily attracted to backyard bird feeders. They are noticeable because they are noisy.

The main food of the Downy Woodpecker is small invertebrates, small fruits, and seeds. Its beak is less dagger-like than that of most woodpeckers, and lacks the chisel-like tip. It is not used as much for drilling holes.

FACTFILE

Length 6.75in (17cm)
Habitat Wide range of forests; comes to backyards
Food Insects, fruits, and seeds
Status Resident throughout range
Voice Thin *chip* repeated after a few seconds

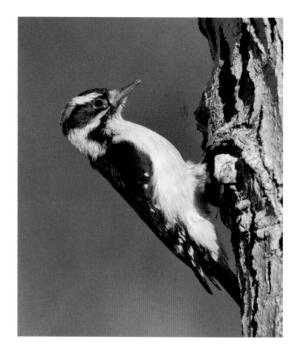

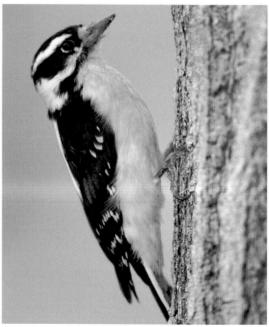

Above Male Downy Woodpecker, identified by his red hind-crown **Below** Female Downy Woodpecker perched on a tree

Hairy Woodpecker

Picoides villosus

The Hairy Woodpecker is medium-sized, has a strongly black-and-white-striped head, black wings with lines of white dots, and white below. They have a large white patch in the center of their backs. The males, but not the females, have a small red patch on the nape. Juveniles have red on the front of the crown until they molt into adult plumage in the fall. They are similar to but larger than the Downy Woodpecker, also differing in their longer, stronger beaks.

There is considerable geographical variation and some ten or more subspecies are recognized within North America. In general, they are larger in the north and at higher altitudes. Birds in the Pacific Northwest are black and pale beige.

Hairy Woodpeckers are resident almost wherever there are trees throughout North America. They can be found in almost all habitats, including suburban areas, and take a wide variety of foods, mainly invertebrates, but they also take seeds and fruits and they come readily to feeders. In early spring their calls and drumming can be heard for long distances.

FACTFILE

Length 9.25in (23cm), but large geographical variation, smaller in south

Habitat All woodlands, commonest in conifers **Food** Mainly invertebrates, also seeds and fruits; comes readily to feeders

Status Resident throughout range **Voice** Fast, high *wicka-wicka*

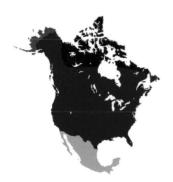

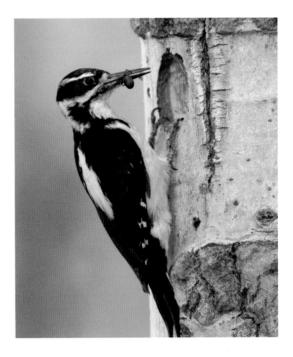

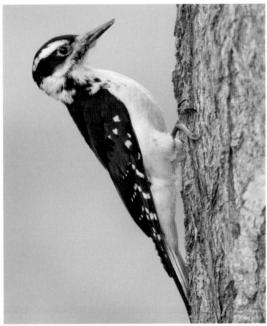

Above Male Hairy Woodpecker, identified by his small red patch on the nape **Below** Female Hairy Woodpecker perched on a tree

Flycatchers

Tyrannidae

A very large number of birds depend on insects for an important proportion of their diet. The Tyrannidae are often called the Tyrant-Flycatchers due to their aggressive nature. This name distinguishes them from the many other fly-catching birds around the world, especially the Muscicapidae, the Old World flycatchers.

There are some 450 species of Tyrannids; this number has been steadily creeping up as more research is undertaken. While this is especially true for the Andes, where many flycatchers occur, even those breeding in North America have required very detailed studies to determine how many species there are, and even here there may yet be more to find. For example, eleven of the genus Empidonax occur in North America—all very similar, small, greenish flycatchers; only careful studies of song and behavior showed that two of these, once known as Traill's and Western Flycatchers, were each actually two species (Alder and Willow, and Pacific Coast and Cordilleran, respectively). Thirty-seven species of Tyrannids have been recorded in North America. This number includes the Rose-throated Becard, which some now believe belongs to a separate family, the Tityridae.

Typically, many flycatchers are small and greenish, with weak legs and relatively broad, flat beaks; they sit on branches and fly out to snap up passing insects. However, not all feed in this way: some use other methods such as foliage-gleaning, where they move along the branches picking off prey using a fine needle-shaped beak. Some mainly hunt along the ground and these tend to have longer, sturdier legs.

In size, they range from tiny, several are little more than 5 inches (13 centimeters) long, through to larger species such as the Great Crested Flycatcher, at up to 9 inches (23 centimeters). The largest, the Great Kiskadee, at about 10 inches (25 centimeters) long, is

a sturdier, more colorful bird with yellow underparts and a black head with a bright white eye-stripe.

While most are inconspicuously colored in browns and greens, a few stand out. Two, the Scissor-tailed and Fork-tailed Flycatchers, have spectacularly long tails; an adult male Fork-tailed Flycatcher may be 16 inches (41 centimeters) long. These two, together with seven others, make up the kingbirds, and are placed in the genus *Tyrannus*. These are middle-to-large Tyrannids and can be very aggressive for their size. Only the Eastern and Western Kingbirds are widespread in North America, both extending into Canada. The male Vermilion Flycatcher has, as its name suggests, brilliant red on its crown and underparts.

Although most flycatchers eat insects, many will take fruits in season and birds such as the Rose-throated Becard seem to eat fruit much of the time. The phoebes are the flycatchers you are most likely to see in your backyard, such as the Black Phoebe and Eastern Phoebe. Most flycatchers are unlikely to visit bird feeders unless mealworms are on offer, but they may hunt over backyards. Some species are hole-nesters and may use nestboxes when natural holes are in short supply.

Tyrannids mostly build cup nests secreted in undergrowth or thick vegetation; some weave a covered nest into tangled vegetation or hanging vines. In most species, the females incubate the eggs alone and in some the male takes no part in raising the brood.

Almost all flycatchers leave North America for the winter, migrating south to find food, with only small numbers remaining along the Mexican border and in Florida. Unlike most flycatchers on migration, Scissor-tailed Flycatchers may gather together in large roosts prior to fall migration.

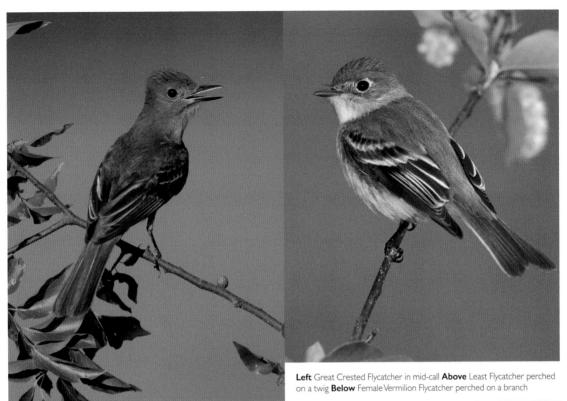

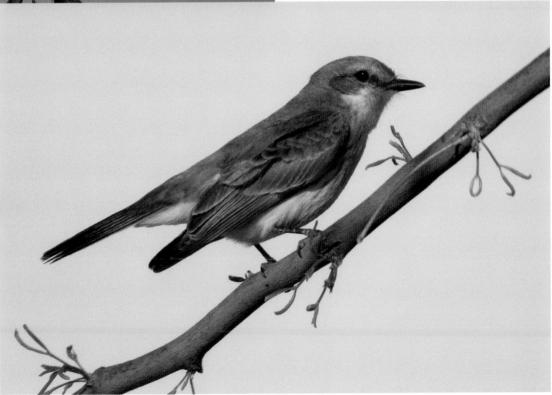

Black Phoebe

Sayornis nigricans

The Black Phoebe is a distinctive, easily recognizable flycatcher, being dumpy bodied and essentially black and white. The sexes are similar. Adults have a black head and chest, grading to dark gray on the back. The wings are black overall but with a hint of pale on the wingbars and subtly pale fringes to the inner flight feathers. The rather long tail is mainly black but with white outer feathers. The belly and undertail are white. Juveniles are similar to adults but the wing coverts and back feathers have brown fringes.

The Black Phoebe is resident throughout the year in southwest U.S.A. It is easy to observe well because typically it is almost oblivious to observers. It usually perches in the open and flies out to catch passing insects. A characteristic behavior is that it wags its tail up and down when perched.

FACTFILE

Length 6.75in (17cm)
Habitat Open woodland, parks, and backyards, usually near water
Food Insects and other invertebrates
Status Locally common resident
Voice Song is a repeated two-phrase tch-wee, tch-sew. Call is a sharp tsiip

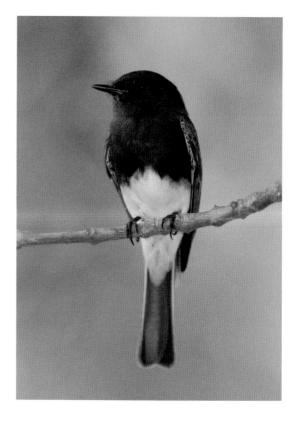

Above Black Phoebe perched on a branch

Eastern Phoebe

Sayornis phoebe

The Eastern Phoebe is a plump-bodied I flycatcher whose plumage lacks any really distinctive features. The sexes are similar. Adults are mainly gray-brown above, darkest on the head. The wings are blackish with two whitish wingbars and pale fringes to the inner flight feathers. The underparts are dull whitish but with a gray wash to the flanks; freshly molted birds in fall show a variable vellow-buff wash to the belly. Juveniles are similar to adults but with buff wingbars and a more obvious yellow wash on the belly.

The Eastern Phoebe is a breeding species across much of eastern North America, mainly from April to September. It spends the rest of the year in southeast U.S.A. and Mexico. Perched birds often pump their tail downward, with a swaying motion. The species flycatches in flight, usually from the vantage point of a low perch. Eastern Phoebes often favor human-made habitats, and nest under bridges or on buildings.

Length 6.75in (17cm)

Habitat Woodland, parks, and backyards Food Insects and other invertebrate

Status Widespread and common summer visitor

Voice Song is a whistled two-phrase sphee-dip, sphee-werr. Call is a sharp chip

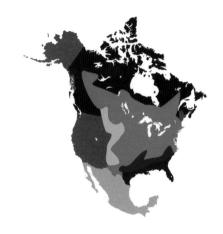

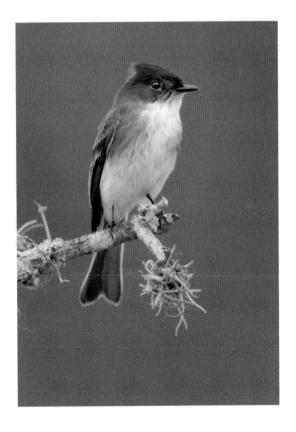

Above Eastern Phoebe perched on a branch

Least Flycatcher

Empidonax minimus

The Least Flycatcher is a compact, short-winged species with a relatively large head. The sexes are similar. Adults have dull olive-gray upperparts; the underparts are whitish, palest on the throat and belly, and with a gray band across the breast and a dull yellow-buff flush to the lower flanks. The dark wings have pale fringes to the inner flight feathers and two white wingbars. Juveniles are similar to adults but the wingbars are buff, not white.

The Least Flycatcher is present as a breeding species from May to August across much of the northern half of North America. It spends the rest of the year in Central America. It usually sits at mid-level in the tree canopy and often adopts an upright stance, regularly flicking its tail and wings. Insects are caught in flight; Least Flycatchers also hover and pick prey from the surface of leaves.

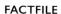

Length 5.25in (13.5cm)

Habitat Woodlands, scrub, and backyards

Food Invertebrates

Status Widespread and fairly common resident **Voice** Song is variable but usually comprises a series of wheezy phrases and ends in a trill. Calls include various harsh, rasping notes

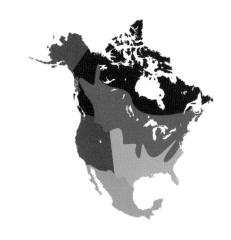

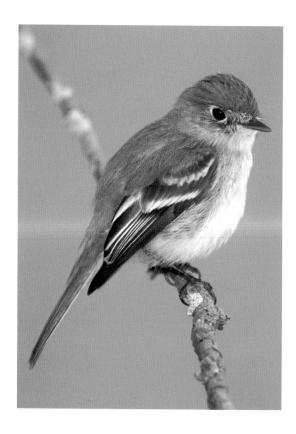

Above Least Flycatcher perched on a branch

Vermilion Flycatcher

Pyrocephalus rubinus

The Vermilion Flycatcher is a distinctive bird. The sexes are dissimilar and males are unmistakable. Adult males have a bright red throat, underparts, and crown, with a dark brown mask, nape, back, wings, and tail. Adult females have gray-brown upperparts, a pale supercilium, dark wings with two pale wingbars, and a dark tail. The underparts are pale overall, with dark streaking on the breast and flanks, and a pinkish-orange flush to the belly and undertail. Juveniles are similar to adult females but have spots, not streaks, on the breast and flanks, and lack color on the underparts. Immature birds in their first year show plumage characteristics intermediate between juvenile and adult plumages.

The Vermilion Flycatcher is present as a summer visitor to the southern states of the U.S.A., mainly from May to September. A few birds are present year-round but most winter in Central America. This colorful species usually perches conspicuously and is indifferent to people, making observation both easy and rewarding.

Length 6in (15cm)

Habitat Open woodland and parks, usually near water

Food Insects and other invertebrates

Status Summer visitor, locally common within its restricted North American range

Voice Song is a series of sharp *pit-a-see* notes, ending in a trill, sometimes given in flight. Call is a thin *psee*

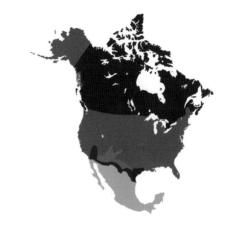

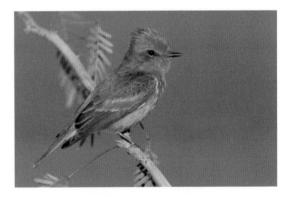

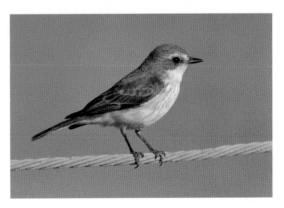

Above Male Vermilion Flycatcher, identified by his bright red throat, underparts, and crown **Below** Female Vermilion Flycatcher perched on a wire

Great Crested Flycatcher

Myiarchus crinitus

The Great Crested Flycatcher is a relatively large, slim-bodied species. The sexes are similar. Adults have a dark brown hood, nape, and back. The underparts comprise a dark gray face, throat, and breast, with a clear separation from the bright yellowish belly and undertail. The wings are dark overall but show two pale wingbars and rufoustinged primaries. The tail is mainly rufous, both above and below. The legs are black and the bill is black overall but with a dark brown base. Juveniles are similar to adults but with subdued colors overall, and rufous wingbars and flight feather edges.

The Great Crested Flycatcher is present as a breeding species across most of temperate eastern North America from April to September. It spends the rest of the year in Central and South America. It perches in an upright posture and feeds by flycatching passing insects, gleaning insects from foliage, and dropping to the ground for prey.

FACTFILE

Length 7-8.5in (18-21.5cm)
Habitat Wide range of wooded habitats
Food Insects, other invertebrates, and fruit
Status Common summer visitor
Voice Song (sung at dawn) comprises a series of whu-eep call-like notes. Calls include an upslurred whu-eep and a harsh chrrrt

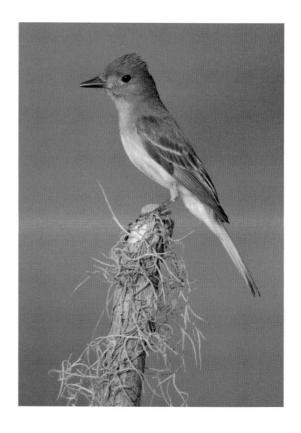

Above Great Crested Flycatcher perched on a branch

Eastern Kingbird

Tyrannus tyrannus

The Eastern Kingbird is a familiar black-andwhite songbird. The sexes are similar. Adults are essentially black above and white below. The black hood, neatly defined by the white throat, grades to dark blue-gray on the back and wings; the wing feathers have whitish margins. A reddish-orange crown stripe is invariably hidden. The black tail has a white terminal band. Although the underparts are mostly white, a diffuse pale gray chest band is present. The bill and legs are dark. Juveniles are similar to adults, although the upperparts are subtly tinged brown.

The Eastern Kingbird is present as a breeding species mainly from May to August across most of temperate North America, except the far west. It spends the rest of the year in South America. Great views can usually be obtained because it is often indifferent to people and perches on roadside wires and fences. It catches flying insects by making aerial sorties.

Length 8-9in (20-23cm) Habitat Wide range of open habitats Food Insects and other invertebrates Status Widespread and common summer visitor Voice Song (sung at dawn) comprises a much-repeated series of call-like trilling phrases. Calls include various trills and a metallic, rasping kedzee-kedzee...

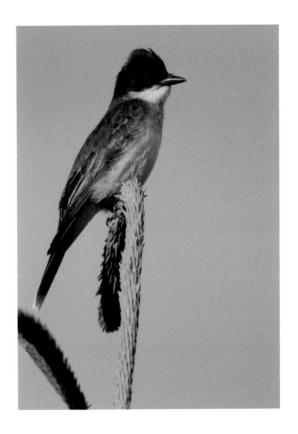

Above Eastern Kingbird perched on a branch

Western Kingbird

Tyrannus verticalis

The Western Kingbird appears rather pale overall when perched. Seen from above in flight, the contrast between the lighter body and dark wings and tail is striking. The sexes are similar. Adults have a mostly pale gray head with a subtle dark "mask" through the eye and a whitish cheek. An orange central crown patch is invariably hidden. The back is pale greenish-gray, the chest is pale gray, and the underparts—including the underwing coverts—are pale lemon yellow. The dark wings have pale feather margins, and the dark tail has pale outer feather margins. Juveniles are similar to, but paler than, adults.

The Western Kingbird is present as a breeding species mainly from April to August. It spends the rest of the year in Central America. It is the most widespread kingbird in North America and is easy to observe since it often perches on wires or dead branches beside farmland roads. Its flycatching sorties attract attention, as does the male's tumbling aerial courtship displays.

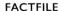

Length 8-9.5in (20-24cm)

Habitat Lightly wooded open country and farmland

Food Insects, other invertebrates, and fruit **Status** Widespread and common summer visitor **Voice** Song (sung at dawn) comprises a series of call-like *chip* notes. Calls include a sharp *chip* and a trilling chatter

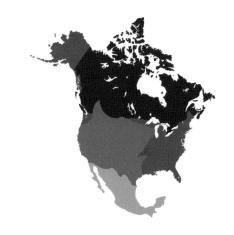

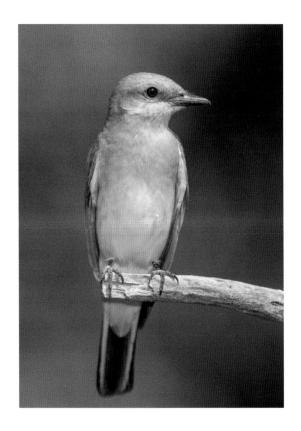

Above Western Kingbird perched on a branch

Northern Shrike

Lanius excubitor

The Northern Shrike is a larger, more heavily built cousin of the Loggerhead Shrike. The sexes are similar. Adults have pale gray upperparts and a black "mask" that reaches the bill but does not continue around the forehead (compared with the Loggerhead Shrike). The underparts are very pale gray. The wings are mainly black but with a white patch at the base of the primaries; this is obvious in flight and more extensive than in the Loggerhead. The long tapered tail is mainly black but with white feather tips. Juveniles are similar to adults but the gray and white plumage elements are replaced by reddish buff; the underparts are barred faintly and the "mask" is faint. This plumage is usually replaced by adult-like plumage by early winter.

Northern Shrikes are present in their Arctic and boreal breeding range, mainly from May to September. The species moves south to central North America for the rest of the year. This bold predator often perches on an overhead wire or dead branch. Larger prey items (small birds and mammals) are sometimes impaled on thorns or barbed wire before being dismembered.

FACTFILE

Length 10in (25.5cm)

Habitat Tundra and taiga forest in summer; open country with scattered trees in winter Food Insects, small mammals, and birds Status Widespread, but never common Voice Song is a series of harsh squawks, chatters, and trills. Calls include a shrill kreek, kreek...

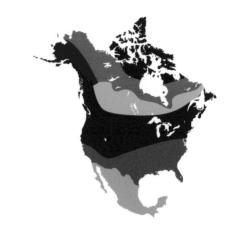

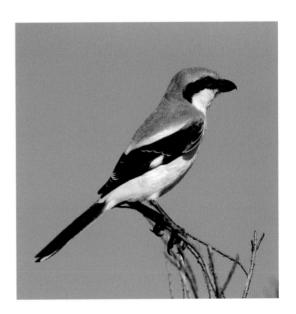

Above Larger than the Loggerhead Shrike, the Northern Shrike clings to a branch

Loggerhead Shrike

Lanius ludovicianus

The Loggerhead Shrike is a boldly masked predatory songbird. The sexes are similar. Adults have rich gray upperparts, the mantle having a white border. A dark "mask" extends through the eye and around the forehead, above the bill; it is defined above by a white margin. The underparts are pale overall, darkest on the breast and palest on the throat. The mainly black wings have a small white patch at the base of the primaries (most obvious in flight). The long tail is tapered and mainly black with white feather tips. Juveniles are similar to adults but the upperparts and underparts appear faintly barred or scaly.

The Loggerhead Shrike occurs year-round in the south of its range, while northern birds are present in their breeding range, mainly from May to September; they move south in fall. It is the smaller counterpart of the Northern Shrike, which is entirely migratory. Despite its size, the Loggerhead Shrike is a fearsome predator of large insects and small vertebrates; larger prey is often impaled on thorns or barbed wire and then dismembered. The species commonly perches on bushes and wire fences.

FACTFILE

Length 9in (23cm)

Habitat Farmland and open country with bushes and wires

Food Insects, small mammals, and birds
Status Widespread but never common.
Northern populations migrate south; southern birds are resident

Voice Song is a series of harsh, repeated chirping phrases. Call is a harsh *chaak*

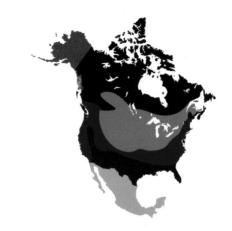

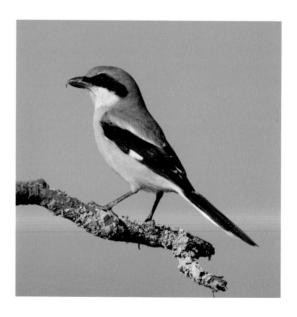

Above Loggerhead Shrike perched on a branch

Red-eyed Vireo

Vireo olivaceus

This is North America's most familiar vireo. The L sexes are similar. Adults have a greenish-gray back and neck, and rather grubby white underparts with a dull yellow flush to the flanks and undertail. The striking head pattern comprises a dark gray crown and long white supercilium, defined above and below by black lines. The eye has a red iris, and the bill is stout and relatively long. Juveniles are similar to adults but the iris color is subtly duller.

The Red-eved Vireo is present as a breeding species across much of northern and eastern North America, mainly from May to August. It spends the rest of the year in South America. It usually forages for insects in an unobtrusive manner, making it hard to spot in dappled foliage; its presence is often detected first by its distinctive song.

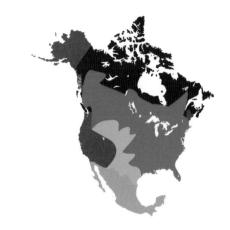

FACTFILE

Length 6in (15cm)

Habitat Deciduous woodland

Food Insects and other invertebrates

Status Widespread and common summer

visitor

Voice Song comprises a series of two- to four-syllable phrases, including tse-oo-wit, tse-oo-ee, and tsee-oo. Call is a nasal zzNrrr

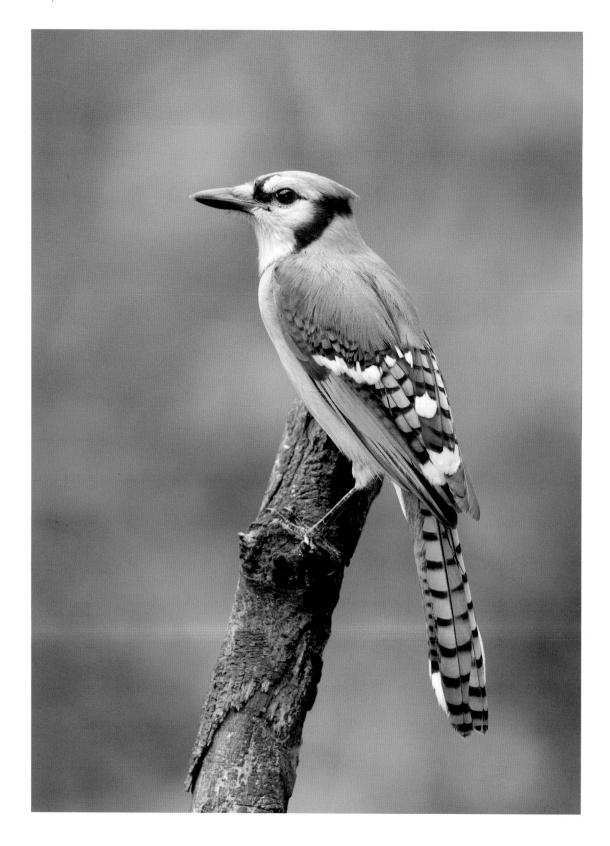

Blue Jay Cyanocitta cristata

The Blue Jay is a familiar colorful songbird with an obvious crest. The sexes are similar. Adults have a purplish-blue cap, nape, and back. The wings are mainly blue but with black barring, as well as bold white patches and a wingbar. The tail is blue with black barring and white outer tips. The underparts are pale gray-blue, with a dark "necklace" on the throat. Juveniles are similar to adults but less colorful.

The Blue Jay is present as a breeding species across most of eastern and central North America. Generally birds are sedentary in their habits but in some years northern populations in particular undertake mass irruptive movements south. The species is a frequent visitor to backyard bird tables and is usually bold and inquisitive in locations such as parks.

FACTFILE

Length 11in (28cm)

Habitat Wide range of wooded habitats, including backyards

Food Omnivorous and opportunistic **Status** Widespread and common resident **Voice** Calls include a shrill *jay-jay-jay*, a whistling *pee-de-de*, and mimicry, especially of raptors

Above Blue Jay in flight **Opposite** A common yet distinctive sight across North America, the Blue Jay

American Crow

Corvus brachyrhynchos

The American Crow is the most widespread bird of its kind in the region and the default corvid to which its relatives should be compared. The sexes are similar. Adults have uniformly glossy black plumage. The bill is proportionately long and dark, and the legs are dark. In flight, the relatively long tail is sometimes fanned. Juveniles are similar to adults but the eye has a pale (not dark) iris and there is a subtle brown tinge to the plumage. The closely related Northwestern Crow (*Corvus caurinus*) is essentially identical to American Crow populations found in the northwest; in areas where the two species do not occur together, geographical range represents the only realistic prospect of separating them.

The American Crow is resident year-round across most of North America except along the northwest coast, and in the far north, where populations migrate south in fall. All manner of food items are eaten and the species is quick to cash in on human wastefulness, visiting garbage dumps and raiding trash cans. It sometimes gathers in flocks outside the breeding season. The Northwestern Crow replaces the American Crow along the northwest coast of British Columbia and Alaska.

FACTFILE

Length 15–18in (38–45.5cm)

Habitat Wide range of habitats, from farmland to urban environments

Food Omnivorous and opportunistic

Status Widespread and common resident and partial migrant

Voice Call is a raucous caaw-caaw

 $\begin{tabular}{ll} \bf Above & {\bf American Crow in flight Opposite American Crow standing in the grass} \end{tabular}$

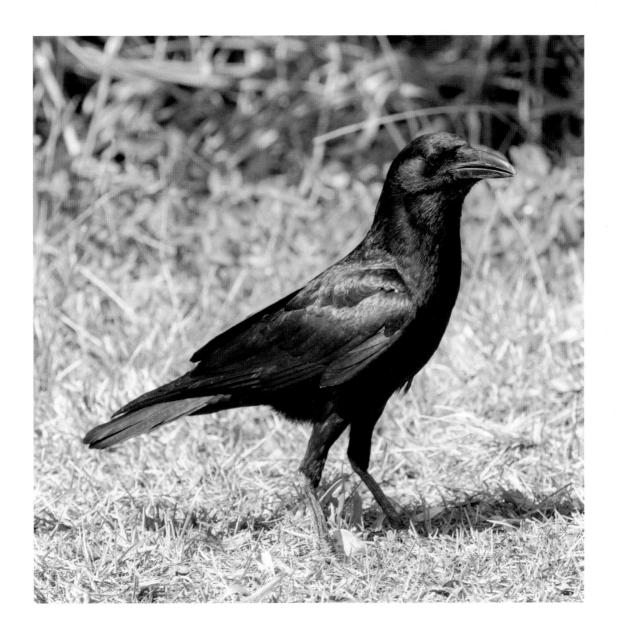

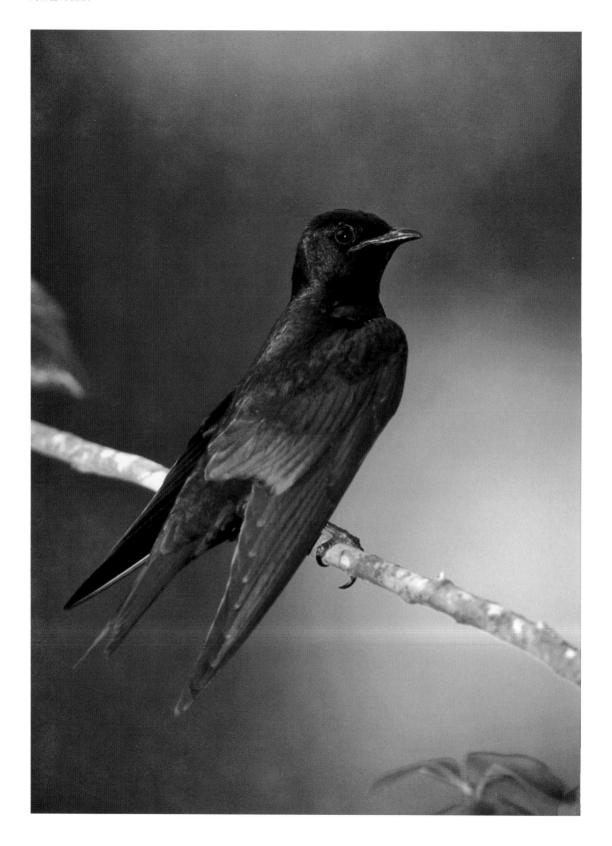

Purple Martin

Progne subis

The Purple Martin is a familiar songbird in ▲ North America. The sexes differ. Adult males are uniformly dark, with a purplish sheen visible in good light. Adult females have gray-brown upperparts with a suggestion of a bluish sheen, and mottled gray-brown underparts, palest as a patch on the belly. Juveniles are similar to an adult female but with much paler underparts. Males in their first spring of life retain a variable extent of juvenile plumage features. In flight, all birds have broadly triangular wings and a relatively long, forked tail.

The Purple Martin is present as a breeding species, mainly from April to August; it is widespread in eastern North America but more scattered elsewhere. It spends the rest of the year in South America. In summer, the species is often associated with human settlement and responds well to the introduction of nestboxes. It catches flying insects on the wing.

FACTFILE

Length 7–8in (18–20cm)

Habitat Suburban habitats and open country Food Insects

Status Locally common summer visitor Voice Song compromises a series of gurgling and croaking notes. Calls include a liquid chrr and various whistles

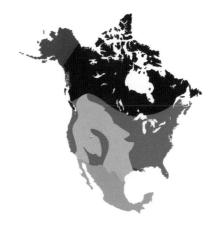

Above Purple Martin in flight Opposite Identified by its striking coloration, the Purple Martin displays its triangular wings

Barn Swallow

Hirundo rustica

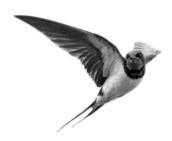

The Barn Swallow is a familiar songbird, often seen in flight or perched on overhead wires. The sexes are subtly dissimilar. Adult males have a blue cap, nape, and back, with a red forehead and throat. A dark breast band separates the throat color from the buffish-orange underparts. The tail has long streamers (extensions to the outer feathers) that are very obvious in flight. Adult females are similar but have much paler underparts and shorter tail streamers. Juveniles are similar to an adult female but with even shorter tail streamers and a dull buff throat and forehead.

The Barn Swallow is present as a breeding species across much of North America, mainly from March to September. It spends the rest of the year in South America. It builds a mud nest, sometimes in a natural setting such as a cave, but often on a ledge in an agricultural barn or shed. It chases insects in flight and often feeds over water.

FACTFILE

Length 6.5–7in (16.5–18cm)

Habitat Open country, including grassland and farmland

Food Insects

Status Song comprises a series of twittering warbles, and grating notes. Calls include a *sharp che-vii*

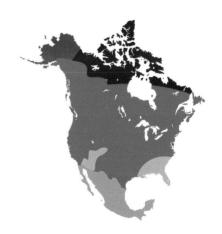

Above Barn Swallow in flight **Opposite** Showing off its tail streamers, a Barn Swallow, perched

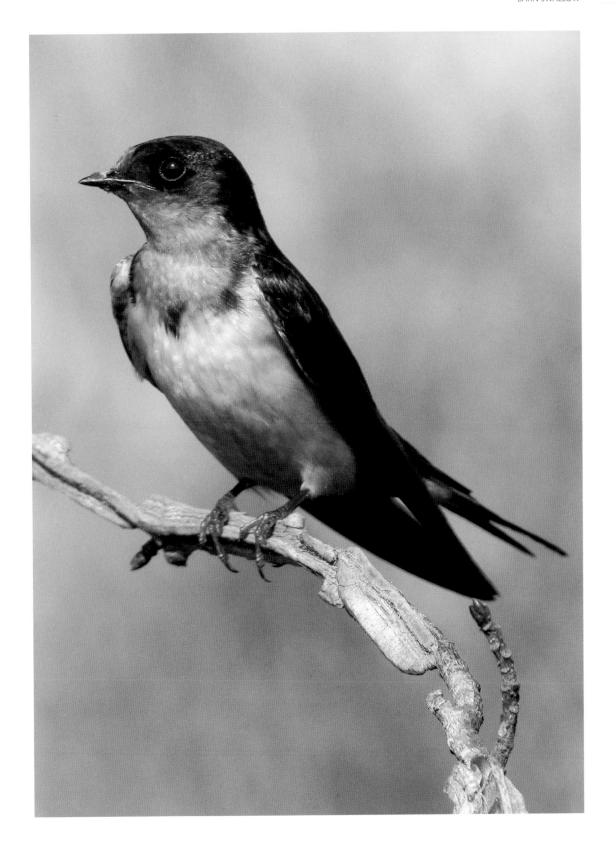

Chickadees and Titmice

Paridae

This little group of small birds comprises eleven species in North America, to which sometimes two others, thought to be close relatives, are added: the Verdin (Remizidae family) and the Bushtit (Aegithalidae family). They include species with which the backyard birdwatcher is particularly familiar. These are the Black-capped Chickadee and the Tufted Titmouse, both regular attendants at feeders and both much studied.

All species are quite small, with strong beaks and legs. The titmice have crests; the chickadees all have some black and white around the head, though this is less distinct in the Boreal Chickadee.

They are typically active birds, and move acrobatically through foliage, often hanging upside down while searching for food. All except the Tufted Titmouse form small groups, and they may congregate to form large mixed groups to forage outside of the breeding season. Black-capped Chickadees live in groups often of around six individuals; these split up into pairs as spring approaches, the dominant members of each sex pairing together. Both are regular members of feeding flocks. The Tufted Titmouse in particular is regarded as a "nuclear" species—those around which other species congregate.

All members of the family feed mostly on invertebrates in the summer, and take seeds, nuts, or

fruit at other times. All species store food—and have been shown to have good memories of where they store the items. Faced with the unnatural glut of food provided by feeders, the birds will carry on storing, removing large quantities of seeds throughout the winter.

All species are hole-nesters and may use nestboxes. Tufted Titmice prefer to use an existing hole—usually one made by woodpeckers—while the Black-capped Chickadee prefers to build its own, excavating soft wood from a dead stump or branch. Both will use nestboxes provided for them, but the Black-capped Chickadee does so rather unwillingly; they seem more likely to do so if the box is filled with chippings that they can remove.

The Black-capped Chickadee is resident in Canada and the northern half of the U.S.A. The other chickadees have more restricted ranges, and all but the Carolina Chickadee are found in the western half of North America. They may hybridize where their ranges overlap. There is little overlap in titmouse ranges.

The least known is the Gray-headed Chickadee, which occurs in northern Alaska and the adjacent Canadian provinces. This species ranges across the high Arctic westwards all the way to Scandinavia, where it is called the Siberian Tit.

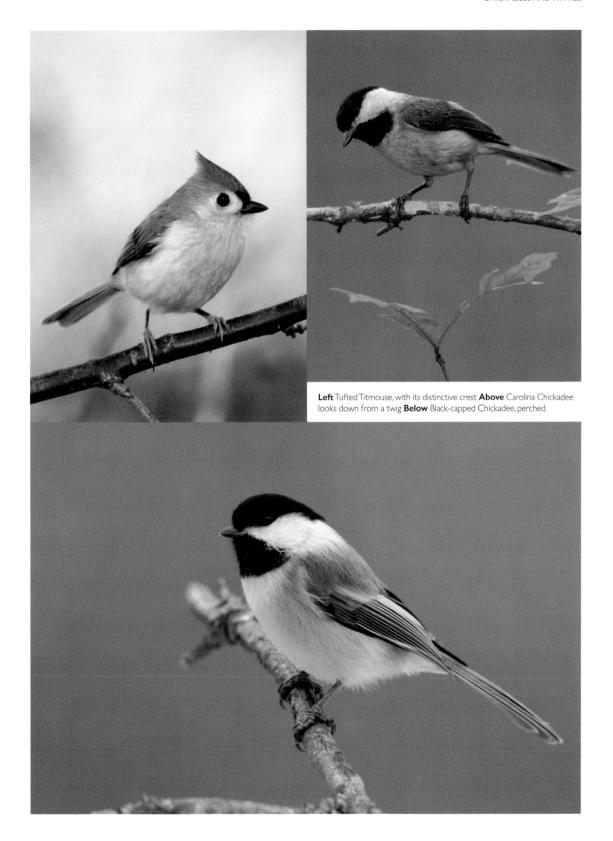

Tufted Titmouse

Baeolophus bicolor

Whith its hallmark crest, the Tufted Titmouse is a familiar and distinctive songbird. The sexes are similar. Adults have pale blue-gray upperparts with a blackish forehead and peaked crest. The very pale gray underparts are palest on the undertail, and suffused with orange-buff on the flanks. The pale face shows off the dark eye. The bill is dark and legs are blue-gray. Juveniles are similar to adults but the forehead is gray.

The Tufted Titmouse is a year-round resident of wooded habitats in eastern North America. It is not shy, making it easy to find and observe well. The species often visits backyard feeders, especially in winter, and responds well to the introduction of nestboxes; these are a substitute for the tree-hole nest sites it uses in the wild.

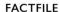

Length 6–6.5in (15–16.5cm)
Habitat Open deciduous woodland, and wooded parks and backyards
Food Invertebrates and seeds
Status Widespread and common resident
Voice Song comprises a series of disyllabric pee-lu phrases. Call is a nasal zee-zee

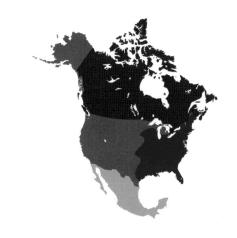

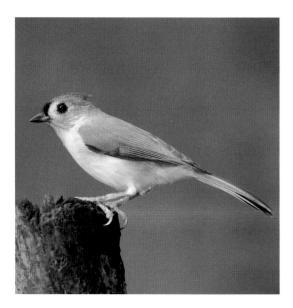

Above Tufted Titmouse perched on a tree stump

Black-capped Chickadee

Poecile atricapillus

The Black-capped Chickadee is a familiar songbird. The sexes are similar, and both adults and juveniles have a gray-buff back. The wings are mostly dark but have a pale panel created by whitish margins to the inner flight feathers and greater coverts. The cheeks are white, and this color extends to the sides of the nape. The head has a black cap that tapers down the nape. There is a black throat and bib, and the underparts are otherwise pale with a subtle pinkish-buff suffusion to the rear of the flanks. The dark tail has pale feather margins, the legs are blue-gray, and the bill is dark.

The Black-capped Chickadee is present year-round across much of central North America. It favors woodland but is a familiar visitor to backyard feeders, especially outside the breeding season. Although generally sedentary, it often consorts with nomadic mixed-species songbird flocks in winter. In the wild, Black-capped Chickadees nest in tree-holes, but they will happily use artificial nestboxes.

Length 5.25in (13.5cm)
Habitat Wide range of wooded habitats
Food Invertebrates and seeds
Status Widespread and common resident
Voice Song is a whistled, disyllabic *fee-bee*.
Onomatopoeic call is *chika-dee-dee-dee*

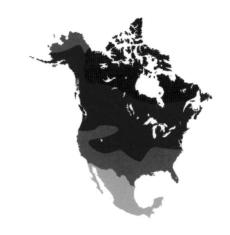

Carolina Chickadee

Poecile carolinensis

The Carolina Chickadee is very similar to its Black-capped Chickadee cousin and, in the limited zone where the two species overlap, certain identification may not always be possible. The sexes are similar and both adults and juveniles have a gray-buff back. The dark wings have pale margins to the inner flight feathers and greater coverts, but these features are less striking than in the Blackcapped. The head has a black cap, throat, and bib (like the Black-capped), and white cheeks that grade to pale gray on the sides of the nape. The underparts are overall pale gray with a faint buff suffusion on the flanks; the result is that the flanks are subtly "warmer" in tone than in the Black-capped. The dark tail has pale feather margins. The legs are blue-gray and the bill is dark.

The Carolina Chickadee is present year-round in wooded habitats in southeast U.S.A. In the wild, it nests in tree-holes but, like many related songbirds, it will happily use a nestbox. It also visits backyard feeders, especially in winter, and outside the breeding season will join nomadic mixed-species songbird flocks as they search for food.

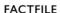

Length 4.75in (12cm)
Habitat Deciduous woodland
Food Invertebrates and seeds
Status Widespread and common resident
Voice Song is a four-note whistling *fee-bee fee-bay.* Call is rapid *chika-dee-dee*, subtly higher in pitch than that of Black-capped Chickadee

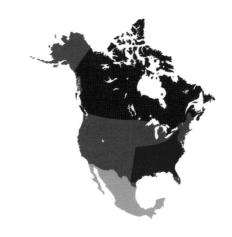

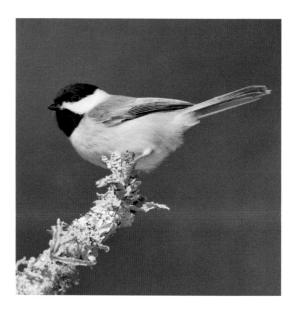

Above Carolina Chickadee perched on a branch

Brown Creeper

Certhia americana

which its downcurved, needle-like bill and streaked brown plumage, the Brown Creeper is hard to mistake for any other species. The sexes are similar. Adults have brown upperparts adorned with pale teardrop spots, and whitish underparts suffused with buff on the flanks and undertail. The face has pale-streaked brown cheeks and a whitish supercilium. The short wings have buff baring and the rump and base of the tail are rufous. Western populations tend to be subtly darker than eastern ones. Juveniles are similar to adults but have faint barring on the chest.

In western and northeastern North America, the Brown Creeper occurs year-round. Elsewhere, it is present in spring and summer in the north, but migrates south for the winter. It feeds in a distinctive manner, climbing tree trunks like a mouse, using its tail as a support. Typically it spirals up a tree trunk, then drops to the base of an adjacent trunk to repeat the process.

Length 5.25in (13.5cm)

Habitat Wide range of forested habitats

Food Invertebrates

Status Widespread and common resident and migrant

Voice Song is a series of high-pitched *tsee-see-see* notes. Call is a thin *tsee*

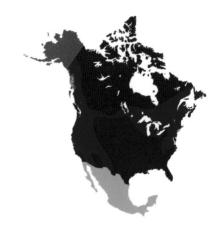

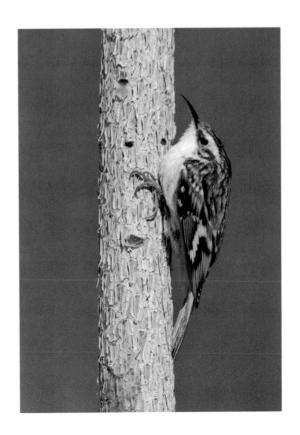

Above Brown Creeper climbing a tree

White-breasted Nuthatch

Sitta carolinensis

he White-breasted Nuthatch is the largest ▲ bird of its kind in the region. The sexes can be separated if seen together. Adult males have a blue-gray back and wings, with contrasting dark centers and pale edges to the tertials and wing coverts. The white face and throat contrast with the black nape and crown. The underparts are otherwise very pale gray, flushed rufous and white on the undertail. Adult females are similar, but the crown and nape are dark gray. Geographical variation occurs across the species' range, represented by several subspecies. Eastern populations have paler gray backs and show more contrast in the wing markings than those from the west. Juveniles are similar to their respective adults but the wing feathers have buff fringes.

The White-breasted Nuthatch is present year-round across its extensive North American range, although it occasionally wanders in winter in response to food shortages. It is a regular visitor to backyard feeders and sometimes joins roving mixed-species flocks of songbirds outside the breeding season.

Length 5.75in (14.5cm)

Habitat Deciduous and mixed woodland

Food Invertebrates and seeds

Status Widespread and common resident

Voice Song is a series of nasal, whistling notes.

Call is a nasal nYen

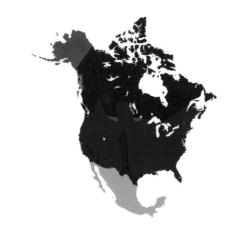

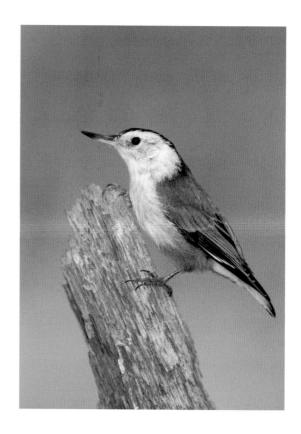

Above White-breasted Nuthatch perched on a tree stump

Red-breasted Nuthatch

Sitta canadensis

The Red-breasted Nuthatch is a plump-bodied 1 forest songbird. The sexes are subtly different. Adult males have a blue-gray back, wings, and tail, and mainly reddish-buff underparts. The head has a black crown and eye stripe, and a white supercilium, face, and chin. Adult females are similar, but the black elements of the head plumage are paler and the underparts are less colorful. Juveniles are similar to their respective adults, but have brown, not black, wing feathers.

The Red-breasted Nuthatch is present yearround across the central part of its North American range, as well as in the west. However, northern populations move south in fall and in winter the species' range extends to most of the southern states. Outside the breeding season, Red-breasted Nuthatches often join roving flocks of mixedspecies songbirds.

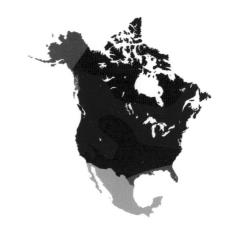

FACTFILE

Length 4.5in (11.5cm)

Habitat Conifer forests

Food Invertebrates and seeds

Status Widespread and common resident, and

partial migrant

Voice Song comprises a series of nasal errn notes, similar to the call, which is reminiscent of the sound of a child's toy trumpet

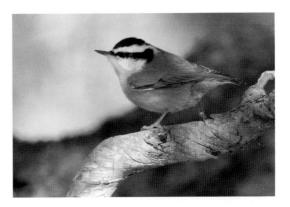

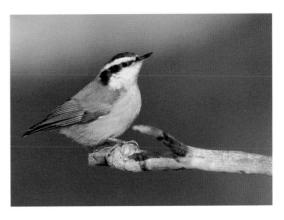

Above Male Red-breasted Nuthatch, identified by his more colorful underparts **Below** Female Red-breasted Nuthatch with paler plumage

House Wren

Troglodytes aedon

The House Wren is a dumpy-bodied songbird with a needle-like bill. The tail, which is proportionately much longer than in other wrens, is often cocked up. Subtle subspecies variation occurs across the species' range. Given this variation, the sexes are similar. Overall, all adults have brown plumage, darkest on the upperparts and with barring on the wings and tail. The face and throat range from buff in eastern birds to gray-buff in western birds. The underparts are otherwise pale with a variable buff suffusion to the breast and flanks, the latter also variably barred dark. On average, eastern birds are a richer brown than western birds, which tend to be grayer overall. Juveniles are similar to their adult counterparts but have a scaly look to the paler face and throat.

The House Wren is present as a breeding species, mainly from May to August across the north of its range. At other times of the year, it migrates south and occurs from southern U.S.A. to Mexico. Where summer and winter ranges overlap, the species is present year-round. It nests in tree-holes and outbuildings.

FACTFILE

Length 4.75in (12cm)

Habitat Wide range of habitats, including woodland, scrub, and backyards

Food Invertebrates

Status Widespread and common summer visitor, local winter visitor, and very local resident

Voice Song is an accelerating series of raspy trills, ending in a flourish. Call is a rasping *tche*

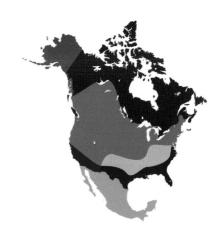

Above House Wren in flight Opposite House Wren, in song

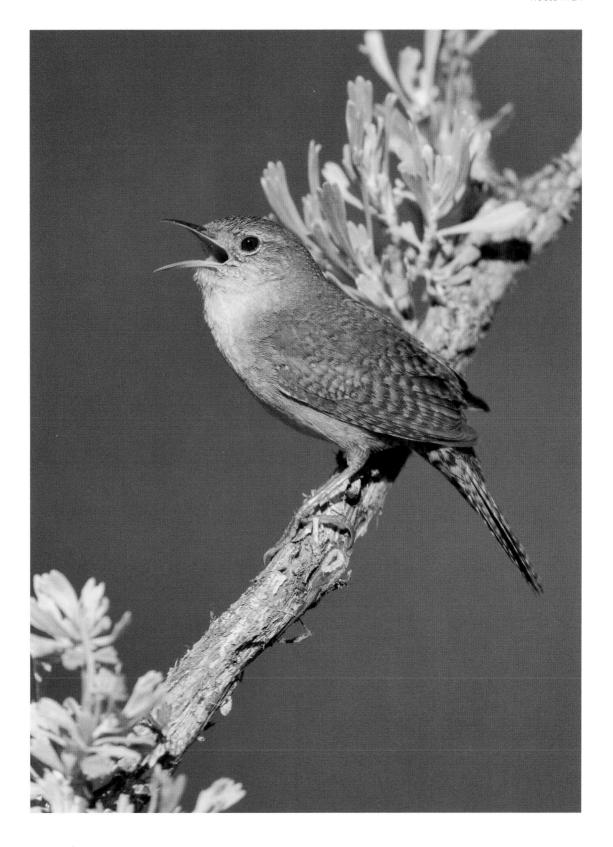

Carolina Wren

Thryothorus ludovicianus

The Carolina Wren is a well-marked and familiar little songbird. The sexes are similar, as are adults and juveniles. All birds have unstreaked, rich brown upperparts and warm buff underparts that are palest on the throat and breast. There is subtle barring on the wings and tail. The wing coverts have white tips that form incomplete wingbars (not present in the similar Bewick's Wren; opposite). The head is marked with a striking white supercilium and a speckled gray face. The bill is thin and downcurved, and the legs are reddish.

The Carolina Wren is present year-round in its eastern North American range. It is mainly sedentary and so northern populations often crash in severe winters. The species is a familiar backyard bird and by wren standards it is quite bold and easy to see. It could be confused with Bewick's Wren where their ranges overlap, but Carolina has warmer-looking brown plumage, incomplete white wingbars, and lacks the white tips to the tail feather of Bewick's.

Length 5.5in (14cm)

Habitat Woodlands, scrub, and backyards

Food Invertebrates

Status Widespread and common resident **Voice** Song is a series of repeated fluty, whistling phrases. Call is a harsh, agitated *tchee-tchee-tchee*

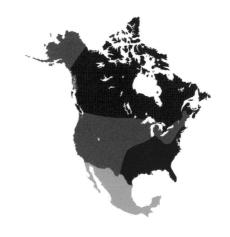

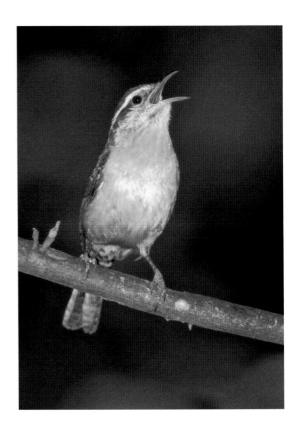

Above Carolina Wren, in song

Bewick's Wren

Thryomanes bewickii

ewick's Wren is a long-tailed wren with Ban obvious pale supercilium. Regional plumage variation exists across its range, but given this variation the sexes are similar. Adults and juveniles have upperparts that are brown in eastern birds but grayer in western populations. The upperparts are unmarked except on the tail, which is barred and has white feather tips. The underparts are grayish white, palest on the throat, and with a rufous wash on the rear of the flanks in eastern populations.

Most Bewick's Wrens are present year-round in western North America, although birds in the far northeast of the species' range do tend to move south in winter. The long tail is often held cocked up and is sometimes flicked from side to side.

Length 5.25in (13.5cm)

Habitat Woodlands, scrub, and backyards

Food Invertebrates

Status Widespread and fairly common resident Voice Song is variable but usually comprises a series of wheezy phrases and ends in a trill. Calls include various harsh, rasping notes

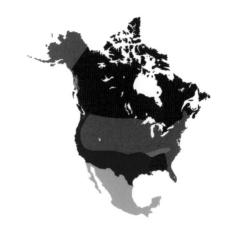

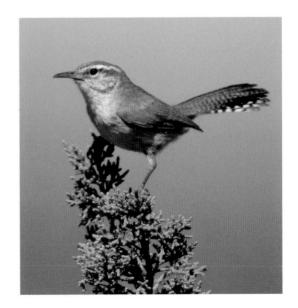

Ruby-crowned Kinglet

Regulus calendula

Although this species is slightly bigger than the Golden-crowned Kinglet (opposite), the best identification feature for separating the two is its plain face. The sexes are dissimilar. Adult males have mainly gray-green upperparts, and dark wings with two white wingbars. The central ruby-colored crown patch is revealed only in displaying birds and is otherwise hidden. On the face, a pale patch surrounds and emphasizes the dark beady eye. The underparts are pale olive-gray. Adult females and juveniles are similar to the male but lack the ruby crown patch.

The Ruby-crowned Kinglet is present as a breeding species across northern latitudes of North America and western mountain ranges, mainly from May to September. Although present year-round locally in the southwest, most birds migrate south in fall and the winter range extends from southern U.S.A. to Central America. The species is extremely active and always on the go, searching for invertebrates among the foliage of trees and shrubs.

FACTFILE

Length 4.25in (11cm)

Habitat Northern conifer forests in summer; wide range of wooded habitats in winter

Food Invertebrates

Status Widespread and common, with distinct summer and winter ranges

Voice Song comprises thin *tsi-tsi-tsi* notes followed by a chattering warble. Call is a rasping disyllabic *ti-dit*

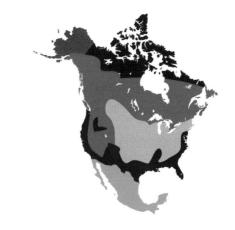

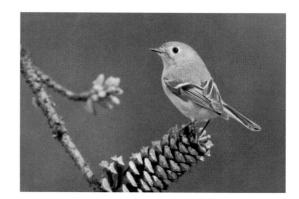

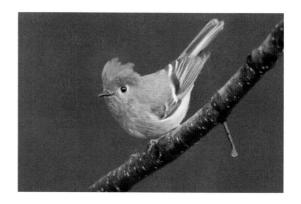

Above Female Ruby-crowned Kinglet, perched on a pine cone **Below** Male Ruby-crowned Kinglet, identified by his red-colored crown patch (only revealed in displaying birds)

Golden-crowned Kinglet

Regulus satrapa

The Golden-crowned Kinglet is a tiny warbler-like songbird. A bold head pattern allows separation from the otherwise similar Ruby-crowned Kinglet (opposite). The sexes are dissimilar. Adult males have a gray-green back, and dark wings with two white wingbars. The head pattern compromises a white supercilium emphasized below by a dark eye stripe and above by a black margin to the golden-centered crown. The cheeks are gray and the throat and the rest of the underparts are pale gray-buff. The legs are black and the feet are yellowish. Adult females and juveniles are similar to the male but the crown center is yellow.

The Golden-crowned Kinglet is present in its northern breeding range, mainly from April to September. It occurs year-round in the northeast and parts of western North America, but most northern birds migrate south in fall, occurring throughout the southern half of the continent. The species is constantly active in search of food and sometimes joins roving mixed-species songbird flocks outside the breeding season.

FACTFILE

Length 4in (10cm)

Habitat Northern conifer forests in summer; conifer and mixed forests in winter

Food Invertebrates

Status Widespread and common, in northern latitudes in summer, and in the southern half of North America in winter

Voice Song is a sweet *tswi*, *tswi*, *tswi*, *tswit-tswit-tswit*. Call is a thin *tswi*

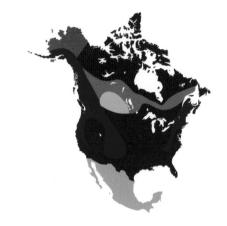

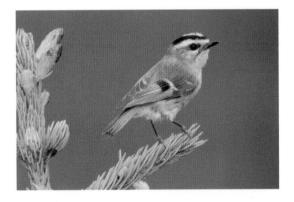

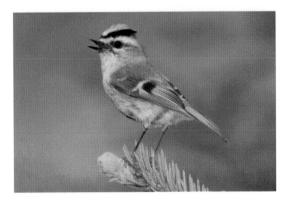

Above Female Golden-crowned Kinglet perched on a branch Below Male Golden-crowned Kinglet, identified by his golden crown

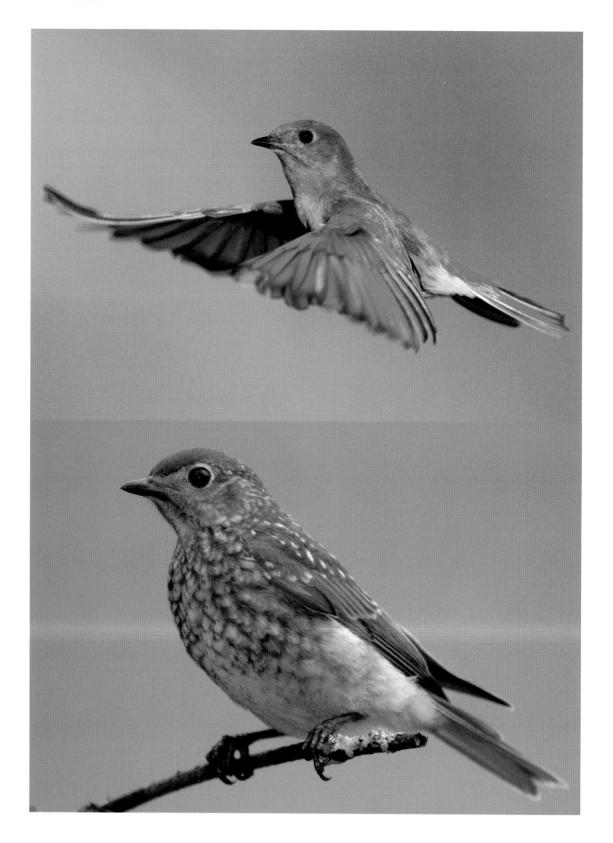

Fastern Bluebird

Sialia sialis

The Eastern Bluebird is a colorful and familiar ▲ songbird. The sexes are dissimilar. Adult males have blue upperparts, and a capped appearance to the head created by the orange-red partial collar. The throat, breast, and flanks are also orange-red, and the belly and undertail are white. Adult females have gray-brown upperparts with a blue tail and flight feathers. The throat, partial collar, and breast are suffused orange while the belly and undertail are white. Juveniles are brown, darker above than below, and with pale spots on the upperparts and scalylooking underparts.

The Eastern Bluebird is present as a breeding species in the north of its range, mainly from April to September. It is present year-round in southern U.S.A. and its winter range extends to Mexico. The species nests in tree-holes and will use nestboxes; it has suffered from competition for nest sites from European Starlings and House Sparrows. Outside the breeding season it forms flocks, when berries and fruits feature in the diet.

FACTFILE

Length 7in (18cm)

Habitat Open woodland, parks, and backyards

Food Invertebrates and fruit

Status Widespread, fairly common but declining summer visitor; present year-round in the south

Voice Song is a series of warbling phrases. Call is a disyllabic tchu-lee

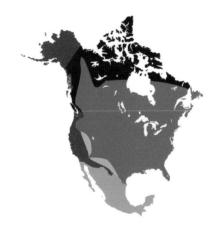

Above Eastern Bluebird perched on a branch Opposite above Male Eastern Bluebird, identified by his blue upperparts, in flight Opposite below Female Eastern Bluebird with paler coloration

Western Bluebird

Sialia mexicana

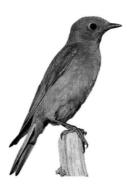

The Western Bluebird is a colorful songbird. The sexes are dissimilar. Adult males have blue upperparts, including the head and throat, with a well-defined separation from the orange-red breast and flanks. The otherwise white underparts are suffused blue in the center of the belly. Adult females resemble a very dull male with gravy-brown upperparts, dark wings and tail with a hint of blue, on orange-red breast, and otherwise pale gray underparts. Juveniles are brown, darker above than below, and with pale spots on the upperparts and scaly-looking underparts.

The Western Bluebird is present as a breeding species in the north of its range, mainly from April to August. Farther south, it is present year-round and its winter range extends into Mexico. It perches on bare branches and wires, and nests in tree-holes as well as nestboxes; it suffers from competition for nest sites with European starlings and House Sparrows.

FACTFILE

Length 7in (18cm)
Habitat Open woodland
Food Invertebrates and fruit
Status Scarce summer visitor and local
year-round resident

Voice Song (sung at dawn) comprises a series of call notes, such as chuu and a disyllabic *chut-et*

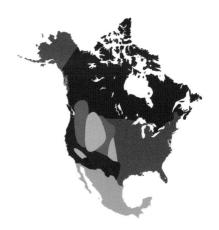

Above Female Western Bluebird perched on a post **Opposite above** Male Western Bluebird, identified by his blue upperparts **Opposite below** Female Western Bluebird on a branch

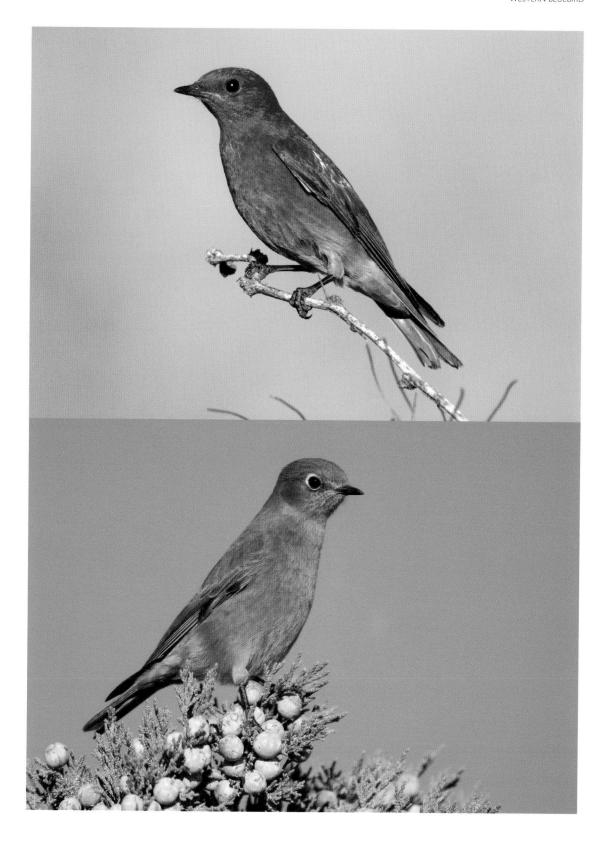

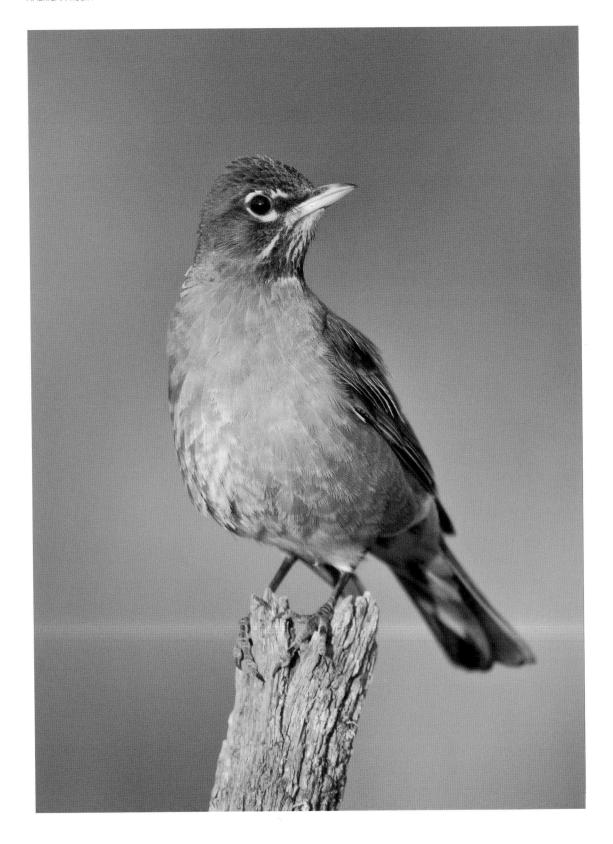

American Robin

Turdus migratorius

The American Robin is an iconic songbird. The L sexes are subtly dissimilar. Adult males have a gray-brown back, rump, and wings. The dark head has bold white "eyelids" framing the eye, and a dark-streaked white throat. The tail is dark brown, and the underparts are brick red with white on the lower belly and undertail. Reddish underwing coverts can be seen in flight. The legs and bill are yellowish. Adult females are similar to an adult male but much less colorful and with a hint of dark barring on the breast. Juvenile plumage recalls that of an adult female but with white spots on the back and dark spots on the underparts.

The American Robin is present as a migrant breeding species to the north of its range, mainly from April to September. It occurs year-round in the southern half of North America, where numbers are boosted in winter by migrants. It is a familiar sight in parks and gardens, and typically it is bold and easy to observe.

FACTFILE

Length 10in (25.5cm)

Habitat Wide range of wooded habitats, parks, and backyards

Food Invertebrates, particularly earthworms, and berries

Status Widespread and common summer visitor and year-round resident

Voice Song comprises a series of whistling phrases, each often disyllabic, and separated by distinct pauses. Calls include a sharp puup. Flight call is a thin trill

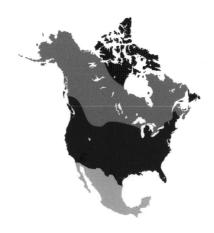

Above American Robin in flight Opposite Female American Robin on a tree stump

Gray Catbird Dumetella carolinensis

The Gray Catbird is a distinctive long-tailed songbird. The sexes are similar, and adults and juveniles are alike. All birds have deep blue-gray body plumage but with a black cap, and dark wings and tail. The brick-red undertail is diagnostic. The eye, legs, and bill are dark.

The Gray Catbird is present as a breeding species, mainly from May to August across much of the eastern and north-central North America. In fall, birds migrate south and the species' winter range extends from coastal southeast U.S.A. to Mexico and the Caribbean generally. It is notoriously secretive and skulking, usually keeping to the cover of dense undergrowth, where it forages in leaf litter. The tail is often cocked up.

FACTFILE

Length 8.5in (21.5cm)

Habitat Dense woodland and scrub

Food Invertebrates and berries

Status Widespread and common summer

visitor; local winter visitor

Voice Song is a series of chattering squawks and whistles, often with some mimicry; the phrases are not often repeated. Call is a catlike *meow*

Above Gray Catbird, singing **Opposite** Gray Catbird, singing its distinctive sounds

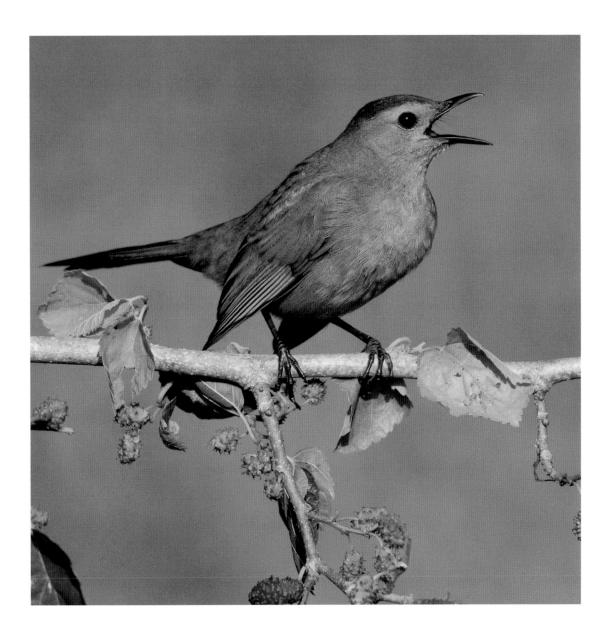

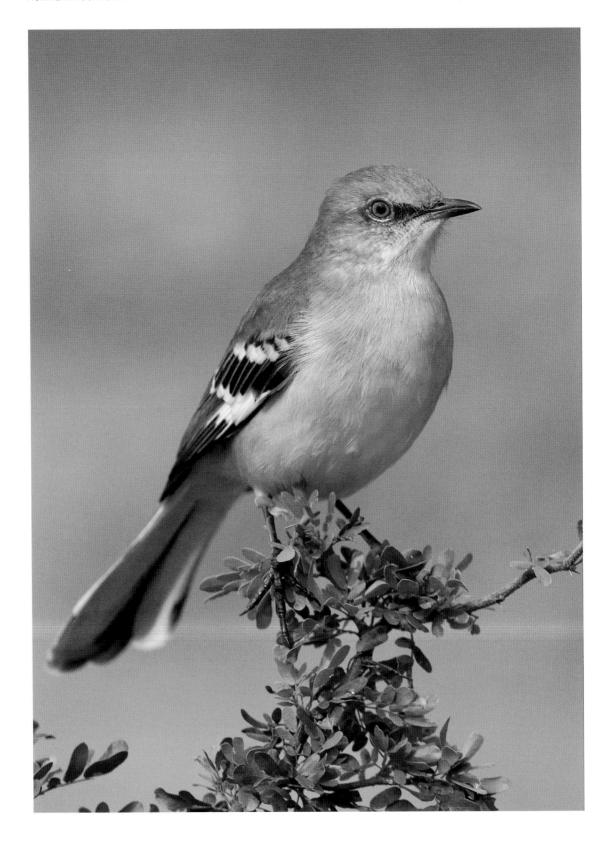

Northern Mockingbird

Mimus polyglottos

The Northern Mockingbird is a familiar bold ■ songbird. The sexes are similar. Adults have gray upperparts and blackish wings with bold white wingbars and a white patch at the base of the primaries. The mainly black tail has white outer feathers. The yellow eye is emphasized by a dark eye stripe, and the bill is slightly downcurved. The underparts are pale gray, palest on the throat and undertail. Juveniles are similar to adults, but with pale buff underparts that are heavily spotted on the throat and breast.

The Northern Mockingbird is present yearround across much of southern U.S.A., although northern populations migrate south in fall. The species often perches prominently on wires and fenceposts, and often sings after dark in artificially lit suburbs.

FACTFILE

Length 10in (25.5cm)

Habitat Wide range of wooded and lightly wooded habitats, including urban locations

Food Invertebrates, fruits, and berries

Status Widespread and common resident, and partial summer migrant

Voice Song consists of warbling phrases, with plenty of mimicry, each phrase repeated several times. Call is a sharp tchek

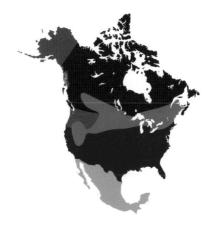

Above Northern Mockingbird in flight Opposite Northern Mockingbird astride a branch

Brown Thrasher

Toxostoma rufum

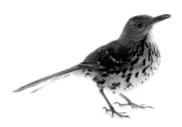

The Brown Thrasher is a richly marked, longtailed songbird with a slender, downcurved bill. The sexes are similar. Adults have reddish-brown upperparts, tail, and wings, the latter with two black and white wingbars. The face is streaked and the eye has a yellow iris. The underparts are buffish white with dark streaks on the breast, belly, and flanks. Juveniles are similar to adults but with dark eyes.

The Brown Thrasher is present as a breeding species across much of northern North America, mainly from May to August. Birds migrate south in the fall and the winter range extends across southeast U.S.A., with numbers boosting resident populations. The species is skulking and generally secretive, except in spring, when territorial males sing and become easier to locate.

FACTFILE

its range

Length 11.5in (29cm)
Habitat Dense, scrubby thickets
Food Invertebrates, berries, and seeds
Status Widespread and common summer visitor; present year-round in the south of

Voice Song is a series of fluty whistles, each phrase repeated two or three times. Calls include a sharp *stukk* and a softer *chrrr*

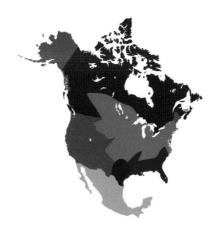

Above Brown Thrasher **Opposite above** Brown Thrasher clinging to a tree **Opposite below** Brown Thrasher in leaves

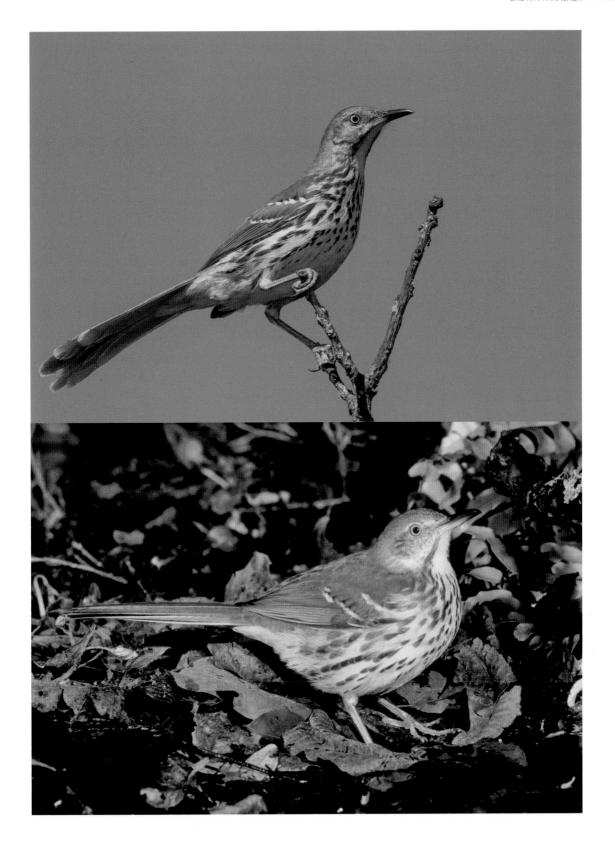

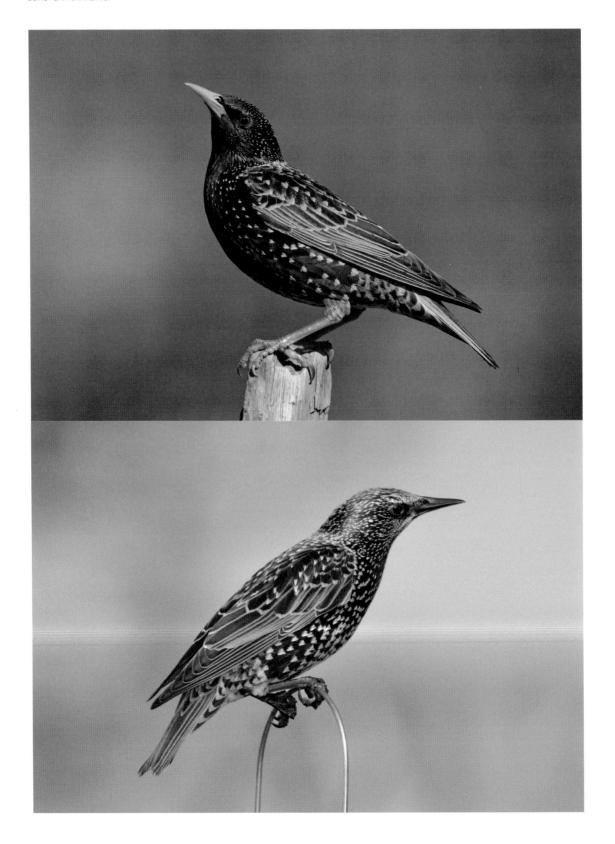

European Starling

Sturnus vulgaris

lthough introduced little more than a century ago, the European Starling is now an abundant bird in North America. The sexes are subtly dissimilar in summer. Summer adult males have dark plumage that shows a green and purple iridescence. There is a blue base to the lower mandible of the otherwise yellow bill. Summer adult females are similar but have some pale spots on the underparts. In winter, all adults have dark plumage adorned with numerous white spots, and the bill is dark. Juveniles are gray-buff, palest on the throat, and have a dark bill; by winter, the body plumage has become dark with white spots, but the head and neck remain buff. The legs are reddish in all birds.

The European Starling is present year-round across much of North America, although northern populations move south in winter. It forms huge flocks in winter, which range widely in search of food.

FACTFILE

Length 9in (23cm)

Habitat Wide range of habitats, from farmland to towns and cities

Food Opportunistic omnivore

Status Widespread and abundant resident, and partial migrant

Voice Song includes various chatters, clicks, and whistles, plus mimicry of other birds and manmade sounds. Calls include chatters and drawn-out whistles

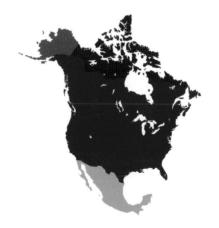

Above European Starling in flight Opposite above Female European Starling perched on a tree stump Opposite below European Starling, with its distinctive plumage

Bohemian Waxwing

Bombycilla garrulus

Whith its plump body and striking crest, the Bohemian Waxwing could only be confused with its cousin the Cedar Waxwing (opposite); subtle plumage differences allow separation. The sexes are subtly dissimilar. Adult males are mainly pinkish buff, palest and grayest on the belly. The head has a crest, a black mask, and a black throat. The dark primaries have white and yellow edges, the secondaries have red wax-like projections, and there is a white bar at the base of the primary coverts.

The rump is gray, the undertail is chestnut, and the dark tail has a broad yellow tip. Adult females are similar to an adult male but with a less extensive black throat, and a narrower yellow tip to the tail. Juveniles are streaked buff; by winter their plumage is similar to an adult but they lack the red wax-like projections and pale margins to the primaries.

The Bohemian Waxwing is present in its northern summer breeding range from April to September. Outside the breeding season it forms roaming flocks that move south; the winter range extends well beyond the zone where birds are usually present year-round. In years when berries are in short supply, flocks move much further afield.

FACTFILE

Length 8.25in (21cm)

Habitat Boreal forests in summer; anywhere with berry-bearing bushes in winter **Food** Invertebrates in summer; berries in

Status Widespread and common visitor; nomadic in winter, when it has an unpredictable range

Voice Does not sing. Call is a vibrant trill

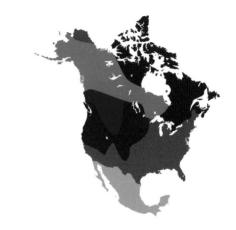

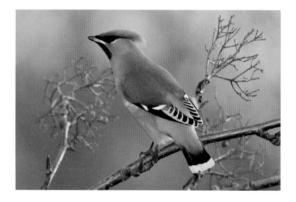

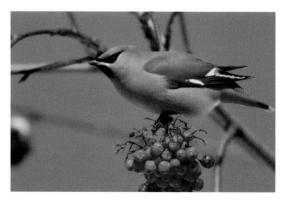

Above Male Bohemian Waxwing perched on a branch **Below** Female Bohemian Waxwing foraging for berries

Cedar Waxwing

Bombycilla cedrorum

Superficially similar to the Bohemian Waxing, the Cedar Waxwing can be distinguished by subtle plumage differences. The sexes are similar. Adults have orange-buff plumage (pinkish-buff in Bohemian), palest on the underparts and white on the undertail (chestnut in Bohemian). The dark wings have white inner margins to the tertials and red wax-like feather projections on the secondaries. The head has a crest, and a dark mask framed by white lines. The rump is gray and the dark tail has a yellow tip, subtly broader in males than in females. Juveniles are gray-buff; by winter they are similar to an adult but lack the red waxy wing projections.

The Cedar Waxwing is present in its northern summer breeding range mainly from May to September. Outside the breeding season birds move south and form roaming flocks. It is present year-round across much of central North America, but its winter range also extends south into Mexico. Winter flocks are nomadic, wandering in search of berry bushes.

Length 7.25in (18.5cm)

Habitat Open woodland

Food Invertebrates in summer; berries in winter

Status Present year-round across much of central North America; common summer visitor farther north, and widespread in winter farther south

Voice Does not sing. Call includes a buzzing *tzee* note

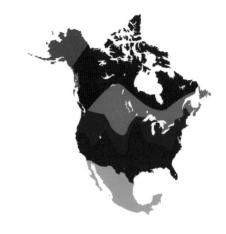

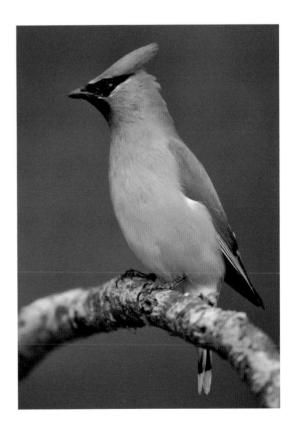

Right Cedar Waxwing with its distinctive crest and dark mask

Warblers

Parulidae and Peucedramidae

ver fifty species of warblers breed in North America; all but one belong to the Parulidae family; the Olive Warbler is placed in a separate family, Peucedramidae. It has a limited range within North America. They are usually referred to as wood warblers or Parulids to distinguish them from the warblers of the Old World.

Except for a few species, and birds living in the milder areas of the southwest, these birds are migrants, coming to North America only for the summer and heading south for the winter; many of these go no further than Central America, but others migrate to the forests of South America. While we tend to think of these as North American birds which leave for a short spell in the northern winter, in fact many species spend longer in their winter quarters than they do in North America, so perhaps should be regarded as Central American birds which fly north just to breed.

The warblers are small, many having a lean weight of just 0.25–0.6oz (8–18g). They are often overlooked by backyard birdwatchers, partly because they are seldom attracted to feeders, preferring to stay high in the trees. Nevertheless, when they arrive—around early May in the south, but later at higher latitudes the woodlands fill with their varied but distinctive songs. Good views in spring show the males of most species to be colorful and attractively patterned, in yellow, green, blue, and red, enabling the observer to identify the species. The males of most species also have a distinctive song, making identification easier. The same is not true of the females, which tend to lack the bright plumage of their mates and do not sing, making identification a challenge even for the experts. Worse, as soon as breeding is over, most of the males molt into a duller plumage and cease to sing, resulting in almost all of them being referred to as "confusing fall warblers."

Almost all species build simple cup nests, concealed in thick vegetation. Different species prefer different heights, some high in the tree canopy, others in shrubs, some on the ground. Two, the Prothonotory Warbler *Protonotaria citrea* and Lucy's Warbler *Oreothlypis luciae*, nest in tree-holes and may use nestboxes.

Wood warblers feed on invertebrates that they pick from tree foliage, sometimes supplemented with

berries, seeds, or nectar. Some feed low down in shrubs or on the ground. They are mostly solitary but may join mixed flocks of chickadees and other passerines out of the breeding season.

An estimated five to ten billion birds leave North America for warmer climates in the fall and the warblers comprise a significant proportion of these. In order to make the long journey they lay down large fat reserves to provide the energy for it. Large numbers of them cross the Gulf of Mexico, a flight of at least 600 miles (960 kilometers). The longestknown flight seems to be made by some of the Blackpoll Warblers, a bird with a lean weight of about 0.35oz (10g); these set off from New England flying south over the sea and do not make landfall until they reach their winter quarters in Amazonia. The longest non-stop flights are around 2,000 miles (3,500 kilometers) a journey that may take almost four days. In order to make such long flights the birds have to lay down large fat reserves. Our Blackpoll Warbler may be twice its lean weight just prior to departure. Most warblers set off on migration around nightfall, but such long flights mean that the birds have to remain airborne all day as well.

There is concern that the numbers of many warblers are in serious decline. One explanation may be that these species have very restricted wintering grounds and these are being seriously reduced by logging and the increase of agriculture. Kirtland's Warbler is thought to winter only in the Bahamas, where its winter habitat is being reduced. Bachman's Warbler, which used to winter in a restricted area of habitat in Cuba, is now thought to be extinct.

Opposite above Male Black-and-white Warbler with its unmistakable markings **Opposite below** Female Yellow Warbler perched on a branch

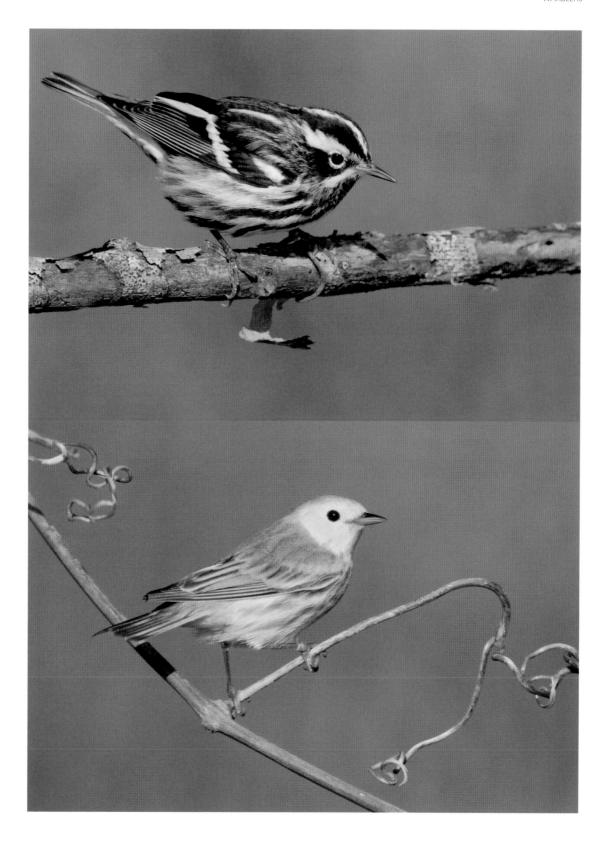

Black-and-white Warbler

Mniotilta varia

The Black-and-white Warbler certainly lives up to its common name. The sexes are subtly dissimilar. Adult summer males have striped black and white upperparts, and the black wings have two white wingbars. The throat is black and the underparts are otherwise mainly white but streaked black on the flanks. By fall, males have acquired a white throat and gray ear coverts. Adult summer females are like a fall male; by fall they sometimes acquire a subtle yellow suffusion to their underparts. Immatures are similar to their respective fall adults.

The Black-and-white Warbler is present as a breeding species, mainly from May to August. It spends the rest of the year in Central America. Unlike most other wood warbler species, it often probes crevices in bark for insects with its slender bill, in the manner of a nuthatch or Brown Creeper.

Length 5.25in (13.5cm)

Habitat Wide range of wooded habitats

Food Invertebrates

Status Widespread and common summer visitor

Voice Song is a thin, repeated *weesa*, *weesa* ... Call is a sharp *tchak*

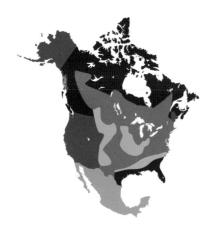

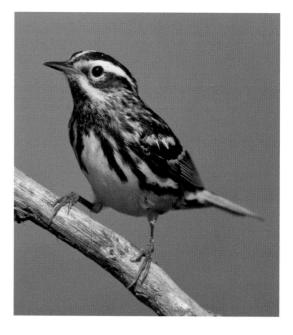

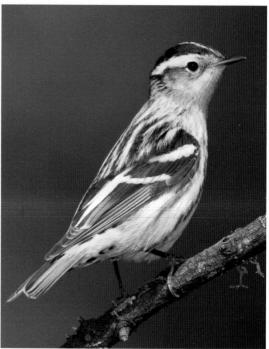

Above Male Black-and-white Warbler perched on a branch **Below** Female Black-and-white Warbler perched in a tree

Yellow Warbler

Setophaga petechia

The Yellow Warbler is an aptly named songbird. The sexes are subtly dissimilar in any given season, but adults are subtly brighter in spring than fall. Adult males are bright yellow, the subtly darker wings showing two pale wingbars. The breast and flanks have reddish streaks. Regional variation exists (represented by several subspecies), with northern birds being darker and most intensely marked, and southwestern birds being plainest overall. Adult females recall their respective regional male but are more uniformly yellow overall, and almost unstreaked below. Immatures are similar to an adult female but much less colorful; some are gray-buff.

The Yellow Warbler is present as a breeding species across most of North America, mainly from April to August. It spends the rest of the year in Central and South America. Typically it forages for insects in low vegetation, making it easy to observe.

Length 5in (12.5cm)

Habitat Scrubby willow thickets and secondary-growth woodland

Food Invertebrates

Status Widespread and common summer visitor

Voice Song is a whistling swee-swee-swee-sweeswit-su-swee. Call is a sharp tchip

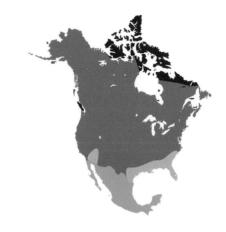

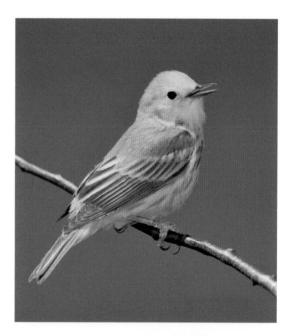

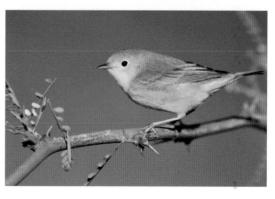

Above Male Yellow Warbler perched on a branch **Below** Female Yellow Warbler with paler plumage

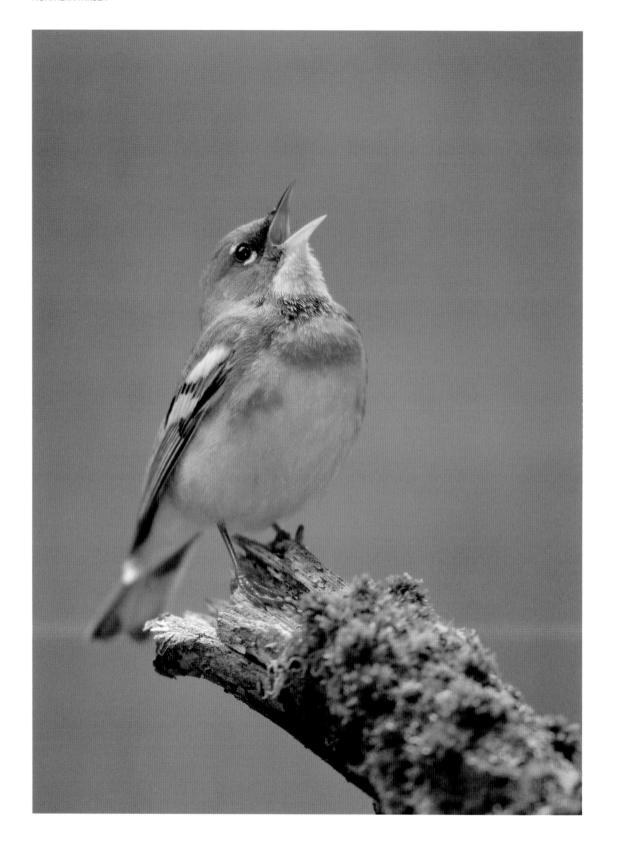

Northern Parula

Setophaga americana

The Northern Parula is a colorful and well-marked wood warbler. The sexes are dissimilar. Adult males have mainly blue upperparts with a greenish patch on the back, and two white wingbars. The face has a broken white eyering. Below the yellow throat is a blue and orange breast band; the rest of the underparts grade from yellow to white on the undertail. Adult females are similar to an adult male but less colorful and without a breast band. Immatures are similar to an adult female but duller still.

The Northern Parula is present as a breeding species in much of eastern North America, mainly from April to August. It spends the rest of the year in Central America. It is an extremely active species that often forages high in the treetops as well as among lichens and mosses growing epiphytically on tree branches.

FACTFILE

Length 4.5in (11.5cm)

Habitat Deciduous and mixed forest

Food Invertebrates

Status Widespread and common summer

visitor

Voice Song is a squeaky trill that rises in tone.

Call is a sharp tzip

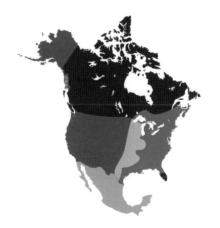

Above Northern Parula, identified by the blue and orange breast band, perched on a branch **Opposite** Male Northern Parula, singing

American Redstart

Setophaga ruticilla

The American Redstart is a well-marked and distinctive wood warbler. The sexes are dissimilar. Adult males have a black head, neck, chest, and upperparts, with orange patches on the wings and base of the tail. There is orange on the sides of the breast, and the underparts are otherwise white. Adult females have gray-green upperparts and grayish-white underparts, with orange elements of the male's plumage replaced by yellow. Immatures are similar to an adult female, although the intensity and tone of the orange/yellow color varies. In their first year of life, birds in spring retain many immature plumage characters.

The American Redstart is present as a breeding species across much of central and eastern North America, mainly from May to August. It spends the rest of the year in Central and South America. It feeds in an active manner, foraging for insects and fanning its tail as it goes, revealing the colorful patches at the base of the tail.

FACTFILE

Length 5.25in (13.5cm)

Habitat Wide range of wooded habitats, including backyards

Food Invertebrates

Status Widespread and common summer visitor

Voice Song is variable but often a whistled see-see-see-see-seweah. Call is a shrill chip

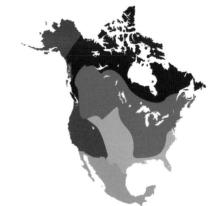

Above American Redstart, mid-song **Opposite above** Male American Redstart, identified by his orange patches rather than the yellow of the female **Opposite below** Female American Redstart perched on a branch

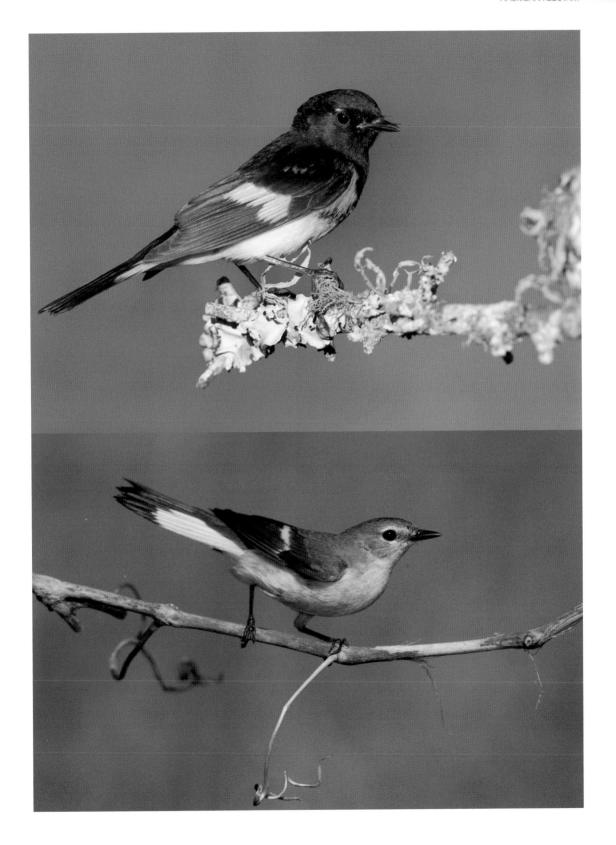

Scarlet Tanager

Piranga olivacea

Abreeding male Scarlet Tanager is one of North America's most stunningly colorful songbirds. The sexes are dissimilar. Summer adult males have bright red body plumage with a black tail and wings. The bill color ranges from pink to gray. Adult males in fall, and immature males resemble a breeding male but red elements of the plumage are greenish yellow. At all times, females have greenish-yellow plumage with a dark tail and wings (not quite as dark as in a fall male).

The Scarlet Tanager is present as a breeding species in eastern North America, mainly from May to August. It spends the rest of the year in South America. Despite its colorful plumage the species can be hard to spot among dappled tree foliage, so listen for its song to detect its presence.

FACTFILE

Length 7in (18cm)
Habitat Deciduous woodland
Food Invertebrates, fruits, and berries
Status Widespread and common summer visitor
Voice Song is a series of whistled phrases
whose tone recalls that of an American Robin.
Call is a sharp tchh-brrr

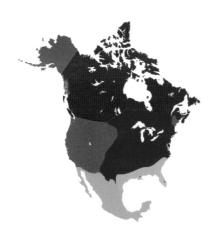

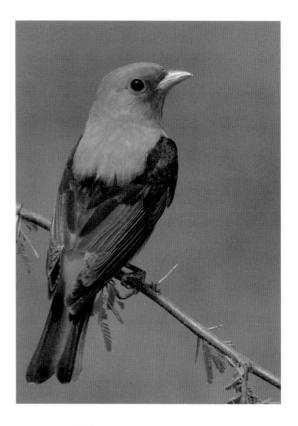

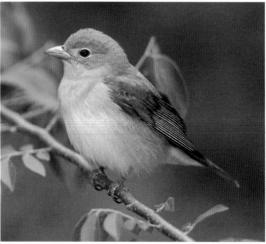

Above Male Scarlet Tanager, identified by his bright red body plumage **Below** Female Scarlet Tanager perched on a branch

Western Tanager

Piranga ludoviciana

male Western Tanager is colorful and almost unmistakable. The sexes are dissimilar. Adult summer males have a black back, tail, and wings, the latter with two wingbars, the upper of these yellow and the lower white. The body plumage is otherwise vellow, and the head is flushed with red. Adult winter males are similar, but yellow elements to the plumage are grubbier and most of the red color is lost, with just a hint retained at the bill. Adult females are similar to a winter male, but black elements of the plumage are gray-green, the red color is entirely absent, and the wingbars are less distinct. Immatures resemble their respective winter adults but are paler and less colorful overall.

The Western Tanager is present as a breeding species in western North America, mainly from May to August. It spends the rest of the year in Central America. Like other tanagers, its colorful plumage helps it blend in remarkably well with dappled foliage in the tree canopy.

FACTFILE

Length 7.25in (18.5cm) Habitat Conifer and mixed woodland Food Invertebrates, fruits, and berries Status Widespread and common summer visitor Voice Song is a series of fluty two-note whistles. Call is a rattling trrrt

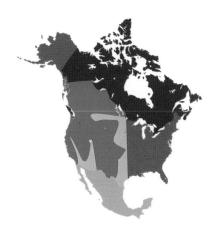

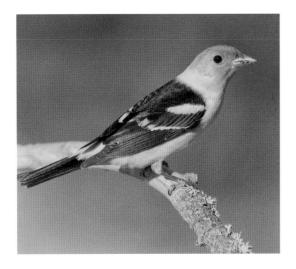

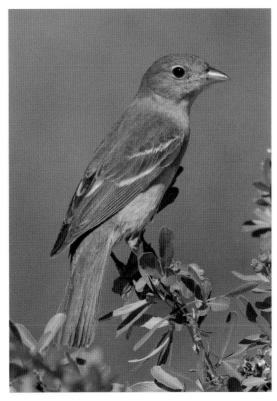

Above Distinctively colored Male Western Tanager Below Female Western Tanager perched on a branch

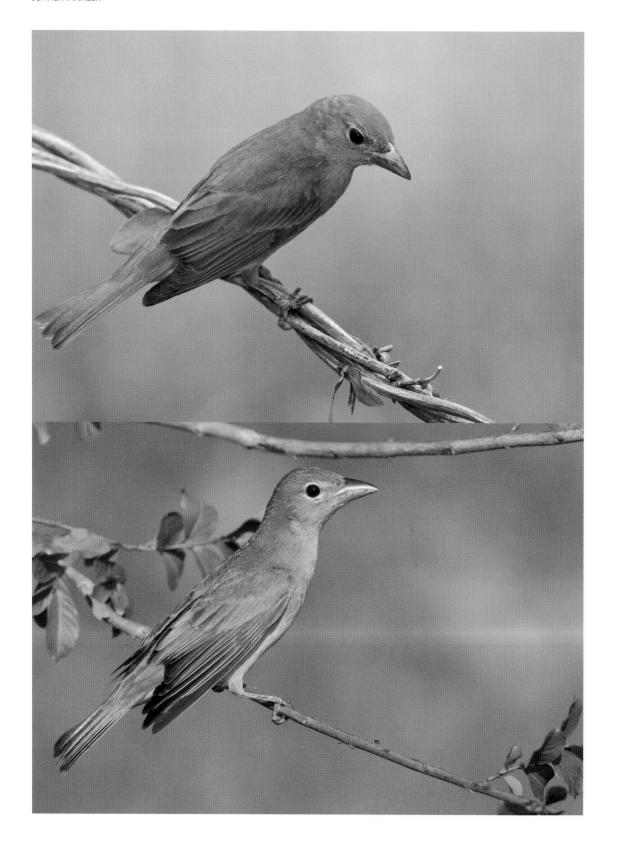

Summer Tanager

Piranga rubra

The Summer Tanager is a colorful and attractive songbird with a peaked, not rounded, crown. The sexes are dissimilar. Adult males are bright red, but subtly darker on the wings and tail than elsewhere. Most females of all ages, and most immature males, are yellow-buff, but subtly darker on the wings, back, and tail than elsewhere; some individuals are very subtly mottled with red. By their first spring, males are blotchy red on their head, neck, breast, and back.

The Summer Tanager is present as a breeding species in Southern U.S.A., mainly from May to August. It spends the rest of the year in Central America. The species is easily overlooked when perched or feeding in dappled foliage.

FACTFILE

Length 7.75in (19.5cm)

Habitat Deciduous and mixed woodland

Food Invertebrates, fruits, and berries

Status Widespread and common

summer visitor

Voice Song is a series of warbling whistles, recalling that of an American Robin (p.122). Call is a rattling pi-tuk

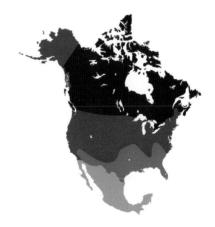

Above Male Summer Tanager perched on a branch Opposite above Male Summer Tanager, identified by being bright red Opposite below Female Summer Tanager perched on a branch

Song Sparrow

Melospiza melodia

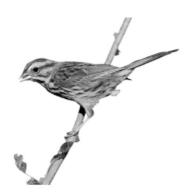

The Song Sparrow has breast markings that usually coalesce to form a central spot. The plumage varies across the species' range but in any given area the sexes are similar. Eastern birds have a streaked brown back, reddish-brown wings with two pale wingbars, and a reddish tail. The head has a brown crown with a pale central stripe, a graybrown face, and a dark stripe behind the eye that emphasizes the pale supercilium. A dark malar stripe separates the pale "mustache" from the whitish throat. The underparts are otherwise pale but heavily streaked on the breast and flanks. Birds from California have cleaner-looking underparts with more strongly contrasting dark markings, and grayer-brown upperparts with contrasting reddish wings. Birds from the southwest are paler and more buff overall. Pacific Northwest birds are darker overall. Alaskan birds are appreciably larger, and duller and darker. Juveniles are similar to their respective regional adults but more buff overall.

The Song Sparrow is present year-round in much of central North America. Northern populations migrate south in fall, and in winter the species range extends to southernmost U.S.A. and the Mexican border.

FACTFILE

Length 6-7in (15-18cm)

Habitat Wide range of scrubby habitats **Food** Mainly seeds, with invertebrates in spring and summer

Status Widespread and common summer visitor, resident, and winter visitor, according to region

Voice Song comprises three or four whistles followed by rich phrases and a trill. Call is a flat *cheerp*

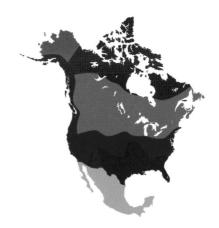

Above Song Sparrow perched on a branch **Opposite** Song Sparrow, singing

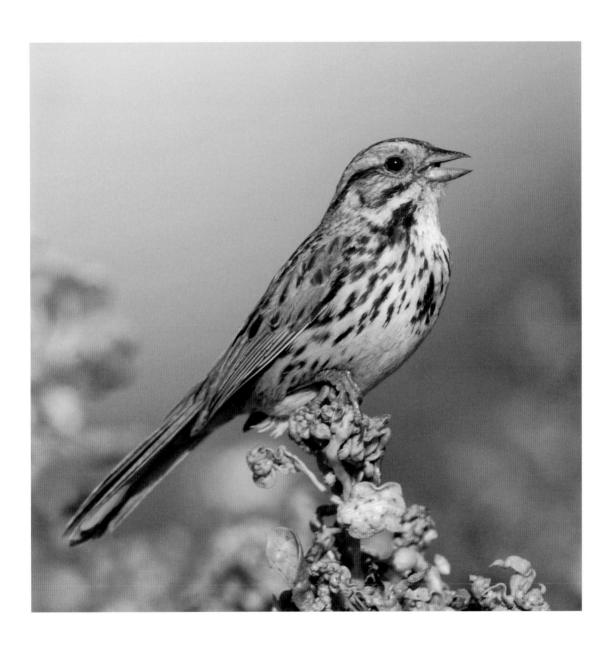

American Tree Sparrow

Spizelloides arborea

The American Tree Sparrow is well marked by sparrow standards. The sexes are similar, and the plumage is brightest in spring and summer. Adults have a rufous back with dark streaks, and rufous wings with two whitish wingbars. The head pattern comprises a gray face, a rufous crown, and a rufous stripe behind the eye, and a faint dark line bordering the gray throat. The underparts are otherwise pale gray with a rufous patch on the flanks and a dark breast spot. Juveniles are similar to an adult but heavily streaked. In all birds, the bill has a dark upper mandible and yellowish lower mandible.

The American Tree Sparrow is present as a breeding species across much of northernmost North America, mainly from April to September. Birds move south in fall and the winter range extends across most of the center of the continent. Outside the breeding season the species is typically seen in flocks.

Length 6.25in (16cm)

Habitat Tundra in summer; rough grassland in winter

Food Mainly seeds, with invertebrates in spring and summer

Status Widespread and locally common **Voice** Song is a series of shrill, warbling notes, ending with a trill. Call is a thin *tseink*

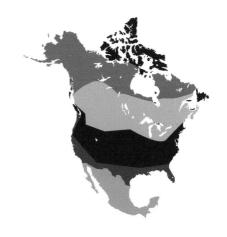

Above American Tree Sparrow mid-song

Chipping Sparrow

Spizella passerina

Thanks to its association with human-made habitats, the Chipping Sparrow is a familiar species. The sexes are similar but there is seasonal plumage variation. Breeding adults have a brown back with dark streaks, and buffish-brown wings with two whitish wingbars. The tail is dark and the pale gray rump is usually only seen in flight. The head pattern comprises a chestnut crown, a white supercilium, and a dark eye stripe. The throat is whitish and the underparts are otherwise pale gray. Non-breeding adults are similar, but the brown crown has a pale central stripe and the supercilium is paler buff. Juveniles are like a non-breeding adult but are heavily streaked; by their first winter, they resemble a pale non-breeding adult.

The Chipping Sparrow is present as a breeding species across most of central and northern North America, mainly from May to September. Most of the population migrates south in fall, boosting resident numbers in the south; its winter range extends to Central America. Outside the breeding season it often forms flocks. In town parks and gardens, birds are often tame.

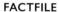

Length 5.5in (14cm)

Habitat Open wooded habitats, including parks and backyards

Food Mainly seeds, with invertebrates in spring and summer

Status Widespread and common summer visitor, partial resident, and winter visitor **Voice** Song is a rattling trill. Call is a thin tzip

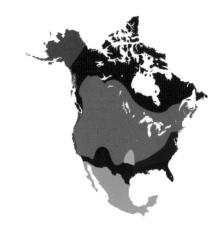

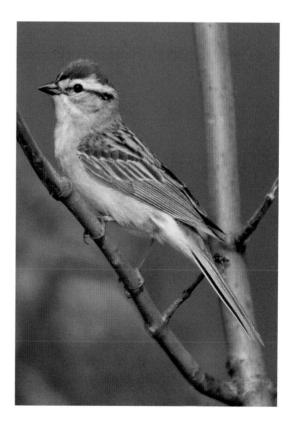

Above Chipping Sparrow in a tree

White-throated Sparrow

Zonotrichia albicollis

The White-throated Sparrow is a distinctive woodland songbird. The sexes are similar but two color forms occur. All adults have a dark-streaked brown back and reddish-brown wings with two white wingbars. The tail is gray-brown. In typical "White-striped" birds the head has a dark crown with a pale central stripe, and a broad supercilium that is yellow-buff in front of the eye but white behind. In "Tan-striped" birds the supercilium is uniformly yellow-buff, and the central crown stripe is buffish gray. All birds have a black eye stripe, gray cheeks, a white throat, a gray breast, and otherwise whitish underparts. Juveniles recall a heavily streaked adult with indistinct head markings; by their first winter they recall a dull "Tan-striped" adult.

The White-throated Sparrow is present as a breeding species in northern forests, mainly from April to August. Birds migrate south in fall, and the winter range is mainly southeast U.S.A. and also down the Pacific coast. Small numbers can be found year-round in the northeast. The species forms flocks outside the breeding season and visits feeders in winter.

Length 6.75in (17cm)

Habitat Northern forests in summer; dense woodland and scrub in winter

Food Mainly seeds, with invertebrates in spring and summer

Status Widespread and common, both in summer and winter

Voice Song is a piercing, whistling *see-tsee-chridede-chridede*. Call is a sharp *chink*

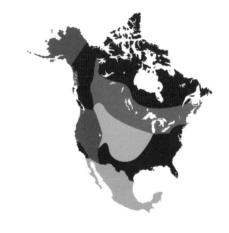

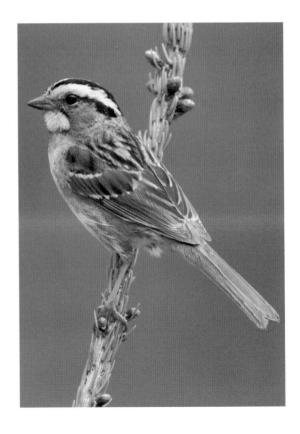

Above White-throated Sparrow, a distinctive woodland songbird

White-crowned Sparrow

Zonotrichia leucophrys

The White-crowned Sparrow is a distinctive songbird. The sexes are similar. Adults have a dark-streaked brown back and reddish-brown wings with two white wingbars. The tail and rump are gray-brown. The head pattern comprises a black eye stripe, and a black crown with a broad white central stripe. In eastern and Rocky Mountain birds, the bill is pink, the lores are black, and there is a white supercilium behind the eye; the underparts are otherwise mostly gray and palest on the belly. In otherwise similar western and northwestern birds, the lores are gray and the white supercilium is complete. The bill is orange in western birds but yellow in northwestern individuals. Juveniles recall their respective regional adults but are heavily streaked; by their first winter, their plumage is closer to that of an adult but black elements of the head markings are brown.

The White-crowned Sparrow is present as a breeding species across Arctic North America and in western mountain ranges.

Birds migrate south in fall, and the winter range extends across southern U.S.A. and into Mexico. The species forms flocks outside the breeding season.

FACTFILE

Length 7in (18cm)

Habitat Taiga woodland in summer, wide range of wooded habitats in winter

Food Mainly seeds, with invertebrates in spring and summer

Status Widespread and common, both in summer and winter

Voice Song comprises a couple of shrill whistles followed by several squeaky chirps. Call is a sharp pink

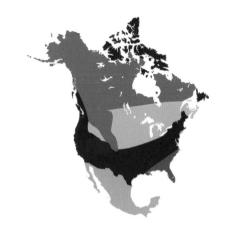

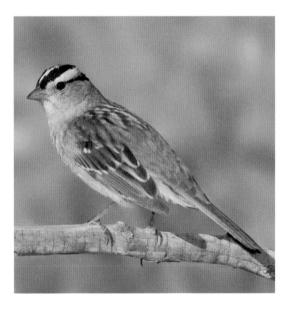

Above White-crowned Sparrow on a branch

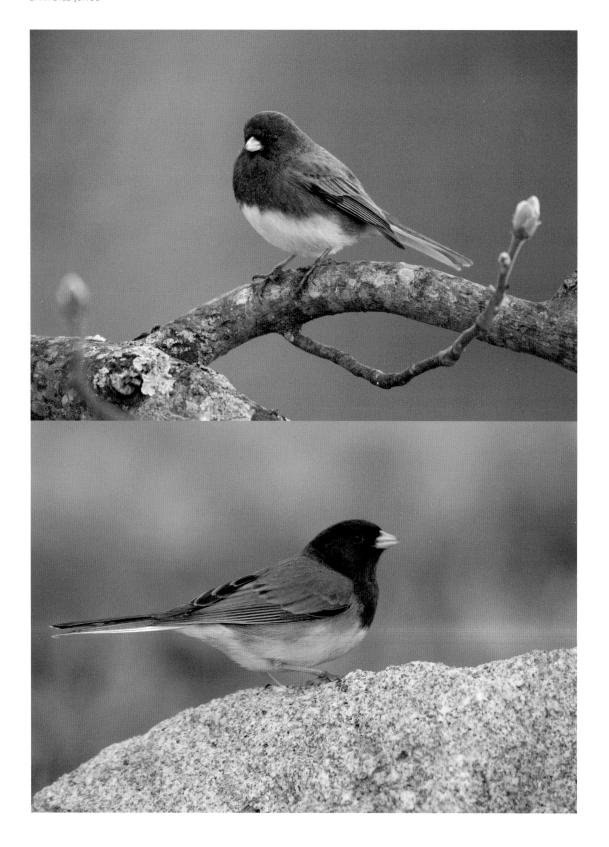

Dark-eyed Junco

Junco hyemalis

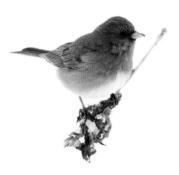

The Dark-eyed Junco has a huge geographical range, with regional plumage differences to match. The large number of subspecies are clumped together in plumage "groups," the commonest of which are covered here. Adult male "Slate-colored" birds (widespread in the east) have slate-gray plumage except for the white belly and undertail. Adult male "Oregon" birds (widespread in the west) have a black hood, a reddish-brown back and gray rump, dark wings, and white underparts with a reddish wash on the flanks. Adult male "Grayheaded" birds (from the southern Rockies) have a gray hood with black lores, a reddish back and gray rump, and a dark tail and wings; the underparts are pale gray. Adult females recall their respective regional males but their upperparts are usually browner overall. Juveniles are similar to a respective regional adult female, but browner still and streaked on the underparts.

The Dark-eyed Junco is present as a summer breeding visitor to northern North America, mainly from May to August. These populations migrate south in fall. Birds are present year-round in the west and northeast, and the species' winter range extends south across the continent. Outside the breeding season it often forms flocks.

Above Dark-eyed Junco on a twig **Opposite above** East Coast Dark-eyed Junco, identified by the slate coloring **Opposite below** Oregon Dark-eyed Junco on a rock

FACTFILE

Length 6.25in (16cm)

Habitat Northern and boreal forests in summer, a wide range of woodlands in winter **Food** Mainly seeds, with invertebrates in spring and summer

Status Widespread and common, both in summer and winter

Voice Song is a rapid trill. Call is a sharp tchht

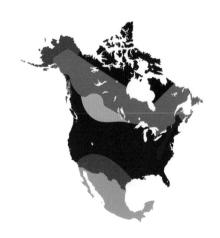

Rose-breasted Grosbeak

Pheucticus ludovicianus

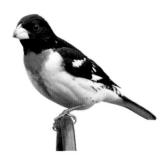

The Rose-breasted Grosbeak is a well-marked songbird with a large bill. The sexes are dissimilar. Summer adult males have a black hood and back, and black wings with white patches and bars. The breast is pinkish red and the underparts are otherwise white, as is the rump. In flight, red underwing coverts are revealed. Adult males in fall are similar, but black elements of the plumage are streaked brown. Adult females and juveniles have streaked brown plumage that is paler below than above. The wings have two white wingbars and the head has a pale supercilium. By fall, immature males are flushed pinkish orange on the breast, and their wingbars are broader than those in an immature female.

The Rose-breasted Grosbeak is present as a breeding species in northern wooded regions, mainly from May to August. It spends the rest of the year in Central America. Silent birds are rather unobtrusive and easy to overlook in dappled foliage.

FACTFILE

Length 8in (20cm)

Habitat Open deciduous woodlands **Food** Mainly invertebrates in spring and summer; fruits and berries at other times **Status** Widespread and common summer visitor

Voice Song is a series of fluty whistles, similar to that of an American Robin. Call is a sharp *peek*

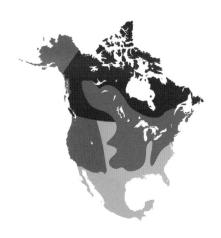

Above Male Rose-breasted Grosbeak, identified by black cap and pinkish red breast, perched **Opposite** Female Rose-breasted Grosbeak with pale coloration

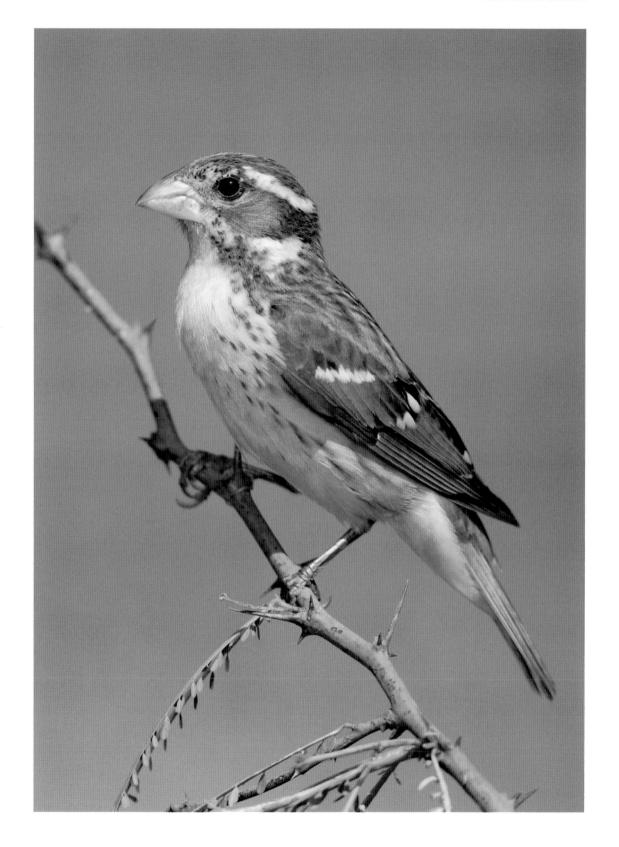

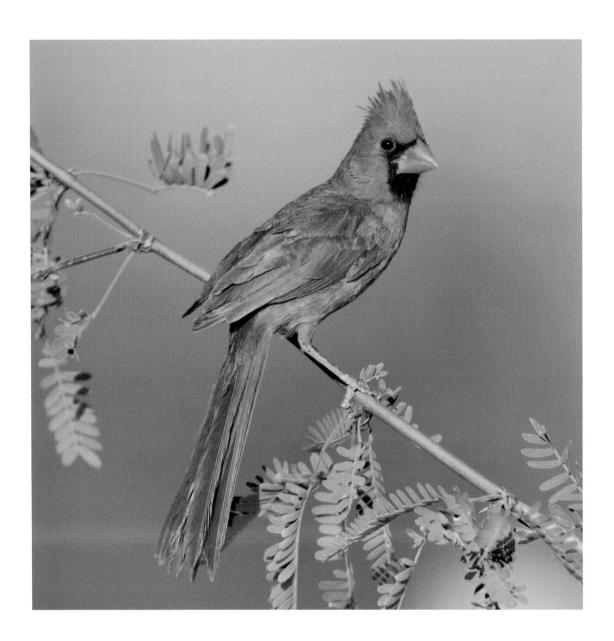

Northern Cardinal

Cardinalis cardinalis

7ith its peaked crest, the Northern Cardinal is an unmistakable and iconic North American songbird. The sexes are dissimilar. Adult males have a black face but otherwise bright red plumage and a bright red bill. Adult females have gray-buff body plumage with a subtly darker face, a red tail, red tip to the crest, and a red tint to the wings; the bill is dull red. Juveniles are similar to an adult female but the plumage is dull gray-buff overall, with a reddish flush to the breast and tail that is particularly noticeable in males; all juveniles have a dark bill. In flight, all birds reveal red underwing coverts that are brightest in adult males, dullest in juveniles.

The Northern Cardinal is present year-round across most of eastern North America and parts of the southwest. In many locations it is accustomed to people and often visits backyard feeders in winter.

FACTFILE

Length 8.75in (22cm) Habitat Wide range of wooded habitats, including parks and backyards Food Mainly seeds and fruits Status Widespread and common resident Voice Song is a series of fluty whistles, typically peek

Above Female Northern Cardinal Opposite Male Northern Cardinal, identified by bright red plumage

Indigo Bunting

Passerina cyanea

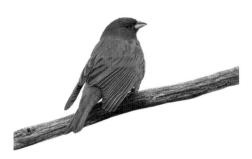

The Indigo Bunting is a familiar little songbird, and the eastern counterpart of the Lazuli Bunting. The sexes are dissimilar. Summer adult males are blue, darkest on the head and grayest on the wings. The conical bill is pale gray. In winter the plumage colors of adult males are masked by brown feather margins; these wear away by spring to reveal blue plumage. Adult females are brown, darker above than below, with faint streaking on the underparts and two indistinct wingbars. Juveniles are similar to an adult female; by their first spring, immature males have acquired some blue feathers but look very blotchy overall.

The Indigo Bunting is present as a breeding species across the eastern half of North America, mainly from May to September. It spends the rest of the year in Central America and the Caribbean region, with small numbers wintering in southern Florida. Perched birds often twitch their tail in an agitated manner. Outside the breeding season it forms flocks.

FACTFILE

Length 5.5in (14cm)

Habitat Scrub, deciduous woodland, and overgrown fields

Food Mainly seeds, with invertebrates in spring and summer

Status Widespread and common summer visitor **Voice** Song is a series of whistling chirps that ends in a trill. Call is a sharp *stik*

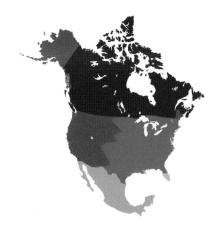

Above Male Indigo Bunting **Opposite above** Female Indigo Bunting perched on a branch **Opposite below** Male Indigo Bunting, identified by blue plumage in summer

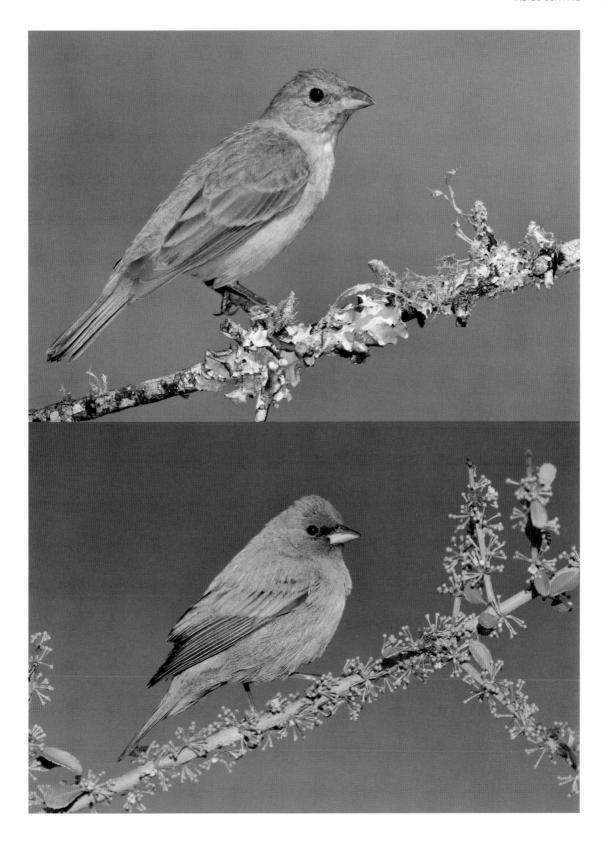

Red-winged Blackbird

Agelaius phoeniceus

The Red-winged Blackbird is a familiar and distinctive songbird. The sexes are dissimilar. Adult males are largely black but have a bold red "shoulder" patch that is edged with yellow in some populations. In winter, the black feathers have subtle brown margins that wear off with time. Adult females are gray-brown and heavily streaked; the plumage is palest (and usually tinged pinkish-buff) on the throat, and the head has a pale supercilium. Immature males are similar to a winter adult male but with more extensive brown edging to the feathers. Immature females recall an adult female but lack the pinkish-buff tinge to the throat.

The Red-winged Blackbird is present year-round across the southern half of North America. In spring, the breeding range extends north to the edge of the Arctic, and the winter range extends south to Central America. Outside the breeding season the species forms huge flocks.

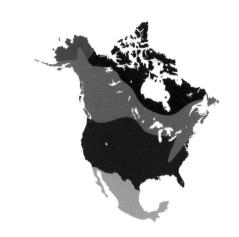

FACTFILE

Length 8.75in (22cm)

Habitat Farmland and marshy grassland **Food** Mainly seeds, with invertebrates in spring and summer

Status Widespread and very common, in the north in summer but present year-round in the south

Voice Song is a series of harsh screeches. Call is a sharp *tchik*

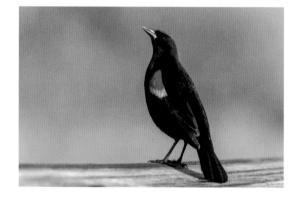

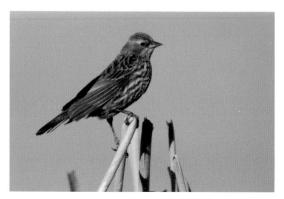

Above Male Red-winged Blackbird, identified by bold red "shoulder" patch, perched **Below** Female Red-winged Blackbird, perched

Brewer's Blackbird

Euphagus cyanocephalus

rewer's Blackbird is a familiar suburban bird **D** in the west of the continent. The sexes are dissimilar. Summer adult males have black plumage but, in good light, the head has a purple sheen and the back, wings, and breast have a greenish-blue sheen. The bill is slender and the eye has a pale iris. Winter adult males have brownish margins to their black feathers; these wear off by early spring. Adult females have dark gray-brown body plumage and a subtly darker tail and wings. In most individuals, the eye has a dark iris. Immatures are similar to their respective winter adults.

Brewer's Blackbird is a year-round resident in the middle of its extensive western range. In the breeding season, the range expands north and east; in the fall, these birds migrate south, and the winter range covers southern and southeastern U.S.A. and Central America. The species range is, to a degree, linked to environments altered by humans, namely farmland and suburban developments.

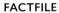

Length 9in (23cm)

visitor elsewhere

Habitat Open country, farmland, and parks Food Invertebrates, seeds, and berries Status Widespread and common. Resident in the center of its range; summer and winter

Voice Song comprises harsh, squeaky whistles. Call comprises tchuk notes

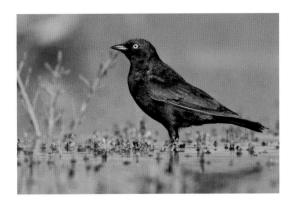

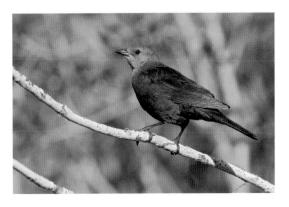

Above Male Red-winged Blackbird, identified by greenish-blue sheen, perched in water **Below** Female Red-winged Blackbird on a branch

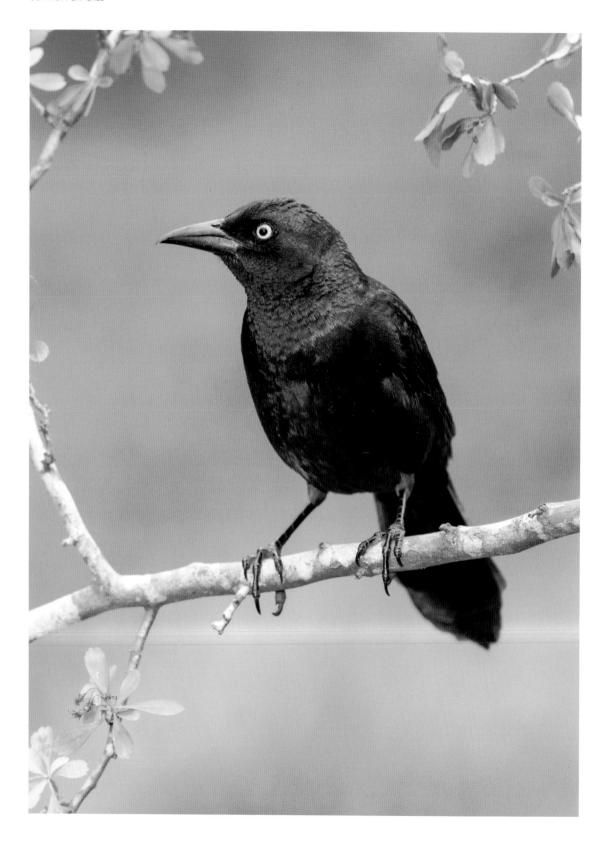

Common Grackle

Quiscalus quiscula

A lthough superficially similar to a blackbird, the Common Grackle has a longer bill and a graduated tail that is folded lengthwise and keeled. Males are larger than females and also differ in their plumage. Adult males across much of the range are black overall, with a blue sheen to the head, neck, and chest, a bronzed sheen on the body and a bluish-purple tinge to the wings and tail. In birds from the southeast, the head and body have a purplish sheen. In all males, the eye has a pale iris. Adult females are similar to an adult male but duller, and they lack an obvious sheen. Juveniles are similar to an adult female but browner overall, and darkest and dullest on the wings and tail; the eye has a dark iris.

The Common Grackle is present year-round in southeast U.S.A., but in summer (mainly from May to September) its range extends north and east. It is easy to see in suburban environments and on farmland, and in spring males perform an interesting display.

FACTFILE

Length 12.5in (32cm)

Habitat Open woodland, farmland, parks, and backyards

Food Invertebrates, seeds, and berries **Status** Widespread and common. Summer visitor in the north of its range; present year-round in the south

Voice Song comprises harsh, grating phrases. Call is a sharp *tchuk*

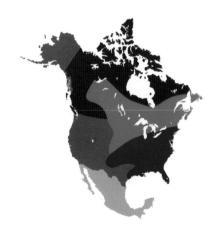

Above Common Grackle, perched **Opposite** Male Common Grackle, with its distinctive blue sheen

Orchard Oriole

Icterus spurius

The Orchard Oriole is a colorful, slim-bodied songbird with a slender, downcurved bill. The sexes are dissimilar. Adult males have a black hood, chest, back, and tail, and a reddish-chestnut rump, underparts, and "shoulders." The black wings have a white wingbar and white edges to the flight feathers. All females are yellow overall but with a dull olive-yellow back and tail; the wings are subtly darker than the body, with two white wingbars and white edges to the flight feathers. Immature males are similar to a female but have a black face and throat.

The Orchard Oriole is present as a breeding species in eastern North America, mainly from May to August. It spends the rest of the year in Central America. As orioles go, it is a fairly bold species and is usually easy to observe.

FACTFILE

Length 7.25in (18.5cm)

Habitat Open woodland and wooded parks

Food Invertebrates, seeds, and berries

Status Widespread and locally common summer visitor

Voice Song is a jaunty series of fluty whistles;

call is a harsh chatter

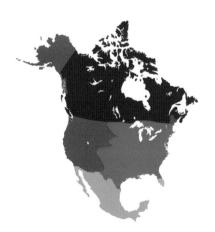

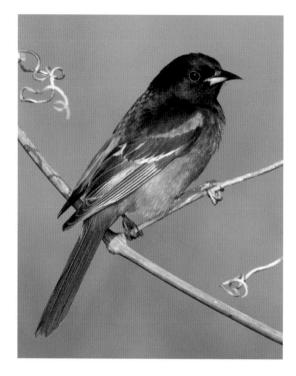

Above Male Orchard Oriole, identified by his black hood, perched **Below** Female Orchard Oriole on a branch

Baltimore Oriole

Icterus galbula

The Baltimore Oriole is a colorful, slim-bodied songbird. The sexes are dissimilar. Adult males have a black hood and back, and orange underparts and "shoulders." The black wings show a white wingbar and white edges to the flight feathers. The rump is orange, and the tail is orange with a dark base and central feathers. Adult females recall an adult male but are less colorful overall, and black elements of the plumage on the hood and back are replaced by variably dark olive-brown. The "shoulder" patch is replaced by a second white wingbar, and the rump and tail are buffish orange. Immatures are similar to an adult female; immature males are a richer orange than immature females (which are yellower) and the upper white wingbar is more pronounced.

The Baltimore Oriole is present as a breeding series in the eastern half of North America, mainly from May to August. It spends the rest of the year mainly in Central or South America, with very small numbers wintering in southeast U.S.A. The species is usually easy to observe.

FACTFILE

Length 8.75in (22cm) Habitat Open woodlands and wooded parks Food Invertebrates, seeds, and berries Status Widespread and common summer visitor; local and scarce in winter Voice Song is a series of tuneful, whistled chewdi phrases. Call is a rattle

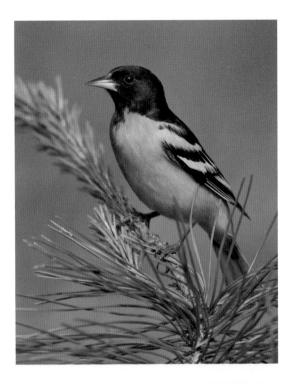

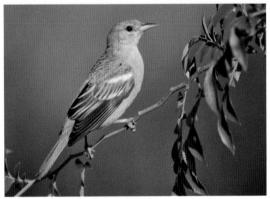

Above Male Baltimore Oriole, identified by his orange underparts Below Female Baltimore Oriole perched on a branch

American Goldfinch

Spinus tristis

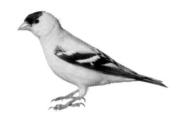

The American Goldfinch is a distinctive songbird, males of which are very colorful. The sexes are dissimilar. Summer adult males have mainly yellow plumage with a black cap and forehead, a black tail, and black wings with a narrow yellow wingbar. The rump and undertail are white. Winter adult males recall a summer male but yellow elements of the plumage are yellow-buff, grading to grayish white on the belly. The dark wings show a pale patch on the greater coverts and a white wingbar. Adult females are similar to a winter male, but are brighter yellow overall in summer and grayer buff overall in winter. Juveniles are similar to a winter female.

The American Goldfinch is present year-round across much of the continent. In the breeding season its range extends farther north, and in winter it extends south throughout southern U.S.A. and into Mexico. Outside the breeding season the species forms flocks that are often seen feeding on thistle seed-heads.

FACTFILE

Length 5in (12.5cm)

Habitat Open habitats, including weedy fields and scrub

Food Invertebrates in summer; mainly seeds at other times

Status Widespread and common resident and summer breeder

Voice Song is a series of chattering notes and whistles. Calls include various whistling notes

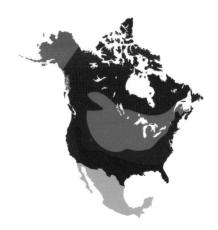

Above Male American Goldfinch **Opposite above** Female American Goldfinch perched on a branch **Opposite below** Male American Goldfinch, identified by his yellow plumage and black cap

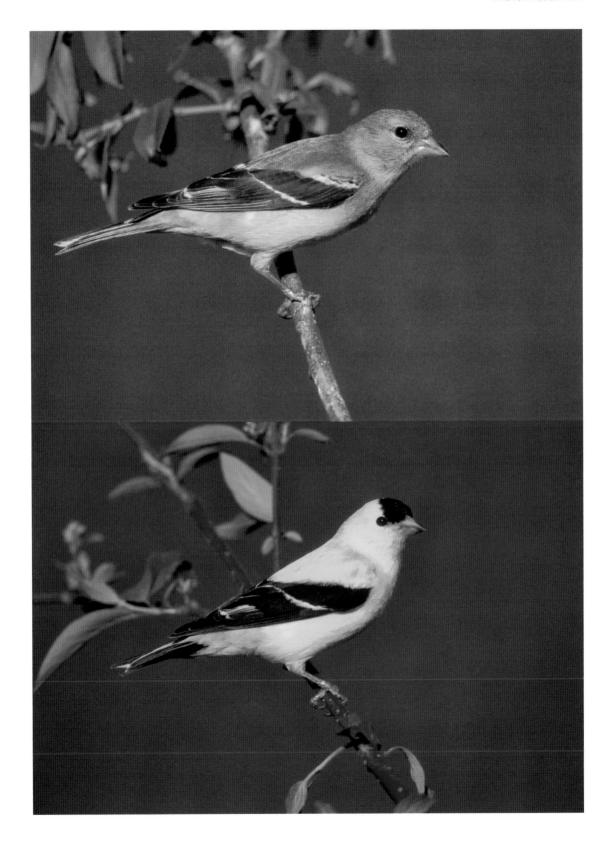

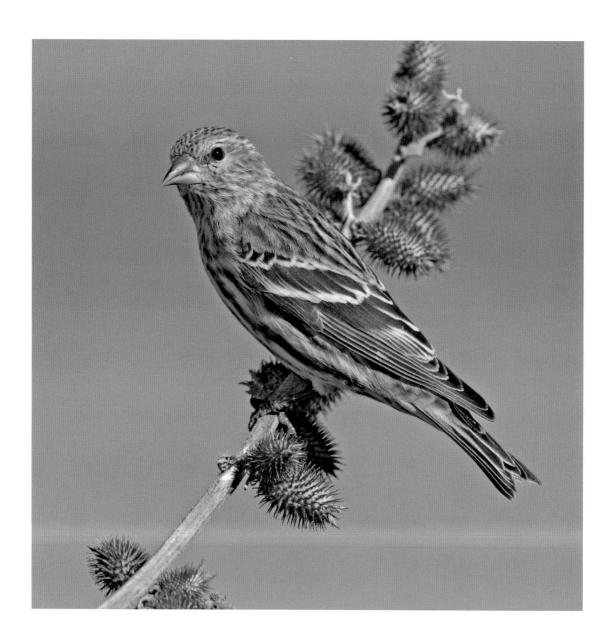

Pine Siskin

Spinus pinus

The Pine Siskin is a compact little finch with a pointed, conical bill. The sexes are dissimilar. Adult males have streaked gray-brown upperparts and dark-streaked whitish underparts. Some birds have a yellow wash to the underparts and rump. The dark wings have two wingbars, the upper one white and the lower one tinged yellow. The yellow edges to the flight feathers appear as an obvious bar in flight. Adult females are similar to a dull adult male but any yellow coloration is much less intense. Juveniles are similar to an adult female but are suffused buffish overall.

The Pine Siskin is present year-round in northern forests and in montane forests in the west. The summer breeding range extends farther north. Outside the breeding season roaming flocks move south and may turn up almost anywhere in the continent except the far southeast. The seeds of birch, alder, and spruce trees are particularly important as food in the winter months.

FACTFILE

Length 5in (12.5cm)

Habitat Conifer forests in spring and summer; conifer and mixed forests at other times

Food Invertebrates in summer; seeds and buds at other times

Status Widespread and common resident, summer breeder, and winter visitor

Voice Song is a series of whistles and trills. Call is a buzzing *zhrece*

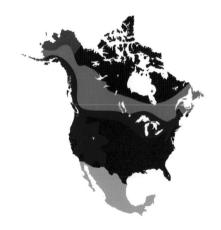

Above Pine Siskin in flight Opposite Pine Siskin on a branch

Common Redpoll

Acanthis flammea

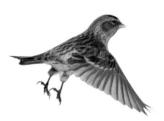

The Common Redpoll is a compact little finch. The sexes are dissimilar. Adult males have streaked gray-brown upperparts, and subtly darker wings showing two white wingbars and white margins to the flight feathers. The streaked gray-brown head has a red forecrown and black chin. The breast and flanks are suffused with pinkish red, which is more intense in summer than winter. The underparts are otherwise whitish but streaked on the flanks. Adult females are similar to an adult male but lack the red flush on the breast at all times. Juveniles are streaked and buffish brown, and lack the adult's red forecrown; this feature is acquired by early winter.

The Common Redpoll is present year-round in boreal forests across the region. Birds that breed farther north in the Arctic are present there mainly May to August; outside the breeding season they form nomadic flocks that move south, roaming in search of reliable sources of alder and birch seeds.

FACTFILE

Length 5.25in (13.5cm)

Habitat Northern forests

Food Invertebrates in summer; seeds and buds

Food Invertebrates in summer; seeds and buds at other times

Status Widespread and common resident, summer breeder, and winter visitor **Voice** Song is a series of trills and twitters. Call is a dry rattle

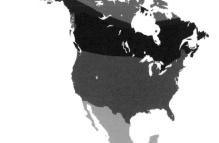

Above Common Redpoll in flight **Opposite above** Male Common Redpoll, identified by red flush on his chest **Opposite below** Female Common Redpoll in snow

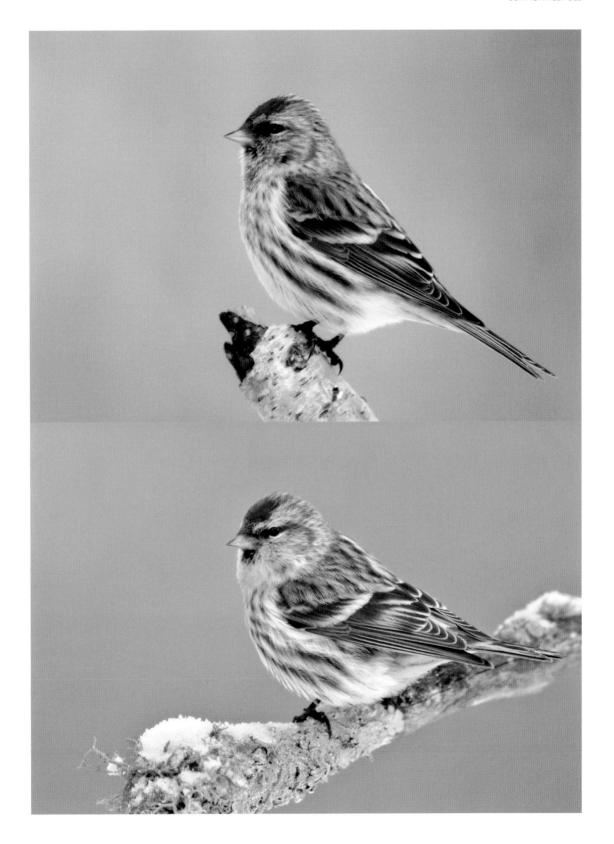

Purple Finch

Haemorhous purpureus

The Purple Finch is a small, plump-bodied $oldsymbol{1}$ songbird with a conical bill and proportionately large head. The sexes are dissimilar. Adult males are reddish pink on the head and breast, grading to streaked reddish brown on the back. The subtly darker wings have two rather indistinct pinkish-buff wingbars and buff margins to the flight feathers. The flanks are flushed pink and streaked. The belly and undertail are white in birds from the east of the range but gray in western birds. Adult females and juveniles have streaked gray-brown upperparts, and pale underparts that are dark-streaked except on the undertail. The brown head has a pale supercilium, submustachial stripe, and throat; the subtly darker ear coverts and malar stripe are more pronounced in eastern birds than in western ones.

The Purple Finch is a breeding visitor to the north of its range, mainly from May to August; in winter these birds spread across much of eastern U.S.A. In the west and northeast of its range it is present year-round.

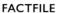

Length 6in (15cm)
Habitat Conifer and mixed forests
Food Invertebrates, seeds, and berries
Status Widespread and common summer
breeder, winter visitor, and resident
Voice Song is a series of warbling phrases. Call
is a sharp pik

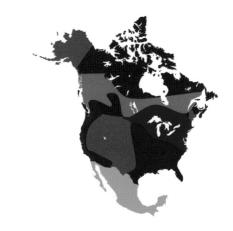

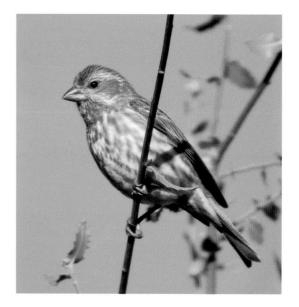

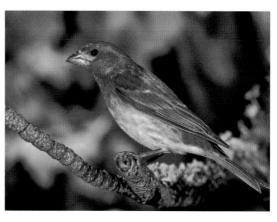

Above Female Purple Finch, perched **Below** Male Purple Finch, identified by reddish-pink head and breast

House Finch

Haemorhous mexicanus

The House Finch is a familiar little songbird. The sexes are dissimilar. In adult males the forehead, broad supercilium, breast, and rump are bright red. The back, nape, and center of the crown are brown, and the dark-brown wings show two white wingbars and pale edges to the flight feathers. The belly and undertail are white with bold streaking on the flanks. Adult females and immatures are graybrown overall and streaked; the subtly darker wings show two pale wingbars and pale edges to the flight feathers.

Once restricted to the west of the continent, the House Finch is now present year-round across much of central and southern North America. It lives up to its name and is often associated with backyards, where it visits birdfeeders.

FACTFILE

Length 6in (15cm)
Habitat Wide range of wooded habitats, including parks and backyards
Food Invertebrates, seeds, and berries
Status Widespread and common resident
Voice Song is a series of twittering, chattering phrases ending with a harsh wheert. Call is a shrill whee-ert

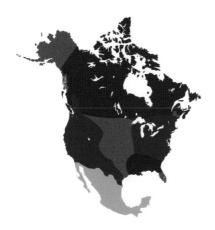

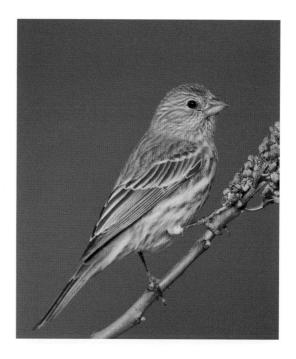

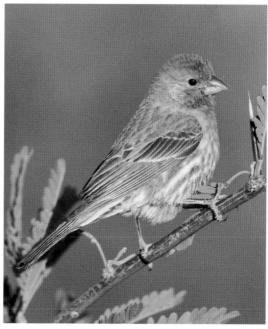

Above Female House Finch **Below** Male House Finch, identified by red forehead and breast, perched on a branch

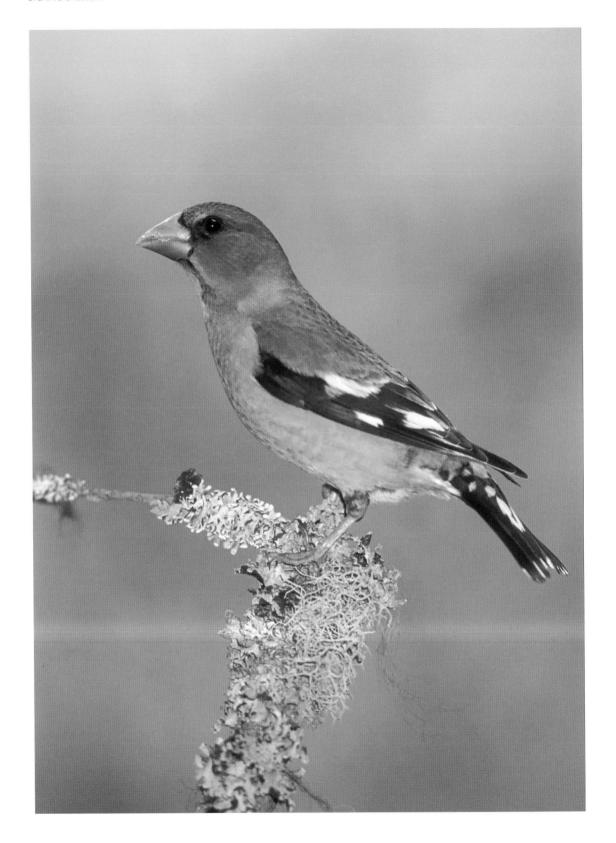

Evening Grosbeak

Coccothraustes vespertinus

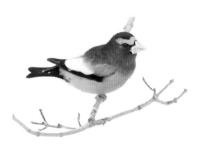

The Evening Grosbeak is a plump finch whose huge bill gives it a distinctive silhouette. The sexes are dissimilar. Adult males have a yellow forehead and supercilium, and an otherwise brown crown, face, and nape that grades to yellow on the mantle. The brown neck grades to golden vellow on the rest of the underparts. The tail is black and the wings are black with a white panel. Adult females are patterned like an adult male but the body plumage is mainly gray-buff, suffused yellow on the underparts. The tail is black with a white tip and the wings are black with two white patches. Juveniles are similar to their respective adults in terms of plumage pattern; juvenile females are similar in terms of color as well, but juvenile males are buffish-brown overall.

The Evening Grosbeak is generally present year-round in its resident range, but in most years there is some movement southwards of nonbreeding flocks. In addition, large irruptive movements related to food shortages occur periodically. The species often visits birdfeeders in the winter months.

FACTFILE

Length 8in (20cm)

Habitat Conifer and mixed forests and woodland

Food Invertebrates, seed, and berries

Status Widespread and common resident and partial migrant

Voice Song is a seldom-heard series of subdued whistling notes. Calls is a soft *pee-irp*

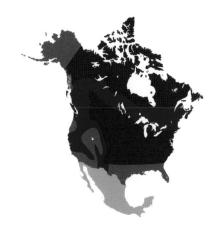

Above Male Evening Grosbeak, identified by his yellow forehead **Opposite** Female Evening Grosbeak perched on a branch

House Sparrow

Passer domesticus

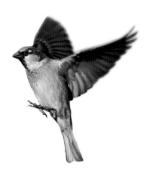

The House Sparrow is a familiar urban songbird. The sexes are dissimilar. Adult males have mainly chestnut-brown upperparts, streaked on the back, and chestnut-brown wings with a white wingbar. The crown, cheeks, and rump are gray. The throat and breast are black, and the underparts are otherwise pale gray. In winter; pale feather margins (which wear away) render the coloration muted at first. Adult females have mainly gray-buff upperparts, including the crown, with dark streaking on the back; the head has a buff supercilium. The underparts are pale gray-buff. Juveniles are similar to an adult female but the markings are less distinct.

Introduced by European settlers, the House Sparrow is now present year-round across much of the continent. It is almost always found in association with suburban and urban parks and gardens, as well as on farmland, where it congregates in flocks around buildings. In many situations it becomes very tame.

FACTFILE

Length 6in (15cm)

Habitat Farmland, town parks, and backyards **Food** Mostly seeds, but also some invertebrates in spring and summer

Status Widespread and common resident **Voice** Song comprises a jumbled series of chipped notes. Calls include various chirps and shrill notes

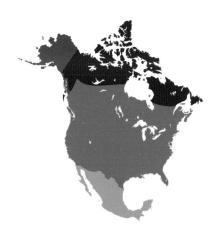

Above House Sparrow taking off **Opposite** Female House Sparrow in a tree

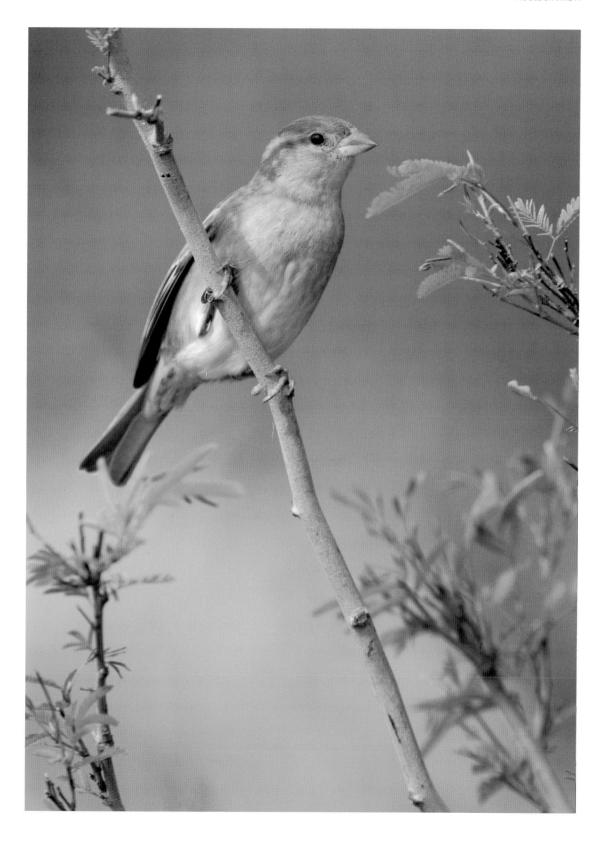

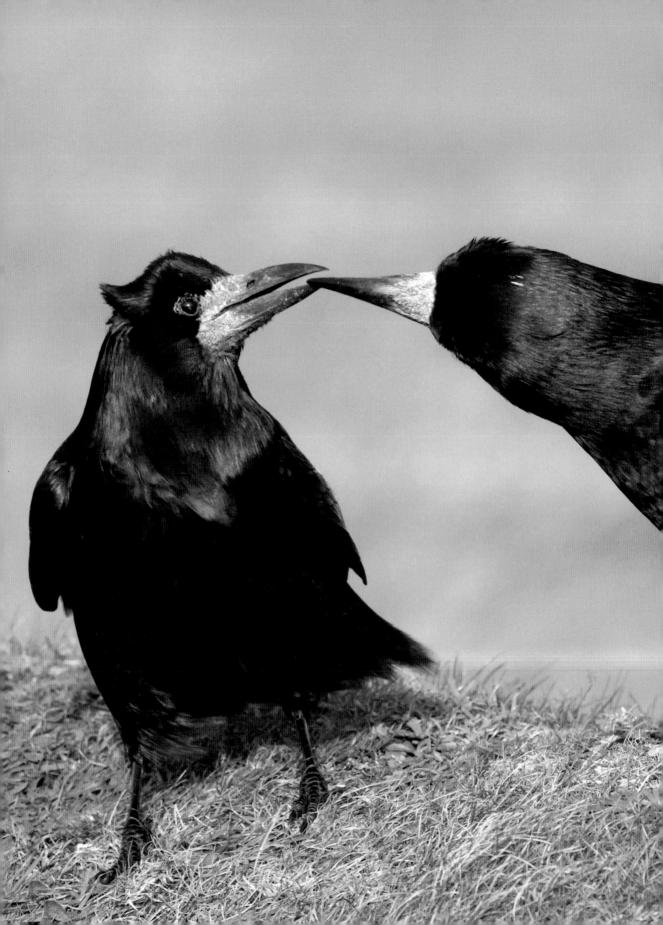

THE STUDY OF BIRDS

We share the Earth with about 11,000 species of birds. We share the same continents, the same countries, our neighborhoods, even our backyards. We breathe the same air. But despite this proximity, birds and humans are not similar; the life of a bird and that of a human are quite alien to each other.

In some ways that is not surprising, because our evolutionary path diverged from birds about 300 million years ago. Our differences are unimaginably vast. We are Synapsids, which include, other than mammals, some of the weirdest creatures that ever roamed the Earth. Birds are Sauropsids, a group that includes reptiles. Your chickadees and bluebirds are more closely related to the great dinosaurs such as Stegosaurus and Brachiosaurus than they are to us.

The upshot is that almost every twist and turn of the life cycle of birds is something of a foreign country. If, miraculously, a human turned into a bird but kept the same consciousness, life would be barely recognizable. A bird's anatomy, movement, senses, lifestyle, reproduction, daily life, and survival are all completely different to ours. We cannot really get under a bird's skin.

That, in part, is what makes birds so endlessly fascinating. Even their basic locomotion—flight—is beyond our reach and has been a source of inspiration for centuries. To most birds, it is everyday life. Flying is so easy for them that a Bar-tailed Godwit, for example, can spend a week flying from Alaska to New Zealand without stopping.

Feathers, essentially modified scales, are the definitive trademark of modern-day birds, although we now know that some dinosaurs had them, too. They form an extremely effective insulation, so much so that some species can remain outdoors during the Arctic and Antarctic winters, in temperatures that can plunge to -40°EYet birds thrive in the tropics, too, and they can also swim. Feathers are the ultimate flexible covering. For birds, the molt, when new feathers are grown and old ones discarded, is a vitally important process.

Reproduction in birds revolves around the hard-shelled, external egg. For almost every bird, that sets a challenge of siting a nest and sometimes building it, of incubating and then brooding chicks, all of which can be hazardous activities. A few circumvent the rules—some Megapodes use the heat generated by soil fermentation, or even geothermally warmed soil to incubate their eggs—but being tied to this mode of reproduction has wide implications. On the whole, reproduction needs to be quick, and in most species parental care is peremptory and expedient.

Even that most easily appreciated of avian delights, bird song, is not what it seems. It can be a source of harmony within a breeding pair, but more normally it is a competitive breeding signal, typically only used by a male in the breeding season, at least in temperate climates. It is a passiveaggressive proclamation of owned territory and breeding intention, and hard work for the singer. Birds produce their songs not with vocal chords, as we do, but lower down in the respiratory tract, where the trachea divides into the bronchi of the lungs. Here lies the syrinx, an organ which varies in complexity among birds. In many songbirds, the song is actually a combination of two songs, a composite of the two bronchi.

Perhaps the most admired of any avian talent is that of migration, the ability to travel vast (or very short) distances, using only what is in a bird's head and what it can perceive. The recent suggestion that birds can "see" magnetic fields is just one of the wonders that we find hard to fathom. Birds have such efficient body clocks that they can use the sun compass as our star moves across the sky. Birds remember landmarks with

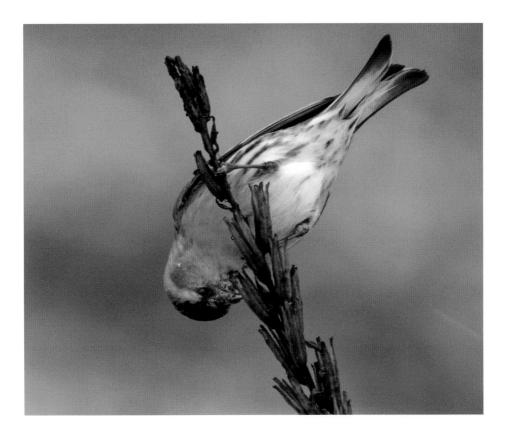

astonishing accuracy. Even more remarkably, a bird inherits its migratory pathway, for example, a Common Cuckoo chick, raised by a completely unrelated foster parent, leaving on its migration months after its genetic parents have left, nonetheless finds its way to Africa.

Birds are astonishing and different in these and so many ways, so it is perhaps not surprising that people view them as objects of intrigue and wonder. People have been observing birds for centuries, all over the

world, and in modern times this has now crystalized into the hobby of birdwatching, a pursuit that is happily growing fast all over the world, and a delight for all kinds of people. This enthusiasm is sorely needed because, however much we might revere birds, we aren't looking after their world very well.

Ironically, while birds are very different to us, it is their need to share the same continents, lands, and air to breathe that has placed them under worldwide threat.

Previous page Rooks are normally encountered in large flocks or at nesting colonies **Above** A Siskin feeds upside down on the seeds of a plant

LIFE OF A BIRD

Apart from bats, birds are the only vertebrates capable of flight. The ancestors of modern birds took to the air some 150 million years ago and since that time the ability to fly has allowed them to occupy almost every terrestrial habitat on Earth, and many aquatic ones, too.

What makes birds special?

or birds, flight would not be possible without feathers, but these lightweight, tough, and resilient structures are also vital for thermal insulation. In addition, contours, shapes, patterns, and colors confer species and gender identity on their owners, and camouflage is also important for many species. Unsurprisingly, there are different kinds of feathers on a bird's body that fulfill a range of functions, those associated with flight being structurally different from those that insulate. In common with their reptilian ancestors, birds lay eggs inside which their young develop. Eggs are laid in nests, which vary from a rudimentary scrape in the ground to an intricately woven basket, depending on the species.

The eggs themselves are protected by a hard, chalky outer casing and the developing chick gains its nutrition from the egg's yolk. Newly hatched birds are vulnerable, and not surprisingly chick mortality is high. The degree to which newly hatched birds can fend for themselves, and the effort invested by their parents in looking after them, varies considerably. With songbirds, and many other bird families, too, adults

brood and feed their young (which are essentially defenseless at first) until at least the point where they fledge, and often for several weeks after they have left the nest. On the other hand, young gamebirds are active almost from the moment they hatch and leave the nest straight away, though they still depend on their parents to a degree for shelter and protection, and to be guided to good areas for feeding.

Not only are there birds in all the terrestrial habitats of Europe and North America, almost all sources of food are exploited by one species or another. Some birds are purely vegetarian, feeding perhaps on seeds, fruits, or shoots, while many more include invertebrates—particularly insects—in their diet during the summer months. A few are strict predators, taking prey that includes other birds. Although some birds lead rather solitary lives, except during the breeding season, many species are gregarious and either breed in colonies or spend the winter months in sizable groups. Complex behavior patterns allow individuals to rub along with one another.

The hatchling

A young bird becomes conscious of its surroundings well before it hatches from the egg. Several days prior to hatching, it will notice the chilling and warming as the incubating parent leaves and returns. More chicks hatch in the morning than in the afternoon, and this suggests that, even in the egg, they already have some kind of diurnal rhythm; this may be as a result of the parents' incubating intermittently during the day, but in a long unbroken spell during the night. Doubtless it will also feel its parent turning the eggs at frequent intervals; this is probably done to prevent the egg membranes sticking to the shell, and to aid the uptake of oxygen, though a few species do not turn their eggs.

At first, the developing chick breathes oxygen which passes into the egg through the surprisingly porous eggshell and the albumen (the white); expired carbon dioxide passes in the opposite direction. In the early stages, respiration is by diffusion, but soon a system of blood vessels develop outside the embryo; then the blood takes up the oxygen and carries it into the embryo. Water is also lost through the shell of the egg as the chick develops and, as this happens, the egg membrane contracts and pulls away from the shell at the blunt end of the egg, leaving an air space just inside the shell. Sometime before it hatches the young bird punctures the membrane with its bill. It can then get its nostrils into the air space and breathe air directly through the shell, using its lungs for the first

time (although it still relies partly on the external blood vessels). Only after this stage can the young bird begin to call.

Eventually, the time comes for the young bird to break out of its egg. It does this by chipping a ring of holes around the blunt end of the egg. It uses a particularly powerful neck muscle for this, the hatching muscle, developed at this time especially for this one purpose, to force the head hard against the end of the egg; it also presses against the shell with a small sharpish spike, the egg tooth. This is a small white protuberance near the tip of the upper mandible (some species also have one on the lower mandible), clearly visible on a newly hatched chick; in most species it drops off a few days after hatching. Occasionally one finds a chick that has died in the egg at hatching time to be missing the egg tooth, ample evidence of the importance of this small structure for this one essential job.

Once the end of the egg is well cracked, the chick forces its head against the loosened end and, at the same time, presses with its legs against the other end; the top comes off. The actual period of breaking loose is quite short in most small birds, but may take several hours in some of the larger species, whose egg's thick shell seems difficult to break; the effort required appears to be considerable, the baby bird having to rest frequently. Eventually, however, the young chick breaks free to start its life as a nestling.

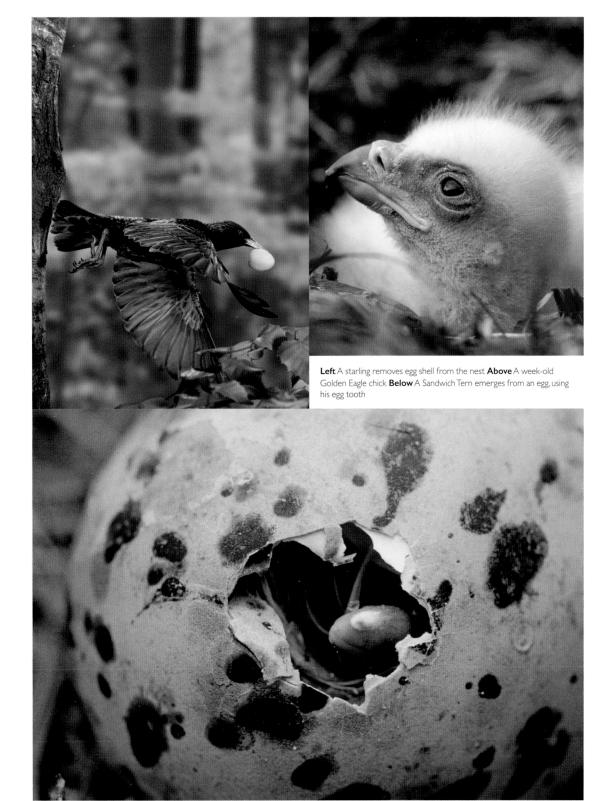

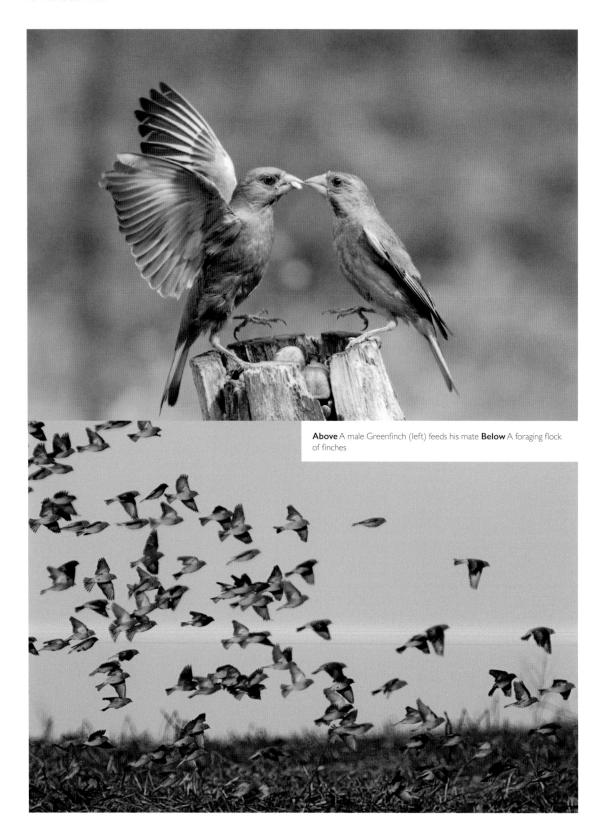

Foraging behavior

Learning to feed

Learning to feed itself is perhaps the most difficult single thing that a young bird has to do, and it is no wonder that so many of them fail the test. For example once young Chimney Swifts have left the nest they get no help from their parents; they have never seen their prey in its natural habitat. Most birds get some sort of assistance from their parents after they leave the nest. We know very little about how they actually learn to catch their prey.

Even parental tuition cannot cover all situations. Resident birds may switch from insects in summer to eating seeds or fruit in winter; the warbler, which leaves a New England woodland for a South American forest, faces a whole range of changes. The habitats, the prey, and the predators all change; all must be learned if the young bird is to survive.

The individual seems to develop its hunting skill in response to reward and failure—continuing to hunt in places where it has been successful and tending to give up on places where it fails to find food.

Flocks and flocking

Many species feed in flocks at rich supplies of food such as gulls on rubbish tips, seabirds on shoals of fish, and vultures, kites, and crows at carrion. Many other species hunt in loose flocks—such as mixed parties of woodland birds, flocks of pigeons in fields, and gatherings of starlings or of magpies and finches. At least in many of these cases, the young bird may be able to learn the whereabouts of food by watching others in the flock. For many birds there is another advantage to living in flocks. The larger the number of birds, the more likely it is that one of them will spot an approaching predator before it gets dangerously

close. Birds spend an appreciable amount of time scanning around for predators, but individuals spend less time on the look-out when they are in a large flock than when in a small one, and so they have more time for feeding.

There is, however, a disadvantage to being in a flock. When an individual in a flock finds an item of food, a nearby bird may come and snatch it before the finder can eat it. This is not usually important where small food items are being taken, since the bird that finds them can swallow them quickly. But a large worm, or a large seed which takes some time to deal with, may easily be snatched by another bird. Food stealing of this type is quite common in birds in winter. Robbing often occurs between individuals of the same species. In small flocks there is usually a clear pecking order among the birds in a flock. Individuals know each other. When birds have previously squabbled they remember who won, and a hierarchy develops. The advantages to the winner are obvious, but to the losers the system may have certain benefits: it is better to give up swiftly and avoid injury than to risk a prolonged and possibly damaging battle. In such dominance hierarchies, older birds tend to dominate vounger ones and the males usually dominate the females. These hierarchies are probably established partly on the basis of the experience of the birds concerned, but also partly on their size.

In mixed-species flocks the larger or more aggressive species often take food from the slower or less aggressive species. A Tufted Titmouse may steal from a Black-capped Chickadee in a mixed flock. American Goldfinches will lose out to both at a bird table, so may prefer to feed from spilled seed beneath a feeder.

Flight

Lift and drag

Flight is achieved by creating lift—an upward force great enough to counteract the force of gravity on the bird's body. Lift is produced by the wings. When air moves over a stationary wing of an appropriate shape, the air which is deflected over the upper surface has to travel faster than the air beneath the wing, because it has further to travel in the same time. The pressure exerted by air passing over the surface of the wing is inversely proportional to the speed at which it is travelling. So, the air that passes above the wing is at a lower pressure than that beneath, and this produces lift. It may seem odd, but most of the lift produced by a wing comes from the passage of the air over the top of it and not from that which passes underneath.

Unfortunately for the bird, there is another force produced by air passing over the wing. As the air hits the wing, the wing tends to be pushed backward; this force is called drag and this too increases with the size of the wing, the airspeed, and the angle at which the wing is held.

Gliding

There are two ways that a bird can glide in still air. First, it can launch itself from a high perch and use the potential energy provided by gravity; its movement is comparable with that of a toboggan on a snowy slope. It can maintain its speed for as long as it is above the surface of the ground; but since it is losing height all the time, the length of time that it can stay airborne will depend on the height from which it launched itself.

The second method of gliding is the reverse of this—maintaining height by loss of speed. Such a glide can only take place when a bird has already achieved a reasonable airspeed; it is using kinetic energy. The moment the bird stops flying and starts to glide it is slowed down by drag. As it slows, it loses lift, since lift varies in proportion to airspeed. The bird can maintain its lift by increasing the angle of attack of its wings. However, this in turn increases the drag and so the bird slows down still further. It is not long before the bird has slowed down so much that it has reached stalling speed. Then it can no longer stay airborne. It may seem that such a method of gliding is not much use, but in practice birds use it regularly every day, for

it is the way in which they land. By approaching a branch or other landing site in more or less level flight they can, if they judge it right, slow down to the speed at which they stall, just as they land, thereby minimizing the shock on their legs.

Powered flight

Most birds have to use flapping flight in order to stay airborne. They must produce enough energy to overcome gravity and counteract their rate of sink, so that they stay aloft, and enough forward force to overcome drag so that they can move forward. The flying power is produced by the downbeat of the wing. During this movement, the wing twists slightly because the wing bones are at the front of the wing and the pressure of the air against it causes it to rotate. As a result, the wing pushes the air downward and backward, propelling the bird in the opposite directions—upward and forward. The wing-beat is in fact more complex than this. Because the bird is traveling forward during the downbeat, the movement of the wing-tip relative to the air is not straight downward, but angled forward. This makes it slightly more difficult for the bird to get propulsion from the downbeat than if the beat was straight downward. Propulsion is aided because the large feathers at the tip of the wing are, like the wing itself, supported closer to their front edge than the rear and so, again like the wing, the feather twists during the downbeat. This results in the air being pushed backward and downward.

Turning

There are a number of ways in which a flying bird can turn. Any unilateral alteration of the bird's shape results in imbalance in the amount of drag on the two sides of the bird and hence leads to the body turning. This can be achieved by the bird sticking a webbed foot out to one side or turning its tail to one side; species with elongated outer tail-feathers, such as swallows, are particularly adept at rapid turns.

Nevertheless most birds rely mainly on adjustment of wing shape for turning; anyone who has watched a tail-less swallow or martin will know that the bird can still manage well. Slight folding of one wing will reduce the surface area and hence both the drag and

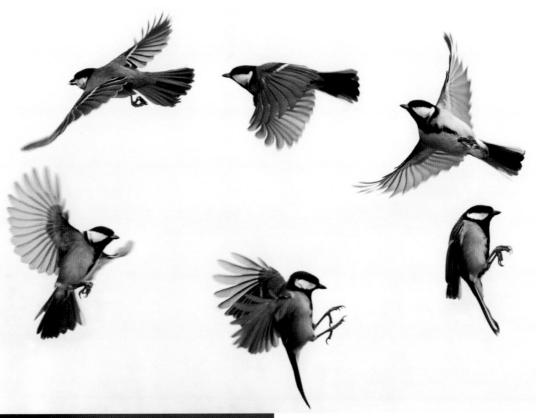

the lift on that wing, with the result that the wing will drop slightly and move forward, relative to the other. Equally, increasing the angle of attack of a wing will result in an increase in both lift and drag, so that wing will be slowed and lifted, relative to the other. Either, or both, of these maneuvers will result in the bird banking.

Take-off and landing

Taking-off requires a lot of energy. The bird must accelerate to normal flying speed, and gain height; both of these require more energy than normal flight. A small bird such as a sparrow or a thrush alters the angle of its body so that it is flying upward and increases its wing-beat; nevertheless, taking-off does not seem to be too difficult. This is not the case for all birds, however, and some species have special problems with take-off. Because of their size, very large birds cannot just jump into still air and fly away; they need to have a good air speed before they can easily get enough lift from their wings. There are two ways of

achieving this. First, many large birds such as swans need a take-off run in order to get up sufficient speed for take-off. Second, and far easier but not always possible, is for the bird to take-off into a strong headwind; the speed of the wind immediately gives the wing a high airspeed and hence valuable lift. Many birds take-off from perches in trees or on cliffs and this provides another useful way of getting up speed: the bird simply drops off the perch, accelerating with the help of gravity.

Landing is achieved by losing the lift. Ideally this is done in such a way that the bird is flying as slowly as possible at the moment of touchdown, so as to minimize the chances of injury. However, those birds which have some trouble taking-off also have certain problems with landing. Large birds such as swans prefer to land on water if possible, since this reduces the likelihood of harm. They can also reduce their speed relative to the ground by coming into land upwind, allowing the wind to give them lift when their land speed is well below their normal stalling speed.

Wing shapes

The shape of birds' wings varies markedly in relation to the type of flight which the species uses. In general birds which need high maneuverability have shortish wings, and often longish tails, enabling them to turn swiftly. For example, Sharp-shinned and Cooper's Hawks, which hunt largely in woodland, have broader wings and longer tails than the falcons, which hunt in the open; they probably fly less swiftly, but they can turn more easily. Another factor which may affect wing shape is the migratory behavior of the bird. Many species which migrate long distances lay down large quantities of fat as fuel for the journey. For two short, but very critical, periods of the year the birds weigh much more than for the rest of the time. For example, the two species the Common Nighthawk and Common Poorwill are very similar in many ways. However, the Common Nighthawk migrates to South America, while the Common Poorwill goes only to southern US and Mexico. The Common Nighthawk has a wingspan

of over 6 inches (15 centimeters) more than the Common Poorwill. Is this related to its need to carry greater weight during migration?

Flight speeds

Every bird can vary the speed at which it flies, within certain limits. The speed at which it chooses to fly depends on what it wants to do. If we drive a car very fast along an expressway, we get to our destination

sooner than if we drive it more slowly. However, if we want to cover the greatest distance on a given amount of fuel, it is better to drive at a slower cruising speed. It is the same for a bird; if it needs to escape a predator or to make as many journeys as possible to its nestlings, it may pay to fly as quickly as possible. If, however, it has to make a long migratory flight without many chances to stop and refuel (see page 213), it pays to cruise at a lower speed because this gives it the greatest range on its fat reserves.

The situation is more complicated for a bird than for a car because the bird is moving through air, which itself may be moving rapidly. If a bird flew at 12 miles (20 kilometers) per hour into a headwind of 12 miles (20 kilometers) per hour, it would stay in the same place. The ideal air speed for a bird to cover the greatest distance for a given amount of energy varies with the force and direction of the wind; it should fly faster into a head wind and more slowly if it has a tail wind. This is not merely theory: Chaffinches have been shown to adjust their air speed in this way. Precise measurements of airspeeds of birds are not easy to make, and many accounts are greatly exaggerated. Even a swooping Peregrine is unlikely to be traveling at more than about 112 miles (180 kilometers) per hour. Level cruising speeds of birds are very much slower than this, and vary with a number of features of wing shape. In general, larger birds tend to fly faster than smaller ones.

Running, hopping, walking, and perching

Two-legged animals such as birds and humans need rather large feet if they are to maintain their balance easily, whereas quadrupeds such as cows and horses can manage with much smaller feet. The possession of large feet enables birds to wrap their long toes securely round branches, and so perch easily. Since their legs are placed far to the back of their bodies, many of the birds that swim well are not good walkers. Some of the diving ducks waddle rather ineffectively, and divers and grebes can hardly walk at all.

The length of the leg varies greatly between groups. The two visible sections of the leg, the tibia and the tarsus, have to be more or less the same length, otherwise the bird could not keep its center of gravity over its feet; it would topple over every time it tried to sit down. Birds with long legs tend to be those that live in open country and need to run well (ostrich, Long-billed Curlew, Wild Turkeys) or those that need to stand in water to feed (flamingos, herons, and many waders or shorebirds).

In contrast, birds that hang upside down from the branches or small twigs of a tree while feeding need to be able to grip strongly. They also need their center of gravity to be as close to their feet as possible; such birds have short legs. Birds which come into this category include the chickadees, finches, and many of the smaller parrots. Birds that spend their time climbing the trunks of trees do not have such short legs. They tend to hang from their splayed feet, often, as in the woodpeckers and creepers, supported by stiffened tail-feathers which they use as a prop. Nuthatches have a different method of climbing. They put one foot ahead of them from which they hang, and the other behind them to steady themselves; they do not use their tail for support. This method can be used equally well for climbing down tree-trunks, an ability unique to nuthatches; in this case the bird hangs from the upper, rearmost foot and uses the other one to steady itself.

Pigeons have very short legs. They spend a lot of their time on the ground, but neither group can run rapidly; they depend on flight for escape. The birds with the shortest legs of all are the swifts and kingfishers. Kingfishers use their legs only for perching above the streams into which they dive for fish. Swifts, the most aerial of all birds, use them only for clinging to vertical surfaces or crawling into their nest-chambers.

Most birds need to be able to tuck their legs and feet away in flight so that they do not affect the streamlining. Usually they do this by folding their legs up and tucking them under the belly feathers; however, birds with long legs cannot do this. Species such as herons, flamingos, cranes, and the Longer-legged Waders or shorebirds have to fly with their legs trailing behind.

Birds which feed on the ground either hop or walk (running is a fast form of walking). Most species, indeed most families, stick to either one method or the other. The crow family is an exception; some members, such as the raven, usually walk while others, such as the jay, usually hop; the magpie tends to walk if it is moving slowly, but changes to long, bounding hops when it speeds up.

Most birds that spend nearly all their time on the ground, such as waders or shorebirds, larks, and pipits, run. Those which hop are primarily arboreal such as thrushes, chickadees, and finches. When moving from branch to branch, hopping is clearly the best sort of locomotion; the bird half jumps, half flies from a perch and lands on another with both feet together. What is not clear is why such birds do not change from hopping to running when on the ground. It seems as if in some way the adaptations for hopping restrict the ability to run. It has been suggested that the ancestral mode of locomotion for the passerines was hopping, and that walking was a later development. The evidence for this is that in some species, such as the raven and the skylark, which walk as adults, the young hop for the first few days after leaving the nest.

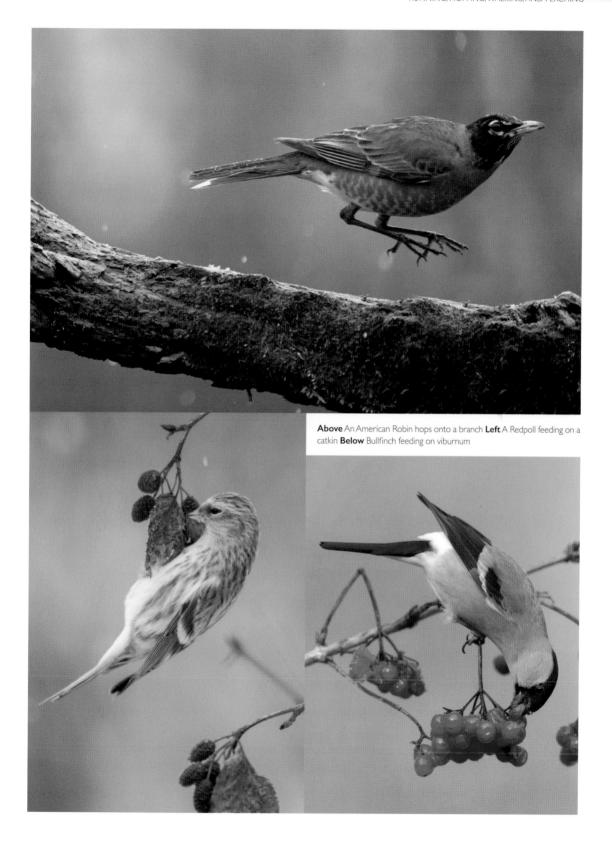

Bird song

bird breathes in air through its trachea (windpipe). At the bottom of the neck, the trachea divides into two tubes, the bronchi, which carry the air to the two lungs. At the junction of these two bronchi lies the syrinx, a complex organ which produces many of the sounds that birds make. The bronchi are composed of cartilaginous rings joined to each other by connective tissue. In the area of the syrinx, these thin tissues are modified to form elastic vibrating membranes, the tension of which can be altered by a complex of controlling muscles. As air passes over these membranes they vibrate, and this produces the sounds we hear. The quality of the sound varies with the tension of the membranes. Not all the sounds are derived from the syrinx alone; for example, the calls made by some of the swans are, at least in part, the result of complex convolutions of the trachea itself.

The design of the syrinx varies markedly in different species of birds and there is still debate as to the exact way in which many of the sounds are produced. However, it is now clear that in certain species which produce complex songs, such as the Brown Thrasher, the full song is made up of two separate parts, produced by the membranes in each of the two bronchi. How the bird controls the two sets of sound from the two bronchi is not understood. The musculature of the syrinx is complicated, but birds have been divided into two groups on the basis of these muscles, the oscines, and the non-oscines; the former being largely equivalent to the passerines.

The structure of songs and calls

The sounds made by birds are used to convey messages to other individuals. Some of the sounds made, especially some of the songs, are very complex. Birds' hearing is somewhat different from ours and it is likely that they are able to get much more information out of a call than we are able to. Even so, birds can produce a wide variety of different calls to convey different messages. At least fifteen different types of calls have been identified in the Black-capped Chickadee. In some species, such as the House Wren and the Yellowthroat, the individual birds have a smaller number of elements which they put together to make a song. They tend to keep these elements in

the same order so that they produce a song which they repeat. They may have more than one song type, and use just a few over and over again. Such a group of song types is called the bird's repertoire. Each individual has a slightly different voice so that, in many cases, individuals can learn to recognize the songs of neighboring birds and the calls of their mates or chicks and distinguish them from other birds.

The function of songs and calls

Birds produce calls or sounds in order to convey information to other birds. In certain cases, the same sound may serve two functions. For example, the territorial song of a male bird may be used to warn other males to stay away, but at the same time serve to attract a female.

The songs of different species are often clearly different. One of the reasons for this is that songs also provide a valuable way of recognizing a species, so reducing the chance of a bird breeding with another of a different species. This is especially important in birds which are similar in appearance, such as some of the warblers.

Some types of sounds have characteristics which make them useful under particular circumstances. For example, calls of less than half a second duration, within a certain frequency range, which start and end sharply, are thought to be very difficult to locate. (They certainly are for humans.) It may be no coincidence that a wide variety of different species give alarm calls which have precisely these characteristics. Alarm calls are given to warn mates and offspring of the presence of a predator; at the same time, the bird that gives the call does not want to give its own position away if it can help it. By using a call that is hard to locate, it minimizes the risk to itself and at the same time warns the other birds. The type of alarm call given may depnd on the type of predator, so further information is supplied to the listener about the particular danger that threatens it.

Opposite A male chaffinch singing on a branch

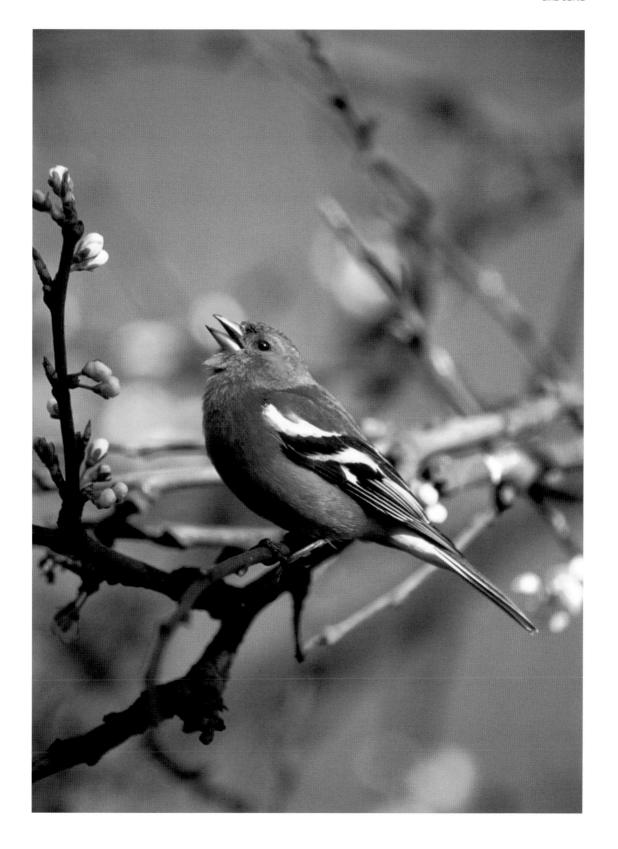

Territories

nce a male bird is ready to breed it must find a place to do so—a territory. The purpose of territories varies so much between species that it's hard to define them simply. They are, however, all fairly vigorously defended and some people have therefore defined a territory as any defended area. Most territories are associated with breeding. But a few birds establish territories, briefly, on migration, and others do so in winter quarters; and some birds may defend other areas for other purposes.

Territories vary from tiny spaces just around the bird to areas of many square miles. Even birds living in the same habitat and with roughly similar feeding habits may differ in the types of areas they defend.

In most species, if the individual fails to establish a territory, it will not be able to breed. If a bird fails to obtain a territory, why doesn't it breed without one?

Three main explanations of the importance of having a territory have been put forward. It is a place where a pair can mate and live without interference; it is an area where the pair can get food for their brood without competition from others of their kind; territories lower the nesting density and this reduces danger from predators.

It seems at first somewhat surprising that, usually, a species will only defend its territory against

members of its own species. For example, Scarlet Tanagers maintain territories against Scarlet Tanagers, and Golden Orioles against Golden Orioles, but Scarlet Tanagers and Golden Orioles territories overlap completely. Since the type of food that the two species eat also overlaps, one could have thought that, if food for the young was an important function of territorial behavior, the Scarlet Tanager would have tried to establish a territory that excluded both neighboring Scarlet Tanagers and Golden Orioles; but this does not happen.

Different species occupy and defend their territories for different lengths of time. Black-capped Chickadees are present for most of the year, but are only strongly territorial in late winter and early spring (although there is some resurgence of territorial behavior for a brief period in the fall). Male and female Hairy Woodpeckers often defend their territories separately; they will usually pair with a previous mate and the female's territory is central for nesting.

The young bird which is trying to stake out a territory for itself for the first time faces a number of problems. Old birds can usually successfully defend their territories against other birds that try to usurp them; the old adage "possession is nine-tenths of the law" seems to hold strongly. Even in migrants, the older males seem able to get back to the breeding grounds before the younger ones, and they establish territories that cover much the same areas in successive seasons. The young bird seeking a territory for the first time really only has two options (since he is unlikely to wrest a territory in direct combat); he has either to find one whose previous holder has died or he must try to squeeze in on the border of two others and expand it little by little. He has the best chance if the territories are large and the owners are hard-put to defend them easily. If he persists he may have a good chance of becoming accepted by his neighbors. He has established himself.

Maintaining a territory

Once he has successfully established his territory, a bird defends it vigorously against intruders, advertising his presence by song or display. Though there is wide overlap, displays tend to be used more in

open country or at close quarters, while song is more important in situations where visibility is limited, such as woodland.

The response of a territory owner to a strange song can easily be seen by playing a tape recording of a song in a territory. The owning male quickly appears and sings at the "intruder."

It has been suggested that the reason why birds have several different song types is in order to confuse would-be invaders. Is a bird moving around its territory singing different songs in different places one bird or is it several? This type of behavior may confuse a would-be intruder into thinking there are many birds holding small territories and that it will be difficult to squeeze in there.

It is probably of value to the established individuals to be able to recognize their neighbors. If they are able to do this, then they do not have to waste a lot of time

going to see who it is singing on the border of their territories. It may equally be of value to be recognized by one's neighbor, since this reduces the chances that he will come charging in every time one starts to sing, just to see who it is.

Usually just singing is sufficient to deter would-be intruders who would like to take over the territory. If singing is not enough and an intruder enters the territory and sings himself, the owner will fly toward him, display to him, and chase him off. On the whole, intruders do not push their luck beyond this; physical fights are rather rare. One reason for this is that the established territory holder usually wins such encounters; possession seems to put the defender at an advantage over the intruder. It is not in the interests of the intruder to run the risk of physical injury in a battle if the chances of gaining the territory are slight.

Nests

Birds must have a safe place in which to nest and raise their young. The siting of the nest is clearly of great importance. The site must be one where the eggs and young can be kept together, kept dry, and kept as safe as possible from predators. Most birds are vulnerable to predators of one sort or another. The best defense is to have a nest which is well concealed; for most small birds this is their main hope of success. In many larger birds concealment is difficult and the best strategy is to place the nest in a site which is as inaccessible as possible.

Nest site

The nest site itself needs to be chosen carefully. For many species which live in open country or on water there is often little opportunity to make the nest in dense cover. A small amount of concealment by nesting alongside a grass tussock may be all that is possible.

For birds nesting in thicker cover, concealment is easier and remains the most important method of defense used by most small birds, such as warblers. Larger birds try to make their nests inaccessible—in the top of a tall tree (for a crow) or on a cliff (for a

raven). This tends to make the birds fairly safe from most mammalian predators (though rodents remain a hazard to many birds). But large nests in inaccessible sites, especially trees, tend to be fairly conspicuous; such sites are probably not much use unless the bird can defend itself against other birds.

For this reason, rather few *small* birds nest in the tops of deciduous trees: even small nests are fairly conspicuous at the beginning of the nesting season before the leaves are out. Some small birds, such as kinglets and, to a lesser extent, Pine Warblers nest in the tops of conifers, but these have good cover from foliage throughout the nesting season.

A great many birds nest in holes of one sort of another. All the woodpeckers make their own holes, usually making a new one every year. Many other species nest in holes, including some owls, chickadees, titmice, and starlings; many of these are dependent on finding old woodpecker nests. The Red-breasted Nuthatch usually excavates its own nest and then carefully plasters resin around the entrance to deter predators. Black-capped Chickadees also excavate their own nest-hole, and all woodpeckers excavate their own holes.

Hole-nesting carries certain advantages; most mammals cannot reach the nests (though foxes can sometimes dig out underground nests). Those in holes up trees are safer still; larger birds cannot normally reach the contents of the nest. As a result many birds that nest in holes tend to be more successful at raising young than birds that nest in the open. So why don't all birds nest in holes? The answer is that, whereas birds which nest in the open may have an almost infinite choice of nest-sites, holes tend to be in short supply. They are competed for, sometimes fiercely, and some birds may fail to nest because they cannot find a suitable nest-site.

Type of nests

For birds which nest in exposed sites, the use of nesting material risks drawing attention to the site. Divers, most waders, and many gamebirds merely make a modest scrape in which to place their eggs, and use almost no nesting material at all.

Many birds build intricate nests. Even the simple twig nest of the woodpigeon has to be built carefully. The birds must find a place on a branch where twigs can be placed so that they will form a firm platform. Many places will be tried and the first twigs are often hard to anchor, but gradually a platform is constructed which is strong enough to hold not just the eggs but the incubating adult and, later, two large chicks. pigeons are not highly expert builders; but crows and jays interweave the sticks more carefully and make a deep cup which they line with woven rootlets. Magpies take this development one stage further and build a nest with a strong dome. In this species, the dome probably gives the magpie protection against raids from other members of the crow family, though the disadvantage is that it makes the nest larger and therefore conspicuous.

Open, cup-shaped nests are made by many species of passerine birds such as thrushes, finches, and warblers. Most make the outer structure of small twigs and line it with finer material such as hair or feathers. Feathers are a particularly valuable form of insulation and are used by many birds for lining their nests. Unlike the ducks and geese, which pull out their own feathers to line the nest, the passerines depend on finding the molted feathers of other species, or whole dead birds from which they can pluck feathers.

Among the most complex nests built by North American birds is the Baltimore Oriole, which builds a complex hanging nest. The Bushtit also builds a hanging nest, which is a stretchy sac and is lined with feathers, fur, and plant fibers.

The nests of Ruby-crowned Kinglets and Golden-crowned Kinglets look as if they are just open cup-shaped nests, but they have a ring of feathers protruding over the top of the cup; these act as a thin cover, reducing the amount of heat lost from the nest. This "door" over the nest is particularly well built in some northern areas.

Some birds use mud for building. Several species of thrushes, as well as the American Robin, use mud in the construction of their nest. Cliff Swallows build extensive colonies of mud nests; the birds may fly some distance to collect the mud.

Speed of nest building

Some resident birds may build their nests slowly, taking up to two or three weeks to complete it. Some of the large birds of prey may add sticks to a nest used in previous years, until a very large structure develops.

Some migrants may pair up within hours of arrival on the breeding grounds, and start to build almost immediately, completing a nest within only a few days. The same can be true of resident species which have lost their first nest: a replacement may be built much more rapidly.

Opposite A Tree Sparrow gathers material for its nest **Above** A warbler's nest

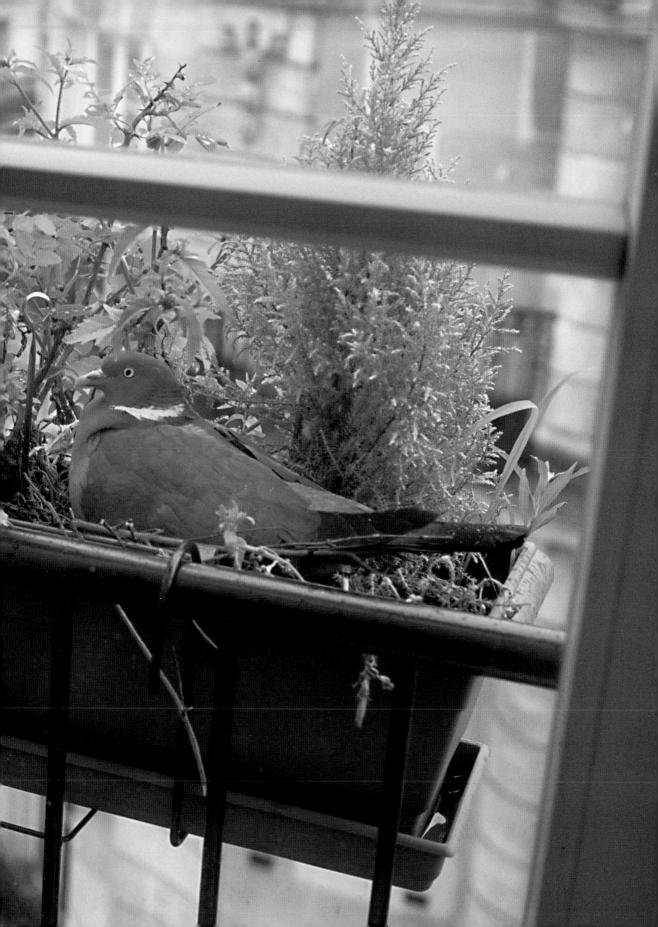

Bullfinch

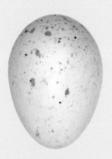

Goldfinch

American Robin

Tawny Owl

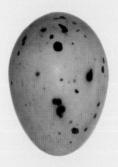

Chaffinch

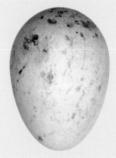

Greenfinch

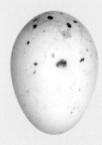

Siskin

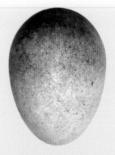

Tree Sparrow

Eggs

Once birds have selected a nest site and built the nest, they are ready to produce the eggs.

Egg size

Two generalizations can be made about the size of eggs in relation to the size of the female's body. First, egg size varies very markedly between families, but less so within families. Second, within families smaller birds tend to lay proportionally larger eggs than larger birds do.

The somewhat conical shape of waders' eggs means that a normal clutch of four form a neat group if they are positioned so that their pointed ends face inwards. The incubating female could not cover as many eggs of such a large size effectively if they were any other shape. Many eggs of hole-nesting species such as owls and kingfishers are rounder, but it is not known why this should be.

Egg coloration

The eggs of different species are very variedly colored and patterned. The usefulness of some egg colors seems clear, but the value of others is puzzling. The camouflaged eggs of ground-nesting species such as waders and nightjars are obviously adaptive, since they are difficult for predators to find. On the other hand, some species lay eggs that are not well-camouflaged at all—such as the white eggs of Mourning Doves, and the pale eggs of pheasants. These eggs are normally covered by the incubating birds (both members of a pair of Mourning Doves

taking turns, but only the female pheasant) and so there is no need for them to be well-camouflaged. The eggs of most hole-nesting birds are white or pale blue, perhaps to make it easier for the parent birds to see them.

Apart from the well-camouflaged eggs of birds which nest on the ground, it has generally proved difficult to correlate the colors of eggs with any particular aspect of the nesting behavior of a species. The nest itself is necessarily a bulky object, much larger than the eggs, and, in the vast majority of cases, it is the nest that is found by the predator, and not the eggs. Building a nest that is well-camouflaged or inconspicuous is important; inconspicuous eggs are not necessarily advantageous.

Interval between eggs

The laying female needs to find a lot of food to form the eggs. In many small species, the female lays her eggs at daily intervals; in those that lay a large clutch, the female may have to find the food required to form one egg every day (since she cannot store all the nutrients required for all the eggs). In some larger birds the interval between the eggs is longer. Canada geese lay at about thirty-six-hour intervals and swans have a two-day interval between eggs. The Chimney Swift, which is dependent on flying insects for its food, also lay its eggs at two-day intervals; but if the weather is bad and therefore food is scarce, it may lay at three-day intervals instead.

Incubation

After the eggs have been laid, the parents must keep them warm so that they can develop. Incubation takes quite a long time; the shortest incubation period of any bird is eleven to twelve days; most species take longer than that. In order to hatch the egg, parents must apply heat to it. They cannot do this properly through their thick (and insulating) feathers, so they have to develop a special brood-patch; this is an area of the belly from which the feathers are shed and which develops large blood vessels just underneath the skin. By applying the brood patch to the eggs, the bird can maintain the egg at close to its own body temperature. In some species both sexes develop brood patches; in others only the female does so.

Share of sexes in incubation

The parent must not only keep the eggs warm, but must keep the whereabouts of the nest secret. Nonetheless, the parents usually need to feed, so they must make visits to and from the nest. Going to feed is obviously less of a problem for species in which both parents incubate: one can take over directly from the other. When only one of the parents incubates (usually it is the female), the eggs may chill when left untended; so the bird must keep its foraging trips short, especially in cold weather. It is not always clear why the male does not incubate; differences occur between closely related species. Even when both parents incubate, the female often does the majority; in particular, she often incubates throughout the night as well as taking a share during the day. The parents may switch over every half an hour or so in small species, or only once or twice a day in larger ones. In Shearwaters and Storm-petrels, which only come to the nesting colony at night, the birds only switch over every two or three nights and exceptionally one bird may have to incubate without a break for eight or nine days.

Hatching synchrony

The moment at which the parents start to incubate their clutch has important implications for the brood. In many species the parents do not start to incubate the eggs until the clutch is complete. Where this happens all the young hatch at more or less the same

time (synchronously). In some species, especially ones where the young are nidifugous (hatched at an advanced stage), it is very important that the young are ready to leave together or they become difficult to look after. In contrast, some parents start incubation before the clutch is complete, so that the eggs do not all hatch together (asynchronously). For example, many owls, such as the Barn Owl, start to incubate the first egg as soon as it is laid. Since the eggs are laid at roughly two-day intervals and each takes the same number of days to develop, the chicks hatch roughly two days apart. The earlier-hatched chicks are at a great advantage over their later brethren. The larger the chick, the greater its chance of getting the food it needs; if food is in short supply, the first chick to hatch may flourish while the later ones starve to death.

At first sight, this may seem to be an inefficient way of breeding, since it leads to the death of many young. Almost certainly, however, the opposite is the case: it is, for the parents, a way of ensuring that they raise as many young as possible. When food is scarce, the parents raise more young if the small ones die quickly and so do not compete with the largest. If they were all of equal size, then all would be equally emaciated, and none might survive. This habit is often referred to as the brood-reduction strategy. It is most commonly found in birds for which the food supply is unpredictable.

Eggshell removal

Once the chick emerges from the egg the parents' behavior changes to deal with young which must be fed. In many species the parents have a special duty to the hatching chick: they must remove the eggshells. This is particularly important in species which nest out in the open. In these the startling white of the inside of the shell contrasts markedly with the camouflaged outside. It is dangerous for the parent to leave the eggshells near the nest; these may well draw the attention of predators to the nest-site so the parents pick up the shells and fly with them some distance from the nest before dropping them.

 $\mbox{\bf Opposite}\,\mbox{\bf A}$ Fieldfare, sitting on its mud-lined cup nest, made of grass and leaves

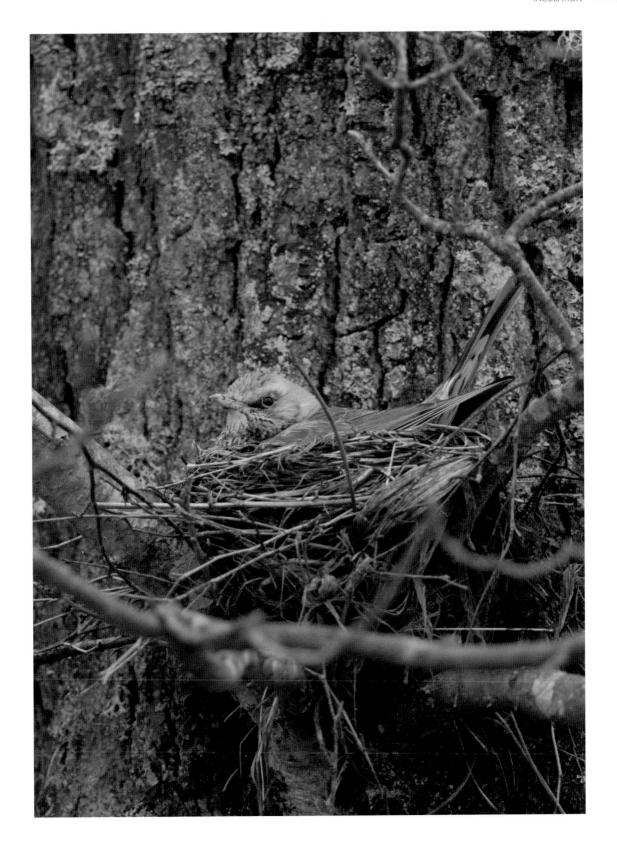

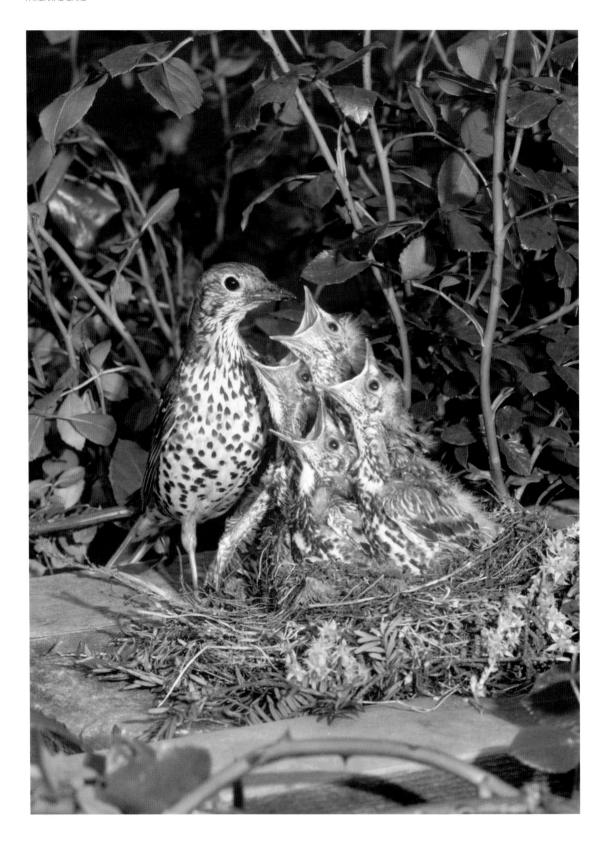

Parental care

nce the young bird has hatched, the parent must bring it food or lead it to where it can feed itself. We know rather little about the detailed behavior of birds with nidifugous young because they are rather difficult to observe. In most species they are led away from the nest within a few hours, a day at the most, of hatching, and for most it is important for them to hatch synchronously. The duties of parents of nidifugous young are mainly to keep them dry and warm, especially when they are very small, and safe from predators. Relatively few bring food to their young. Most take them to good feeding places where they feed for themselves.

Nidicolous (hatched in an undeveloped state) young may still need a lot of brooding—they will not be able to maintain their own body temperature until they are much larger, especially in cold weather. This can pose a problem for the parents of small passerines where both parents normally collect food for the young. They need to go and hunt for food for the chicks, but the chicks may chill if they are away too long. In warm weather the chicks need little brooding and so both parents can collect food, but in cold weather one of the parents may have to brood the young and this effectively cuts the feeding rate by half. Even though they are kept warm, the young may die of starvation.

It is obviously important to bring to the nest as much food as possible in the time available, and at the same time to reduce as far as possible the amount of effort involved in doing so. Many birds use their crops to bring food back to the nest. They can bring large quantities at each visit, hence they need to make fewer flights between food and nest, and so save energy. Finches bringing seeds and swallows bringing small insects would waste an enormous amount of time if they brought in each item individually. A Chimney Swift, for example, may carry in its huge gape more than 200 insects each time it visits the nest. Nevertheless, many insectivorous species, like chickadees, flycatchers, and the bee-eaters, do bring in only a single item on most visits. Apparently, this is because many insects have to be beaten and killed so that they do not sting or bite the young birds. Even the jaws of caterpillars must be broken so that they cannot bite the chick after being swallowed. Since it appears

to be too difficult for the adult to hold one prey while preparing another, the items have to be brought in one at a time. But these birds do try their hardest to be efficient: they eat the small prey they find themselves, and take only larger ones to their young.

The size of prey brought in is obviously important. It may be necessary to catch small prey for tiny chicks as they may not be able to swallow larger prey. This is not usually a great problem since many of the parents which bring large food items, such as the birds of prey, can tear them into small portions if necessary.

The quality of the food may also be important. In general it seems that a vegetable diet is not a good one for raising small, rapidly growing young. Almost all birds which feed on vegetable material will feed insects to their young when they are adult. Most finches feed their small young on insects; later they may bring increasing amounts of seeds.

The parents bring food to the nest in response to begging by the chicks; the more begging the chicks do (i.e. the hungrier they are), the greater the likelihood that the parents will work harder to provide more food for them. However, there is a point beyond which they do not seem able or prepared to go. Clearly it is of little value if they endanger themselves too much; if they die, there is little or no hope for the young anyway. As well as bringing food to the nest, most passerines keep the nest clean by removing the feces which are produced in a gelatinous sac by the young. These are carried some way from the nest before being dropped so that the site of the nest is not revealed to a predator by a pile of conspicuous droppings.

In almost all species parental care continues for some time after the young have left the nest. There may be a conflict between the interests of the parent and the young at this time. It is in the interests of the young to stay close to the parents, benefit from the safety of the territory, and perhaps get fed. In due course the chick will be ignored by the parent, or actively chased away. The parents will then be free to see to their own affairs, which may involve the raising of another brood, undertaking a molt, or preparing for migration.

Opposite A Mistle Thrush feeding its young

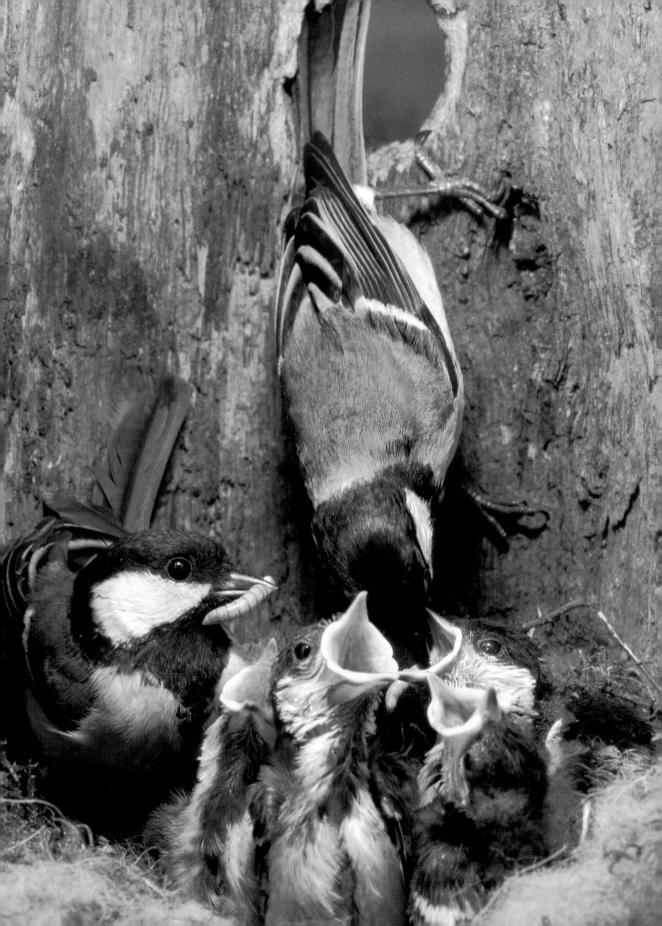

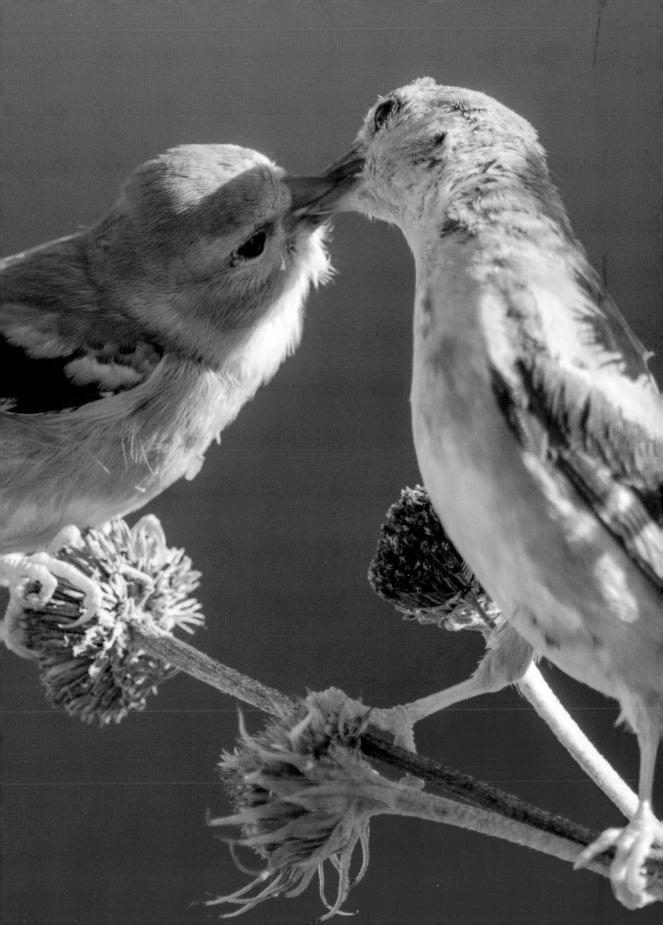

Migration

Flight enables birds to travel great distances, over both land and water, in a short time. Flight enables birds to exploit many places where food is plentiful at certain times of the year, but absent or unavailable at others.

Migration may be defined as "a regular, large-scale shift of the population between a restricted breeding area and a restricted wintering area." This is not a completely watertight definition, since, as we shall see, not all migration is between breeding and wintering areas. Nonetheless, it covers the great majority of cases.

Evolution of migration

Migratory habits have arisen as a result of a set of complex "pros" and "cons." In North America, we tend to think of the hummingbird as leaving its home and going to a warmer area, with more insects, until home is habitable once more. In fact this is the wrong way around; it is nearer the truth to say that Mexico/Central America is the hummingbird's home and that it comes to North America for our summer so as to cash in on the rich supply of insects for its young. Certainly this is the way its journeys came about.

Partial migrants

Another group of birds which give us some insight into the evolution of migration are the so-called partial migrants. These are species in which different populations, and indeed different individuals in the same population, show marked differences in migratory behavior. In the North-West the American Goldfinch is almost wholly migratory, whereas in the South only a few migrate. The tendency to migrate is related to the harshness of the winter: the more difficult it is to survive the winter on the breeding ground, the more advantage there is in being a migrant.

In another partial migrant, the House Finch, the individuals of the same population differ in their tendency to migrate. In Scandinavia the migratory tendency seems to be related to the severity of past winters. After a series of hard winters, most of the chaffinches migrate in winter whereas after a series of

Previous page left Great Tits feeding their young, they seek tree-holes or suitable gaps in walls and buildings to nest, and also use nest boxes, if available **Previous page right** American Goldfinch feeding offspring

mild winters a much higher proportion spend the winter on the breeding ground. What happens is that, in these northern areas, the balance between the advantages of staying put and of migrating is fairly even. During a severe winter the migrants survive better than the residents, whereas in mild winters the advantage lies with the residents. The individual birds are not making a choice; rather, when there is a severe winter, those with the migratory tendency survive better and so leave more offspring (which inherit the same tendency to be migrants), whereas in a mild winter the residents survive better and leave more offspring.

In the blackbird, another partial migrant, females are more likely to migrate than males, and juveniles more likely to migrate than older birds. This is the opposite of the pecking order noted in birds feeding in winter. Since males are more likely to survive on the breeding grounds than females, and adults than juveniles, the old and the males stand to gain less by migrating than the young and the females. Hence the pattern noted is in keeping with the relative chances of surviving on the breeding grounds. In Germany it has been shown that the tendency to migrate or stay is inherited. Because the advantage of staying versus migrating varies markedly between years, the population of blackbirds can swing from being mainly migratory to being mainly resident over a few years, depending on the harshness of the winters. These studies show that the migratory habits of some species may vary over even a short span of years. If conditions change permanently, the habits may also change permanently. One species in which this appears to have happened is the House Finch.

Migratory species

Most insect-eating groups, such as the warblers and swallows, migrate south from northern breeding grounds. Other groups which are mainly sedentary contain migrants. For example, the Sandhill Crane, Burrowing Owl, and sapsuckers all head south, although the distance varies, while the other gamebirds, doves, owls, and woodpeckers are mostly non-migratory.

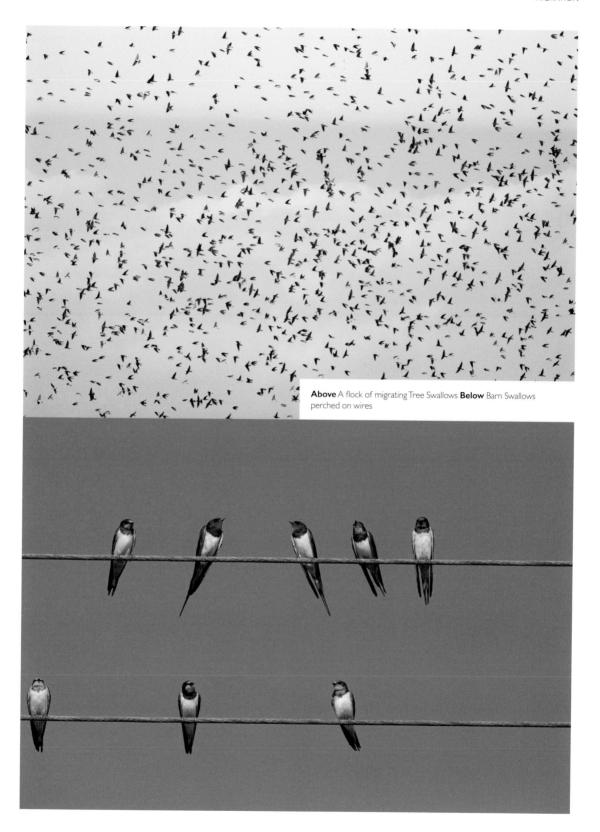

Ecology of migrants

Most migrants fall into one of two categories. One contains species in which almost all individuals leave North America for Central or South America, though some migrate shorter distances within North America. Over 650 species of land-birds breed in North America, and about half of them leave the area completely for the winter (though a few stragglers may stay behind in some cases).

The second category consists of a large number of species which migrate to the southern parts of North America where it is easier both to survive (less food is needed at higher temperatures) and to find food (the land is less likely to be frozen or covered with snow).

Although there is overlap, there are some ecological differences between these two groups of birds. Those that migrate longer distances include almost all the true insectivores (swallows, swifts, flycatchers) and most of those that rely largely on insects (warblers). Many of those that come migrate to winter in North America are ducks, geese, and waders that breed in the

far North and Arctic regions. These birds feed mainly on grass or other vegetable material or invertebrates along the shore or in fields.

Migratory routes

There are almost as many migratory routes as there are migratory species. In most cases, especially where the birds are night migrants, there are no specific routes on which the birds are concentrated. Most warblers, for example, migrate on a broad front, spread out over wide areas. The same is probably true for many of the diurnal migrants; they do not concentrate in flight lines. Seabirds and sea–ducks often try to keep out over the water, but may become concentrated as they pass certain headlands. Many of the soaring birds concentrate at the short sea crossings; but after that they spread out on much wider fronts.

Some species have no true migratory routes, but nevertheless manage to move to much milder areas for the winter. These are those species that live high in the mountains in summer.

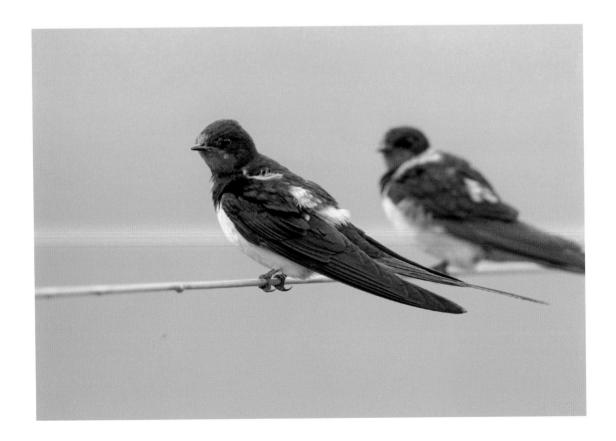

Distances flown in a single flight

Since many of the smaller birds, such as the warblers, fly at only about 25 miles (40 kilometers) per hour, such long distances pose great problems for them: they must expect to have to fly non-stop for perhaps seventy-two hours. At these speeds, even a light headwind may prove disastrous. For example, a 9-mile (15-kilometer) per hour headwind would slow a warbler down to 15 miles (25 kilometers) per hour and make a 1,555-mile (2,500-kilometer) journey take 100 hours instead of sixty-two; this might well mean death. On the other hand, if the birds can judge it right, a tail-wind would make life a great deal easier for them. One species, the Blackpoll Warbler, which flies non-stop from the New England coast to northern South America, a flight of some 2,500 miles (4,000 kilometers) or more, changes altitude several times on route apparently to take advantage of favorable winds; even with this help, it still takes over 100 hours to make the journey.

Fat reserves for migration

To be able to make these long flights, the migrant birds have to lay down fat reserves. Fat is a particularly good source of energy for a flying animal because it produces more energy per gram than do stores of protein or carbohydrate. In addition, as it is used up, one of its by-products is water; for a migrant which is on the wing for two or three days at high altitude, and without the opportunity to drink, this may be crucial.

The numbers of migrants

The scale of migration is sometimes difficult to comprehend. The number of birds which leave Europe and western Asia for Africa each year is very large indeed (and the figures given below do not include those birds that migrate into or within Europe). In many European countries bird censuses have been undertaken and these, coupled with measurements of the extent of the relevant habitats, can be used to obtain the approximate numbers of breeding pairs and their offspring.

Opposite Barn Swallows preparing to migrate **Next page** A large gathering of swallows resting during migration

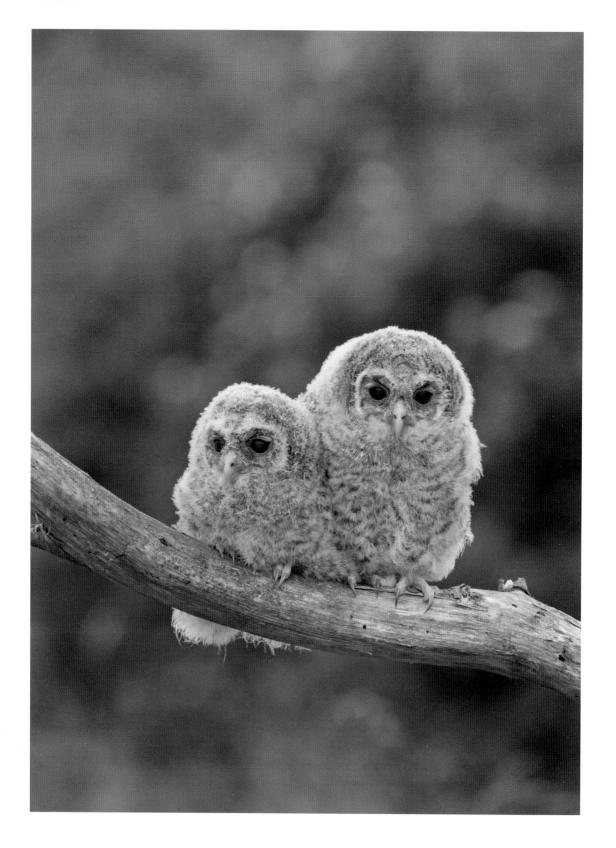

Population

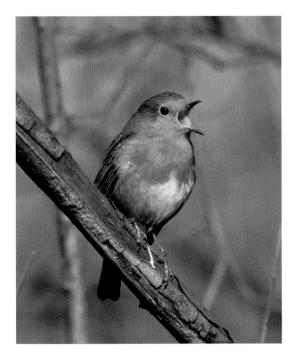

Stability of numbers

In nature, the populations of most species remain remarkably stable. This does not mean that there are no changes in numbers—populations may decline after a very cold winter, for example—but over a longish period of years the numbers remain more or less the same. There are usually one or two pairs of blackbirds, robins, or chickadees in our backyards, seldom none or many pairs.

These casual observations are borne out by detailed studies of particular species; such populations tend to fluctuate remarkably little. Similarly, although the numbers of smaller birds, such as chickadees, fluctuate a little from year to year, sometimes even doubling or halving between years, over the longer term the numbers remain fairly stable. In the chickadees and some other seed-eating species, the numbers fluctuate in proportion to the seed crops available during the winter. When there is a good crop, survival is good; when the crop is poor, so is survival. The reason why

Opposite Tawny Owl chicks often leave the nest before they are fully fledged. This is normal and they are still attended by their parents. Above A European Robin singing on a branch

most bird populations are stable is that the number of birds born into the population is matched by a similar number which die.

Potential rate of increase

This stability of populations is surprising when we consider the remarkable potential birds have for raising young. A Red-winged Blackbird can have three broods, each of three or four young, in a single season; and an American Robin can have three broods, each of three or four young. If all of these young and their parents were to survive to the next year, there could be seven pairs where there had been only one the previous year. If, in their turn, all these birds and their offspring survived and bred for a mere four years, there would be 2,401 pairs where there had been but one.

We all know that this does not occur. But what does happen to this enormous production? As we have seen, most of these nests fail, or the young die during their first few weeks of life. Many others, together with some of the parents, also perish before the next breeding season. Although in the long term the number of young birds which survive long enough to breed matches the number of adult birds which die, there are inevitably differences from year to year between these two numbers. As a result, populations often increase or decrease slightly between years.

The potential for extremely rapid increases in numbers is not, of course, normally realized. Numbers are kept in check. However, such calculations are not just figments of the imagination. Under exceptional circumstances, such as when a species is introduced to a new area, birds may increase very rapidly indeed. Several species that were introduced from Europe to other parts of the world have shown dramatic increases in numbers. In the United States, eight pheasants were introduced to an island in the State of Washington; after six breeding seasons there were 1,989. Both starlings and House Sparrows have shown similar rapid changes in numbers after being introduced to the New World. Either 120 or 160 starlings were released in New York in 1890 and 1891. By 1950 they had spread across the whole of the United States and were estimated to have increased a million-fold!

Long-term changes in numbers

Although, in the short term, populations may be remarkably stable, long-term changes occur in many species. The number of White Storks breeding in Western Europe has declined markedly during this century. This is apparently because of the draining of the wet meadows which the storks use for hunting, though changes in their winter quarters (in Africa) may also have had an effect. Another species which seems to have declined as a result of changes in its winter quarters, deforestation in South America, is the Golden-winged Warbler. Its numbers showed a very sharp decline during the mid-1970s; this has been associated with the series of droughts in the Sahel area of Africa where the birds spend the winter.

Changes in habitats can also lead to a change in numbers. The numbers of pairs of Great Tits breeding in a Dutch wood increased over a period of thirty years. The wood was a young plantation when the study started but it had matured into rich woodland and by the end of the study. Apparently the carrying capacity of the wood increased as the trees grew up.

One of the most remarkable changes in the population of any species in North America is the case of the House Finch, once a bird of the Western USA. This species was released in New York in 1939 and colonized most of the Eastern States during a period of fifty years. It is now so common in many areas as to be virtually uncountable. It is not known why this bird has increased so strikingly, but it lives in close association with humans and seems to have, quite suddenly, found that this habitat was a very suitable one.

Immigration and emigration

A very high proportion of the deaths of young birds occur during the late summer, soon after they become independent. Since birds are small and dead ones are rapidly consumed by other animals, this loss is mainly noticed as a drop in numbers. The birds simply disappear. Many people find it hard to believe that so many young birds die before reaching breeding age. They suggest that when young birds disappear from an area, they have not died, but have emigrated to other areas. Birds do, of course, move between areas: any piece of habitat has both immigrants and emigrants. However, emigration (as opposed to death) is not likely to be the explanation for local drops in numbers. This is because, in most species, local

populations tend to fluctuate in synchrony with one another. For example, robins tend to have good breeding success in years when the ground is damp for long periods (so the parents can easily get food for the young). Since such conditions tend to obtain over wide areas at the same time, robins over wide areas have good or poor breeding success together. The disappearance of the young from one area is likely to be accompanied by similar disappearances in other areas. The birds cannot be emigrating from all areas at the same time.

Of course, ebb and flow on a local level can sometimes have an effect. In an area of mixed woodland and suburban habitat, for example, breeding success of chickadee will tend to be higher in the depths of the forest than in somebody's backyard, where sources of disturbance (like children) or predators (like cats) abound. After a typical breeding season, the woods will be thronged with young and mature chickadees and titmice, and many of them, under pressure from competition for food, may naturally stray into backyards beyond the forest.

Population regulation and maintaining numbers

We have seen that bird populations are usually stable over quite long periods of time and that, in spite of there being a large production of young, most of these die before reaching breeding age. What factors affect the way in which these numbers balance? The answer is that populations are regulated largely by their own numbers. Such numbers affect the survival of the individuals present.

The fact that birds produce more young than seem to be needed to maintain their numbers is one of the most important aspects of their biology. Without this overpopulation they could not quickly increase in numbers when conditions are favorable. This is not merely useful when the opportunity occurs, such as when the Rock Pigeon spread rapidly into new areas, but it is essential to all populations. From time to time, all populations encounter poor conditions and their numbers decline. The fact that they are able to produce so many young enables them to make good their numbers as soon as better conditions prevail. Many species go up and down in numbers quite frequently; if they could not rapidly increase in the good years, they would become progressively scarcer.

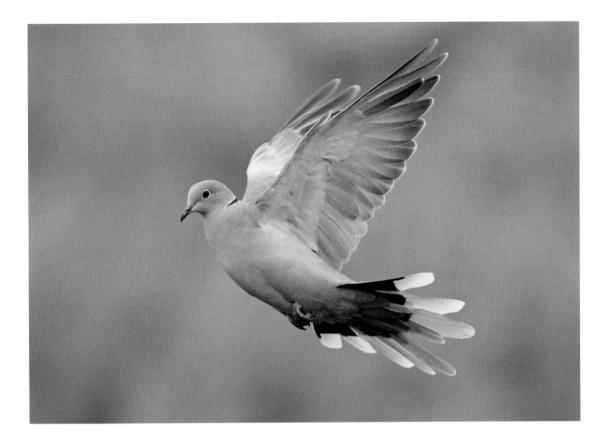

The basis for evolution

Overproduction is the very basis on which evolution operates. Charles Darwin was the first to point out how many young animals fail to reach adulthood and he realized the importance of this. There is great variation between individuals, and they compete for the opportunity to survive to breed. Those individuals which are fittest will be those that survive to leave offspring which will, in their turn, bear many of their parents' characteristics. Thus, over many generations, the characteristics of a species can change to enable it to cope with a changing environment; eventually new subspecies and new species may evolve. Darwin called this process natural selection.

Survival rates

The number of birds in a population depends on the survival rates of the individuals and the success they have at raising young. We have seen that many young birds die before they reach breeding age, and that the annual survival rates of breeding adults varies markedly between species.

Above A Collared Dove coming into land Next page A flock of goldfinches, greenfinches, and Tree Sparrows fills the sky

Protection and conservation

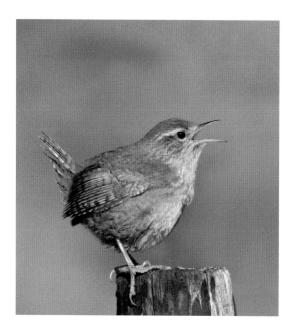

As we have seen, birds will quickly make good their numbers after some natural disaster. They have been doing so for millions of years. Hence there is no real reason to worry about most species if their numbers drop sharply after some difficult period such as a very cold winter. Even birds such as winter wrens, which are very sensitive to cold winters, can quite quickly make good their numbers after bad periods. What does matter to such species is any change in habitat; this may affect survival rates or reproductive rates. A change in habitat is likely to be permanent and so the balance of numbers may be permanently affected.

Humans have had a greater effect on the landscape than any other agent since the Ice Age. Many natural habitats have almost disappeared. There is almost no truly natural woodland left over most of Europe, and much concern is now being shown over the rapid disappearance of tropical rainforests. In an attempt to prevent too great a loss of wildlife, many bodies are now concerned with various aspects of conservation. There is a great shortage of resources for such activities, and of land for nature reserves; so it is imperative that we make the best use of what is available by making sure that we understand the *key needs*. In one sense, this is stating the obvious; but it is by no means always clear what the priorities should be.

Protection of individuals

It is necessary, perhaps, to stress the difference here between caring for individual birds and being concerned for the well-being of populations as a whole. Cold winters result in an increased mortality of individuals, but they do not endanger the population.

Should we therefore interfere with nature by providing food to help the weaker individuals to survive, since the populations of most backyard birds decline markedly in cold winters, even though a lot of people feed them? For species that have only small populations in restricted areas, a natural disaster may have a more marked effect and even lead to the extinction of some local populations. The species may then be absent, briefly or for a long time, until such areas are recolonized by birds from elsewhere. The more reduced and dissected populations become, the longer recolonization may take. It might never happen. Putting effort into reducing the effect of natural disasters on such species may allow them to cling on, enabling their population to recover in better times.

The protection of rare species takes up a great deal of the conservationist's time. One difficulty is that it is not always easy to define what is a rare species and what is not. Some species considered rare are, in fact, reasonably common somewhere else and are simply on the edge of their range—a place where, almost by definition, a species finds it difficult to survive. In this sense birdwatchers may be like gardeners: forever trying to persuade species to flourish in places where they cannot easily do so. Effort may be better targeted at where species are declining throughout their range.

Protection of habitats

In contrast to the fact that healthy populations may need little or no protection, the preservation of suitable habitat is of prime importance. Even small environmental changes may be important because they tend to be permanent, rather than happening once in a while as is the case with natural disasters. To this end, it might be more important to our backyard birds to plant trees and bushes for them, or to buy and protect more woodland, than to provide food in winter.

Above left A wren sings, perched on a post **Opposite** A goldfinch feeds by extracting seeds directly from plants like this teasel

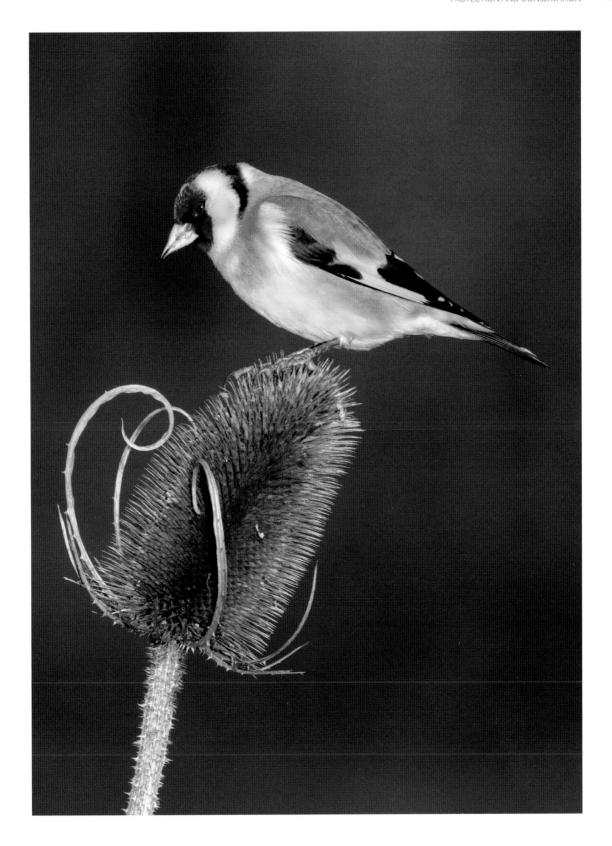

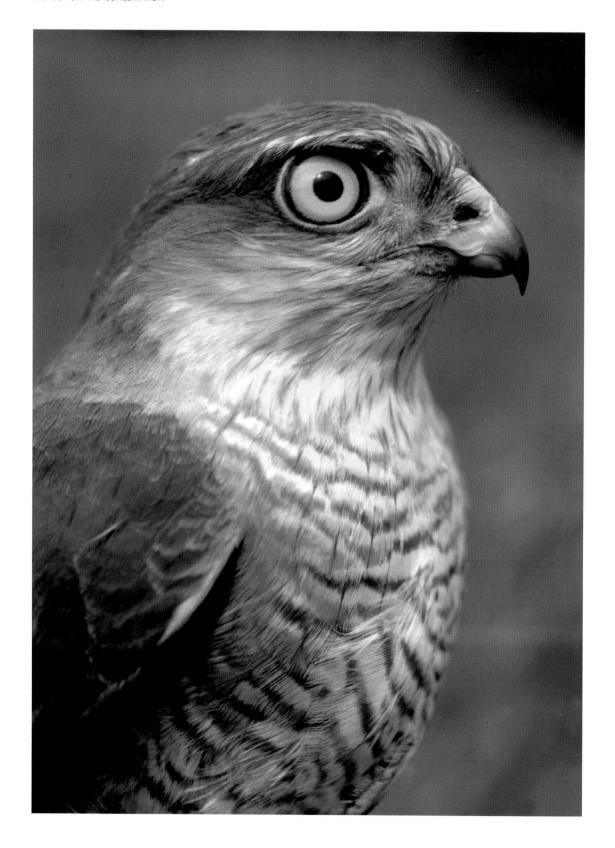

In recent years there has been greater recognition of the problems which arise from trying to protect a single species. Conservation now tends to put much of its emphasis on preserving representative areas of a wide range of habitats. In many cases this has the desired effect of protecting many of the rarer birds anyway, and brings the added bonus of giving protection to all the other flora and fauna which occur in such habitats.

Even so, there are problems associated with trying to maintain natural habitats. Even if one can obtain and give protection to large areas, this does not guarantee success, since it is not possible to keep the birds in such areas in total isolation. Certain threats to bird populations cannot be eliminated just by setting up reserves. Many species have been affected by the use of poisons aimed primarily at insects, but which also poison birds. These, such as DDT and related substances (often referred to as the chlorinated hydrocarbons), are applied to fields to protect crops. Since they do not break down readily, they have slowly spread into all habitats, partly by the movements of animals carrying them. For example, a Mourning Dove may eat the treated seeds, fly to roost in the woods, where it is eaten, chemicals and all, by a Peregrine Falcon. Chemicals have also been washed out of the soils and carried down rivers into the seas, where they have built up in the marine food-chains and hence in the seabirds. Plastics and other pollutants that do not break down find their way into the food-chains and nests of birds all around the globe, causing sickness and death. Such is their persistence, and so great the quantities used, that they have even been found in the Antarcticmany thousands of miles from where they were originally applied.

Opposite A Sparrowhawk has large eyes and exceptional vision
Next page left A Marsh Tit and a Great Tit forage on sunflower seeds.
Next page right Dried sunflower heads offer the perfect snack for peckish finches, chickadees, titmice, and nuthatches

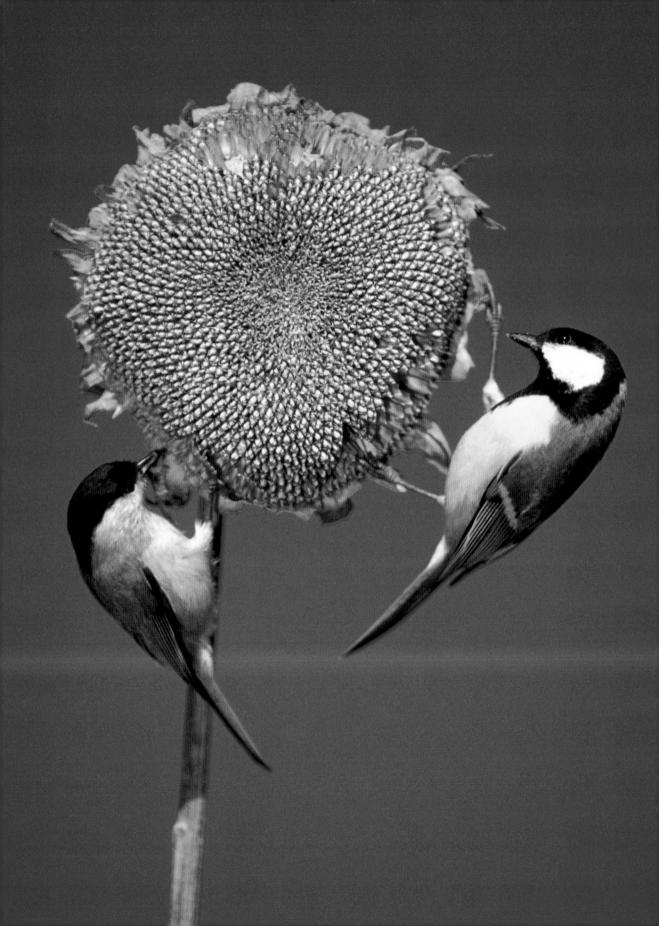

The changing scene

A brief history of North American and European habitats

orthern hemisphere habitats have changed markedly during the last 15,000 years or so, since the peak of the last glaciation. During the last two million years there have been several glaciations, interspersed by warmer periods. During these glacial periods, the Arctic ice-cap covered vast areas of Europe, extending down to southern Britain and much of central Europe. In North America it covered the whole of Canada and large parts of the center-east south to the Ohio and Missouri Rivers, as well as sections of the Rocky Mountains. These areas were of little or no interest to birds. To the south lay the Arctic tundra, usable, as it is today, by waders, geese, and a few other species during the summer months.

The habitats which we see today in northern Europe and Boreal North America were not eliminated during the Ice Ages, rather they moved southward and northward with the changes in climate. As the climate got colder, the plants in any given habitat would die out on the northern edge, but spread on the southern edge. As the climate warmed up, this pattern was reversed. Botanists have built up a good understanding of the movements of the habitats. Ornithologists do not have comparable information on the birds, but it seems reasonable to assume that these stayed in the habitats that they prefer today, and that they too moved as their habitats shifted back and forth.

In North America, the last glaciation left behind the huge natural legacy of the Great Lakes and their associated region. The lake basins were carved out by glaciers and filled initially with meltwater, creating the unique set of landscapes that we see today. At about the same time the Prairies formed, the newly raised Rocky Mountains forming a rain shadow that prevented the formation of forests downwind owing to the low precipitation. The glaciers left behind sediment on which grasses began to grow.

Between 10,00 and 6,000 years ago the habitats stopped moving northward. They settled into a pattern which, if things had followed the pattern of the previous inter-glacials, would have remained unchanged until the ice began to move southward once again. But the current inter-glacial (if that is what it is) differs from all previous ones in that a new factor intervened to make other changes to the

habitats. Humans arrived in ever-increasing numbers, affecting habitats as never before.

The natural habitats and the arrival of people

Before people arrived, most of Europe was covered by a forest of oak, ash, beech, spruce, and pine. Grassland was almost non-existent. The only open lowland areas, apart from marshes, were sand-dunes and temporary clearings where there had been fire or where large trees had fallen and left small glades.

The situation in North America was somewhat different. Although much of the land was forested, it was more diverse; the continent has 680 species of trees. The many different types of forests included eastern and northern hardwood forests, pine-oak forests, open oak woodlands, pinyon-juniper, cordilleran Forest, northwestern coastal forests, riparian woodlands, subtropical forest, and, as in Europe, boreal forests. In addition to the limited open habitats described above, North America has several kinds of deserts and, in a sharp contrast to Europe, the Prairies. These extensive grasslands formed the stage for a truly magnificent ecosystem, with many millions of buffalo and other herbivores grazing the lush grass, indulging in great migrations. A unique, specialized avifauna evolved, the remnants of which we can still enjoy today.

Much has been discovered recently about the early peoples in North America. There are two theories, one suggesting that humankind first crossed over from Asia via the Bering land bridge about 40,000 years ago, while the other school of thought times their arrival at about 14,000 years ago, roughly coinciding with the Clovis culture (at least 13,000 years ago.) Paleo-Indians were hunter-gatherers, as in Europe, but agriculture and land clearance occurred in North America as well as Europe, and about the same time. However, on the whole, up to contemporary times, more of North America retains its wildness.

There is more original forest left in North America than in Europe, and still some wilderness.

Opposite The Downy Birch, one of the few original trees of the natural forestland

However, in most parts of the continent the loss of forests has been every bit as severe as in Europe, particularly the deciduous forests of the east. On the other hand, a terrible loss has been the prairies, the wild and distinctive grasslands that once covered about a third of the continent. Native peoples lived sustainably on the prairies by hunting the huge populations of herbivores. It took the advent of European colonization to seal their fate. The prairies became the breadbasket of the world, but at enormous ecological cost. It is thought that less than one percent of natural grassland survives, a terrible toll.

The birch and conifer forests of the far north of Europe and North America are probably little altered. Elsewhere, only one or two areas of almost natural forest remain in central Europe. Some of the scrub forest in the drier parts of southern Europe, or on mountains near the limit of the tree-line, may be fairly unchanged, though many have been heavily felled or grazed. As mentioned above, while much has changed, there is still substantial natural or semi-natural vegetation remaining in some parts of North America.

Changes in birdlife

The changes which humans have made to the environment have been covered in some detail because they have had very profound effects on the bird fauna of Europe and North America. Indeed they could be said to be the dominant factor in the distribution of many of the birds we have today.

The losses

Recent years have shown enormous declines in almost every category of bird, both in Europe and North America. A recent study has shown that North America has lost three billion individual birds since the 1970s, and the situation isn't any better in Europe.

In North America, several species have been lost in addition to the Great Auk, which occurred on both continents and is now globally extinct. While the Demoiselle Crane, Common Hemipode, and Steppe Eagle are still extant elsewhere in the world, birds such as Labrador Duck, Bachman's Warbler, Ivory-billed Woodpecker, Eskimo Curlew, Carolina Parakeet, and, most notoriously, the Passenger Pigeon, have been eliminated from North America and thus the world. The Passenger Pigeon, its ecology closely tied into the existence of vast, undisturbed tracts of eastern deciduous forest, and generally considered to be the

most numerous bird ever to have lived, is arguably the most anguished extinction of all time.

The gains

The changes humans have made have not just brought about reductions. A number of species must have found human-made habitats to their liking. Many of the birds which live in towns and backyards were originally occupants of the extensive forests; many individuals still live there. Such species include the thrushes (the Varied Thrush and American Robin), the Chickadees (especially Tufted Titmouse and Black-capped Chickadee), various North American sparrows, juncos, nuthatches, Blue Jay, chaffinches, greenfinches, and, in larger areas of parks and backyards, Great-spotted, Hairy, and Downy Woodpeckers, and Tawny Owls. These birds may even have preferred woodland edge to the deep forest. Moving into agricultural scrub and hedgerow and into backyards may not have seemed a great change to them.

Some very common backyard birds are not woodland species. Who knows where the House Sparrow, a Eurasian species that was introduced to North America in the 1850s, lived before humans opened up the countryside? It is hard to imagine the House Sparrow without people, and recent studies suggest that it might have evolved at the dawn of human agriculture in the Fertile Crescent as recently as 11,000 years ago. It would not occur in most of Europe today were it not for human activities and would never have reached North America. The European Starling, now found on both continents owing to similar deliberate introductions to the House Sparrow, nests in trees; but it feeds, for most of the year, on areas of short grass. However, it also nests in holes in cliffs, and feeds along the shoreline. Was this its natural habitat in Europe before humans arrived? We need to speculate less about the Brown-headed Cowbird. This was a confirmed grassland species in North America until the 1800s, occurring in the central prairie belt. Since then, however, forest clearance has opened up millions of acres of agricultural land ideal for Cowbirds and their destructive tendencies, laying eggs parasitically in the nests of many host species.

 $\ensuremath{\mathsf{Opposite}}$ The Tawny Owl is a forest species that has adapted well to the human environment

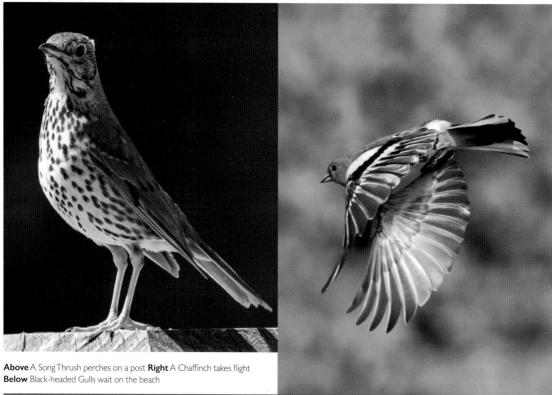

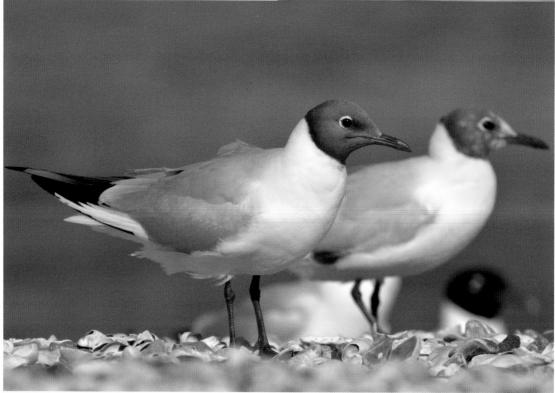

The primeval countryside may also have been less suitable for the Buzzard, Red-tailed Hawk, Broadwinged Hawk, Red Kite, White-tailed Kite, and Common and American Kestrel, all nesting in trees, but feeding over open country. Gray Partridges, Sky and Horned Larks, Meadow and American Pipits, mockingbirds, killdeers, and Burrowing Owls have all expanded from their original habitats. After all, the Purple Martin of North America was once a bird of forest edges and marshy areas, but now, at least in the East, it is virtually confined to breeding in artificially provided birdhouses. We can reasonably assume that these species are much commoner today than they were before humans appeared on the scene.

Changes of habits

Some of the birds which occupy human-made habitats may well have been able to colonize them with little or no change of behavior, since the habitats were sufficiently similar to the ones which they lived in already. In other cases birds may well have changed their habits somewhat, and this enabled them to increase their numbers markedly. Many of the European birds have had 2,000 generations or more to adapt to the changes people have made, while North American birds have had to adapt more quickly. However, some small changes can be observed in 100 generations or less; a recent study of Cliff Swallows has shown that they have evolved shorter wings in the space of thirty years, a physical change that has made them less susceptible to being hit by road traffic. Gulls throughout Europe and North America have learned to take food provided by people in the form of household trash, as well as making use of the waste at harbors and wharfs. Mallards and Canada Geese thrive on urban and park lakes, often taking food directly from people. Few human changes have had more positive effects than the provision of food in backyards. Not only have some species made backyards their refuge from intensive agriculture, many have also changed distribution owing to human largesse. A clutch of North American species have spread northward since the 1970s owing partly to backyard provision, among them Northern Mockingbirds and Northern Cardinals.

Overall change: the future

The result of all these changes is difficult to summarize. Overall, we haven't lost many species, but a significant majority are now much less numerous than they once were. Along with the three billion loss of North American birds mentioned earlier, Europe is thought to have lost 421 million from the overall bird populations in the last 30 years. And while some species that were scarce must now be much commoner than they were before humans made their mark upon the scene, even some of these are beginning to decline sharply, mostly in the face of modern intensive farming. Agri-deserts are not of benefit to wildlife.

If you take the long view, the changes people have wrought are similar to those that have always been going on; new species have arisen while others have evolved new adaptations to new situations. In one important way, however, the alterations brought about by people are different from most of those wrought by nature: they occur much faster. Our increasing technological skills enable us to make ever swifter, more marked changes. In many areas of the world, especially the tropical rainforests, where birds are closely adapted to highly specialized forest types, changes are occurring very much faster than they have in Europe. Such changes bring about huge losses of plant and animal species.

Equally, the future is not particularly rosy for many animals in Europe and North America; changes will almost certainly occur more rapidly in the future than they did in the past. In spite of the growing awareness of the need for a greater ecological conscience, financial pressures are still very powerful and, in the emergent, or developing nations, where there are unsolved needs of rapidly growing human populations, wise long-term planning may be pushed aside by short-term expediency.

It is to be hoped that the growing appreciation of the need for wildlife—not just for its aesthetic merits, but also as evidence of a healthy world—will make our successors more careful and more clever in the ways in which they handle our natural resources than we have been so far. This does not mean that there will be no further changes. Even if we are able to avoid further serious alterations to the world, natural selection will still remain a powerful active force.

History of birdwatching

As long as humankind has existed, people have watched birds. Birds have had their place in countless human cultures around the globe, worshipped one moment and hunted the next, everywhere from Aboriginal Australia to ancient Egypt. The study of birds is not new. There are descriptions of bird behavior in the Bible, and even back in the fourth century BCE, Aristotle realized that something was amiss in the behavior of the Common Cuckoo.

Birdwatching as a hobby, however, is a much more recent development, dating back to the end of the nineteenth century and the beginning of the twentieth, at a time when most people interested in natural history were shooting, and whose primary concern was for either collecting specimens for its own sake, or for scientific purposes. A less destructive approach to birds was signaled with the formation of the National Audubon Society in the U.S.A. in 1886, and the Society for the Protection of Birds in the UK (later RSPB) in 1889, both of which came out of campaigns to restrict the use of feathers in women's fashion, and were largely driven by women. The term "birdwatching" was coined in Britain by Edmund Selous in his eponymous book of 1901, while Elliott Coues produced his Key to North American Birds further back, in 1872. The first U.S. Christmas Bird Count took place in 1900, led by the early wildlife campaigner Frank Chapman.

However, the hobby would never have taken off without three major developments. The first of these was the production of suitable optics. The binoculars we know today originated from an optical system of prisms invented by Ignatio Porro in 1854 and perfected by the firm Carl Zeiss in 1894. As time went on, binoculars improved, became widely available and eventually cheaper, ready for the real take-off in birdwatching after the Second World War.

The second big development came with field guides. Many books had been published with illustrations of birds, but the real breakthrough came with Roger Tory Peterson's (see page 327) A Field Guide to the Birds in 1934. This was the original "field guide," with similar North American species pictured close together with arrows indicating their salient features. The Book of Indian Birds, published in 1941 by

Salim Ali, had a similar effect on birdwatching there, while Roger Tory Peterson produced *A Field Guide to the Birds of Britain and Europe*, together with Guy Mountfort and Philip Hollom in 1954. Many field guides followed, and these days there is a field guide to the birds of almost every country in the world.

The third development was leisure time, which grew along with economic prosperity, mainly in the western world at first. In Britain in the eighteenth century, people would routinely work thirteen-and-a-half-hour shifts in factories; some of these were young children. There was no time for leisure, except for the highest echelons of society, and it was primarily the wealthy who had much time to look at birds. After the two World Wars there was a cultural shift in the West towards mass participation in hobbies of all kinds, of which one was birdwatching.

Towards the end of the twentieth century birdwatching boomed. It did so principally in its heartlands of the U.S.A. and UK, but other countries quickly followed, including the Netherlands and Nordic countries. With the advent of international travel, birdwatching tourism began, and even specialized birdwatching vacations (the first tour company was Ornitholidays, a British company founded in 1965). A few people began to go all over the world, seeing hitherto unimaginable numbers of species.

Right up until the end of the twentieth century, a significant proportion of birdwatchers were men. In the last 20 years, however, their dominance has been swept aside and birdwatching has become a mass participation hobby for everybody. It is currently sweeping the globe, too, taking in both Japan and China, for instance, and in emergent countries a growing number of local guides are beginning to make a good living from birding tourism. Such people are also enjoying birding for its own sake, of course.

We can only expect to see birdwatching growing in the years to come. This is to be welcomed in every way, especially when it is aligned with a care for the environment and interest in nature. The latter is essential to guide us through the dangers the planet faces. If our climate emergency cannot be contained, there won't be many birds left to watch.

Opposite An ornithologist wanders in the woods in 1908

liarly ornamented with feathers of different texture or structure from those of the general plumage; but an instance of this is seen in our Lewis' wood-pecker. The noteeum, on the contrary, is often the seat of extraordinary development of feathers, either in size, shape or texture; as the singularly elegant plumes of the herons. Individual feathers of the notasum are generally pennaceous (§ 4), in greatest part straight and lanceolate; and

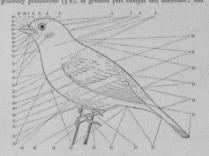

as a whole they lie smoothly individuals (like shingles on a roof). The gastraed feathers are more largely planulaceous (§ 4), less flat and imbricated, but even more compact, that is, thicker, than those of the upper parts; especially among water birds, where they are all more or less carly, and very thickset. There are subdivisions of the § 38. Nor.xun. Beginning where the neck ends, and ending where the tail coverts begin, this part of the bird is divided into back (Lat. doesnn; fig. 4, 1) and rump (L. nroppypium fig. 4, 1). These are direct continuations of each other, and their limits are not precisely defined. The feathers of both are on the pterpla doesnits (§ 8, b). In general, we may say that the anterior two-divides of these-quarters of motern is back, and the rest rump. With the former are generally included the scapular feathers, or scapulars; these are they that grow on the pterplae humeroles (§ 8, b): the region of

PARINE, TRUE TITMICE. - GEN. 12.

obvious seasonal or sexual changes of plumage. All but one of our species are plainly clad; still they have a pleasing look, with their trim form and the tasteful colors of the head.

Subfamily PARINÆ. True Titmiee.

Exclusive of certain abernat forms, usually allowed to constitute a separate subfamily, and sometimes altogether removed from Provide, the Titinice compose a natural and protty well defined group, to which the foregoing diagnosis and remarks are particularly applicable. There may be about seventy-flwe good species of the Provine, than restricted, most of them falling in the genus Privac, or in its immediate neighborhood. With few exceptions they are birds of the northern benisphere, abounding in Europe, Asia and North America. The larger proportion of the genera and species inhabit the Old World; all those of the New World occur within, our limits, except two—Pachipearus audanostis and Paras accordiously, which are Mexicam, though they have been lately included in our systematic works. The former is a very distinct and beautiful species; the latter is perinps only a southern variety of the common Chickadee.

12. Genus LOPHOPHANES Kaup.

* **Conspicuously crested. Leaden-gray, often with a faint olivaceous shade, paler or whitish below; wings and tail unmarked. (All the figures are of natural size.)

Teffel Titmonee. Forehead alone black; nearly white below; sides washed with rusty-brown; feet leaden-blue. Young birds have the crest plain, thus resembling the next species; but they are nearly white below, the sides showing rusty traces. Largest of our species of the family, 4.6-4; wing 3-3; tail about the same. Eastern United States, north to Long Island; "Nora Scotia" (Actol.), Winx., 1, 137, pl. 15, 15, 15, 17, 11, 143, pl. 125; Bb., 384. meroton. Plain Titmonee. Plain leaden gray with faint olive shade, merely paler below; no markings anywhere. 5j-6; wing and tail about 2½. New Mexico, Arizona and California. Cass., Ill., p. 19; Bb., 385; ELLIOT, pl. 3; COOC., 42, ..., NORINATUS.

Cass., Ill., p. 19; Bu, 386; Ellior, pl. 3; Coor., 42. . . INGENATUS.

Bluck-crested Tituonse. Size of the last, or rather less; similar to the

first in color, but forehead whitish, and whole crest black. Valley of the Rio Grande. Cass., p. 13, pl. 3; Bp., 385; Coop., 43. ATRICKISTATUS.

Bridled Titmouse. Olivaceous-ash; below soiled whitish; chin and

Opposite Ornithologist Elliott Coues, author of Key to North American Birds Above Pages 16 and 80 from Elliott Coues's Key to North American Birds from 1872

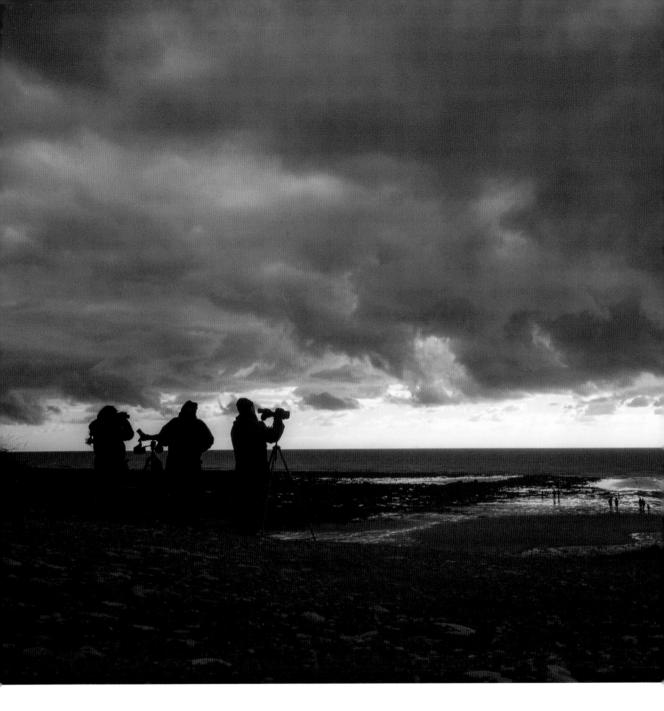

INTRODUCTION TO BIRDWATCHING

If you're thinking of taking up birdwatching, congratulations. Not only will the hobby bring you fun and delight, you are joining an increasing movement around the world who have seen the benefits of looking at birds for their physical and mental health. Once the preserve of a relatively small section of society, birdwatching is now a pastime for everybody, regardless of background, gender, and temperament. Already one of the most popular outdoor pursuits in Britain and the U.S.A., its glory days are still ahead.

There are many reasons why you should take up birdwatching but here, to begin with, is one. Few other hobbies fit so seamlessly into everyday life. You can watch birds when you are gardening, or cooking, or when you are washing dishes; you can watch birds while walking or hiking, or playing golf, or cycling. Birds are there on your commuting trips to and from work; and when you are bored in an office meeting, there are birds outside the window! If you cannot see them, you can often hear them; people have been known to listen and enjoy the bird chorus from a hospital bed.

The ubiquity of birds makes watching them easy, and there are few pastimes that are easier to take up. At the same time, beginning birdwatching is the tip of a wonderful iceberg, with endless possibilities for expanding into something that can become increasing important in your life.

First steps: backyard identification

In theory, you can watch birds without spending any money at all. However, sooner or later you will need a pair of binoculars to help you see birds enough to put a name to them. To do the latter, you will also need an identification guide, which could be a book—normally called a field guide—or an app (see pages 259 and 389). Both have their merits. For the beginner, a book is probably better and a little more satisfying for browsing through all the possible bird species in your area. The section on Equipment (see page 256) will help with choosing the right binoculars and identification aids.

Most people begin in their backyards, and they soon run into a near-universal problem. Some birds are very easy to identify, such as Northern Cardinal and Blue Jay, but others are much more difficult. Species are also very variable, which means that males and females may look quite different, as is the case with House Sparrows. On the other hand, some species of birds look very similar to each other—a good example is Hairy and Downy Woodpecker, or House and Purple Finch. Your first foray into bird identification should make you realize that this hobby isn't always easy. It takes time and effort to improve, and you shouldn't be discouraged if you are finding it difficult.

There are ways to overcome these awkward first steps. One is to find an experienced birdwatcher to help, especially if you are getting frustrated. Another is to visit a different place for birdwatching, such as a pond with ducks, or a nearby wood. Eventually, however, if you keep practicing and putting in time, you will crack it organically.

However, there is a short cut to proficiency, and that is learning how to look at a bird thoroughly, from top to toe. For anybody who might not have a photographic memory, this takes practice and patience, but it is invaluable. It simply means looking at every part of a bird—the head, the body, the wings and tail—trying to remember the colors, patterns, and shapes during the time you are observing it. The more you note down—in your mind, notebook, or phone—the more likely you are to identify it correctly.

Take two examples of how useful this can be. What is the color of a Northern Cardinal's bill? It is, of course, red. But in summer you might see Cardinals with black bills, which are juveniles, and if you see Cardinal with a yellow bill or a pale bill—you have a Pyrrhuloxia! So it's important to take in the whole bird. And how many black bands has a Killdeer got across its breast? It always has two full bands, which distinguishes it from Snowy, Piping, Wilson's, and Semipalmated Plovers. If you practice looking thoroughly at birds, you will notice these small details, many of which are very important. As we will see later, looking at a bird's shape, especially of the bill, is often a great clue.

If you wish to improve your observation, there is no short cut to the task of learning the parts of a bird, each of which have technical, but not complicated names. The reality is that, among birdwatchers, thorough observation is counter-intuitive, and few people are good at it. Most just improve their birdwatching organically.

There is one more first step that will greatly improve your birding skills, and that is to keep looking at familiar birds and learn them thoroughly. If you manage to do this—and then again, it is counter to human nature, as most people quickly get excited and want to see as many birds as quickly as they can—you will eventually become a much better birdwatcher. If you are truly familiar with common and backyard birds, you will be much better able to spot something different and unusual.

Opposite Birdwatchers at Flamborough Head in the UK

Immersion

Tone of the first steps mentioned in the section above is compulsory. Many people enjoy their birds at a certain level and are happy not to strive to become any more proficient at identifying them, while others just seem to have an aptitude for birding and quickly become excellent without seeming to try too hard. It doesn't matter which path you have followed, you will soon enter the next phase of your birdwatching life, which could perhaps be described as immersion. If you spend enough time in places where there are birds, you will eventually begin to understand them.

Birds are wild animals that have evolved to treat humans with extreme suspicion. Some are tamer than others, of course, and you will see birds on any walk you do, but our birdwatching will be richer if the objects of our interest are unaware that we are there. We need to make ourselves inconspicuous, by being quiet, slow in our movements and relatively concealed.

Being quiet helps in two ways: we can approach a bird more closely than if we are noisy, and we also clear the airwaves so that we can hear what sounds it might be making (there is more about bird songs and calls on page 251). Obviously, the closer a bird is, the better a view we get, and an undisturbed bird is more likely to come into the open. Another advantage of being quiet is that it helps us to become immersed in a place, and to become accustomed to nature's pace. Of course, sociable birdwatching is fine, too, but a bubble of conversation is better than a rabble.

Being still also works in two ways. Most birds have panoramic vision and, more than anything, are adapted to flee when they perceive sudden movements. This means that certain human tics, such as pointing toward a bird, lifting binoculars up too quickly or coughing, need to be avoided where possible. It is also a good tip to move slowly when birdwatching, and not to try to cover too much ground. Once you arrive at a spot, stay there and give the birds a chance to move around and show themselves, especially in the summer when they are breeding. Also, if you find yourself among birds, stay with them. It is often tempting, if you are hiking a trail, to want to see what is around the next corner; but the answer might be nothing. If you are seeing things, get the best out of where you are before moving on. In many parts of the world, birds move around in flocks (in temperate regions this is typical of winter woodlands and anywhere in the fall), and away from these hubs of activity it can seem to be dead.

As a large mammal it is difficult to be completely concealed from a small, highly alert animal with enhanced senses, but it does pay off to make yourself inconspicuous. If a bird is close, just staying still can help. Birds have color vision that is several times more sensitive than ours, so wearing neutral clothes is a good idea, too. Another good tip is to stand in the shade on a sunny day. Try not to walk along so that your profile is obvious; don't walk on top of a bank, but below it. Crouching, rather than standing up, can also help.

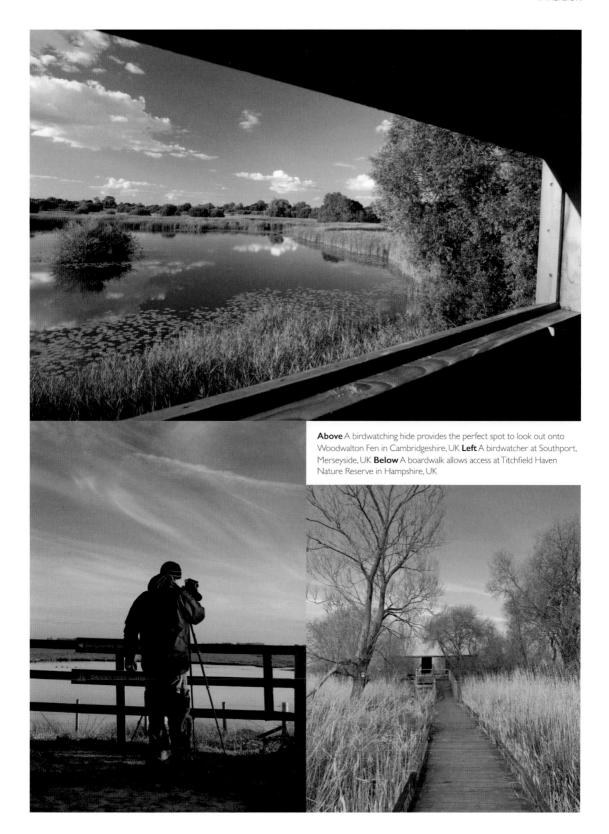

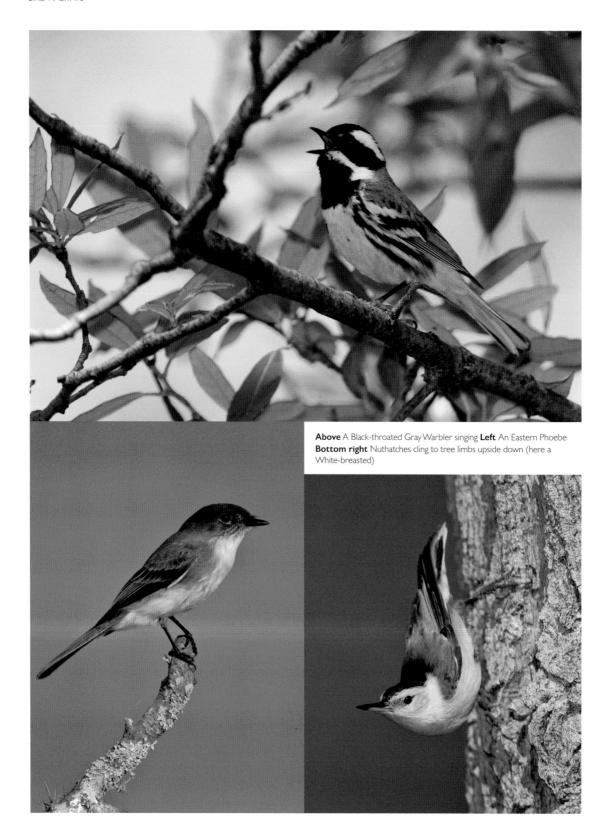

Bird habitats

A beginner will quickly discover for themselves that different species live in different types of areas—that is, different habitats. Some of this is obvious even to those who aren't particularly interested in birds, who know that ducks like water and House Sparrows like buildings. Almost every species has a preferred habitat. Some are very specific, such as Marsh Wrens, which are found in banks of reeds and cattails with standing water, and nowhere else. Others cover a broad range, such as the ubiquitous American Crow or, worse, the destructive Brown-headed Cowbird.

Getting to know birds in their respective habitats is a large part of birding. It makes it easier to identify birds because it cuts down the range of possible species. For example, imagine you have spotted a nuthatch in a forest; if it is in a pure deciduous stand, or one that has a few conifers, it will almost certainly be a White-breasted Nuthatch. In a northern Boreal or mainly coniferous forest, it will probably be a Red-breasted Nuthatch. In a south-eastern pine forest, it will be a Brown-headed Nuthatch.

The more time you spend outside, birdwatching, the more habitat aware you become. This also means that you can start to predict what you might see before you see it. With experience you can begin to appreciate great subtleties. It becomes possible to

predict which birds will be in a particular part of an estuary, or which birds are associated with certain types of trees or types of growth. You will, for example, begin to expect an Eastern Phoebe beside a bridge, a Black-throated Blue Warbler in the shady forest understorey and a Black-throated Gray Warbler in dry oak/juniper forest.

Certain habitats are particularly good for birds, and every birdwatcher should allow themselves the opportunity of visiting them as often as possible. The coast is often richer than inland. If you live inland, however, look for any kind of water, be it a river, a lake, or a pond; better still, a freshwater marsh. Woodland is often hard work, good though it can be; oddly enough, the edge of a wood is usually better than the middle, both for bird species and activity, and the edge of a field is also better than the center. Not surprisingly, this is known as the "edge effect." Another prime habitat is known as scrub, or shrubbery. Along the coast, lagoons, and estuaries are usually hotspots, and in the summer rocky coasts are good for breeding seabirds.

There is great joy in appreciating birds in their wild habitats. Not only can you find out where to find birds, but you will learn a great deal about the great outdoors as well, and all the subtleties of landscape.

Times, weather, and seasons

Birdwatching is a hobby; you don't have to get up early to enjoy it—but it helps. All birds have daily rhythms, and the vast majority are most active in the early morning, just after dawn. The early rising birdwatcher invariably sees more species, hears more species, and sees more individual birds, doing more varied activities. Part of the reason for this is that there is less disturbance from humans, but the main reason is that birds wake up hungry with the dawn.

On an average day there will still be some appreciable activity roughly into mid-morning, and then a slump. The late afternoon heralds another peak in feeding and moving about, which carries on until dusk. Then nocturnal birds take over, but even their daily rhythm peaks in twilight at both ends of the night.

There are some exceptions. In the middle of the breeding season, birds will simply keep going all day. The same happens in deep winter, when the days are so short that no bird can afford to let up, not even for a few minutes. Another major exception takes place at the coast, when it is the state of the tide that determines what birds do. On an estuary in winter birds often roost at high tide, but the hour before and after may show spectacular flurries of activity. At low tide the birds might be too far away to see.

Weather affects everything a bird does, and what a birdwatcher does, too. You might think that rain is the biggest problem, but that isn't so—wind is the real disappointment. Not only does wind buffet birds around and cause them to skulk in bushes, but it also makes them much more difficult to see and, above all, hear. In windy conditions, seek a shelterbelt behind a building or some shrubbery—or just stay at home. Rain can promote bird activity, although it isn't always fun getting wet. In warm weather, the periods of morning activity are shorter and end earlier. Severe weather—storms, heavy frost and snow, gales at sea—can disrupt birds and herald unusual sightings.

One of the many joys of living in temperate parts of the world lies in the changing seasons, which

provides a broad and colorful canvas for the brush strokes of bird movements. Seasons provide moments—the first Warbler of spring, for example—which define them and lift the spirits. Every season, even the darkest winter days enlivened by chickadees and colorful ducks on the ponds, by grackle roosts and replete estuaries and freshwater lakes, has its signature birdwatching delights. After all, what is the best season for birds swarming into the backyard? It is usually the middle of winter, especially after snow and frost.

Many people have no idea of this, but the season of song starts in mid-winter, after the shortest day. Despite the lack of food, birds set up territories and sing lustily right from January onward, unless the weather is particularly fierce. They will tussle for food at a feeder one moment and proclaim territory the next. The late winter and early spring resound to bird song, which often reduces by May, and the land falls almost silent in June. April, and May are the main months of spring migration, when you can go out almost anywhere and see almost anything, especially by the coast, and every species in its breeding finery. For most birds, nesting is done as quickly as possible. Even by late June some birds have finished and are already preparing to leave for their winter quarters, amazing though it may seem.

June and July explode with young birds doing their thing, usually very badly, but they learn fast, and have to. July and August are molting time, and the latter month heralds the general southward migration, which is much more leisurely than it is in spring.

The delightful things about being a birdwatcher is that you always feel part of the changing seasons. Birds ebb and flow through the year, with different names making appearances like actors in a year-long stage play, and all with their own dramas, too. You can witness this. Over the years you begin to predict what is going to happen, and relish it all the more.

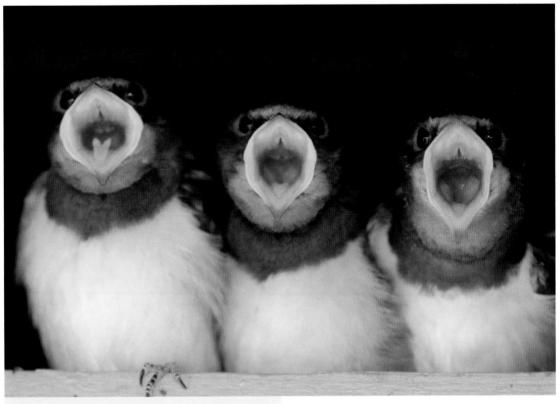

Above Young swallows wait for food **Below** Birdwatching can mean an early start **Next page** But the sunrises can be worth it

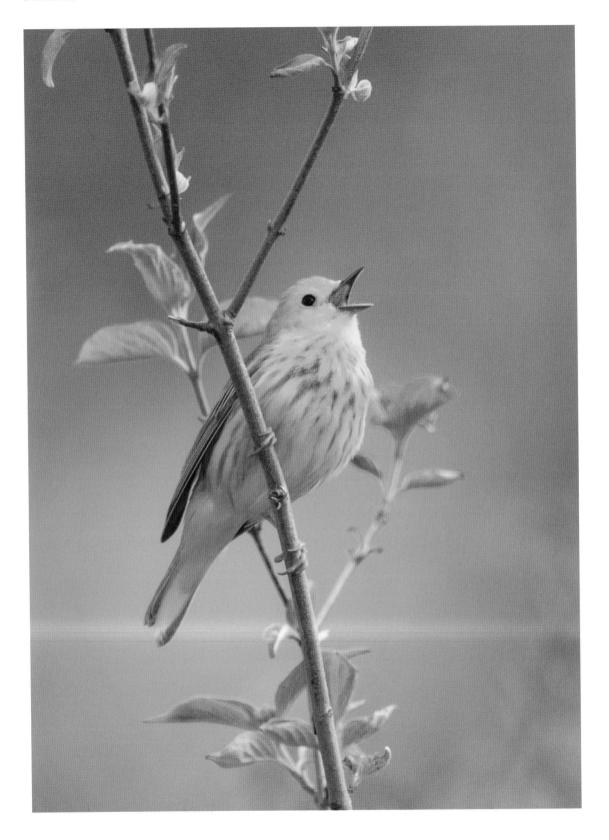

Bird sounds

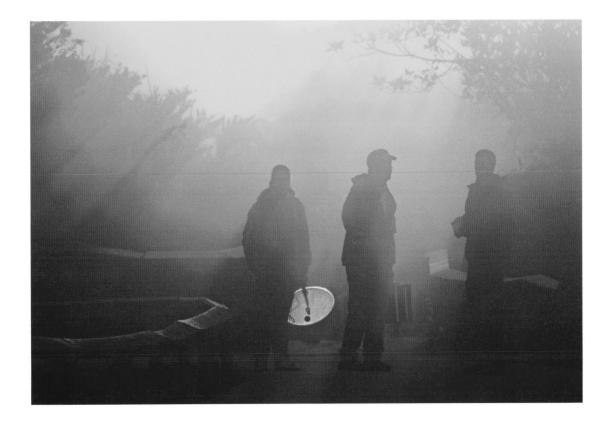

There is no getting away from it; the best birdwatchers are good at recognizing birds from their sounds. Learning bird song, though, is arguably the most difficult aspect of birdwatching.

In some ways, it shouldn't be. After all, people can recognize hundreds, or even thousands, of different human voices without thinking about it. It is certain that all of us have the capability. People might say they cannot cope with bird sounds, but that could simply be a lack of confidence or commitment. After all, most people can recognize a Mourning Dove, an American Crow, and so on.

Learning the bird songs and calls in your neighborhood is as much a task as learning a foreign language. But, as with the language, you can at least pick up words and phrases, and know more each day. It's the same with bird sounds. It is also important to recognize the difference between a song and a call. A song is the territorial voice of a breeding male bird, and is often quite complex, at least a "sentence" or

"phrase." On the other hand, calls are the everyday vocabulary of birds, keeping in contact or being alarmed. Most calls are just one or two syllables, "words," if you like.

The backyard is possibly the best place of all to pick up bird sounds. After all, your backyard will only draw a small range of species in, and being resident there, you will hear many of them again and again. One good tip is to listen to an unknown sound and then do your very best to see the songster and identify it; this will give you a visual and aural image at the same time.

Many apps (see pages 259 and 389) will include bird sounds to help you learn. There are also a few books specifically on bird sounds on the market.

Opposite A Yellow Warbler singing from its perch on the branch of a tree **Above** Birdwatchers recording bird song at dawn in the Florida Everglades, Florida

Types of birdwatchers

Birdwatching is such a flexible hobby that you can follow it where your enthusiasm takes you, and no further. You can spend no money at all and watch the birds in your backyard, or you can spend all your savings on optics and on foreign trips in pursuit of exotic gems. These differences have spawned a fascinating culture among birdwatchers, with different strands of interest and commitment. It is best not to take these too seriously, and you can be a member of more than one tribe.

You will soon find out there is a distinction between birdwatchers and birders. On the whole, birdwatchers are the sort of people who love birds and enjoy watching them, invariably in their backyard, but also go elsewhere. They will take regular trips to bird reserves; they might even go abroad and watch birds as part of their vacation. The crucial distinction for such people is that this is their leisure; they like being able to identify birds correctly, but this is not their primary focus. They might engage somebody to take them

birdwatching and teach them, but they won't normally spend time alone trying to improve their field skills.

Birders (who are called Birdos in Australia and elsewhere) are slightly different. They love birds and birding is leisure, but they care more about the identity of the birds they see or hear and take serious steps towards making a correct identification. They care more if they get something wrong. Visiting good places for birds is an important part of their life. If they go abroad or on vacation, they will consider what birds they might see *before* they go. They might well have a list of target species, even if only in their minds, and the quality and number of targets they hit will impact on how much they have enjoyed themselves.

As any birdwatcher's experience increases, there are different strands to follow. Many will follow the photography route, or an artistic one. It was once difficult to take a good photograph of a bird, but with the advent of superb, relatively cheap digital cameras, and digiscoping (see page 259) almost anyone can

produce stunning images. For many people, a birdwatching trip is only as good as the images from it. Many photographers wow their followers in blogs and online accounts. At the same time, many creative people become artists or sketch-makers, again with online followers marveling at their skills.

Birdwatching can also lead its followers down the conservation path—hopefully every birder will become more aware of environmental concerns as their commitment deepens, and many people already with deep feelings toward the natural world will gravitate toward watching birds. Hopefully, all birdwatchers of whatever genre will contribute their money toward conservation. For many, however, their main focus will be on the plight of birds and how they may be preserved. Such people will often volunteer to help their local nature reserve in practical tasks, or for fundraising.

When a birdwatcher leans toward being a birder, they will often specialize, and one of the best-defined tribes is known as a "patch-watcher." This is invariably a keen birder who focuses their time on watching and recording the comings and goings of birds (and often other wildlife) at a single location. Such a person may visit their "patch" as regularly as every week (or even more) and gets much delight in seeing how the seasons advance and how a place differs year on year. Such people often visit at all times of day, and often cherish their "patch-list" of what they have seen. Of course, such people will enjoy regular days away, and vacations, but the patch will be their focus.

With increased experience, birdwatchers or birders will sometimes gravitate toward such specialized activities as "seawatching" (watching birds moving over the sea), or "skywatching" (watching birds flying over) or, self-explanatorily "hawk-watching." Others might seek mainly to improve their bird song recognition.

Every hobby attracts those who go head-over-heels in commitment, even nudging into the subset of eccentricity. It is a matter of regret that birdwatching as a pastime has been indelibly linked in the past with some of these characters, as if there were no other kind. For many years, a small minority of birders, known as "twitchers," or sometimes just "listers," attracted attention and even notoriety for their antics.

especially in the press, who love extremes. Twitchers are people to whom the list of birds they have seen, and especially the number they have seen, is everything. Once they have ticked off the birds in their local area, they must then travel to see the rest. When something rare turns up, they arrive to tick it off, sometimes en masse. Occasionally they are so desperate to tick off a species that they trespass, or behave in other antisocial ways, thus cultivating negative headlines.

There is, of course, nothing wrong with twitching or listing, save producing an enhanced carbon footprint. But most birdwatchers don't feel at home at this end of the spectrum.

And while birdwatching does indeed cater for a wide variation in commitment, one observation almost always holds true. It seems, simply, that people who steep themselves in nature and birds are, by and large, friendly souls. The degree of mutual encouragement is remarkable, truly. Rivalries occur, but these are swamped by a general empathy among like-minded birdy people.

To that end, everyone starting birdwatching will soon find their own community to join. Local groups of birdwatchers are everywhere, both in the flesh and on the internet, and shouldn't take long to find. Whichever tribe you might be drawn to, you won't be alone.

Opposite A birdwatching hide can be a very rewarding place to spot birds Next page Binoculars are an essential tool for most birdwatching pursuits

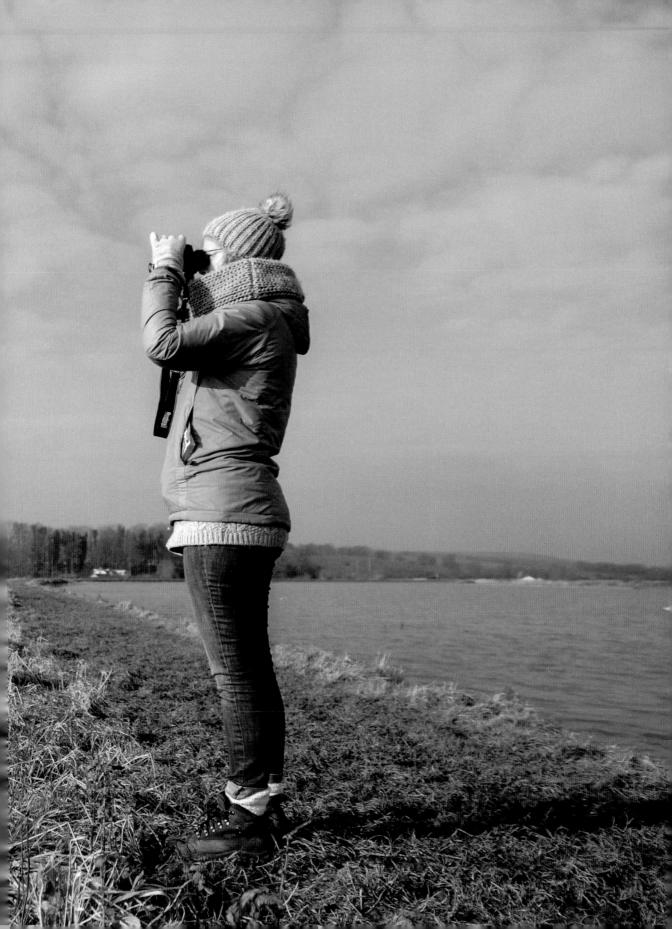

Birdwatching equipment and outfitting

As mentioned earlier, it is possible to enjoy birdwatching without buying anything at all, just using your eyes and ears, especially in the backyard. People with impaired vision or hearing are not excluded from the hobby; indeed, individuals with vision impairment regularly demonstrate exceptional skills in bird sound recognition. On the other hand, there exists a broad range of equipment to enhance your enjoyment. This section will look at these.

There are only two pieces of equipment that most birdwatchers would consider essential: a pair of binoculars and a field guide.

Binoculars

Binoculars are optical aids that magnify an image. Birds are relatively small and highly mobile, so rather than you trying to approach a bird, your binoculars will give the impression of bringing them closer. Strictly speaking, you could use a monocular instead. However, by virtue of being heavier, binoculars are steadier and focusing feels more natural.

By virtue of being sophisticated optical devices, binoculars are by far the most expensive required outlay for a beginner birdwatcher. Some people try to avoid this by using a hand-me-down from a relative, but binoculars have improved so much in recent years, particularly in the bright images they display, that it is well worth getting a modern pair. Buying new, you should expect to spend several hundred dollars at least, but good binoculars will last some years.

The range of binoculars available can be intimidating to the beginner, but you can save yourself a great deal of hassle by taking some simple steps. Be hands-on, literally. If possible, find your way to a shop at a nature reserve that sells optics, or go to a specialist shop where you can try out a variety of models. There is a lot more to consider than just technical specifications. Everybody is different, which might mean that a top-of-the-range pair is useless for somebody because it is too heavy, for example, and the user feels uncomfortable, so they give up the hobby. Binoculars must never be too cumbersome, and they need to feel right. Small details such as grip in the hands and ease of focusing are important. You wear binoculars, so you need to make sure they fit you

as a person, taking as much trouble over them as you would with clothes.

If you wear glasses it is particularly important that you try out binoculars. A binocular has a specification known as "eye-relief," the distance between eye and eyepiece. It should be at least 15–18mm. If it's less than 10–12mm, the pair won't be suitable.

The moral of the story is that it is best to avoid, if possible, cutting corners and budgets by going online without checking first. The best stockists will encourage you to try different models, because it helps nobody if you buy the wrong pair. As in all forms of transaction, if something is suspiciously cheap, it will probably be a waste of money.

There are some basic binocular specifications that you do need to consider, though. Binoculars are defined by two numbers separated by a times ("x"), such as 8 x 30. The first figure, the 8 in this case, is the magnification. People are often seduced by high magnification, based on the assumption that the higher magnification, the better the view of the bird. However, too high a magnification leads to two problems: firstly, it is difficult to hold the binoculars still enough to enjoy it. And secondly, high magnification reduces the field of view, which means that you might have difficulty picking up the bird you are trying to see. Make sure that your binoculars have a magnification between 7 and 10. The general consensus among birders is that 8 is about ideal. If you are expecting to spend a lot of time in the open, when birds are often far away, 10 might be better.

The second figure is the diameter in millimeters of the objective lens (the larger lens furthest from the eyes). This is a guide to the field of view—the "breadth" of what you can see—and also impacts the brightness of the image, since the wider the objective lens, the more light gets in. In an ideal world, the larger the objective the better, but once again the sheer weight of the column comes in. You won't find many binoculars with an objective of more than 50mm, and most are 30 or 40. Optics are so good these days that it doesn't matter.

Opposite Birdwatching in the colder months is often excellent

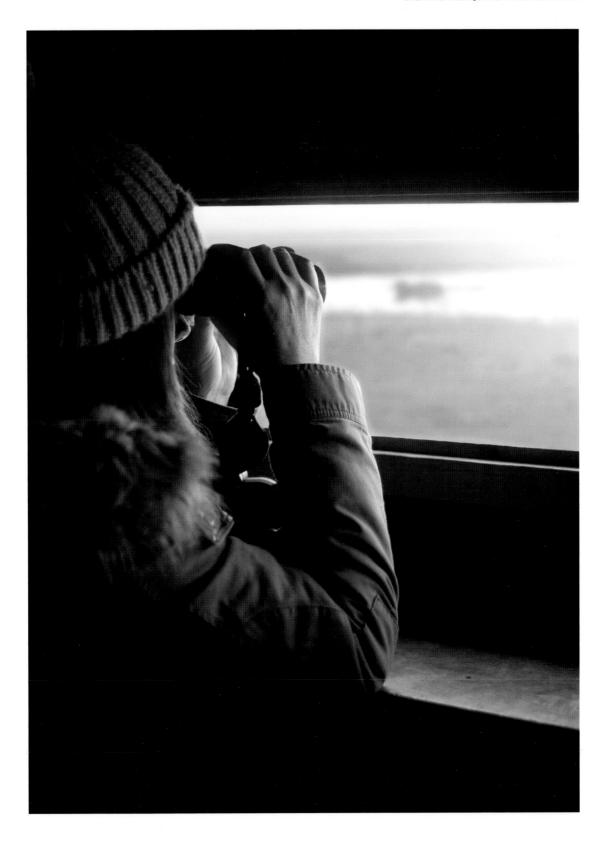

Two extra types of binoculars are worth considering. Small binoculars (compacts) are very popular if being lightweight is really important, for example, for children. These will often have objective lenses of only 20mm, and they do suffer in terms of image brightness, particularly in dark or overcast conditions. However, many people love the fact that you can put them in your pocket or handbag and keep them with you at all times, and in most conditions they are adequate for the task. They are a good option. Another interesting option is Image Stabilizers. These include technology to compensate for movement, including handshake, and can therefore allow for higher magnification. They are invaluable for use on boats and other moving vehicles, and some people swear by them. They have two disadvantages, though; they tend to be heavier than normal binoculars and are expensive.

Once you have your pair, make sure you adjust them to your eyes, because most people's left and right eyes focus slightly differently. Firstly, adjust the distance between the two binocular barrels to suit the distance between your eyes; this is surprisingly important and often forgotten. You should see one image. Now you need to fine tune to adjust the focus for each eye. First, locate an object, shut your right eye and use the focusing wheel until the image is sharp for the left eye. Then, shut your left eye and adjust the dioptre (a wheel at the base of the right eyepiece) until the image for your right eye is sharp. Then open both eyes to check you have a bright and clear image.

Using binoculars well takes time, but here is a good tip to help you practice. If you are looking at a bird with your naked eye and wish to align your binoculars on it, make sure that you keep your eye on the bird as you bring the binoculars up—don't look down. Practice on moving objects other than birds.

One more tip will be of incalculable use. Clean your binoculars as often as you can, preferably before each field trip. Use a lens cloth, and a soft brush if necessary. If your binoculars are smeared, that's several hundred dollars of good optics not being used!

Telescopes

In today's birdwatching world, many people routinely carry both binoculars and a telescope, sometimes known as a spotting scope (and a camera, too!). The obvious issue with a telescope is that it can be heavy and cumbersome, especially since it invariably requires

a tripod. It is possible to buy straps that lighten the load, but for a long walk a telescope isn't always practical. Not many people have a use for a telescope in their backyards.

Spotting scopes are, however, marvelous. They come into their own especially when you have a vista in front of you with birds near and far, or you are watching over the sea. Invariably you can identify more birds with them, at much greater distance, and you don't get tired holding them up, as you would with binoculars. They are also a godsend for a birdwatching tutor who can simply allow somebody to look through the scope without recourse to explaining where the bird is! You can get telescopes of fixed magnification and zoom, the latter usually preferable if you enjoy identifying truly distant birds.

As is the case with binoculars, shop smart and don't be beguiled by magnification; you're looking for birds, not stars and planets. A good scope will start at about x20 and may zoom to about x60. Make sure you get an appropriate tripod that will stand up to a moderate wind. A good telescope on a wobbly tripod becomes a bad telescope.

Cameras and lenses are beyond the scope of this book, except to say that photographing birds takes skill and good equipment, invariably a telephoto or zoom lens. These days, many birdwatchers use an attachment for their smartphones that allows them to take pictures through a telescope, often with remarkable results—this practice is known as "digiscoping." There are many tutorials online.

Field guides

A field guide is an aid to bird identification using paintings or photographs of the species found in a region, state, or country. The depictions show a bird species in its varying plumages, including male, female, young, breeding plumage, and non-breeding (winter) plumage, whatever is appropriate. Most field guides include extra details on the sound a bird makes, tips for identification, habitats, and migratory movements. Some interpose similar species for comparison.

The field guide has been a basic tool for birdwatchers for a hundred years, and in that time innumerable guides have been published, especially for Britain, Europe, and North America. Up until recently, these have all been books, but these days you can buy apps, too. Apps have the advantage of including bird sounds, being relatively inexpensive and light. Books

have the advantage of being much more beautiful, are better for flicking through to get a feel of what birds are in your area, and also for comparisons of the possibilities within large families, such as warblers or ducks.

In North America, at least, by far the most popular of the apps is the Merlin app, a marvelous free app from Cornell University. This has direct connections to eBird. It will even identify your photos, or at least narrow them down (see Further Reading and Resources, page 389).

There wouldn't be many different guides if they didn't each have something to offer, and choice is personal. You should be able to avoid the bad ones by reading online reviews. You can also browse books at stores and decide what you like. If you are only interested in your backyard birds, you can buy guides limited to these.

Notebook

Most birdwatchers enjoy recording what they see. Once upon a time, everybody used notebooks and wrote things down. Some would include sketches and even paintings in their notebooks, and most would record numbers of each species seen and other pertinent facts. These notebooks could be things of great beauty, much treasured as souvenirs of happy birdwatching days.

A lot of birdwatchers still use paper and pen and swear by it. The best notebooks are hardback, preferably with a waterproof cover, and small enough to fit in a pocket. However, technology has changed everything. Now you can record your sightings by smartphone, while you are out and about, adding them to a personal and public database. At present, British birdwatchers usually put their sightings on the BirdTrack app, and these are available automatically for anyone who logs on to the website, so everyone can know what is about and track, for example, migratory arrivals. Most of the rest of the world uses eBird, developed in the USA. It uses a similar principle but has many more features, including access to songs and calls.

Clothing and footwear

Few human trappings are quite so personal as clothing, so it's always dangerous to make recommendations. You can wear a tuxedo if you wish (it's been known), a ballgown, or the full goth. Nobody minds, least of all

the birds. However, if you are leaving the backyard and venturing outside, there are a couple of practical needs to bear in mind.

As mentioned above, birds have enhanced vision and see more colors brighter than we do. Therefore, if you wear garish colors you will give yourself away. Plain dark colors, such as brown or green, will give you a slight advantage. Some people wear camouflage, especially photographers who depend on getting close to their subjects. Some clothing is noisy and, if possible, you should cut this down—waterproof pants are often the culprits. Whatever clothing you adopt, it's your hobby, and it is important that you feel right, when you're birdwatching, otherwise you won't go.

Comfort, we can all agree, is important, and to that end the usual rules apply. Birdwatching often demands that you stay still, sometimes for a long period, in the outdoors, so take steps to ensure that you remain warm. When you set off on a walk, a very good rule is to wear one more layer than you think you will need, and then fit anything extra into their backpack. A huge range of waterproof jackets are available from outdoor shops and specialist retailers. A good smattering of pockets is ideal for notebooks, lens caps, snacks, and the like. You might also consider having padded shoulders to ease the weight of your binoculars.

Birdwatching is a year-round activity, so you will often need a warm hat and gloves in winter and a sunhat (and sunblock) in the summer. Birdwatchers are a very accepting group of people and realize that your birdwatching attire is not an accurate reflection of your fashion sense.

Footwear is less accommodating to variety. Most people wear walking boots, the same you'd use for hiking, but sneakers are usually fine. High heels can be a challenge.

Opposite Some of the equipment you may require to take up birdwatching Next page Birdwatching is a richly rewarding hobby and can be sociable, too

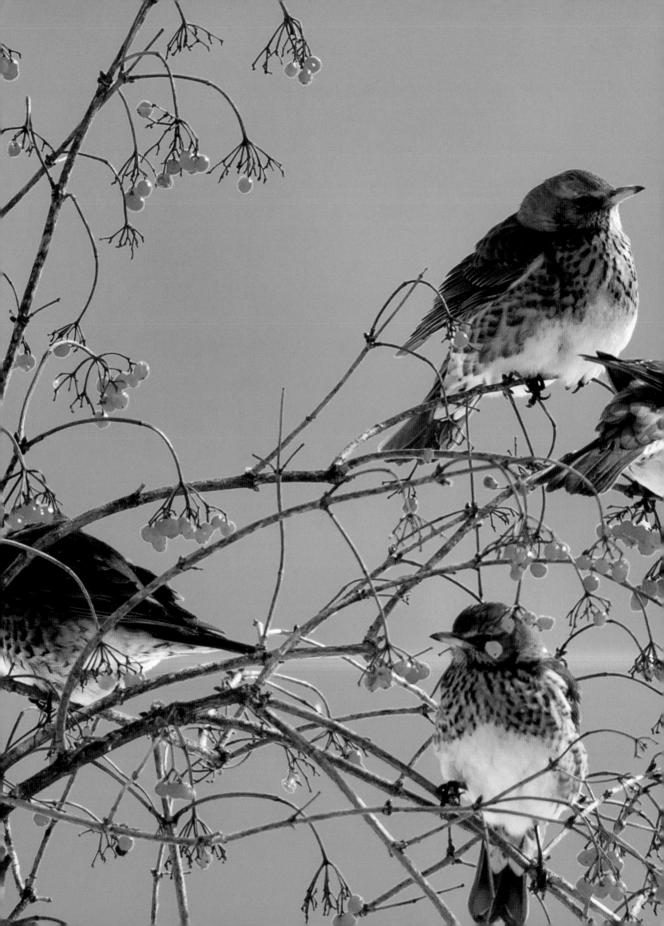

CHAPTER THREE

ATTRACTING BIRDS

THE BIRD-FRIENDLY BACKYARD

Birds are a joy to watch, uplifting to listen to, and vital to the biodiversity of the world. Creating a bird-friendly backyard helps individuals and species of birds survive, supports other beneficial wildlife such as butterflies and bees, and can inspire beautiful backyard design at the same time.

Take a little time to stand quietly in your backyard, look out of your window, or go for a walk in your local neighborhood or park. Are there any birds around? What is it that brings them to this particular environment? Perhaps they are foraging for insects, seeds, or berries, on the ground or in the foliage of hedges, shrubs, or trees. You might see them perching on branches, stumps of wood, rooftops, or telegraph lines; or hear a warbling of birdsong from within bushes or climbers, often up high. Certain species of birds might prefer a particular plant or habitat, become more visible or animated at a certain time of year, or flock around bird tables or feeders in search of extra sustenance.

What birds are fundamentally looking for is a place to Forage and Feed (see page 268) and a space that supports Breeding and Shelter (see page 290). If they can get this in the wild, they will naturally go there, but if such habitats can no longer supply what they need to survive, they will look elsewhere. The more closely we mimic nature, by introducing familiar native plants or similar (non-invasive) species, the better chance we have of attracting greater numbers and types of birds to our patch.

With thousands of plant species and their cultivated forms to choose from, guides to bird-friendly Trees and Hedges (see page 272); Flowers, Grasses, and Shrubs (see page 277); Climbers and Vines (see page 292); and Woodpiles and Compost Heaps (see page 296) can help. Identify the plants that suit the size, location, and purpose of your space, from re-wilding larger landscapes with a broad range of vegetation—including large trees, perhaps—to filling borders or pots with a select offering or two. A bushy vine

such as ivy (where it is non-invasive) or clematis is a good place to start, with potential for fruit, seeds, perches, and roosting or nesting spots. Grow one along a fence, a backyard wall, or even up a small piece of trellis on a balcony. The birds will love you for it.

Birds can also benefit from extra food and shelter during harsh weather or the breeding season, especially with issues such as climate change affecting the weather, seasons, biodiversity, and, thus, provision of natural food and shelter. Consider installing a bird table, bird feeders, bird baths, or even a bird café within your space, sourced from a bird conservation organization (see page 389) or homemade (see pages 284-289) to cater for a range of birds or a particular species you want to attract. Make your own nest boxes at the same time (see page 301), designed for safe breeding and adapted into cozy roosts for when winter sets in. Plus, Think Sustainably (see page 306) as you design your green space. We need birds as much if not more than they need us, so plant up and accessorize carefully for the long run. Creating a bird-friendly backyard with the environment and all our futures in mind is a great way to add even more passion and vigor to the cause.

Previous page Omniverous Fieldfares (Turdus pilaris) feasting on winter berries as grubs and worms become harder to find Opposite A bright yellow, male American Goldfinch (Spinus tristis) seeks out nutritious seeds from a purple coneflower (Echinacea purpurea)

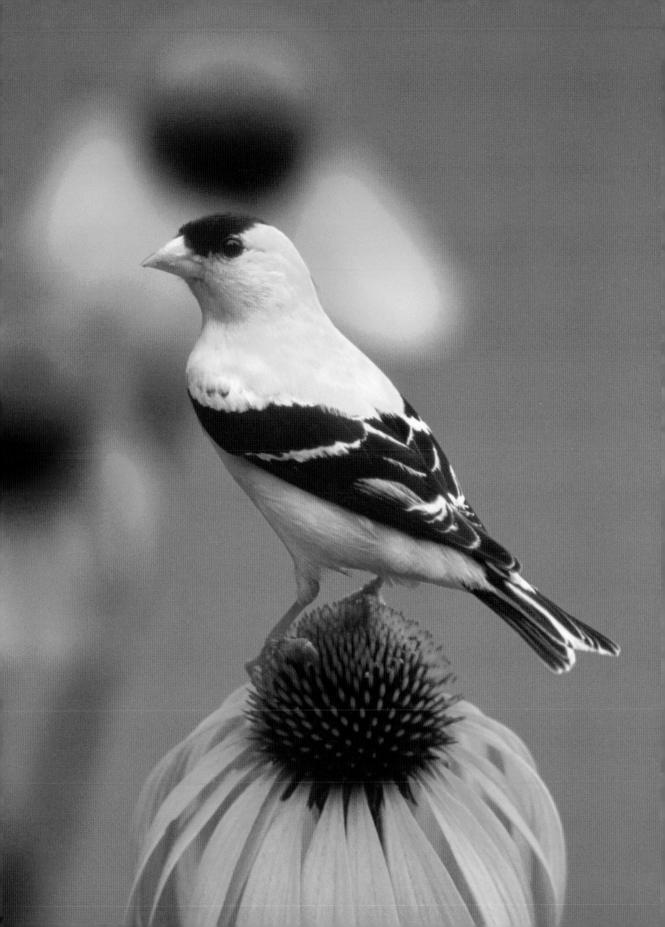

FORAGING AND FEEDING

Entice more species of birds to your backyard or patch with a homegrown seasonal buffet of the kind of food that they eat in the wild, including insects and berries. Catering for birds' varied diets and foraging and feeding habits can also be beneficial to plants and your backyard.

One of the easiest ways to encourage birds to visit your backyard is by offering them food. Putting out nuts or seeds in feeders or on tables is one way to do this (see Bird Tables, Feeders, and Baths, page 282) and can help many birds survive the winter months. But planting or maintaining natural sources of food comes with a range of added benefits: birds get a balanced diet that's ideal for their evolutionary needs in the form of insects, berries, seeds, or even sap (sapsuckers) and nectar (hummingbirds); they can forage with the added cover, protection, and nesting opportunities afforded by thick foliage, branches, or thorns; and a range of foraging styles are catered for, from those that peck on the ground or under bark to those that need to perch, hang upside down, or catch their food on the wing.

The symbiotic relationship between birds and plants can also work its magic via the mutual advantage of providing food for birds in return for seed dispersal or insect pest control, which benefits your plants. In addition, some of the most bird-friendly food also happens to be delivered by wonderfully ornamental as well as functional plants from star-flowered serviceberry trees, bright-berried firethorn, light-catching panic grass and scented rambling roses, to lavender, coneflowers, alliums, and globe thistles—ideal in a herbaceous border.

Attracting birds to your backyard with plants can also be inspired by simply observing birds foraging and feeding in the wild: insect-eating birds such as nuthatches, chickadees, sparrows, warblers, and woodpeckers make the most of a steady supply of leaf, bark, and soil-dwelling insects and other invertebrates during the spring and summer months, including common garden pests such as aphids, mosquito larvae, and some caterpillars; ground-feeders such as blackbirds, thrushes, sparrows, and robins can

Opposite Help supplement the mainly beetle and caterpillar diet of a hungry Eurasian Nuthatch (Sitta europeaea) with a ready banquet of sunflower seeds Right The small, fleshy, sugar-rich fruits of the serviceberry tree (Amelanchier canadensis) are irresistible to Cedar Waxwings (Bombycilla cedrorum) Next spread, left Pack mesh feeders with suet pellets to attract acrobatic little Blue Tits (Cyanistes caeruleus) Right Upright feeders of peanuts are a great way to bring stiletto-beaked Great Spotted Woodpeckers (Dendrocopos major) to your backyard

be seen hopping around looking for invertebrates in the soil or among grasses or low-lying foliage; chickadees spend a significant amount of time hanging upside down, examining leaves or branches for grubs; while swallows and swifts catch flying insects or floating spiders on the wing.

In fall and winter, when the days are shorter, the nights are colder, and insects more scarce, many birds turn to plant food such as berries and seeds, increasing their likelihood of eating every day and getting the nutrition they need to stay warm or migrate. Larger hips, haws, sloes, and cherries attract bigger birds or those that can make use of some seeds, while smaller pickings as found on a rowan tree or holly bush are more easily eaten by blackbirds, thrushes, and robins. Seedeaters, meanwhile, such as finches, have specially adapted beaks to help them crack through outer casings of seeds, grains, or nuts to reach the nutritious seed kernels inside.

Read on for more in-depth, bird-friendly planting descriptions for Trees and Hedges (see page 272), Flowers, Grasses, and Shrubs (see page 277), Climbers and Vines (see page 292), and beneficial plants to grow near Woodpiles and Compost Heaps (see page 296).

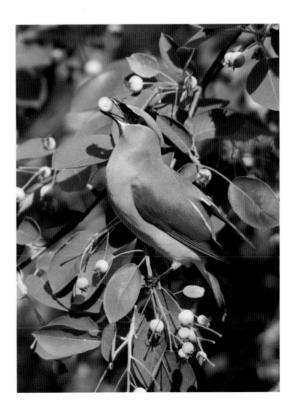

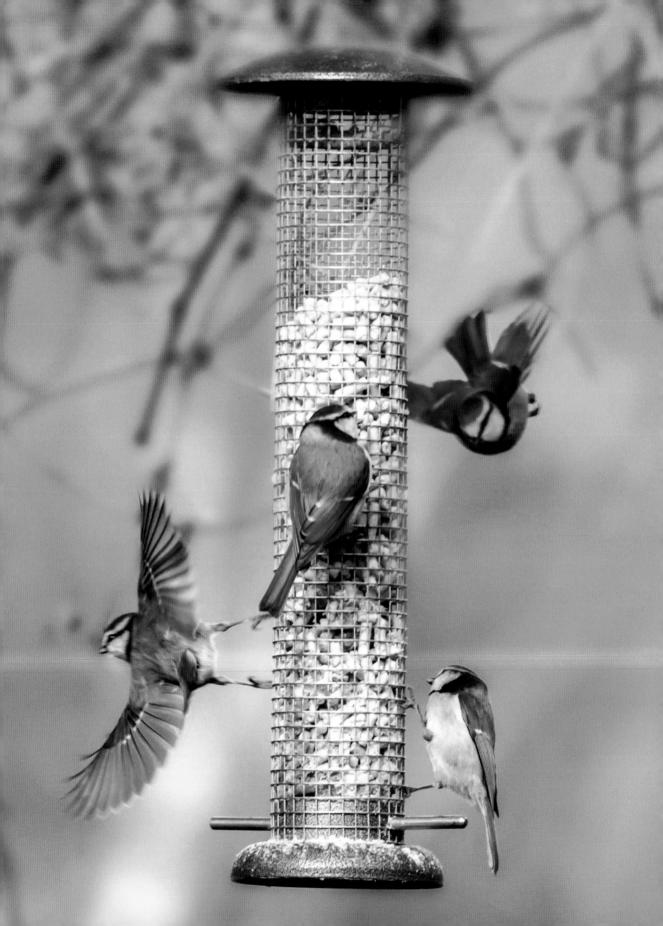

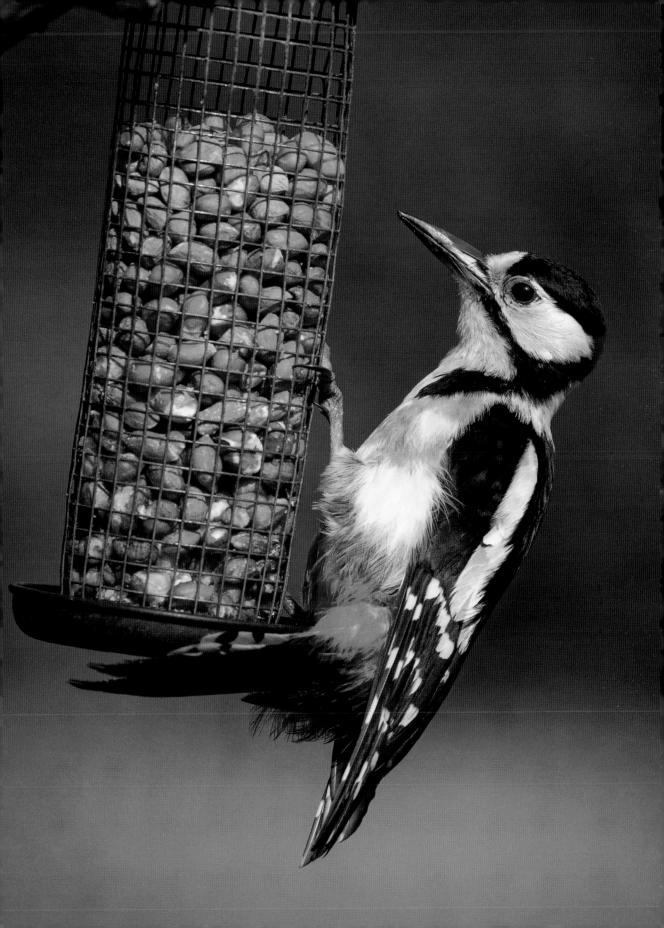

Trees and Hedges

Want to attract more birds to your backyard? Introducing or maintaining trees or hedgerow shrubs is one of the best places to start, as they offer shelter, protection, foraging and food sources, and nesting places, as well as ideal posts for perching passerines such as warblers, thrushes, jays, and sparrows.

Not only can trees and hedges add welcome, varied height, structure, texture, color, and natural screening to a backyard, they also play host to numerous forms of wildlife, including insects, small mammals, and birds. Planting or maintaining native tree or hedging species where possible also helps to support the natural ecology and biodiversity of an area. For birds, this means ready access to vital food sources, shelter, nesting sites and materials, and perching posts while simultaneously helping to control insect populations or disperse plant seeds for future germination.

Those lucky enough to have a large backyard or roaming landscape have a range of options, including tall or broad bird-friendly specimens such as oak (Quercus spp.), hornbeam (Carpinus spp.) maple (Acer spp.), pine (Pinus spp.), spruce (Picea spp.), cedar (Cedrus spp.), and cypress (Cupressus spp.). Hedging options could be similarly adventurous, including layers of beech (Fagus spp.), hawthorn (Crataegus spp.), and holly (*Ilex* spp.) intertwined with rambling rose or ivy (see page 292 for Climbers and Vines). Combining deciduous trees (flowering and fruiting species that shed their leaves in winter) with conifers (nonflowering, typically evergreen, trees with needles or feathery fronds and cones), and denser shrubs can lend ornamental interest but will also, crucially, support a wider range of birds from insect-, seed-, and berryeating species to ground-roaming foragers and height-loving songbirds.

A well-designed front yard or less spacious backyard can usually accommodate at least one smaller tree or type of hedge, however, potentially bringing hosts of birds such as thrushes, waxwings, finches, or warblers to your domain. Graceful birches (*Betula* spp.), gorgeously blooming serviceberries (*Amelanchier* spp.), fruit-laden crab apple (*Malus* spp.), or mountain ash (*Sorbus* spp.) are ideal upfront, while firethorn (*Pyracantha* spp.) and dogwood (*Cornus* spp.) offer fall color in beds, borders,

or along fencing via richly colored fruits, foliage, and stems. Dwarfed cultivars of conifers such as Lawson cypress (*Chamaecyparis lawsoniana*) or Leyland cypress (*Cupressus x leylandii*) are potential candidates for space-restricted hedging if managed well, and give dense evergreen cover and nesting spaces for birds, while hazel (*Corylus* spp.) offers lovely broad leaves and nutritious nuts.

If you're really pushed for space, opt for a dwarf or naturally diminutive tree in a pot and hang a feeder or two from the branches (see page 286). While the tree itself might not produce masses of fruit or a place to nest, passing warblers or songbirds may be on the lookout for an ideal perch and could reward you by returning time after time.

Please note: In the planting suggestions throughout this chapter, "NA" refers to "North America."

PLANTING SUGGESTIONS

Hawthorn

Crataegus spp.

This ancient hedgerow shrub or tree with its lobed leaves and pretty pink-white, late spring flowers provides thorn-protected nesting and shelter, numerous treats for insect-feeding birds and their young, and antioxidant-rich autumnal haws (berries) for birds such as thrushes and waxwings.

Suggested species include English hawthorn (Crataegus laevigata—native to UK); European hawthorn (Crataegus monogyna—native to UK and Europe); Washington hawthorn (Crataegus phaenopyrum—native to NA), downy hawthorn (Crataegus mollis), and cockspur hawthorn (Crataegus crus-galli—native to NA)

Mountain ash

Sorbus spp.

Clusters of creamy-white, nectar-rich flowers give way to masses of bright-red, berrylike pomes in fall providing food for all kinds of birds, including waxwings and thrushes, which then help disperse this long-living tree's seeds—an ideal

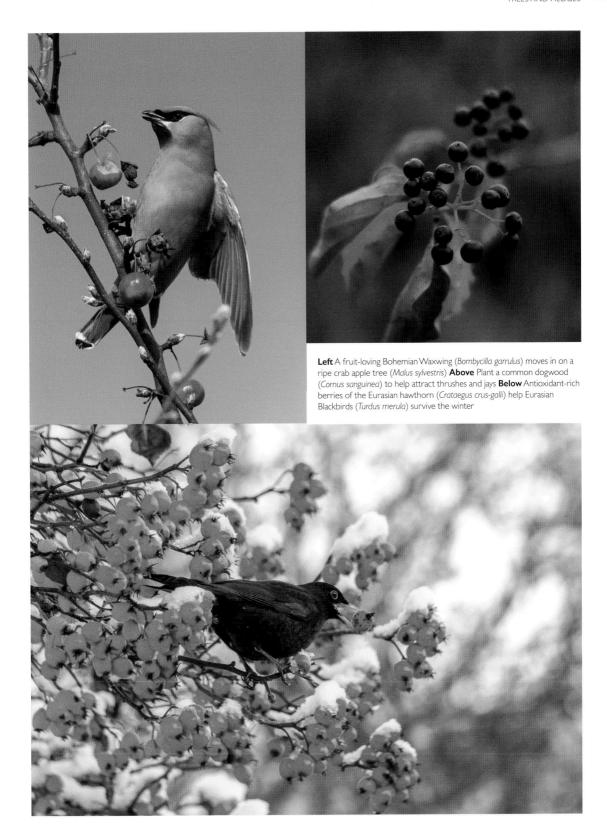

medium-sized species for a front or backyard.

Suggested species include European mountain ash or rowan (*Sorbus aucuparia*—native to UK and Europe); American mountain ash (*Sorbus americana*—native to NA); northern mountain ash (*Sorbus decora*—native to NA)

Firethorn

Pyracantha spp.

Shiny evergreen foliage, pollinator-friendly flowers, pendulous red, orange, or yellow berrylike pomes to help birds through the winter, angled branches for nesting or training, plus sharp thorns to keep predators at bay and create a natural security barrier give firethorn the edge when it comes to backyard hedging.

Suggested species include scarlet firethorn (*Pyracantha coccinea*—native to south-eastern Europe to Caucasus; naturalized across UK and parts of NA, although invasive in some states)

Crab apple

Malus spp.

Crab apple really comes into its own in the fall when spring's showy, pink-tinged white blossom, once pollinated by bees, transforms into yellow-green, sometimes red-flushed, fruits among golden deciduous leaves. Robins, starlings, finches, and thrushes are all fans of this abundant feast.

Suggested species include European crab apple (*Malus sylvestris*—native to UK and Europe); southern crab apple (*Malus angustifolia*—native to eastern and south-central NA)

Hazel

Corylus spp.

One of the few nut-bearing shrubs, large serrated-leaved hazel can be woven into a natural hedge or grown as a small tree, adding an uplifting burst of bright green in spring/summer, turning golden-bronze in fall. All hazelnuts are edible, although woodpeckers, jays, and nuthatches may well get there first.

Suggested species include common/European hazelnut (Corylus avellana—native to UK and Europe); filbert (Corylus maxima—native to south-east Europe); American hazelnut (Corylus americana—native to NA), and beaked hazel (Corylus cornuta—native to NA)

Lawson cypress

Chamaecyparis lawsoniana

A popular garden ornamental or screening choice native to the eastern United States and Japan, this often dwarf conifer in cultivated shades of green, blue, or gold provides welcome winter refuge and nesting sites for birds such as finches among dense branches of feathery, flattened, evergreen foliage.

Suggested cultivars include narrow and conical Chamaecyparis lawsoniana "Elwoodii"; more rounded and stout Chamaecyparis lawsoniana "Minima"; dwarf variety Chamaecyparis lawsoniana "Gnome'; and large, stately Chamaecyparis lawsoniana "Colmnaris"

Birch

Betula spp.

Food for birds in the form of seeds from cone-shaped strobili, buds, numerous species of insects and caterpillars, and a high sap content plus distinctively colored, striped, and often papery bark, dainty leaves and catkins, and an open canopy make birch a great choice for bird-lovers and gardeners alike.

Suggested species include silver or European birch (*Betula pendula*—native to UK, Europe, and NA); downy birch (*Betula pubescens*—native to UK and Europe); paper birch (*Betula papyrifera*—native to NA)

Serviceberry

Amelanchier spp.

An ideal tree for a front yard thanks to its relatively diminutive size, beautiful star-shaped white flowers and pink to green to gold foliage, the serviceberry is also loved by birds such as finches, blackbirds, robins, and waxwings for its deep-red to rich-purple, nutrient-rich, soft and tasty fruits.

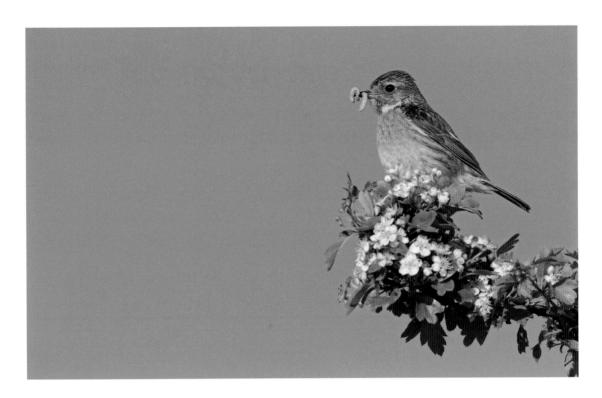

Suggested species include snowy mespilus (Amelanchier lamarcki—native to eastern US, widely introduced to UK and Europe); downy serviceberry (Amelanchier arborea—native to eastern NA); shadblow serviceberry (Amelanchier canadensis—native to eastern NA)

Holly

Ilex spp.

Help provide winter food, shelter, and protection for birds such as thrushes, finches, and robins care of holly's bright-red berries (drupes) and dense, shiny, often prickly evergreen foliage. Holly is dioecious, with male and female components on separate plants, so include at least one of each in a border or hedge.

Suggested species include European or English holly (*Ilex aquifolium*—native to UK and Europe); American holly (*Ilex opaca*—native to south-eastern NA)

Dogwood

Cornus spp.

Clusters of insect-attracting creamy-white flowers and fresh green leaves followed by tempting red or black berries provide a ready banquet for birds such as thrushes, bluebirds, and jays. Kaleidoscopic fall leaves or twigs of crimson and gold (depending on species) can also add ornamental color.

Suggested species include common or bloody dogwood (Cornus sanguinea—native to UK and Europe); flowering dogwood (Cornus florida—native to eastern NA); Pacific or mountain dogwood (Cornus nuttallii—native to western NA)

Above Common Stonechats (*Saxicola torquatus*) find tasty grubs within the dense foliage and blooms of trees such as the hawthorn (*Crataegus* spp.), too

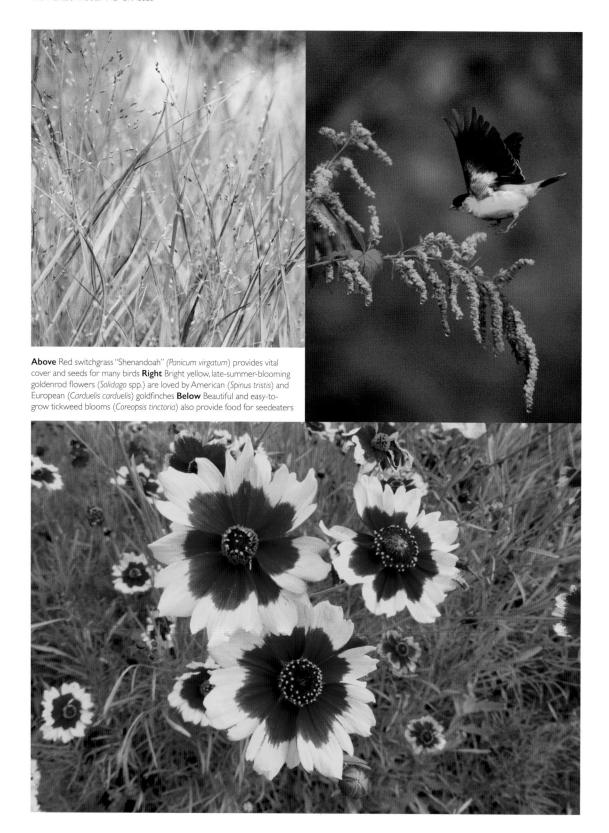

Flowers, Shrubs, and Grasses

Pack borders or pots with a beautiful display of native and pollinator-friendly flowers, shrubs, and grasses to help provide a seasonal pick-and-mix of insects, spiders, worms, fruit, seeds, and nectar for the varying diets of different birds. Such plants can also offer vital shelter for ground-feeders.

Flowers, grasses, and ornamental shrubs are an obvious choice when it comes to beautifying your backyard or patch and can also help attract a host of beneficial creatures, including bees, butterflies, and birds.

Pollinator-friendly shrubs such as lavender (*Lavandula* spp.) add year-round or seasonal structure, color, and scent plus cover for ground-feeding birds, low perches for songbirds, insects such as caterpillars during spring, and a late-summer banquet for seedeaters. Some birds are also known to line their nests with aromatic herbs to potentially create an antibacterial and therapeutic environment for their newborn or fledgling offspring. Flowering and fruiting shrubs such as guelder rose (*Viburnum* spp.) and firethorn (*Pyracantha* spp.—see Trees and Hedges, page 272) also create fragrant and colorful border backdrops as well as a berry banquet for finches and thrushes.

Tall or bushy ornamental grasses such as panic grass (*Panicum* spp.) are softly textural and light-catching and can provide a real feast for grain-eating birds via their plumes, spikes, and sprays, plus cover and insects for ground-foragers among lower foliage. Care needs to be taken when choosing the right species of grass for your zone, however: opt for native species of grass where possible; avoid those considered to be invasive (such as the species form of *Miscanthus sinensis*); and choose warm-season or cool-season varieties depending on climate and position. Fresh grass lawns attract birds looking for worms and seeds, while dry grass is ideal for building and lining nests.

Finally, there are the flowering, herbaceous perennials, annuals, and biennials with which to create swathes of color, perfume the air, fill gaps between shrubs, adorn containers of every shape and size, and create contrast and movement via a range of foliage, blooms, and seed-heads. Grassland or arable wildflowers—many of them from the Asteraceae or daisy family—such as coneflowers (*Echinacea* spp.), cornflowers

(Centaurea spp.), zinnias (Zinnia spp.), black-eyed Susans (Rudbeckia spp.), poppies (Papaver spp.), asters (Astereae spp.), and globe thistle (Echinops spp.) are particularly bird-friendly, providing accents of summer color and cut flowers as well as vital protein-rich seeds for birds through fall and winter.

Alliums (Allium spp.) and teasels (Dipsacus fullonum) are also top choices for seedeating birds and give great winter interest, although the latter can be invasive outside of its native reach. Top of the seedbearers, however, is the mighty sunflower (Helianthus spp.), with tall cultivars such as "Russian Giant" producing thousands of seeds as a ready banquet or to dry and hang out as feeders during the colder months (see Bird Tables, Feeders, and Baths, page 282). For nectar-eating birds in more tropical climes, choose red-petalled sages (Salvia spp.), columbines (Aquilegia spp.), and bee balms/bergamots (Monarda spp.).

PLANTING SUGGESTIONS

Sunflower

Helianthus spp.

Plant large-headed golden sunflowers for a late summer supply of protein- and essential oil-packed seeds loved by finches, nuthatches, and chickadees and titmice. Let birds harvest direct from the plant (protect seeds with muslin until fully ripe), or remove seed-heads and dry them in a warm spot to offer as feeders (see page 289).

Native species and cultivars include common sunflower (*Helianthus annuus*—native to western NA but introduced worldwide); giant-headed common sunflower (*Helianthus annuus* "Russian Giant"—native to NA but introduced worldwide)

Coneflower

Echinacea spp.

This long-blooming, easy-to-grow perennial with its large, downward-drooping and thus cone-shaped daisy-like florets is lovely in borders as a cut flower and is loved by the bees and the birds: the former for its nectar, the latter for the seed-rich spent flowers. Leave *in situ* to provide a ready winter feast.

Suggested species include purple coneflower (*Echinacea purpurea*—native to eastern and central NA but introduced to parts of Europe and Asia); narrow-leaved coneflower (*Echinacea angustifolia*—native to central and southern NA)

Cornflower

Centaurea spp.

Once a mainstay of arable fields and meadows, the overuse of herbicides in farming means that annual cornflowers rarely seed themselves naturally. Plant these frilly flowered blue beauties in borders or pots, where small seed-eating birds can also enjoy their bounty in late summer.

Suggested species include common cornflower (Centaurea cyanus—native to Europe but naturalized across UK and parts of NA); mountain cornflower (Centaurea montana—native to Europe but now naturalized across UK and NA)

Lavender

Lavandula spp.

This aromatic woody shrub for borders or pots attracts pollinating bees, butterflies, and hummingbirds (Americas). Some birds also line their nests with herbs such as lavender, mint (*Mentha* spp.), and curry plant (*Helichrysum italicum*) for naturally antibacterial as well as aromatherapeutic effects.

Suggested species include widely cultivated English lavender (*Lavandula angustifolia*—native to parts of Europe); tuft-flowered French lavender (*Lavandula stoechas*—native to parts of Europe and North Africa); more broad-leaved spike lavender (*Lavandula latifolia*—native to parts of Europe)

Panic grass

Panicum spp.

This warm-season cosmopolitan grass is long living but slow spreading, with a typically dense, columnar form of stiff green stems turning to gold or red in the fall. Seed plumes ripen from pink to purple and persist well into winter, providing proteinpacked morsels for sparrows and buntings. Suggested species include switchgrass (*Panicum virgatum*—native to NA, introduced to UK and parts of Europe)

Globe thistle

Echinops spp.

Also known as the blue hedgehog thistle, the steely blue globular flowers on branched or singular stems attract hummingbirds (Americas) and produce a buffet of seeds for birds such as goldfinches, which can also help keep self-seeding down. *Echinops* is also lovely as a cut or dried flower.

Suggested species or cultivars include blue globe thistle (*Echinops bannaticus*—native to UK and parts of Europe—in "Taplow Blue"); southern globe thistle (*Echinops ritro*—native to parts of Europe, Mongolia, and Turkey—in "Veitch's Blue"); great globe thistle (*Echinops sphaerocephalus*—native to parts of Europe, Eurasia, and the Middle East, and introduced to NA—in "Arctic Glow")

Teasel

Dipsacus fullonum

A familiar sight in grassland or wasteland, common teasel can also create structure, height, and interest in borders with purple-ringed green, prickled flower-heads giving way to brown seed-heads loved by European goldfinches and other birds. Teasel needs careful managing as it can become invasive.

Suggested species include common, wild, or fuller's teasel (*Dipsacus fullonum*—native to UK, Europe, and temperate Asia; considered invasive in NA as, left unchecked, it can crowd out other species)

Aster

Astereae spp.

This large tribe of typically pink-purple, yellow-centred, daisy-like flowers, including perennial species of aster and *Sympyotricum*, bloom in late summer and fall and provide food and a haven for year-round or migrating seed-eating birds such as goldfinches, sparrows, nuthatches, buntings, and chickadees and titmice.

Suggested species include New England aster or Michaelmas daisy (Symphyotrichum novae-angliae, formerly Aster novae-angliae—native to NA, introduced to UK and Europe); New York aster (Symphyotrichum novi-belgii, formerly Aster novi-belgii—native to NA, introduced to UK and Europe; European Michaelmas daisy (Aster amellus—native to Europe and Caucasus)

Tickweed

Coreopsis spp.

Seed-eating birds such as goldfinches love to snack on the tick-like seeds of this low-maintenance, drought-tolerant, long-blooming and cheerful plant. Grow in borders or pots for upright clumps of bright yellow, orange, or pink-red flowers, cutting back mid-season to produce more flowers and seeds.

Suggested species and cultivars include large-flowered tickseed (*Coreopsis grandiflora*—native to eastern NA, introduced to UK and Europe); whorled tickseed (*Coreopsis verticillata*—native to eastern NA, introduced to parts of Europe); dyer's tickseed (*Coreopsis tinctoria*

—native to NA, introduced to UK and parts of Europe)

Guelder rose

Viburnum spp.

Fabulously fragrant and frost resistant, species of *Viburnum* can be grown as bushy screens, manageable shrubs, or in pots, providing evergreen or semi-evergreen foliage and balls or sprays of pink or white lacy flowers. The berries are an important food source for some finches and thrushes.

Suggested species include guelder rose (*Viburnum opulus*—native to UK and Europe, Siberia, Turkey, and small parts of NA); avoid sterile *Viburnum opulus* "Roseum," which has beautiful white snowball-like flowers but no berries

Below Plant a mini meadow of bright blue cornflowers (Centaurea cyanus) in borders or pots to attract small seedeating birds **Next spread** Add swathes of grasses and globe thistles (Echinops spp.) to extend the seed feast and provide shelter for ground-foraging birds

Bird Tables, Feeders, and Baths

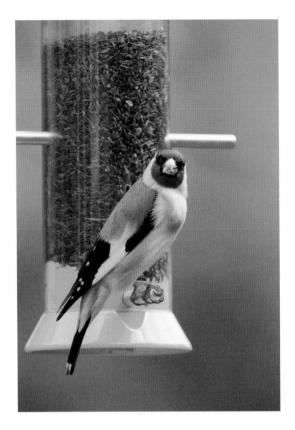

Putting out food and water for birds is a great way to get closer to certain species, observe their fascinating behavior, and help sustain them through the seasons. Choose from a range of bird tables, feeders, and baths to suit your space and, by catering for their natural habits, the kind of birds you hope to attract.

Feeding through the winter benefits birds the most, as this is the season when natural food supplies are most scarce. Food shortages (in the form of insects, seeds, fruits, sap, or nectar) or access to water can occur at any time of the year, however—during exceptionally wet, dry, or cold spells, for example, or when there are young to provide for—so refill bird tables, feeders, or baths year-round.

What to feed backyard birds also relates to the seasons. Birds need high-energy (high-fat) foods during the winter to help them get through long, frosty nights. While in spring and summer they

require high-protein food, especially when they are molting. This includes black sunflower seeds; pinhead oatmeal; soaked sultanas, raisins, and currants; mild grated cheese, mealworms, waxworms, mixes for insectivorous birds; good seed mixtures without loose peanuts; soft apples and pears cut in half; or bananas and grapes. Avoid putting out bread, fat, or peanuts during this time as such foodstuffs can pose a choking risk to young chicks.

Certain foods and feeders also attract particular species of birds. Ground-feeders such as blackbirds, mockingbirds, cardinals, robins, dunnocks, and doves prefer to feed from a bird table (see Make a Bird Table, page 284), platform, or safely placed ground tray. Smaller birds prefer a low-roofed table or one where the height of the cover can be adjusted to prevent larger birds from taking over. Bird tables or platforms should also be placed away from dense hedges or fences to help prevent cats from accessing them.

Birds found flocking around hanging feeders include species of finches, sparrows, chickadees, and siskins that like to feed while clinging or perching. Choose a feeder with a perch ring to help facilitate the latter or try fat balls (in winter) or dried sunflower seed-heads hung direct from branches or specially designed feeding stations.

Our feathered friends also need a regular supply of water for drinking and bathing, particularly during winter or a summer drought when natural supplies—from droplets on leaves or the shallow edges of ponds or streams—may be frozen or dried up. Bathing in water also helps birds to preen by loosening dirt so that feathers can be more easily rearranged and spread with oil to help them stay waterproof and warm. Whether they like to take a dip (blackbirds, American robins, thrashers, and starlings) or sit in the water to cool off (pigeons and doves), watching birds make best use of your bird bath (see Make a Bird Bath, page 287) or pond (if you have the room and the inclination to create one) can be quite a delightful performance to watch.

Above Help attract European Goldfinches (*Carduelis carduelis*) with a Niger seed feeder—the yellow base is a draw, too

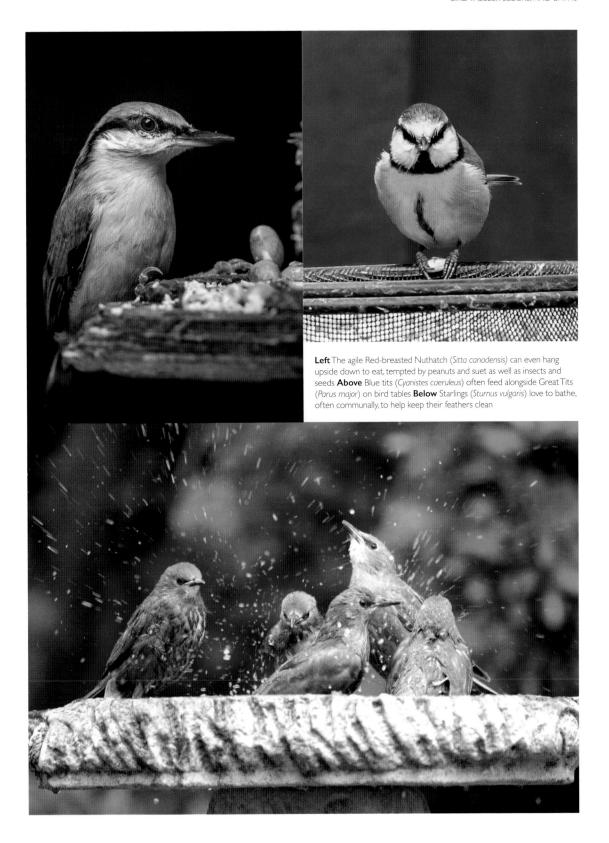

Make a bird table

Create a raised or hanging bird table to feed ground-feeding birds such as blackbirds, robins, cardinals, and blue jays.

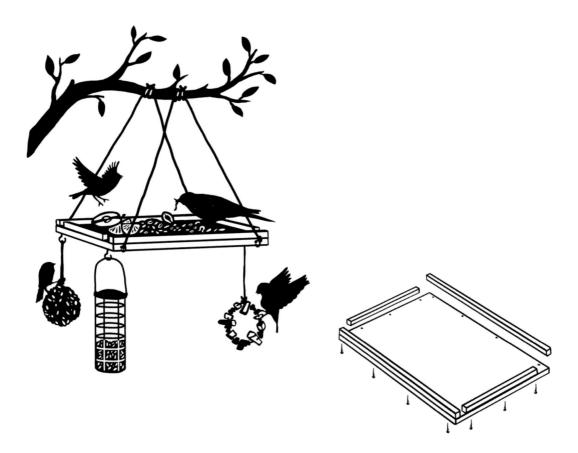

Find or purchase a 0.5in (15mm) piece of exterior-quality, sustainably sourced plywood, hardwood (oak or beech), or softwood (pine) timber for the platform element. Ensure that this wood will not split or disintegrate when wet (untreated softwood will naturally deteriorate faster). Sand it smooth to remove crevices that could harbor dirt and encourage disease. Untreated is best but, if treating is required to prolong its life, use a water-based preservative and ensure the wood is fully dry before use.

Use a length of sanded 0.5in (15mm) stripwood to create a rim around the edge of the table or platform to help stop food falling or blowing off. Leave a gap at each corner so that rain can drain away. Sand it before attaching and use brass or galvanized self-drilling screws to secure it in place from below: 1in (30mm) long are ideal for the measurements above.

Attach 1in (30mm) zinc- or brass-plated screw eyes to the side edges of the platform on each corner from which to attach a hanging device; use light chain, wire, or strong cord but ensure to hang from two points rather than a central point (see main illustration) or the table will spin around. Attach further 1in (30mm) screw eyes into the base of the platform from which to hang nut or seed feeders or fat balls.

To make a freestanding bird table, add a cross-shaped base using self-tapping screws (or pre-drill the holes) and diagonal supports to secure the base to the post. Use pegs and rubber straps to secure the base to the ground.

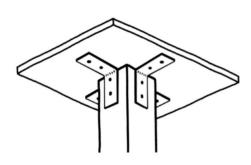

Bird tables can also be mounted on wooden posts that can be driven directly into the ground. Use angle brackets to fix to the platform.

Put out a varied banquet of high-quality foods and kitchen scraps (dried fruit, mild grated cheese, cooked potatoes and pastry), mixed seeds, flaked maize, sunflower seeds, pinhead oatmeal, mealworms and waxworms (in spring), bruised fruit, and fat balls or fat cakes (in winter or cold spells) to cater for the greatest range of species. Include a mix of high-oil seeds such as black sunflower, sunflower hearts, peanuts, and niger seed (this needs a special feeder with a small slits so that the tiny seeds don't fall out), and cereal grains, plus additional insects or high-fat ingredients in spring. Avoid split peas, beans, dried rice, or lentils as only large species can eat them dry, and steer clear of mixtures containing green or pink lumps, which can only be eaten when soaked.

Make a fat ball

Help birds put on an extra layer of fat and keep active with an energy-boosting buffet of seed-. nut-, and oat-enriched suet balls or cakes.

- Choose suitable molds such as paper cupcake cases, small clean yogurt pots, or half coconut shells. Pierce the mold to hang from top (coconut shell) or base (paper cases or vogurt pots) and add a loop of strong twine. Or choose to roll your fat ball using your hands (add twine at rolling stage).
- Place 5oz (150g) unsalted and unsweetened dry ingredients such as sunflower seeds, oats, chopped peanuts, and dried fruit into a large bowl. Use a dedicated bowl (not used for human consumption) if adding ingredients such as mealworms. Avoid adding dried fruit if you have cats or dogs, or peanuts if any risk of allergy.
- Place a smaller glass bowl over a pan of hot water. Pour 9oz (250g) of beef or vegetable suet into the bowl, turn on the heat and simmer until the suet is melted.
- Pour melted suet over the dried ingredients and mix well until a clumping consistency is formed. Spoon mixture into your chosen molds or use your hands to roll into around 2in (5cm) diameter balls, breaking into two to add a loop of twine before firmly pressing the halves back together again. Fat balls or cakes can also be placed on cake pop sticks for placing in plant pots or left as they are to put on bird tables or in mesh feeders.

- Put molds or balls on a tray and place in the fridge for several hours or overnight to set. Fat balls, cakes (with paper cases torn off), or filled yogurt pots or coconut shells can then be hung directly from branches or bottoms of bird tables and placed on platforms or in feeders.
- Don't put out too many fat balls at once as this can attract pests. Make it seasonal and only put out in winter or cold spells. Never feed birds cooking fat from roasting tins or dishes as combined meat juices can be super salty, lead to smearing and create a breeding ground for bacteria. Soft fats such as polyunsaturated margarines or vegetable oils can also smear feathers, destroying waterproofing and insulating qualities.

Below Make sweetly shaped homemade fat balls to attract birds such as the European Goldfinch (Carduelis carduelis)

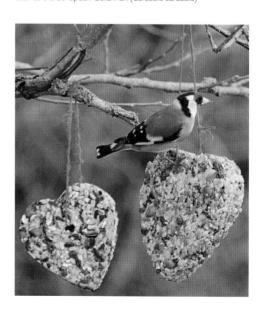

Make a bird bath

Give birds a safe and reliable source of fresh water for drinking and bathing, especially vital during hot or cold spells.

- Source a suitable vessel such as a circular plant pot tray or even an upturned garbage can lid. Choose something as wide as possible with an ideal size and shape being 4in (10cm) deep, at least 12in (30cm) wide and with sloping sides.
- Choose a suitable spot in an open lawn or border with a good all-around view. Nearby bushes or trees are great for birds to retreat into but avoid enabling predatory cats with a similarly perfect hiding and pouncing spot.
- Place four bricks on the ground and position your vessel on top, adjusting until stable. Add a handful of pebbles or rocks to help birds get a better footing and avoid slipping.
- Fill regularly with fresh water, keeping your bath well topped up in summer, hot spells, or a drought, and ice-free in winter (knock ice out with a suitable tool or melt it with a little warm water).

Keep it clean

Whatever kind of feeding station you choose, ensure that bird tables and hanging feeders are cleaned regularly (outside, wearing gloves) with a mild (5%) disinfectant solution to help prevent poisoning or disease from contaminated birds, other wildlife, or their droppings. Consider moving feeding stations to a slightly different place each month to avoid droppings accumulating underneath. Replace or reduce food to keep it fresh and meet demand. Water containers should also be cleaned if contaminated by droppings and rinsed out daily, especially during the warmer months. Allow them to dry before fresh water is added.

Below Treat bath-loving European Robins (Erithacus rubecula) to a regularly topped-up body of water in your backyard

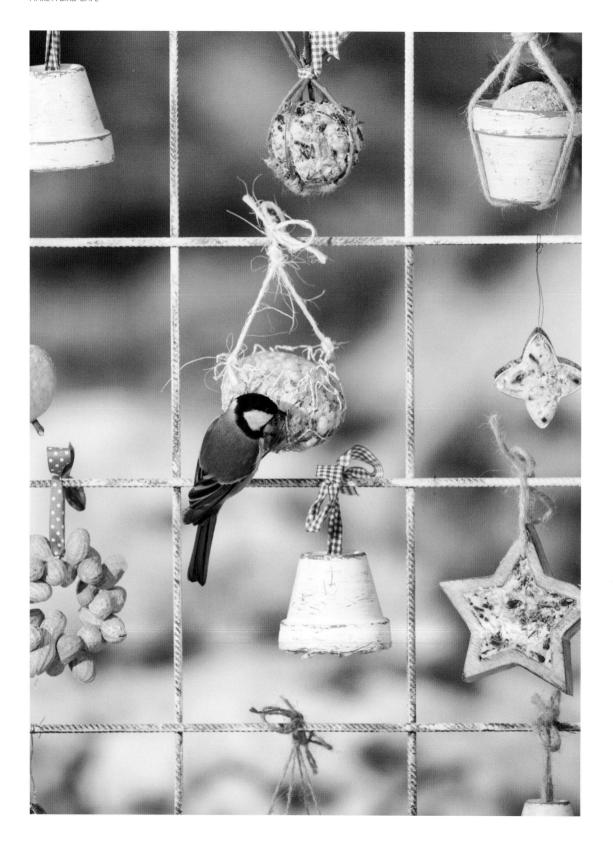

Make a bird café

Put out a variety of food on bird tables or platforms, in tubed or mesh feeders, or hanging direct from trees or feeding stations to attract greater numbers and species of birds.

Small seeds such as millet

Best scattered in small quantities directly on bird tables or ground feeders (away from predators). Mostly taken by house sparrows, dunnocks, finches, reed buntings, and collared doves

Flaked maize

Has a low oil content and can be dusty and difficult to hold in mesh feeders, so best for bird tables. Loved by blackbirds.

Peanuts

Crushed or grated nuts attract robins, dunnocks, and wrens, while nuthatches often hoard these nuts. Do not use salted or dry-roasted peanuts; put whole nuts or large pieces out in spring/summer and be aware of people with nut allergies.

Sunflower seeds

A great year-round food that's often more popular than peanuts. Black sunflower seeds have more oil content than the striped ones, while sunflower hearts (husked kernels) are less messy to eat. Whole sunflower seed-heads can also be left on plants (cover with nets until fully ripe) or removed, dried, and threaded with twine to hang from branches or feeding stations.

Niger (or nyjer) seeds

Place these small, black, oil-rich seeds in a special feeder to attract goldfinches, chickadees, titmice, house sparrows, nuthatches, siskins, and great spotted woodpeckers.

Pinhead oatmeal

This valuable inner part of an oat has often been finely chopped to make it easier for birds to eat. Suitable for many birds including wrens, dunnocks, robins, blackbirds, and song thrushes.

Birdseed mixtures

Better birdseed mixtures contain flaked maize, sunflower seeds, and peanut granules. Suitable for mesh feeders and bird tables and attractive to a range of species.

Mealworms

Relished by robins plus insect-eaters such as pied wagtails. Ideal for feeding birds throughout the year, although ensure stocks are always fresh.

Waxworms, ant pupae, insectivorous, or softbill food

An expensive option but ideal to attract insect-eating birds including creepers and wrens.

Fat balls or cakes

Balls or cakes of beef or vegetable fat combined with seeds, oats, peanuts, dried fruit, and even mealworms can really help birds survive the winter. See page 286 for how to make your own.

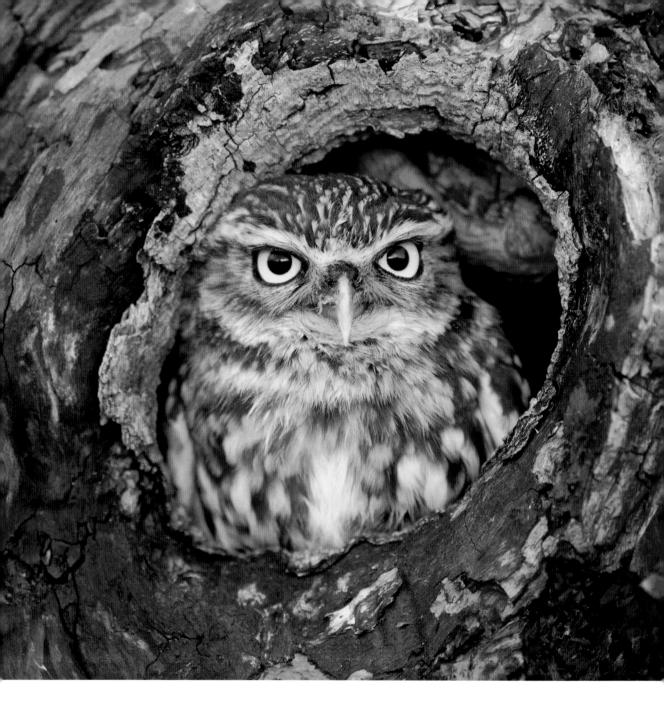

BREEDING AND SHELTER

Combine bird-friendly planting with supplementary nest boxes, roosting pockets, and nesting material to give birds safe, year-round, and often-vital spaces in which to breed and shelter. Birds need shelter for safety, weather protection, to forage and feast on plant food, and to provide an ideal nesting site for raising their young.

Observe birds in the wild and you'll spot them perching in trees, flitting into hedges and shrubs, hopping among thick ground cover or grasses, diving for the protection of a nearby tree or peeping out from holes formed in dead wood, piles of branches, little burrows in riverbanks, the crevices of rocks, or the eaves of a house.

The best way to provide ready shelter is by introducing or maintaining a bird-friendly backyard (see page 266), combining a good mix of deciduous, evergreen, and fruiting Trees and Hedges (see page 272)—where space allows—with a variety of Flowers, Grasses, and Shrubs (see page 277), Climbers and Vines (see page 292), and relatively untouched areas such as Woodpiles and Compost Heaps (see page 296). Many of the best plants for food also offer vital nesting, roosting, or sheltering spots for many birds.

Spring is mating and breeding season for most species of birds (although some birds, such as some pigeons, do it year-round when given ready access to food), usually announced by an increase and heightening of birdsong in mid-winter designed to attract potential mates and protect territory. Breeding times do vary, however, dependent on geography, availability of food and water, the duration of the caring period, brood numbers, and nesting sites. The further north a bird's breeding range is, for example, the later its mating season will begin, while migrating birds need to reach their breeding destination before they can even attempt to make a suitable nest.

Different species of birds also locate or build their nests in different ways. European rooks, for example, start early in the season by dropping branches into tall trees to lay the foundations of their large, unruly nests. Blackbirds, robins, and song thrushes build nests in the classic design comprising neat cups of woven grasses and small twigs camouflaged with moss and lined with mud. Finches fashion them in the forks of trees using sticky cobwebs as a kind of mortar on which to anchor and combine other materials, while long-tailed tits make intricate and delicate cup-and-dome contraptions, camouflaged with lichens and lined with hundreds of feathers.

Opposite Help provide birds including the lovely Little Owl (Athena noctua) with natural shelter to help them breed and survive **Right** Or install a nest box or two to give species such as this Eastern bluebird (*Sialia sialis*) a helping hand

Some birds eschew making nests altogether in favor of pre-made cavities in trees or rocks; others fly great distances to source the right materials for their temporary home. Many birds appreciate a little helping hand in the form of a Nest Box (see page 301 for tips on how to make your own) or ready piles of useful twigs, grass, moss, mud, freshly pruned plant clippings, grass, and animal fur (avoid this if your pet has recently been treated for fleas or other medical conditions).

In hot or cold weather birds need shelter of different kinds—roosts in which to regulate body temperature or stay dry. Evergreen trees, thick bushes, hedges, and reed-beds are great for winter night-time roosts or shade, while chickadees and titmice and wrens can be found roosting in empty nest boxes or supplementary roosting pockets (fill these with straw or wood chippings), huddling together for extra warmth. The greater the camouflage and shelter, the better chance birds have of foraging for their ideal food, too (see Foraging and Feeding, page 268).

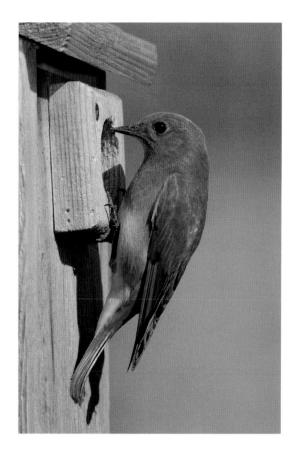

Climbers and Vines

Climbers and vines such as wild rose, honeysuckle, and clematis ramble through the understory or over structures, twine through hedges or cling to the surfaces of trees or walls, creating nesting pockets and shelter for small birds and food in the form of berries, seeds, visiting insects, and grubs.

Climbers and vines are a versatile option for all kinds of backyards, as an ornamental covering for fences and walls, to add a trans-season burst of color and scent in the higher reaches, or grown in pots and trained upward over trellis or a small structure where space is tight—ideal for a balcony or small patio or courtyard.

Birds love them as much in yards as they do in the wild, nestling into foliage for shelter and protection, picking off ripe berries and haws in fall and winter, and searching for insects among the ground cover that some creeping species of vine provide. Climbers also provide a high perch for songbirds and passing migrating birds.

Wild rose

Rosa spp.

Intertwine rambling species of rose or their single-petalled cultivars through established hedges or train them up walls for a profusion of scented, insect-attracting blooms in summer, vitamin C-rich orange-red hips to help thrushes, waxwings, and blackbirds through the winter, and thorny foliage for shelter.

Native species include dog rose (Rosa canina—native to UK and Europe, widely introduced to NA and Australia); beach or Japanese rose (Rosa rugosa—native to eastern Russia and Asia, introduced to UK and Europe, considered invasive in parts of US); Virginia rose (Rosa virginiana—native to NA); wild prairie rose (Rosa arkansana—native to NA); Woods' rose (Rosa woodsii—native to NA)

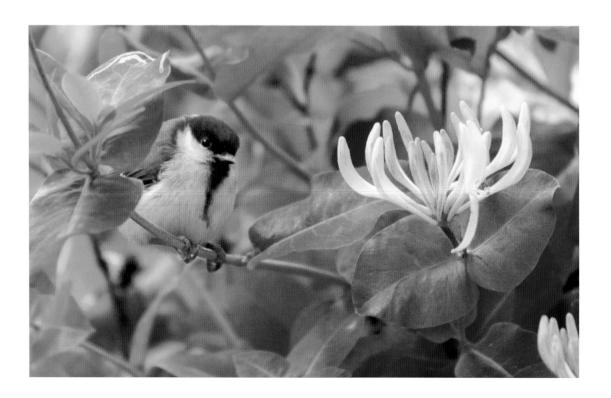

Ivy

Hedera spp.

Give ivy something to climb up and it will repay you with a dense spread of sheltering evergreen leaves plus flowers and purple-black berries in higher spots which ripen in winter, providing a vital food source for blackbirds and song thrushes when other food is scarce. Ideal for pots and baskets.

Suggested species include common or English ivy (*Hedera helix*—native to UK and Europe, invasive in some parts of NA)

Honeysuckle

Lonicera spp.

Hardy honeysuckle looks best scrambling through a hedge as per its native habitat but can be trained up a wall, fence, or support. The sweetly perfumed, nectar-rich, exotic flowers attract hummingbirds (Americas) and insect-feeding birds, while warblers, and thrushes love the fall berries.

Suggested species include common honeysuckle or woodbine (*Lonicera periclymenum*—native to UK and Europe); coral or trumpet honeysuckle (*Lonicera sempervirens*—native to parts of NA)

Blackberry

Rubus spp.

Bird-lovers with larger or wilder yards that can take a bramble's vigorous, dense, and thorny habit will be handsomely repaid with clusters of white blossom in early spring, shiny red-black edible berries, and flocks of birds that come for the insects, the nutritious fruit, plus shelter and nesting spots.

Suggested species include blackberry (*Rubus fruticosus*—native to UK and Europe); Allegheny or common blackberry (*Rubus allegheniensis*—native to NA, introduced to UK and Europe)

Clematis

Clematis spp.

Choose from hundreds of species, hybrids, or cultivars of twining clematis offering an array of spectacular early or late blooming flowers—some with equally showy wispy seed-heads, ideal for lining nests—tangled foliage for nesting within, plus insects and berries for bug- and fruit-eating birds.

Suggested species and hybrids include traveler's joy or old man's beard (Clematis vitalba-native to Europe, Middle East, and North Africa and introduced to parts of NA, it can be extremely invasive and is banned in New Zealand): mountain or anemone clematis (Clematis montana—native to central and East Asia; winter flowering clematis (Clematis cirrhosa—native to Mediterranean Europe; golden clematis (Clematis tangutica—native to central and East Asia, introduced to parts of NA); downy clematis (Clematis macropetala—native from China to Siberia); evergreen clematis (Clematis armandii—native to China and Myanmar); Clematis florida; sweet autumn clematis (Clematis paniculata—native to New Zealand); first large-flowered hybrid (Clematis "Jackmanii"); leatherflower or vase vine (Clematis viorna —native to south-eastern NA)

Virginia creeper

Parthenocissus quinquefolia

Given enough sun this show-stopping creeper provides bee-friendly midsummer blooms followed by deep-blue berries on scarlet stems with equally bright-red autumnal leaves. Birds such as bluebirds, woodpeckers, and sparrows love the fruit, while tendril-attached foliage is ideal for nesting in.

Suggested species include Virginia creeper (*Parthenocissus quinquefolia*—native to NA and Central America, introduced to UK, Europe, North Africa, and Asia)

Opposite Climbing honeysuckle (*Lonicera* spp.) provides a perfect perch for a fledgling Great Tit (*Parus major*) waiting for a parent to bring back food

Next spread For those with a large enough plot, the pretty white flowers (**left**) of Old man's beard or traveler's joy (*Clematis vitalba*) give way to silky seed-heads (**right**), an important food source of goldfinches and finches

Woodpiles and Compost Heaps

Onsider leaving less-cultivated backyard areas where dead wood, leaf matter, decomposing plants, weeds, and wildflowers can be left in place. This may also be an ideal spot for a compost heap. Birds will come for the many insects, spiders, and worms that live there as well as nearby berries or seeds.

Woodpiles and compost heaps in backyards provide rich pickings for birds and other wildlife and can be made even more inviting through the plants and flowers that grow or are introduced there. For larger landscapes or backyards, simply allocate a dedicated area—away from the house if you prefer—where native plant species are allowed to run wild through their natural lifecycles, dead trees can be left to rot undisturbed, and fallen twigs or branches collect under hedges or in the understory along with tree debris and fading or seeding perennials. Such a relatively undisturbed habitat provides a haven for invertebrates such as insects, worms, slugs, and spiders; small mammals such as mice; and amphibians such as toads and newts. They also provide native nectar sources for pollinators such as bees and butterflies and an abundance of food, shelter, and nesting places for birds.

This is the perfect place to build or source a composting structure where grass clippings, vegetative food waste, deciduous leaves, and pruned plants can be left to rot. Leaving the compost heap open makes for easier turning but also provides insect predators such as robins and blackbirds with ready meals of worms, slugs, and bugs. Let weeds, wildflowers, and mineralrich plant species such as nettles (*Urtica* spp.), dock (*Rumex* spp.), yarrow (*Achillea* spp.), wild carrot (*Daucus* spp.), dandelion (*Taraxacum* spp.), comfrey (*Symphytum* spp.), clover (*Trifolium* spp.), cleavers (*Galium aparine*), and borage (*Borago officinalis*) colonize the vicinity to feed beneficial pollinators and their young, and provide shelter and fall seeds for birds.

Nitrogen-rich plants such as nettles and borage are particularly useful when composting as their chopped leaves can act as an accelerator. When transferred to beds and borders, nutrient-rich compost also attracts earthworms as they pull the goodness down into the ground and send soil up to the surface—good news for plants and birds that benefit from their presence. Just don't transfer the seeds or roots of persistent plants such as dandelions to the heap or you'll end up with a host of unwanted weeds as well as goodness wherever compost is spread.

While open compost heaps are not so viable for smaller backyards or balconies, there's always room for a woodpile, even if it's just a small pile of sticks between planters, a square of logs, or an aerated bucket filled with a mixture of soil and wood chippings. You could also part-bury a log or two in a container as a feature. In all cases, select a shady spot and as long as there's a feasible route to it, insects such as pill bugs and beetles should move in, hopefully followed by one or two curious feathered friends.

Nettle

Urtica spp.

Nettles attract more than 40 species of insects to their serrated leaves, including aphids, ladybugs, and caterpillars; plus, it produces a bounty of seeds in late summer providing spoils for insect- and seed-eating birds alike. Throw their nitrogen-rich leaves in the compost heap to help accelerate decomposition.

Suggested species include stinging nettle (*Urtica dioica*—native to UK and temperate Eurasia, introduced to parts of NA and South America, and South Africa); annual nettle (*Urtica urens*—native to temperate Eurasia, introduced to UK, parts of NA and South America, Africa, and Australia)

Borage

Borago officinalis

Prettify your compost heap or woodpile and add trace minerals to the soil with a colony of bright-blue, star-flowered borage. A magnet for bees and butterflies due to an abundant supply of nectar,

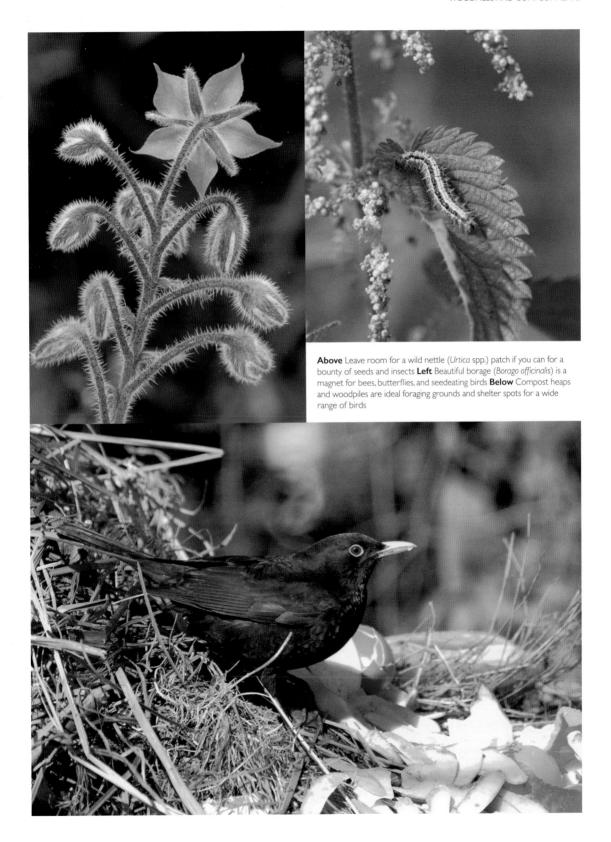

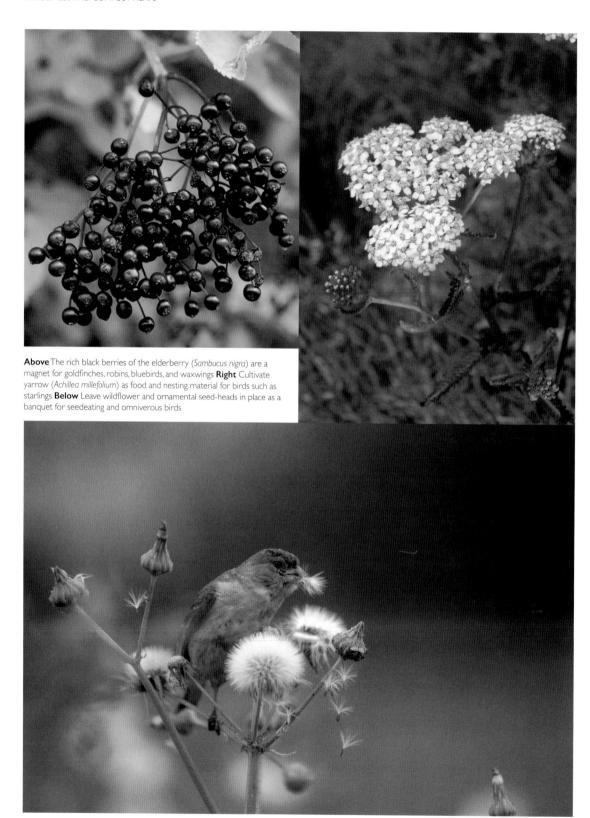

the pollinated flowers then produce a banquet of thistle-like seeds for birds such as finches.

Suggested species include borage (*Borago officinalis*—native to west and central Mediterranean, introduced to UK, other parts of Europe, and South America)

Cleavers

Galium aparine

This sprawling annual weed is known for its sticky stems, leaves, and round seeds that are dispersed by passing animals, birds, and humans. Numerous insects are also attracted to the foliage and tiny white flowers, providing ready meals for bug-eating birds. Avoid composting after seeds have set.

Suggested species include cleavers or goosegrass (*Galium aparine*—native to large swathes of UK, Eurasia, and North Africa; introduced to NA and South America, Africa, and Australia)

Yarrow

Achillea millefolium

A pretty white or pink-tinted, flat-topped perennial wildflower that grows easily on uncultivated land, yarrow provides nesting material for the dwellings of cavity-nesting birds such as starlings, and seeds for a variety of songbirds. Mineral-rich yarrow leaves are also useful as a compost accelerator.

Suggested species include common yarrow (*Achillea millefolium*—native to temperate and sub-Arctic, NA, UK, and Eurasia; introduced to South America, southern Africa, Asia, and Australia)

Dandelion

Taraxacum spp.

Birds such as goldfinches, siskins, blackbirds, and sparrows eat the seeds, while bees and other pollinating insects come to languish in blooms thanks to the early spring offering of nectar. The yellow flowers also brighten up a log-pile patch, but avoid placing dandelion roots or seeds in compost.

Suggested species and hybrids include common dandelion (*Taraxacum officinale*—native to UK, Europe, and Asia; naturalized throughout NA and South America, southern Africa, South America, New Zealand, and Australia); redseeded dandelion (*Taraxacum erythrospermum*—native to Europe to Caucasus and Mongolia; introduced to NA)

Elderberry

Sambucus spp.

Fragrant white lacy flowers followed by clusters of shiny red-black berries deliver an abundant feast of insects and fruits for goldfinches, robins, bluebirds, and waxwings. Elderberry foliage also provides shelter while fast-decomposing, activating leaves and twigs can be added to the compost heap.

Suggested species include European elderberry (Sambucus nigra—native to UK, Europe, and the Middle East; introduced to South America); American black elderberry (Sambucus canadensis—native to southern NA, Central and South America)

Nest Boxes and Roosts

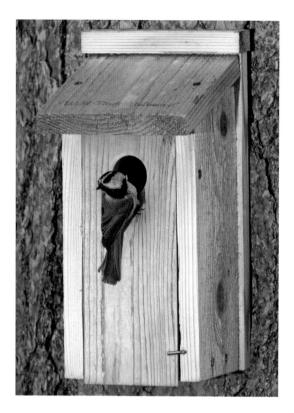

Furnish your garden, balcony, or backyard with nest boxes and supplementary roosting points to offer birds additional protection from predators and harsh weather conditions, plus a place to safely raise their young—especially vital when natural shelter and nesting sites are scarce.

Nest boxes are easy to source or make (see Make a nest box, opposite), providing a range of small birds with a ready space within which to raise their brood. The key to attracting certain species of birds is to ensure that the entrance hole is the right size for them to easily come and go, but also keep predators or usurping birds at bay: smaller holes for chickadees; medium for sparrows; large for nuthatches and house sparrows; and the biggest of all for starlings. Entrance holes also need to be high enough up and perch-free to prevent predators from getting in.

A simple, sloped-roof, closed-front, lid-topped nest box (with entrance hole) made from exterior-grade plywood or softwood such as pine serves this purpose well. The box should naturally weather over time to provide an element of camouflage but could be painted a neutral shade of green, brown, or gray to allow it to recede into surrounding vegetation, bark, or walls. Use an eco-friendly, water-based paint that won't harm birds or the environment; avoid painting around the entrance hole on the inside where birds may peck, and allow it to fully dry for at least a few days before use.

Boxes for chickadees, nuthatches, sparrows, or starlings should be 6.5-13ft (2-4m) up a tree or a wall and (if your yard is large enough) spaced out enough to cater for several territories. House sparrows, bluebirds, purple and house martins, and starlings will readily use nest boxes placed high up under the eaves of your house or in specially made "towers." These species nest in loose colonies so two or three boxes close together is ideal. Woodpeckers need their boxes to be at least 10ft (3m) up a tree trunk, with a clear flight path and away from disturbance. European and American robins, phoebes, mourning doves, and wrens prefer open-fronted boxes placed low down, below 6.5ft (2m) and well hidden by foliage but with a clear outlook. If fixing your box to a tree, attach it with a nylon bolt or wire around a trunk or branch rather than a nail; trees grow in girth as well as height so check the fixing every couple of years to ensure fixings, especially wire, are not cutting into the bark. Face nest boxes away from strong sunlight and avoid windy or unsheltered spots.

It's best to put nest boxes up in fall to give birds time to view a potential nesting place to which they can return in spring; this is important for some species, although titmice or chickadees do not seriously investigate sites until after winter. Remember that nest boxes can also double up as vital roosts during the cold season but check strict national laws around removing used nests or eggs, even out of breeding season. Roost boxes or woven roost pockets are another easy-to-source option with specially designed nest box cameras becoming increasingly popular for watching breeding and roosting birds in action. If you don't have access to such equipment, try to stay well away or observe from a distance to give birds and their chicks the best fighting chance of survival.

Above A Mountain Chickadee (*Poecile gambeli*) finds a welcome breeding ground and shelter in a safely mounted nest box

Make a nest box

Making a nest box for birds such as chickadees and titmice, robins, nuthatches, sparrows, and starlings is a fun project and provides such birds with an ideal place to breed and potentially roost.

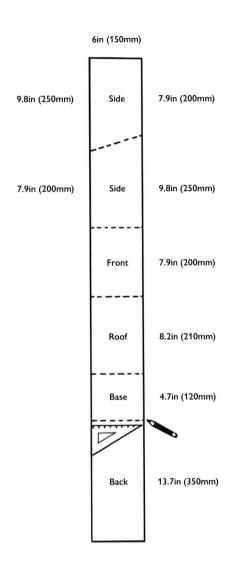

- Find or purchase a piece of sustainably sourced timber for the main body of your nest box: exterior-quality plywood for a lighter box; hardwood such as oak or beech; or softwood such as pine, but this will deteriorate faster. A long plank 6in (150mm) wide × 0.5in (15mm) thick × at least 5ft (1.5m) that can be cut into pieces is ideal. Ensure that this wood will not split or disintegrate when wet. Untreated is best but if treating is required to prolong life, use a water-based preservative and ensure wood is fully dry before use.
- Use the diagram plus a measuring triangle and pencil to measure and mark your plank into the relevant pieces. These measurements are designed to accommodate the minimum interior box measurement for the use and comfort of the smallest birds, which is 4in (100mm) square.

- Rest the plank on a suitable surface and position it to cut along measurement guides using a saw (a Japanese saw is a great hand tool for small projects or thinner pieces of wood). Sand each piece apart from what will be the inside front surface. Keeping this surface rough will help young birds when they are ready to clamber up. Remember, adults should be in charge of any steps involving sharp tools or materials.
- Use an appropriately sized spade drill bit or use a hole saw or jigsaw to cut your entrance. Ideal entrance hole sizes are: 0.9in (25mm) for smaller titmice or chickadees; 1.1in (28mm) for great tits and tree sparrows; 1.25in (32mm) for nuthatches and house sparrows; and 1.8in (45mm) for starlings.

- Take your front piece and use a triangle and pencil to mark out a line 5in (125mm) from its bottom edge with an intersecting line at its central point. Use a compass to mark out the positioning and diameter of your entrance hole. The lowest point of your hole should not extend past your 5in (125mm) guideline to help prevent cats from scooping birds out with their paws.
- Use a standard drill bit to create a couple of small drainage holes in the base piece to stop the nest box from getting damp inside.

- Set the roof to one side. Then follow the diagram to attach the sides to the backboard, then the base and finally the front. All should be flush to the base. Use 1in (25mm) self-tapping wood screws, pre-drilling screw holes if required (harder woods).
- Position the nest box on a suitable tree, wall, or under the eaves (see page 298 for species-relevant advice), facing away from direct sunlight or strong winds if possible, and out of reach of predators such as cats. Birds also benefit from a direct flight path, a measure of privacy, and nearby food.

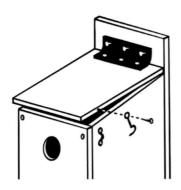

Position the roof on top of the front and sides. Create a hinge by nailing on a strip of scrap leather, roofing felt, or thin rubber such as a recycled piece of bicycle inner tube. Creating a hinged lid allows for easier cleaning in fall. If necessary, attach a swing hook box clasp or latch to close.

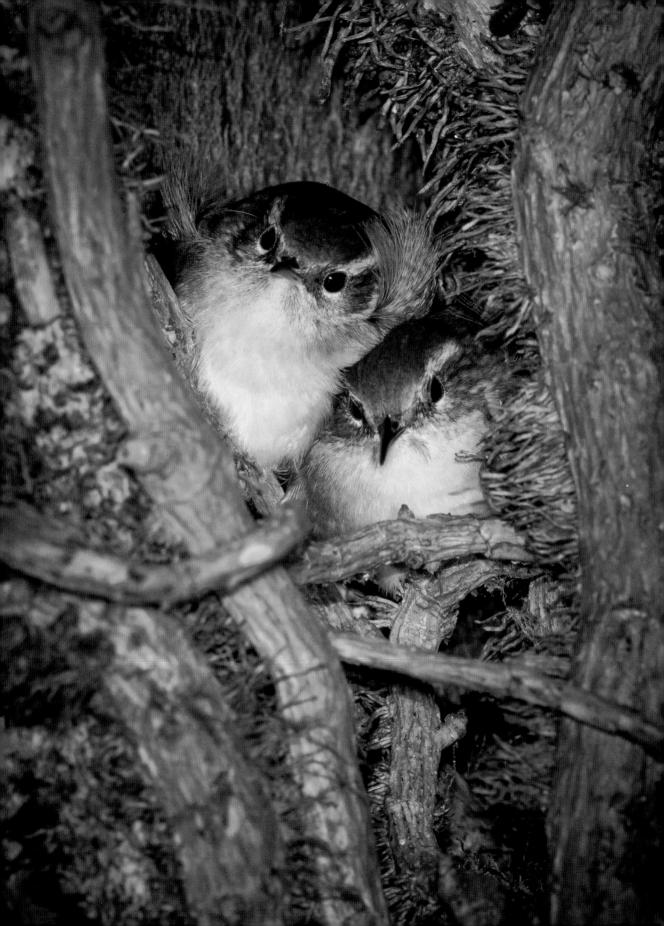

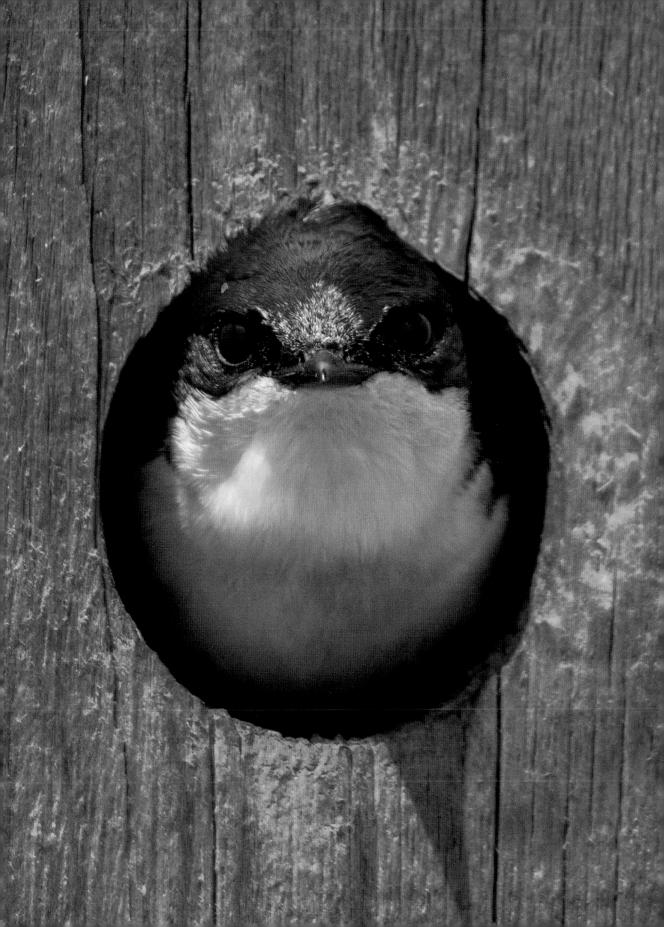

Thinking Sustainably

Birds are hugely important to the world's ecosystems, with changes in bird behavior serving as an early warning sign for pressing concerns such as climate change. Bolstering plant diversity, providing supplementary food and shelter, and supporting bird conservation are just some of the ways that we can all make a difference.

In 1859, renowned English naturalist Charles Robert Darwin published his theory of evolution by natural selection: *On the Origin of Species*. A collection of around fifteen species of passerines, now collectively known as "Darwin's Finches," had a starring role. Known for their remarkable diversity in beak form and function, these variously sized "finches" (or tanagers, as it now transpires) illustrated how species emerge, change, and potentially become extinct in response to changes in the environment, and the importance of biodiversity in the natural world.

This phenomenon is not, of course, particular to the Galapagos Islands, where Darwin observed his "finches." Changes in environment happen and are happening all over the world, from entire biomes such as rainforests, grasslands, or coastal areas to the ecosystem of your neighborhood or backyard—with birds often the first to ring such changes, through their dwelling places, feeding habits, breeding times, migration patterns or, in some cases, their decline.

Birds pollinate plants, including a significant number of species used for human medicine or food. They spread seeds and nutrients by dispersing them through their droppings, in turn helping to restore biodiversity where natural habitats may have been seriously affected or destroyed—this includes vital coral reefs. They transform entire landscapes, helping to store carbon, oxygenate the air, transform pollutants into nutrients, and keep the climate stable. Plus, they maintain the delicate balance between plant and herbivore, predator and prey, and control pests by eating insects and other invertebrates. In short, birds play an essential role in the functioning of the world's ecosystems, as well as being beautiful or inspiring to watch or live among.

But they are also being hugely affected by issues such as climate change: forced out of some natural habitats such as high-altitude forests; moving further north to find suitable dwelling places; migrating earlier or later in the season; or altering breeding patterns to ensure that they have enough food to feed their young, as changes in weather affect the availability of plants or insects. Which is why helping to conserve birds is so important, both in your backyard and as part of a global community.

Supporting a national or worldwide bird or wildlife conservation organization such as the Audubon is one way to help (see page 389 for a helpful list). This includes helping fund global conservation initiatives, volunteering locally, purchasing supplementary shelters or food, or taking part in vital bird counts. Attracting birds to your backyard or balcony is another. Provide birds with a place to Forage and Feed (see page 268), the right balance of food, and suitable shelter for Breeding and Shelter (see page 290) and your flocks should naturally increase. One small flutter for birdkind, one giant soar for birds.

Previous spread, left A pair of Treecreepers (Certhia americana) roost through the night among tree-creeping ivy (Hedera spp.) Right An adult tree swallow (Tachicineta bicolor) takes shelter in an empty bird box Opposite Help conserve endangered birds such as the sweetly singing Nightingale (Luscinia megarhyncos), one of many species that has been seriously affected by habitat loss and climate change

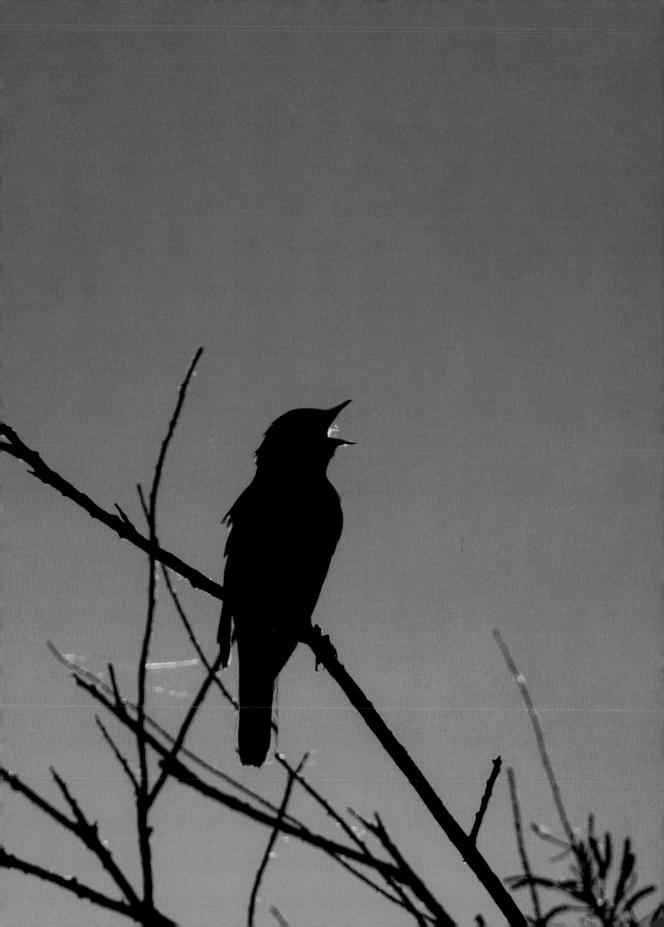

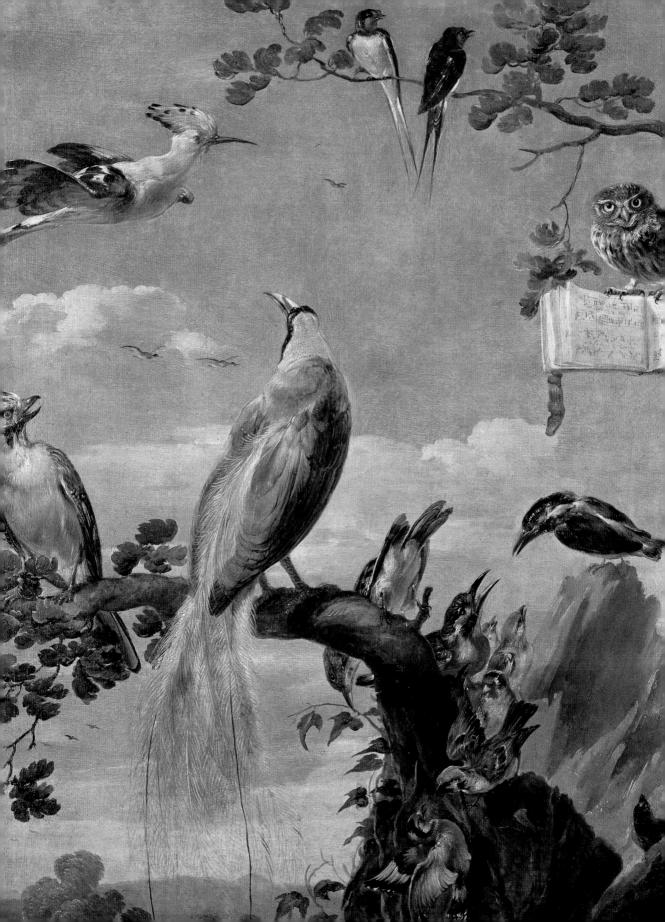

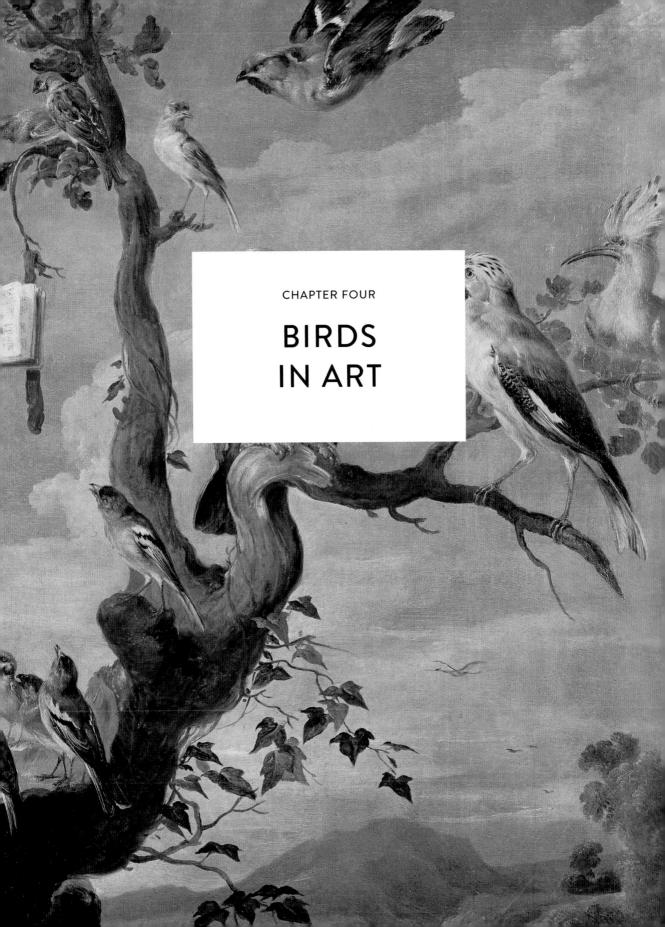

THE ART OF BIRDS

Birds have intrigued and inspired humans around the world for an estimated 40,000 years, the artistic and scientific documentation of their habits and habitats intrinsically entwined with the record of our own.

As fellow warm-blooded creatures of the animal kingdom we feel a natural affinity for birds and yet are fascinated with their evolutionary adaptations and differences: their extraordinary feathers, colorful or patterned plumes, captivating songs, ingenious nest-building and mating skills, predatory prowess, perfectly formed eggs, and their ability to fly sometimes huge distances across the globe. Birds also help maintain balance in our ecosystems in a way that directly impacts our health, food crops, habitats, and natural environments. Given this longstanding, intrinsic, and mutualistic relationship, the bird as muse features widely in the history of art, over a wingspan of thousands of years.

Fledgling impressions

The first fledgling portrayals of birds date back to Palaeolithic times: the shamanistic, beaked "birdman" of Lascaux Cave (c.15,000 BCE) in the Dordogne, France, sporting beside him a clear effigy of a small bird perched on a falling staff as he faces off a large bison. In Chauvet-Pont-d'Arc Cave in the Ardéche, an owl stares out from a cave wall—the first image illustrating this bird's unique ability to turn its head through 180 degrees? While paintings of giant emu-like birds thought to have become extinct some 40,000 years ago adorn the walls of a cave on the Arnhem Land plateau in Australia.

Birds were later incorporated into art as symbolic representations of freedom, power, royalty, immortality, or peace, soaring embodiments of humanity's hopes and dreams, a direct link between Earth and the spiritual realm. As the reach of Ancient Egypt (*c*.3150–332 BCE) and Greco-Roman Egypt (332 BCE–CE 629) spread along the wildlife-rich banks of the fertile River Nile,

so the teeming population of native and migratory birds including herons, hawks, falcons (relating to the god Horus), ibises (relating to the god Thoth), and geese were incorporated into the higher powers and hieroglyphics of the day. Further east, in the carved caves of Ajanta, India, birds can be found in breathtaking Buddhist frescoes, thought to date back to the Gupta dynasty of the fifth and sixth centuries CE. While, to the west, rock art in the Bighorn Basin in north-west Wyoming and Twin Bluffs, Wisconsin, in the Mississippi Valley are rich in eagle-like petroglyphs thought to be the first visual symbols of the legendary Thunderbird, a supernatural being of enormous strength and protective power, widespread in the bird-rich mythology of Native American and First Nations peoples.

As early indigenous and colonial civilizations advanced, so then bird forms and features along with other fauna and flora were also used decoratively and as part of illustrative records. Avian-inspired artifacts from this time include bird-inspired frescoes, statues, ceramics, and ceremonial or symbolic headdresses and masks—the latter sometimes adorned with feathers or other bird parts as worn by ancient Mayan, Aztec, Native American, First Nations, Polynesian, and Sub Saharan peoples. By the tenth century CE the graceful tradition of bird-and-flower painting had taken root in Tang-era China. Birds were also becoming commonplace in illuminated medieval manuscripts, especially around CE 1250-1350, the popular motif of the European goldfinch symbolizing the resurrection of Christ, fertility, and healing.

Previous page Concert of Birds (1629–30) by Frans Snyders includes "legless" birds of paradise (see page 313)

Top left Two Studies of a Bird of Paradise (1630) by Dutch artist Rembrandt Harmenszoom van Rijn **Top right** A Great Tit, Blue Tit, Cole Tit, and Marsh Titmouse From Thomas Pennant's British Zoology (1761–6) **Below** Pages from the ground-breaking A Natural History of Uncommon Birds (1743–51) by the "Father of British Ornithology" George Edwards

Ornithological forays

With Christianity prevailing across much of Europe, bird-referencing books of the time were either religious or compilations of classical authors such as Aristotle or Theophrastus. That is, until the arrival of what is thought to be the first illustrated ornithological work, De Arte Venandi cum Avibus or On the Art of Hunting with Birds (c. 1240s) by the maverick Holy Roman Emperor Frederick II. Covering a range of experimental and observational content from whether eggs hatch from the warmth of the sun to whether birds use their sense of smell while hunting, the detailed writing is accompanied by over 900 meticulous drawings of birds, and other animals.

Banned by the Church for its scientific lean, it was resurrected in the sixteenth century, joining printed and illustrated versions of Pliny the Elder's first-century *Historia Naturalis* (CE 77; printed 1469)— of which volume ten is entirely devoted to birds; Konrad von Megenberg's *Das Buch der Natur* (1475); Conrad Gesner's *Historiae Animalium* (1551–87), illustrated by Lukas Schan; Pierre Belon's *L'histoire de la nature des oyseaux* (1555) and *Pourtraicts d'oyseaux* (1557); and *Ornithology* (1599–1603) by the globetrotting Italian Aldrovandus, mainly produced using the art of woodcut.

Over in Persia, a manuscript of the witty and profound Sufi poem known as *The Conference of the Birds* by Farid ud-Din Attar (*c.* 1145–*c.* 1221), was exquisitely illustrated with ink, watercolor, and gold and silver paintings by Habiballah of Sava (1590–1610). In Ming-dynasty China, birds also featured frequently in literary works, literati paintings, and porcelain, while birds such as Manchurian cranes, golden pheasants, and Mandarin ducks, embroidered in badges of silk brocade, denoted the rank of scholarly court officials.

The golden age of engraving and still life

By the end of the sixteenth century, engraving was the up-and-coming illustrative technique of the day, as seen in John Jonston's much-translated field guide-style Historiiae naturalis de avibus or Natural History of Birds (1650–7); or Francis Barlow's Birds and Beasts in Sixty-Seven Excellent and Useful Prints (1655), Birds and Fowles of Various Species (1658), or his popular illustrations for Aesop's Fables (1666).

The turn of the seventeenth century also set the scene for a new genre of still life and wildlife painting, led by Dutch and Flemish painters such as Roelandt Savery—now famed for his images of the dodo (c. 1626, see page 375), soon to be extinct—Pieter Holsteyn the Elder, and Melchiorde Hondecoeter—the latter attempting to fly his birds across urn-embellished Italianate landscapes with postures of flight for many exotic species that could only have been imagined from their skins.

These imaginings become even more apparent in impossible pairings of South American macaws, Indonesian cockatoos, Eurasian jays, and European green woodpeckers in the work (1660-9) of Hungarian-British artist Jakob Bogdani who had a taste for including pops of red in his paintings, including the vivid plumage of a scarlet ibis and the cartoonish, redfeathered, male northern cardinal. A closer look at the great artist Hamenszoon van Rijn Rembrandt's ink-and-chalk drawing Two Studies of a Bird of Paradise (1630), Frans Snyder's Concert of Birds (1629-30), or Paul de Vos and Jan Wilden's Garden of Eden (1630s) also reveals legless, permanently flying birds of paradise, the skins of these beautiful creatures transported from the island of New Guinea as such, perpetuating the much-rumored myth that these really were "birds of the gods."

Suitably perched

Fast forward one hundred years and such symbolic illusions were cast away in favor of the suitably perched birds of Eleazar Albin's *A Natural History of Birds* (1731–8), patronage provided by the influential Irish doctor, naturalist, and collector Sir Hans Sloane. Albin shared his talents with his

daughter Elizabeth Albin, now recognized as the first female bird book illustrator, signing forty-one plates as her own.

Sloane also offered his support to "the father of British ornithology," George Edwards, who used his position as librarian of the Royal College of Physicians to embark on his A Natural History of Uncommon Birds (1743-51) and Gleanings of Natural History (1758-64). Notable for including a large number of North American birds—via the skins and live species imported from the New World, many of them for the first time—and acute, accurately described observations, around 350 of his descriptions were later used by the great Swedish naturalist Carl Linnaeus for his ground-breaking System Naturae (1758). Edwards also engraved his own plates under the tutelage of naturalist and artist Mark Catesby, donned "the father of American ornithology." Catesby's History of Carolina, Florida and the Bahama Islands (1741-3), including 220 hand-colored engravings of 109 birds, became the standard work on American birds, plants, and other wildlife until the end of the eighteenth century.

Other major contributions to eighteenthcentury bird art include Thomas Pennant's British Zoology (1761-6), Indian Zoology (1769), Genera of Birds (1773), and Arctic Zoology (1784). Also, John Latham's A General Synopsis of Birds (1781-5) including new species from the recently explored land now known as Australia, Index Ornithologies (1790) using a Linnaean system to list 3,000 apparently known bird species of the world (although some were later found to be the same species with different names) and his final ten-volume opus, A General History of Birds (1821-8) including birds from North America. Pennant also broke ground by employing the female artist Sarah Stone to illustrate some of his plates.

Birds of a New World

At the turn of the eighteenth into the nineteenth century, ornithology received another popularity boost thanks to the innovative intaglio white-line wood engravings and contemporary design of British artist Thomas Bewick's A History of British Birds (1797-1804). Over in France, similarly sympathetic bird compendiums included the Comte de Bouffon's Histoire naturelle, generale et particuliere (1749-89) with engravings by François Martinet and his team of more than eight artists and assistants, and Jacques Barraband's beautiful representations of exotic birds in François Levaillant's Histoire naturelle des oiseaux d'Afrique (1796-1808).

As global exploration gathered pace, so artists began to accompany naturalists on their voyages of discovery, including Sydney Parkinson, who sailed on Captain James Cook's HMS Endeavour across the Pacific Ocean between 1768 and 1771 to document flora and fauna collected by Joseph Banks and Swedish naturalist Daniel Solander. Following in his footsteps were doctor-artist William Ellis on Cook's voyage on HMS Discovery to New Zealand between 1776 and 1780, George Raper on board HMS Sirius, focusing on Australian birds c.1796–97, Ferdinand Bauer (1760-1826) on the HMS Investigator, and Scottish convict Thomas Watling (1762-1814) who was sent to the "land down under" for fraud but became one of Britain's most esteemed wildlife artists.

Across the Atlantic, naturalist John Abbot (1751–1840) was sent to investigate the plants and animals of Virginia by the Royal Society and amassed some 570 specimens in his first two months in the field.

Ornithologist Alexander Wilson followed suit with his *American Ornithology* (1808–14), when he traveled thousands of miles across the land in search of bird species and bird-loving subscribers. His request for support from a Louisville storekeeper and artist by the name of John James Audubon was rebuffed, while simultaneously inspiring Audubon's hugely successful *Birds of America*

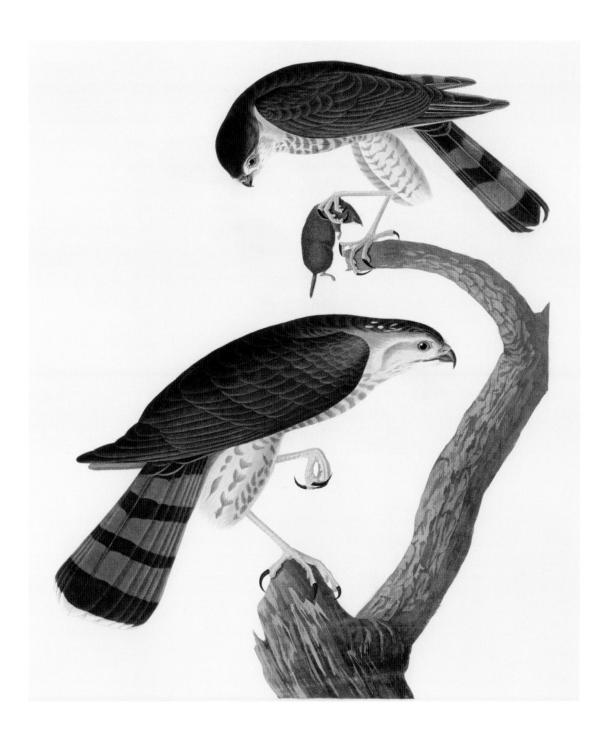

Sharp-shinned Hawk (Accipiter striatus) from John James Audubon's Birds of America (1827–38); still widespread across the Americas

Top left John and Elizabeth Gould's Blue and Yellow Tanager (Thraupis bonariensis darwinii) from Charles Darwin's Zoology of the Voyage of the HMS Beagle (1809–82) **Top right** Archibald Thorburn's Starling (Winter plumage) from Thomas Alfred Coward's The Birds of the British Isles and their Eggs (1920) **Below** The Pigeon (c.1890) by British artist Joseph Crawhall

(1827–38, see page 321). Upon finding success in the newly United Kingdom of Great Britain and Ireland, Audubon went on to commission Scottish ornithologist and artist William MacGillivray (1796–1852) to write much of the text.

Flights of fancy

Audubon's artworks were produced using copperplate etching, engraving, and aquatint, techniques soon superseded by lithography which allowed artists such as William Swainson (1789-1855) to draw directly onto stone (as opposed to relying on an engraver to transfer a design onto a metal plate) and pull multiple prints in the same run. Lithography also provided the tools to create such avian-inspired masterpieces as A Century of Birds from the Himalaya Mountains (1830-2), Birds of Europe (1937), part three of Darwin's the Zoology of the Voyage of HMS Beagle (1832-6) and The Birds of Australia (1840-8) by John and Elizabeth Gould (see page 324); John also created Birds of Great Britain (1873) after Elizabeth's untimely death due to the rigors of childbirth and travel. Other female artists making strides at this time include the intrepid Victorian artist Marianne North (see page 326) and her richly observed plants and animals.

John Gould also commissioned Edward Lear (see page 359) and Joseph Wolf to provide illustrations for his books, the former having already produced *Illustrations of the Family of Psittacidae, or Parrots* (1830), the latter having the enviable knack of being able to turn observations of lifeless bird skins into dramatic, soaring illustrations. When William Hart and Joseph Smit worked together to produce watercolors and lithographs for *Exotic Ornithology* (1866–99), the trade in bird specimens and bird books was fully fledged across all four corners of the globe.

The last half of the nineteenth century saw the production of beautiful plates by artists such as John Gerrard Keulemans and Henrik Gronvold for Gregory Mathews's monumental *The Birds of Australia* (1910–27), but a new raft of bird artists were also producing watercolors of common and backyard birds. Joseph Crawhall is lauded for his unlikely masterpiece *The Pigeon* (*c*.1890) while Leo Paul Samuel Robert (1851–1923) somehow incorporated a bird's-eye view into his work. By the close of the nineteenth century, new techniques such as photogravure and three-color letterpress were coming onto the scene, as seen in Henry Eliot Howard's *The British Warblers* (1907–14).

Fine artists were also exploring new mediums and methods of mark-making, including Swede Bruno Liljefors's (1860-1939) dramatic oil paintings of golden eagles, Eurasian eagle owls, and other birds of prey, and his as yet unmatched paintings of birds in flight. There was also Scottish artist Archibald Thorburn's watercolor portrayals of bird feathers and other fine features for Walter Swaysland's Familiar Wild Birds (1883) and Lord Lilford's Coloured Figures of the Birds of the British Islands (1885–98).

Birdwatching for the masses

Thorburn's latter set of illustrations reached an even wider audience when they were also used for Thomas Alfred Coward's *The Birds* of the British Isles and Their Eggs (1920) and for the pocket-sized Observer's Book of British Birds/Observer's Book of Birds, which sold millions of copies between 1939 and the 1970s. Thorburn's self-penned British Birds (1915–16) was also one of the first books to illustrate several related species of birds side by side, setting the scene for future field and identification guides.

Fellow artist George Edward Lodge also helped bring the wonder of birds and their habitats to the masses via his delightful paintings for David Bannerman's twelve-volume *Birds of the British Isles* (1953–63) as well as for numerous galleries and private collections. As did birds of prey expert Claude Gibney Davies and Marinus Adrianus Koekkoek, illustrators for *The*

Handbook of British Birds (Witherby, Jourdain, Ticehurst and Tucker, 1938–41) which, due to the clearly depicted plumage, habitat, and the male, female, and young of each species, became *the* handbook for a growing army of British ornithologists and birdwatchers.

This was joined by the American Citizen Bird (1923) dedicated to "All boys and girls who love birds and wish to protect" them by Elliot Coues and Mable Wright, with enigmatic drawings by the bird painter and tireless traveler Louis Agassiz Fuertes. Soon to add to the roster were the similarly loved wood engravings (1869) of Allan Cyril Brooks, Allen William Seaby (1867–1953) and Charles Frederick Tunnicliffe, the latter of whom created dramatic engravings for Henry E. Williamson's classic tale of Tarka the Otter (1932).

Conservation aware

The ability to capture the "jizz" or "giss" of a bird—the overall impression of a bird from its shape, posture, flying style, size, coloration, voice, habitat, and location—was now embraced by artists such as former cartoonist James Affleck Shepherd (1867-1946) and Eric Ennion (1900-81), a particularly skilled and patient observer of avian life. Many bird artists were also becoming increasingly concerned about the conservation of wildlife. Leading figures include British painter and naturalist Sir Peter Markham Scott, who contributed to The Birds of the Western Palearctic (1977)—a handbook of the birds of Europe, the Middle East, and North Africa. Scott founded the Wildfowl and Wetland Trust in 1946 and helped found the World Wildlife Fund (now the Worldwide Fund for Nature) in 1961. Another example is Roger Tory Peterson (see page 327), author and illustrator of the Guide to Birds (1934), and hailed as the first modern field guide, who was one of the founding inspirations for the twentiethcentury environmental movement.

Artists and illustrators such as David Allen Sibley (see page 328) and Jane Kim (see page 330) have then brought the art of

ornithology into the twentieth and twenty-first centuries, via *The Sibley Guide to Birds* (2000) and Kim's evolutionary *The Wall of Birds* (2015) mural, commissioned by The Cornell Lab of Ornithology in Ithaca, New York.

Figures such as American Modernist artist Charley Harper (page 362) and British bird artists and ornithologists Robert Gillmor (see page 366) and Matt Sewell (see page 329) have also popularized birding via their stylized yet duly observed depictions of our feathered friends. Gillmor's contribution is particularly important for his iconic rendering of an avocet for the RSPB (The Royal Society for the Protection) logo, as well as numerous illustrations for books, magazines, and exhibitions.

Soaring into the twenty-first century

Today, there are numerous ways to capture the identifying features and spirit of birds from photography and film to contemporary painting and sculpture, printmaking, and craft. The invention of photography in 1839, and most especially portable gadgets such

Top Current RSPB logo. Reproduced by permission of RSPB, © 2020 All rights reserved. Source: RSPB **Bottom** Current Cornell Lab of Ornithology Logo. See the Useful Resources section at the end of this book for further details on these organizations and more, aimed at promoting understanding and conservation of the birds of the world

as the Kodak Box Brownie, introducing snapshots to the masses from 1900, offered new ways to share images of birds from the pioneering work of early English wildlife photographer Eric Hosking (see page 346) and the high-tech hide observations of Bence Máté (see page 356) to Leila Jeffreys' (see page 354) portraits of parrots and pigeons or Thomas Lohr's zoomed-in photos of wings, bellies, and other bird parts (see page 355).

International photography competitions such as Wildlife Photographer of the Year and Bird Photographer of the Year (see page 343) have helped to inspire new and innovative ways to portray birds and the various aspects of their lives, while photographic bird identification guides now also sit alongside still-vital illustrated ones. *Collins Life-Size Birds* (Paul Sterry and Rob Read, William Collins, 2016) is a new addition to this beautiful flock.

The advent of the moving image in the late nineteenth century and, more recently, digitalized cinematography has also inspired such mind-blowing avian insights as David Attenborough's The Life of Birds (1998), bringing the sights, sounds, and weird and wonderful habits of birds from around the world directly into people's homes (see page 348). Other notable documentaries include Winged Migration (2001), a bird's-eye view offered by Earthflight (2011-12) and Luc Jacquet's award-winning March of the Penguins (2005), illustrating the heartwarming mating rituals and the quest to survive of emperor penguins in the frozen landscape of the South Pole.

The depiction of birds in fine art moved on from the stilted poses of still lifes and classically themed landscapes of the seventeenth century to include Pablo Picasso's iconic paintings and drawings of doves (see page 336); Constantin Brancusi's pared back bronze and marble representations of soaring birds (see page 338); Georges Braque's childlike collages and lithographs of birds in flight (see page 334), and Frida Kahlo's multiple self-portraits with her menagerie of parrots (see page 340).

More recent explorations include Mark Dion's giant walk-in aviary known as *The Library for the Birds* and the background flora and fauna of Kehinde Wiley's arresting portraits.

Last but not least, the aesthetic and symbolic qualities of birds have also been particularly inspiring for printmakers around the world and through time: the poetic tradition of pairing birds and flowers in what is known as Japanese kacho-e (see page 333) by artists such as Kitagawa Utamaro, Utagawa Hiroshige, and Katsushika Hokusai; the decorative designs of William Morris and C.F.A. Voysey, see page 360) segueing into Art Nouveau designs; or the linocuts of Rachel Newling (see page 368) and Angela Harding (see page 370). Artists such as Taiichiro Yoshida (see page 372), Andy Singleton, and Diana Beltran Herrera also enthuse with their bird-inspired artworks crafted from metal, feathers, and paper.

While humans may never have the physiological power of flight we can certainly observe birds exercising theirs—via 40,000 years or more of bird art as well as in our backyards—and imagine what it feels like to soar high above it all.

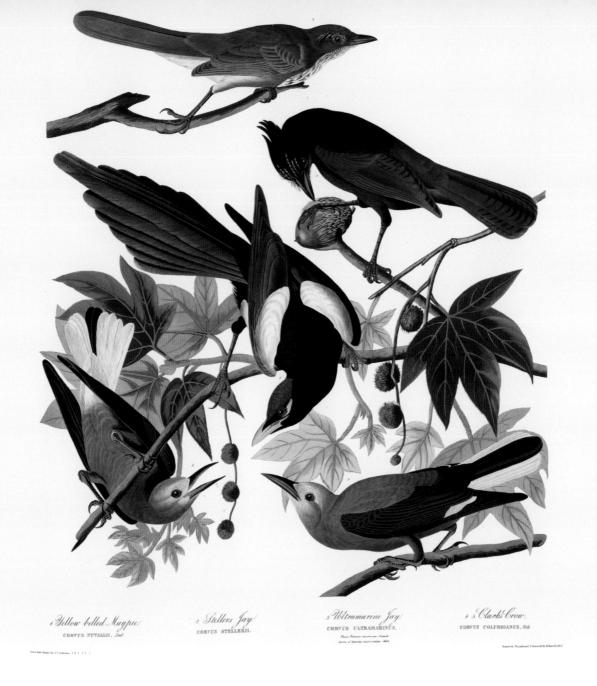

ORNITHOLOGICAL ART AND ILLUSTRATION

Thanks to esteemed ornithologists, natural historians, and writers such as Jonathan Elphick (*Birds: The Art of Ornithology*, Natural History Museum, 2014) and Roger J. Lederer (*The Art of the Bird*, University of Chicago Press, 2019) the many-feathered history of ornithological art is finally being given the platform it deserves. From celebrated works such as James Audubon's *Birds of America* to the lesser-spotted forerunners of today's bird identification guides or conservational works, these combined volumes reveal as much about our past and present human nature as they do about the lives of what now amounts to nearly 10,000 known birds, plus all those that were sadly left behind.

John James Audubon

(1785 - 1851)

What makes this stunning portal into the natural world even more intriguing is the complex backstory of its creator, self-taught naturalist, painter John James Audubon.

Born in the French colony of Saint-Domingue (now Haiti), the illegitimate son of French sea captain and plantation owner Jean Audubon and his chambermaid and mistress Jeanne Rabin (who died during his infancy), the young Audubon was first raised by Sanitte Bouffard, the mixed-race mother of John's half-sister, Rose. When the slaves of the island began to revolt, Jean moved his children to Nantes, France, where they then became the wards of his French wife, Madame Bouffard. To avoid conscription into Emperor Napoleon's army at the age of eighteen, he was then sent to America, taking up residence on the family owned estate at Mill Grove (now in the village of Audubon), near Philadelphia. Not only did this opportunity give him the chance to make his own fortune and meet his wife Lucy Bakewell, the 130-acre (53-ha) grounds were a paradise for indulging childhood passions for nature, birds, and art. Developing the first known system of ringing birds to track them, by tying strings around eastern Phoebes, and learning to set specimens for drawings took his avian interests to a new level.

Life as a tradesman eventually led him down the Ohio River to western Kentucky where he took up

Opposite Yellow Billed Magpie, Stellars Joy, Ultramarine Jay and Clark's Crow from John James Audubon's Birds of America (1827–39) **Top** "American Woodsman" John James Audubon (1785–1851)

residence in an abandoned log cabin and set up a dry goods store, hunting, fishing, and building up an impressive portfolio of bird drawings in his spare time—although 200 of these were at one point eaten by rats. Although relatively successful, when hard times hit due to rising tensions with the British, he was briefly jailed for bankruptcy. He began drawing deathbed portraits and for a short time worked as the first employee of the Museum of Natural History in Cincinnati to pay his way.

To Audubon this was obviously a pivotal moment, where he decided that he may as well follow his true calling rather than prop up a failing business. Leaving his stalwart wife behind with their two sons, and a new breadwinning role as tutor to wealthy plantation owners, he set off in 1820 down the Mississippi River—with nothing but his assistant Joseph Mason, a gun, his artist's materials, and survival skills picked up from Native American communities—to depict all of North America's birdlife with eventual publication in mind.

Audubon's risk paid off. Although away from his young family for months at a time, and rebuffed by some of America's leading scientists for being nothing more than a romantic backcountry upstart presenting birds in unnecessarily dramatic poses, his work was met with high praise across the Atlantic at the height of Europe's Romantic era. Touring England and Scotland in 1926 with 300 drawings to hand, he managed to raise enough funds to publish his work via advance subscriptions, exhibitions, oil painting exhibitions, and specimen skins.

Originally engraved by Robert Havell Jr. in aquatint on 'Double Elephant' paper, with "Ornithological Biographies" of each species later added by Scottish ornithologist and artist William MacGillivray (1796–1852), Audubon's *Birds of America* is now hailed as one of the world's greatest books and works of art of all time. As a keen observer of birds and other wildlife, an early pioneer for the conservation of nature, and a man of legendary strength and endurance, his legacy also continues via the crucial work of the National Audubon Society, working in the United States and beyond to protect birds and their habitats, now and for the future.

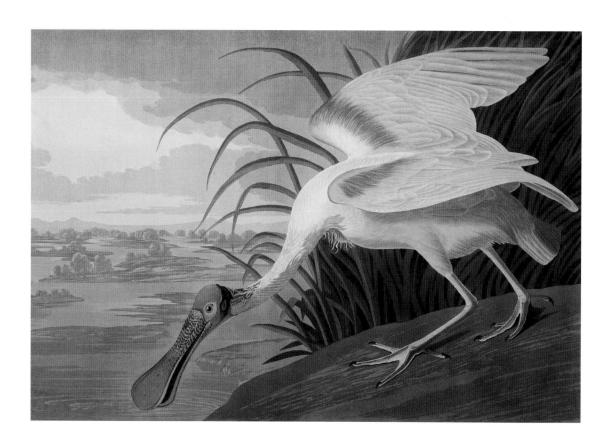

This page Roseate Spoonbill (Platalea leucoradia) and **Opposite page** Snowy Owl (Nyctea scandiaca), produced as hand-engraved plates of John James Audubon's original watercolors for his *Birds of America* (1827–39)

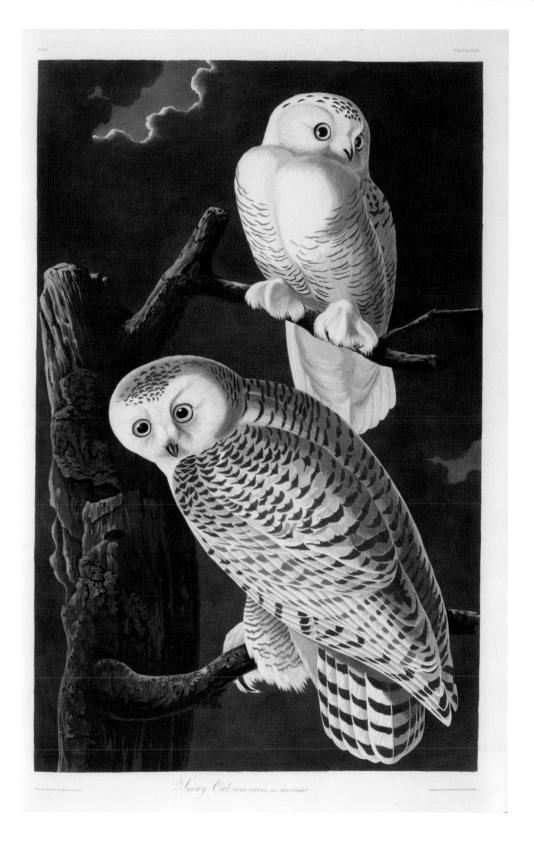

John Gould (1804-81) and Elizabeth Gould (1804-41)

ften referred to as "John Gould and his wife Elizabeth," this ground-breaking couple is jointly responsible for some of the Victorian era's most celebrated illustrated monographs on birds and are, thankfully, now credited as so.

The son of a gardener, a career he also initially pursued, it was John Gould's skill in the art of taxidermy that led to his making, becoming the first curator and preserver at the Museum of the Zoological Society in London. While there he was inspired to compile his first avian publication, A Century of Birds from the Himalaya Mountains (1830–2) based on specimens of birds' skins that he was given to mount and curate. John commissioned Elizabeth to draw the illustrations and create lithographs for eighty plates of the book, based on his notes and sketches.

A gifted artist, Elizabeth Gould (née Coxon) was born in Ramsgate into a relatively well-off military family. Marrying John at the age of twenty-four helped her escape a temporary role as a governess and provided a suitable outlet for her creative talents. She went on to illustrate and create lithographs for *Birds of Europe* (1832–7) and *The Birds of Australia* (1840–8)—both also featuring work by a young Edward Lear (see page 359) and part three (the birds volume) of *The Zoology of the Voyage of the H.M.S. Beagle* (1841). For the latter, Elizabeth was drafted in to illustrate Charles Darwin's now famous "finches" after John Gould helped identify and categorize them.

The Birds of Australia was a landmark publication in Victorian ornithology, featuring some 681 avian species, more than 300 of them new to Western science at the time. The trip forced Elizabeth to leave her young children for two years, however, and she sadly died not long after the birth of her eighth child. Although she didn't live to see her Antipodean observations in print, her legacy of more than 800 bird illustrations survives to tell her tale. One of the birds she drew, Mrs. Gould's Sunbird (Aethopyga gouldiae), is named in her honor. Various species of birds, including Gould's Toucanet (Selenidera gouldii) are named after John Gould.

Top Common Cactus Finch (Geospiza scandens) from The Zoology of the Voyage of the H.M.S. Beagle (1841) **Bottom** Western Wattlebird (Anthochaera lunulata) and **Opposite** Gouldian Finch (Erythrura gouldiae), both from The Birds of Australia (1840–8)

Marianne North

(1840 - 90)

"I am a very wild bird, and like liberty,"

penned botanical artist Marianne North in her Recollections of a Happy Life, Being the Autobiography of Marianne North (edited by her sister and published in 1892, after her death), summing up an extraordinary life rubbing shoulders with the largely male world of botany and quite literally painting her way around the natural world. Most well known for the 832 oil paintings patch-worked across the walls of the Marianne North Gallery, opened in 1882 in the Royal Botanic Gardens at Kew, in the UK, and for her prolific illustrative depictions of the plant kingdom, often made while traversing arduous terrain, a closer look at North's work also reveals numerous species of wildlife, including small mammals, insects, and birds. Thanks to these vividly colored, richly backgrounded illustrations—showing a bird's habitat as well as its markings and habits—"Parokeets of Madagascar" nestle within the long-leafed foliage of the "Ordeal Plant or Tanghin" (Cerbera manghas), "Sugar Birds" feed upon and nest near the "Fruit of Cythere" (Spondias dulcis) in the Seychelles, "Humming Birds" (Selasphorus rufus) congregate on the petals of a "California Dogwood" (Cornus nuttalli) and "Honeyflowers" (Protea mellifera) attract "Honeysuckers" in South Africa. At a time when many women spent much of their life indoors, this hyper-real snapshot of life on Earth provided breathtaking escapism not yet afforded by the wonders of color photography or today's social media scroll.

Top Marianne North painting the flora and fauna of South Africa c.1883 **Bottom** Avian life beside bird of paradise blooms in Marianne North's Streitzia and Sugar Birds

Roger Tory Peterson

(1908-96)

"Woods! Birds! Flowers! Here are the makings of a great naturalist."

So read the description of American naturalist, ornithologist, illustrator, educator-and one of the founding inspirations of the twentieth-century environmental movement-Roger Tory Peterson in his Class of 1925 yearbook. Although often teased for his intense passion for nature, he found an ally in his seventh-grade teacher, who signed up the whole class to the Junior Audubon club and often taught her students outside. As a budding art student Peterson then used the subject of birds to practice art and photography, with submissions to ornithological art competitions, published articles in Bird-lore magazine and membership of America's oldest ornithological organization, the Nuttal Club in Boston, winning him acclaim and contacts. One such meeting with Francis H. Allen, an editor at Houghton Miffin Company, led to the publication of the seminal A Field Guide to Birds (1934; sixth edition 2008), inspiring a brand new species of layman-friendly guidebook using the Peterson Identification System for the shape, pattern, and field marks of birds—in this case a wide range of hand-drawn and painted birds of North America—as opposed to a phylogenetic one, with clear notes on bird sounds and the most likely habitat and season in which to spot them. A truly ground-breaking invention, Peterson Field Guides are now available for spotting insects, plants, and other natural phenomena as well as birds of the world.

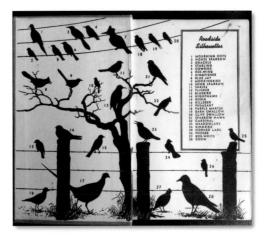

Top Dr. Roger Tory Peterson in the field on Hilbre Island, 1952 Bottom End pages of Peterson's A Field Guide to Western Birds (1947)

David Allen Sibley

(1961-present)

"Birds make any place a chance for discovery, they make a garden seem wild, they are a little bit of wilderness coming into a city park, and for a birdwatcher every walk is filled with anticipation,"

wrote American ornithologist and largely self-taught illustrator David Allen Sibley for an article on "Why Do Birds Matter" for Audubon.com in 2013. The son of a Yale ornithologist, Sibley's fascinated appreciation of birds was set at an early age. Childhood birding trips in Connecticut inspired the drawing of birds, which were soon accompanied by notes on the natural history of each species. The seed for the wildly successful The Sibley Guide to Birds (Alfred A. Knopf, 2000) was born. Its publication defined a new era in identification of birds in the field. Taking over six years to complete, Sibley set himself the challenge of representing hundreds (810 in total) of native and visiting North American bird species—not just as one image each, but with additional illustrations and layout and text options for every significant plumage variation, flight from above and below, and the complete range of vocalizations for each species and all significant subspecies variations. A second edition, published in spring 2014, included 600 completely new images, 111 additional species and more than 3,000 revisions—each bird painstakingly hand drawn and colored in gouache, from life.

Top Acorn Woodpecker and Bottom Wood Duck from David Allen Sibley's What It's Like To Be A Bird (Alfred A. Knopf, 2020)

Matt Sewell

(1976-present)

Every generation has their bird-spotting or inspirational bird book. For British birders finding a love of ornithology somewhere around the 2010s, that accolade quite possibly belongs to Matt Sewell's Our Garden Birds (Ebury Press, 2012). Featuring stylized watercolors of fifty-two of Britain's best-loved birds—one for each week of the year alongside innovative and witty descriptions inspired by Sewell's "Bird of the Week" blog posts for arts-natureculture collective Caught by the River, the book quickly became a cult hit. Sewell's parallel passion for birds and street art, plus a stint at art school and as a commercial illustrator, shines through via his bright, quirky watercolor renderings. Sketched as quickly as possible to help capture the over-riding character traits of each feathered friend, the science is still there—in directly observed and researched markings and via scientific species names allowing those wanting to know more to cross-reference with more traditional guides. For those sticking with Sewell's charming foray along the flight paths of the British Isles, further publications include Our Songbirds (Ebury Press, 2013), Our Woodland Birds (Ebury Press, 2014), A Charm of Goldfinches & Other Collective Nouns (Ebury Press, 2016), and the perfectly pocketsized Spotting and Jotting Guide (Ebury Press, 2015), in addition to worldwide art exhibitions and commissions for the RSPB, the National Trust and the Victoria and Albert Museum.

Top Bullfinch couple **Bottom left** Wren **Bottom right** Goldcrest and Firecrest, all from *Our Garden Birds* (Ebury Press, 2012) © Matt Sewell

Jane Kim

(1981-present)

"One Planet, 243 Families, 375 Million Years,"

reads the strapline of *The Wall of Birds* (Jane Kim with Thayer Walker, Harper Design, 2018), a sumptuously produced book celebrating artist Jane Kim's remarkable mural of the same name, produced for The Cornell Lab of Ornithology in Ithaca, New York. Commissioned by the lab's director John W. Fitzpatrick, who happened across some of Kim's mural work in *National Geographic* magazine, the mural stretches 78ft (24m) by 35ft (11m) and depicts 270 life-sized and scientifically accurate bird species and their relatives, simultaneously telling the story of their evolution and diversity.

A graduate of the Rhode Island School of Design, Kim then received a master's certificate in scientific illustration and won an internship at Cornell's prestigious ornithology department in Ithaca, New York. Having walked past the mural space numerous times—then a long stretch of wall painted a drab olive green above a flight of stairs—and already won acclaim for her large-scale work such as *Migrating Mural* (2012) along a 120-mile (193-km) stretch of California's Highway 395, the commission was a dream come true, spawning further nature-inspired murals under the guise of Ink Dwell studio.

A breathtaking example of science meeting art, Kim had to submit every sketch of her selected birds to a team of experts for an accuracy review before charcoal drawings were used to create to-scale renderings. Colors were applied directly with help from a specially created Avian Pantone Chart featuring such particulars as Finch Feet (a peachy mauve), Albatross Light (a light grayish blue), and the ubiquitous Cassowary Neck (a soft ocean blue). Extinct species including relatives such as dinosaurs were painted in a ghostly grayscale.

All in all, the evolutionary mural took two and a half years to complete, and depicts species from every modern bird family and across every continent, from the tiny spatuletail hummingbird to the 30-ft-long (9-m-long) *Yutyrannus* (ancestor of the first feathered dinosaur), with the National Audubon Society dubbing Kim the Michelangelo of the avian Vatican: soaring praise indeed.

Top San Francisco's section of the Migrating Mural by Jane Kim, Ink Dwell studio pays homage to the Monarch butterfly Opposite page top Artist Jane Kim at work on her The Wall of Birds mural at the Cornell Lab of Ornithology, Ithaca, New York Opposite page bottom Detail of The Wall of Birds mural by Jane Kim, Ink Dwell studio featuring a White-necked Rockfowl, a Yellow-billed Oxpecker, an African Finfoot, a Green Woodhoopoe, a Pin-tailed Wydah, and the foot of a Secretary-bird

Find out more about Jane Kim at www.inkdwell.com. To explore *The Wall of Birds* online visit: https://academy.allaboutbirds.org/features/wallofbirds/

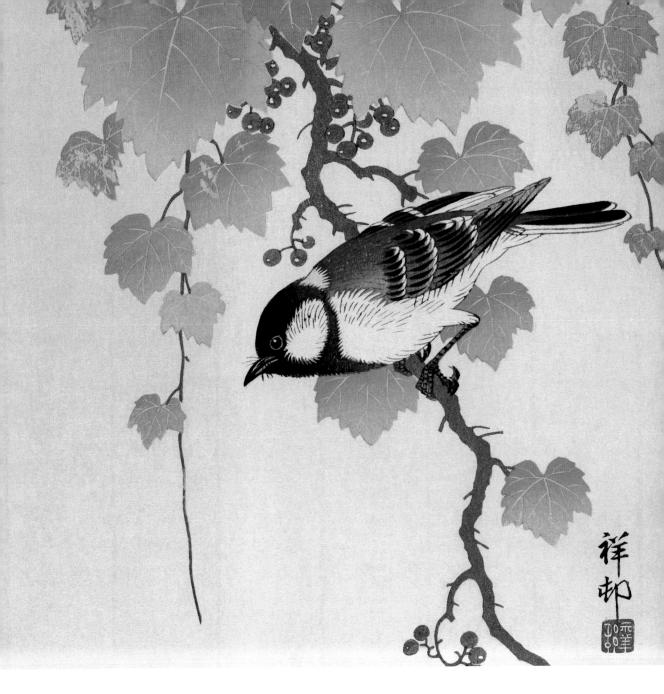

PAINTING AND SCULPTURE

The human relationship with birds and their breadth of species can also be traced through various depictions of avian life in painting and sculpture, from early Australian cave paintings dating back an estimated 40,000 years and spiritual homages to birds and flowers from the Far East, to the twentieth-century works of art history giants such as Pablo Picasso, Georges Braques, and Constantin Brancusi, and the more recent explorations of Mark Dion and Tracey Emin. Such works remind us of the symbolism, expressive energy, and survival instincts of birds, as well as their beautiful feathers, fascinating form, and enviable power of flight.

Kacho-e

(bird-and-flower print, 16th-20th century)

A great tit sits on a plum branch (*Great-tit on a Plum Branch*, Utagawa Hiroshige, c.1830s), barn swallows chat chatter in a cherry tree (*Barn Swallows on Weeping Cherry*, Ohara Koson, 1910), a blue bird perches with pride within the burnished foliage of an autumnal acer (*Blue Bird in Autumn*, Ito Sozan, c.1910s), a finch prepares to take flight from the stem of a hibiscus flower (*Finch and Hibiscus*, Utagawa Hokusai, c.1830), and pairings of birds burst into poetic song (from Kitagawa Utamaro's *Myriad Birds*, 1790). Centuries of artistic and spiritual Chinese and Japanese tradition pervade these beautiful, fleeting moments in the life of flora and fauna—specifically the depiction of "birds and flowers"—captured by some of the most iconic Asian artists of their time.

Although scenes of nature are centuries old in both Chinese and Japanese art, the specific tradition of kacho-e, focusing specifically on bird and flower motifs, elevated the avian world to soaring new heights. A subgenre of the ukiyo-e style of Japanese woodblock print and painting popularized in the Edo period (1603-1868), such scenes presented an alternative to the usual play and entertainmentthemed "Pictures of the Floating World" of female beauties, kabuki actors, sumo wrestlers, historic folk tales, travel scenes, and erotica. Living in the moment, kacho-e style allowed the viewer to be transported into a world beyond everyday fracas, a world of blossom-strewn, gently warbling peace and tranquillity. Look once and see a bird on a flower, look again and become part of that scene.

The eighteenth and nineteenth centuries are considered by many to be the "golden age" of kacho-e. One such master of the woodblock print, Kitagawa Utamaro, already well known for his images of beautiful women and courtesans, produced several nature-inspired collections of prints paired with romantic poetry, including his *Myriad Birds* (1790). Kitao Masayoshi was commissioned to interpret a pre-existing set of Chinese bird-and-flower handscroll paintings, and produced his softly colored

Opposite page Detail of *GreatTit on Paulownia Branch* (c.1925–36) by Ohara Koson (1877–1945) **Right** Detail of *Waves and Birds* (c.1825) by Katsushika Hokusai (1760–1849)

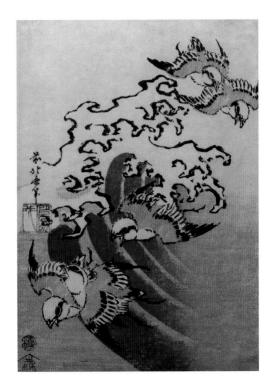

Compendium of Birds Imported from Overseas (1762). Utagawa Hiroshige, most famous for his collection One Hundred Famous Views of Edo (1856–9), added to his portrayal of landscapes, temples, shrines, and teahouses with deftly painted and colored, verticalformat depictions of finches, long-tailed tits, songbirds, kingfishers, sparrows, parrots, pheasants, and waterfowl among wild roses, creeping vines, blossoms, and grasses. While Katsushika Hokusai (1760–1849), best known for his Thirty-six Views of Mount Fuji (c.1830–2), including the internationally iconic color-print masterpiece The Great Wave off Kanagawa, also produced stylized prints of birds at rest and in flight.

Moving into the twentieth century and the Shin Hanga (new print) era, Ohara Koson (1877–1945)— also signing under the names Shoson and Hoson—is the undisputed master of kacho–e, proliferating what was by this time a ready market with literally hundreds of bird and flower prints. Working for renowned publishers such as Watanabe Shozaburo alongside other kacho–e artists of note, including Imao Keinen (1845–1924) and Ito Sozan (1884–*c*.1926), his work was often exported to the United States and Europe where the highly decorative, characterful, and tranquil nature of the works held much appeal.

Georges Braque

(1882 - 1963)

enowned alongside Picasso as the co-founder of KCubism, the great French painter, collagist, and sculptor Georges Braque first began to experiment with the motif of birds in the 1930s as a way to illustrate the Cubist philosophical investigation into differences between reality and representation. In Braque's Quatre Oiseaux (1950), for example, are the ghostly birds floating by real or a depiction of a pre-painted bird on a canvas against a studio wall? And in later works, such as the mesmerizing pinkand-black lithograph L'Oiseau Noir et L'Oiseau Blanc (1960), how much is this work an image of birds and how much a representation of the artist's personal artistic quest? It's also notable that Braque made many of his bird works toward the end of his life and certainly with a more simplified, childlike style than earlier, heavily Cubist creations. This was a turnaround in focus to themes of flight and transcendence that marry perfectly with his perpetually enquiring refusal to rest on the wing but also his nearing departure from this world. Famously commissioned to paint a ceiling fresco at the Louvre Museum in 1952, the Salle Henri II is now adorned with his soaring Deux Oiseaux against a bright blue sky, a bold rejection of the oppressive order, rigor, and symmetry of the pre-war world as well as a brilliant, color-injecting celebration of nature. As quoted in Alex Danchev's biography Georges Braques, A Life (New York, 2005),

"The bird is a summing up of all my art ... It is more than painting ... It's as if one heard the fluttering of wings."

Top Georges Braque's soaring oil on carvas *Deux Oiseaux* (1953), painted on the ceiling of the Louvre Museum in Paris **Opposite page** The beautiful lithograph *L'Oiseau Noir et L'Oiseau Blanc* (1960) appeared as the frontispiece of *The Order of Birds* (1962), a book printed to commemorate Braque's 80th birthday

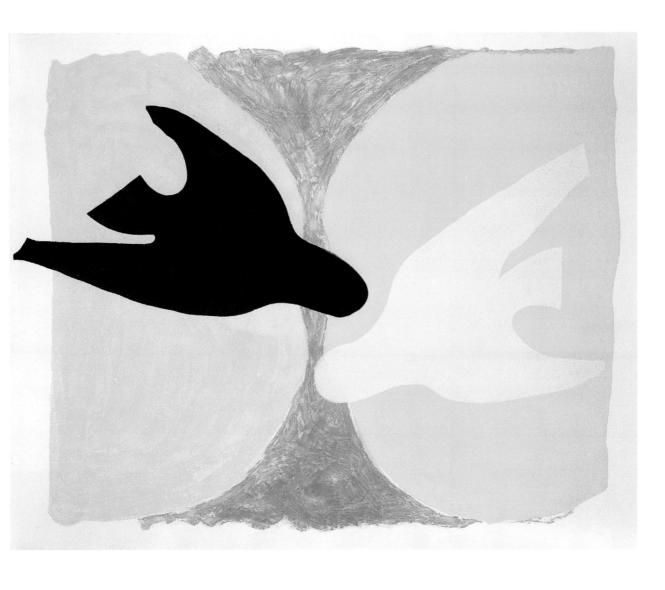

Pablo Picasso

(1881 - 1973)

A ccording to French painter and long-time partner of Picasso, Francoise Gilot, "Pablo loved to surround himself with birds and animals. In general they were exempt from the suspicion with which he regarded his other friends." Studio companions thus included a dachshund called Lump, an injured owl from Antibes, canaries, pigeons, and doves—a particular love of birds inherited from his artist father José Ruiz y Blasco, who specialized in the painting of them.

Picasso's earliest bird-inspired work is an oil painting entitled Child Holding a Dove (1901), created when he was just nineteen years of age. One of his last is the monumental sculpture known as the Chicago Picasso (1967), speculatively thought to be an abstract portrayal of beast, bird, or possibly female muse, or a chimera of all three. The most well known is La Colombe (The Dove) selected by the poet, surrealist, and Communist Louis Aragon to illustrate the poster of the first World Congress of Partisans for Peace held in Paris in 1949. A simple vet striking composition of a white dove on a black background, masterfully rendered in black in wash, it symbolizes peace and resilience in response to the fascist-led atrocities of the Spanish Civil War and the Second World War. In this case, Picasso's dove is a portrait of a snow-white Milanese pigeon gifted by fellow artist, friend, and lifelong rival, Henri Matisse (1869-1954). Paying a final homage to the master of the paper-cut, The Studio (Pigeons), in 1957, is a wistful scene of an open window looking out upon the Mediterranean, surrounded by doves. Picasso's Dove of Peace series, meanwhile, includes two of his most recognizable works, one being a simple graphic line drawing of a bird with a twig (1949), the other a similarly abstract version with colorful flowers made the same year and used as the emblem of the World Peace Council to this day.

Top The Spanish artist Pablo Picasso in his workshop in Antibes (1946) with his pet Little Owl, Ubu **Bottom** Dove (pastel on paper, 1949), one of several iconic images produced by Picasso of this symbolic bird **Opposite page** Picasso's Child Holding A Dove (oil on canvas, 1901), now residing in the National Gallery in London and produced when Picasso was just 19 years old, illustrates a love of birds from a young age

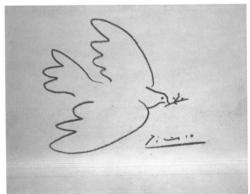

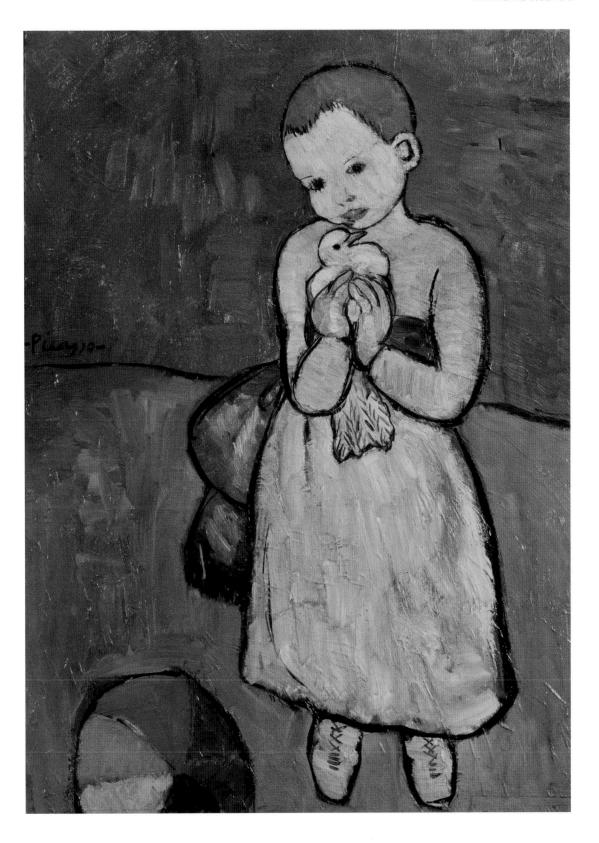

Constantin Brancusi

(1876 - 1957)

any artists have become preoccupied with $extbf{VL}$ the theme of a bird in flight. For France-based Romanian sculptor Constantin Brancusi, his paredback representations of soaring birds—a series of sixteen versions of an initial Bird in Space (1923)—not only paid homage to the wonders of the avian world, they questioned the very nature and meaning of art. Seeking to convey the essential nature of a bird elegantly soaring upward in flight, he intuitively eliminated wings, feathers, or an obvious beak in favor of an unfettered thrusting column of bronze or marble, balanced on a slender conical footing, swollen at its center and sliced cleanly off at the top in a slanted oval plan. Movement rather than physical attribute being the driving force, the title of the work serving to enlighten the viewer should they query the inspiration behind the piece.

To question the artistic merit of such a beautiful and much-heralded piece of sculpture today seems unthinkable, but Brancusi's Bird in Space series was once the subject of a court dispute on exactly that. Arriving in New York from France in 1926 on board the steamship Paris, final destination the Brummer Gallery as part of an exhibition of works curated by Brancusi's friend and advocate Marcel Duchamp, a 1926 bronze version of Bird in Space (now in the collection of the Seattle Art Museum) was stopped at customs as not fitting the tax-exempt description of sculptural art. That is, "reproductions by carving of casting, imitations of natural objects, chiefly the human form." Refusing to let it into the country without a 40 percent "manufactured metal objects" taxation charge, it was eventually released on bond under the category of "Kitchen Utensils and Hospital Supplies." Customs continued to contest its validity as art and the issue went to court, with artists and art experts testifying both for and against the defence.

As director of the Brooklyn Museum at the time, William Henry Fox, affirmed, "It [Birds in Space] has the suggestion of flight, it suggests grace, aspiration, vigour, coupled with speed in the spirit of strength, potency, beauty, just as a bird does." Brancusi's sixteen birds now thankfully reside in many of the leading galleries of North America and the world.

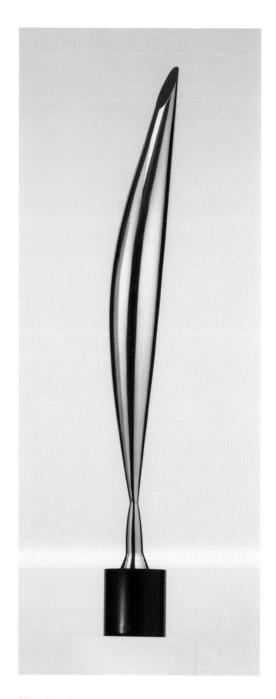

Above *Bird in Space* (polished bronze, 1924), one of sixteen versions of this game-changing series of artworks by Romanian sculptor Constantin Brancusi. Now residing in the Philadelphia Museum of Art, the soaring sculpture epitomizes a bird in flight

Barbara Hepworth

(1903-75)

▼n 1961,Yorkshire-born sculptor Barbara Hepworth **L** was invited by the iconic British department store John Lewis to design a sculpture for the façade of their newly restored flagship branch on Oxford Street, London, on the premise that the work should "have some content that expresses the idea of common ownership and common interests in a partnership of thousands of workers." Hepworth originally submitted a piece called Three Forms in Echelon but John Lewis wanted something more "Hepworth." The accepted proposal, a 19-ft (5.8-m) aluminum cast Winged Figure, created 1961-2, based on an earlier work from 1957, Winged Figure I, and pen and ink drawings now found in The Hepworth Wakefield Gallery, is now one of her most iconic pieces of art as well as a muchloved twentieth-century London landmark. "I think one of our universal dreams is to move in air and water without the resistance of our human legs," she explained."I wanted to evoke this sense of freedom. If the Winged Figure in Oxford Street gives people a sense of being air-borne in rain and sunlight and nightlight I will be very happy." Indeed, flight and birds were a life-long preoccupation for Hepworth, be it "the weight, poise, and curvature of the ovoid as a basic form" in works such as Bird Form (1963/8/9) or the anatomical and metaphysical properties of wings in Stringed Figure (Curlew), Version I (1956) or Version II (1959).

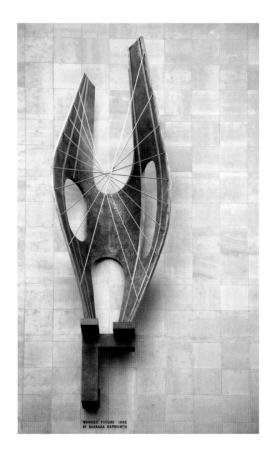

Above Winged Figure by the British artist Barbara Hepworth (1903–75) exists as both iconic artwork and landmark upon the flagship John Lewis store in London

Frida Kahlo

(1907-54)

ike Pablo Picasso (see page 336), Mexican artist Frida Kahlo shared her studio with a menagerie of pets, including parakeets, macaws, hens, sparrows, an eagle not so eloquently referred to as Gertrudis Caca Blanca (Gertrude White Shit), a fawn called Granizo, a hairless Mexican Xoloitzcuintle (a breed of dog with an ancestry traceable back to the Aztecs) by the name of Mr Xoloti, a parrot called Bonito (who would perform tricks at the table for pats of butter), and a couple of spider monkeys known as Fulang Chang and Caimito de Guayabal. Following a case of polio as an infant, a life-changing bus accident as a teenager, and subsequent health and reproductive problems throughout her adult life-not to mention a tumultuous marriage with fellow artist Diego Rivera —these treasured animals kept her company at her main residence of Casa Azul (the Blue House), brought her fleeting moments of joy and appeared in countless paintings, many of them self-portraits. Parrots are particularly present in her work especially in the period following the death of her father and at the onset of intense physical painincluding Self Portrait with Bonito (1941), Me and My Parrots (also 1941), and Self Portrait with Monkey and Parrot (1942). Rather than detract from Kahlo, the parrots add weight to the strength of gaze, provide rich color and texture, and contribute to the folkloric symbolism, intimacy, and self-analysis that pervade Kahlo's work. Birds of a feather, as it were.

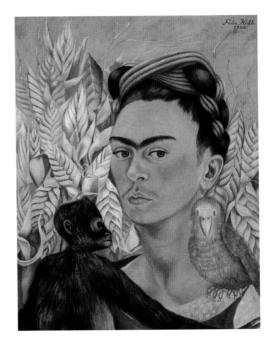

Above Mexican artist Frida Kahlo shared her studio with numerous pets, inspiring several paintings including *Self Portrait with Monkey and Parrot* (oil on masonite, 1942) as now found in the Museo de Arte Latinoamericano de Buenos Aires, Argentina

Karl Martens

(1956-present)

wedish-American artist Karl Martens's exquisitely rendered watercolor paintings of birds of prey and waterfowl stem from many years of dedicated observation of the avian world. Having drawn and painted birds from childhood and previously created extremely detailed ornithological works, his winning approach no longer includes painting directly from life. Taking influence from both Eastern and Western philosophies, especially Zen Buddhist meditation, he now prefers to paint entirely from memory, applying watercolor from above onto handmade paper positioned on the floor of his studio. Using a selection of traditional Japanese and Chinese paintbrushes he then brings his birds and their typical habits and characters to life via sweeping washes and calligraphic brushstrokes until wings, breasts, tail feathers, beaks, and colorful markings come together to make a whole."The best result is achieved when no thought is given to it; when the mind rests in emptiness and intuition takes over," explains Martens, seeking out the emotional essence and intrinsic movement of each subject, from battling pigeons, inquisitive yet tentative wrens, and proudly plumed kingfishers to soaring eagles, predatory kites, and running mallards. By confronting the unexpected, the unexpected takes flight, delighting bird and art lovers around the world.

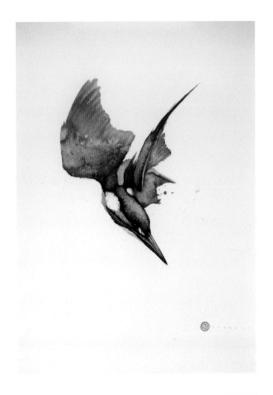

Top Swedish-American artist Karl Martens uses sweeping washes and calligraphic brushstrokes to bring birds to life, such as *Kingfisher*, 2020 (20.5in/52.07cm × 14.5in/36.8cm, Watercolor on Arches Paper) and **Bottom** *Golden Eagle*, 2016 (39.5in/74.9cm × 59in/149.8cm/, Watercolor on Arches paper)

PHOTOGRAPHY AND FILM

The birth of practical photography in 1839, followed by motion picture cameras in the 1890s, provided huge potential for the documentation and expressive illustration of birds, although it would be some decades before technology allowed for the subtle approaches, shutter speed, and zoom required for getting a good shot. From the first inspiring and impressively captured black-and-white images of Eric Hosking to the magnificence of full-color, high-resolution digital artworks by award-winning bird photographers such as Bence Máté or Leila Jeffreys, the medium of film continues to stunningly capture birds' majesty.

Bird Photographer of the Year

(BPOTY; 2014-present)

Dalmatian pelican on Lake Kerkini in Greece Λ runs toward the hopeful lens of award-winning photographer Caron Steele in Dancing on Ice (2019). Yellow reptilian-like feet peek out from the zoomedin black-and-white belly feathers of a mature northern goshawk courtesy of Pal Hermansen's watchful eye and long lens. While an endangered black skimmer swoops low over water in Ocean City, New Jersey, in the hope of snapping up some tiny fish for its newborn chicks in an image taken from the perspective of a crouching and very patient Nikunj Patel. Each image is a snapshot into the fascinating world of birds, into the power and potential of modern technology, and proof of the old adage that good things come to those who wait. Together, they mark five years of the Bird Photographer of the Year Award (BPOTY) in all its avian glory and photographic prowess.

Founded in 2014 by internationally renowned wildlife author and photographer Paul Sterry, nature image expert, author, and photographer Rob Read, and natural historian and conservationist Andrew Cleave MBE, BPOTY is now a popular highlight of wildlife and cultural calendars, featuring images from a global collective of amateur and professional photographers and birders, across a selection of inspiring categories: Attention to Detail, Best Portrait, Bird Behavior, Birds in Flight, Birds in the Environment, Black and White, Creative Imagery, Garden and Urban Birds, Inspirational Encounters, Best Portfolio, and Conservation Documentary. Judged by an evolving panel of naturalists, bird experts, passionate conservationists, top wildlife photographers, and creatives, the call out culminates in a touring exhibition of the most captivating shots. Plus there's a collectable compendium of winners, runners-up, and commended entries in the annual William Collins-produced Bird Photographer of the Year book.

By entering the competition, photographers not only gain recognition, a potential prize, and show their passion for birds: part of the money raised via

Opposite page Detail of a stunning close-up of a Northern Goshawk (*Accipter gentilis*) by Norwegian photographer Pål Hermansen won the "Attention to Detail" category of the Bird Photographer of the Year (BPOTY) 2019

submission fees goes toward supporting vital work in bird conservation by organizations such as the British Trust for Ornithology, Wildlife Worldwide, Birdfair, the World Land Trust, the National Biodiversity Network, and Hookpod. As such, the BPOTY team launched a new Conservation Documentary award for 2020, aimed at highlighting a bird-related conservation or environmental issue via a series of three to six photojournalistic images with extended captions to help the story unfold. Judged by legendary conservationist Mark Carwardine and environmental campaigner Mark Avery, entries for the category's launch included a tale about the loss of nesting habitat of swifts through modern building methods—a situation that could be addressed by factoring nesting sites into new builds—and the danger of major roads to low-flying barn owls scouring grass verges for food.

Indeed, the judges of BPOTY are testament to the quality of the entries, with past and present luminaries including English naturalist, nature photographer, presenter, and author Chris Packham CBE, and award-winning wildlife photographers Brian E. Small and David Tipling. In Packham's own words, "[Birds] fly off, don't listen to a word you say and are a much-favored subject in the wildlife photography genre—hence there is massive competition, making it hard to 'say something new' with an image. But the winning image [of the Bird Photographer of the Year] exemplifies this art perfectly—a much photographed, familiar and accessible subject is represented in an entirely new and fabulously imaginative way." With a Young Bird Photographer of the Year (YBPOTY) also open to young people of all ages up to eighteen, hopefully a new generation of birders and photographers can help celebrate and conserve birds well into the future.

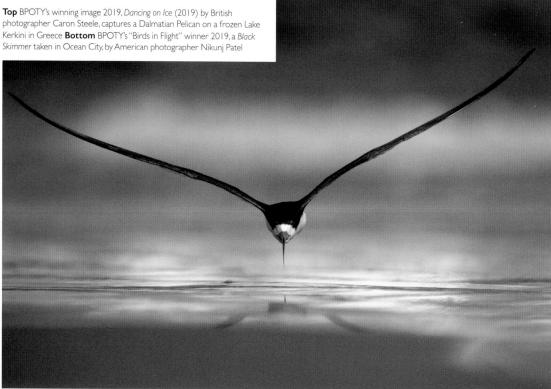

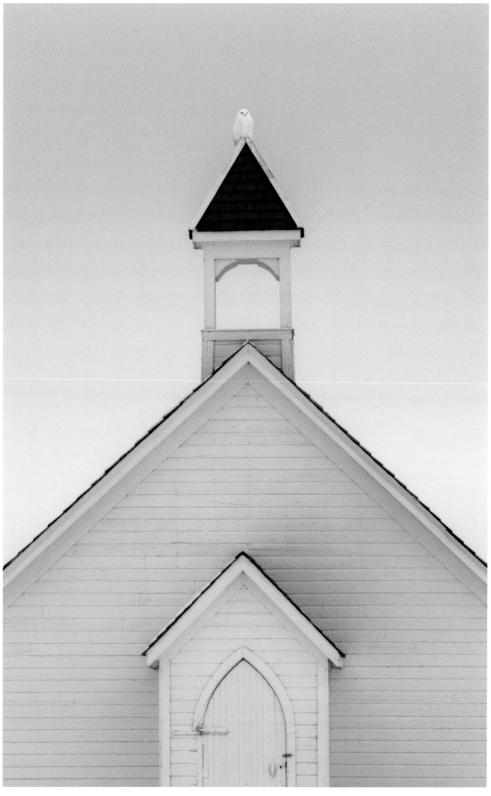

Snowy Owl perching on a rooftop by Canadian photographer Chad Larsen, winner of BPOTY's "Garden and Urban Birds" category 2019

Eric Hosking

(1909 - 91)

I magine taking photographs of birds, not with today's perfectly portable digital devices or the aid of other numerous technological advances, but with an early Kodak Box Brownie (a very basic, pioneering film camera) or a cumbersome Sanderson field plate camera. For a young Eric Hosking, the arduous task of lugging such equipment around on bird-watching trips, waiting for that winning single shot, or working in black and white were not enough to put him off. In fact, such technical obstacles appear to have only spurred the legendary English wildlife photographer and ornithologist on, not only to produce a remarkable body of work but also to help develop new ways of observing and capturing the world on film.

As Eric Hosking's best-selling biography *An Eye for a Bird* (1970) illustrates, birdwatching and photography was once the pastime of the eccentric few, certainly not something to earn a living from. Having caught the bird photography bug at the tender

age of eight with a picture of a song thrush in its nest, followed by his first commercial sale—of an image of a child at London Zoo next to a baby elephant seal, —Hosking was determined that this was the career for him.

Despite then losing the sight in his left eye after being struck in the face by a tawny owl, he followed his dream, honing his photographic skills, building an extensive library of avian images, and taking the first ever flash photograph—ironically, of an owl with its prey. By the mid-1970s he had photographed virtually every species of bird in Britain, was invited by the big names in ornithology to join them on major expeditions around the world, and had invented a bird-operated electronic triggering mechanism for ultra-high-speed photography of birds in flight. As British natural scientist and author Miriam Rothschild wrote in her foreword for Eric Hosking's Classic Birds: 60 Years of Bird Photography (Jim Flegg and David Hosking, HarperCollins, 1993), a pictorial tribute to Hosking's work,

"Eric Hosking brought birds into all our lives. He opened our eyes to the beauty of their world, their grace and fascination. He probably achieved more for avian conservation than any other naturalist of our day."

Top Trailblazing British photographer Eric Hosking in the field **Opposite page top** Hosking's *Barn Owl* (*Tyto alba*) in flight with prey (1948) **Opposite page below left** A Sanderson Field Plate camera image of a *Tawny Owl* (*Strix aluco*), the owl that took Eric Hosking's eye, 19 April 1938 **Below right** Hosking's image of *Mantagu's Harrier* (*Cicus pygargus*) in flight, May 1938, also inspired the crest of the RAF's 193 Squadron

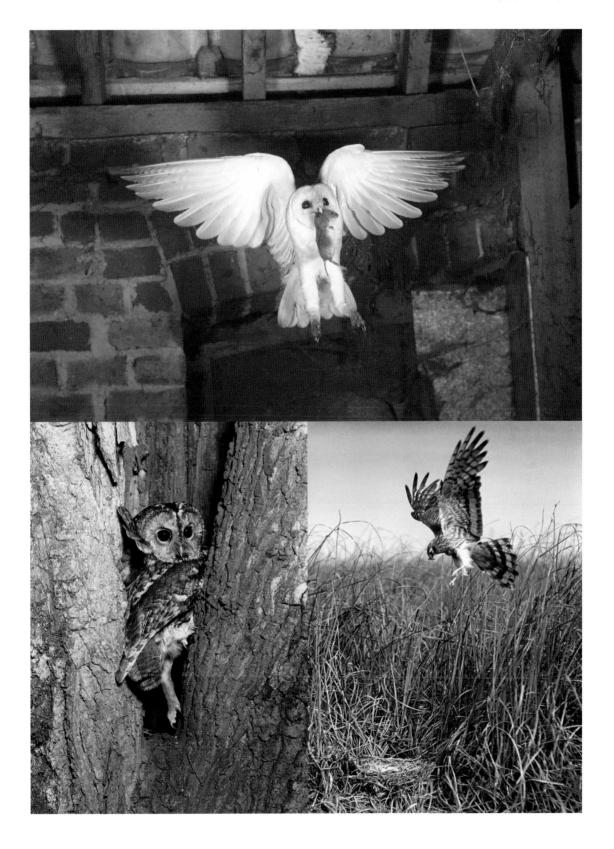

David Attenborough

(1926 – present)

7ith the far-reaching documentaries of David Attenborough we have now been gifted even greater insights into the as yet mysterious avian world. Part of British naturalist and presenter David Attenborough's "Life" series of documentaries The Life of Birds (1998) brought the extensive wonder of the avian world into homes around the globe including, but also far beyond, the backyard species of the everyday. Expanding on an episode entitled "Lords of the Air" from Attenborough's ground-breaking natural history series (1979), The Life of Birds took two and a half years to film with a huge amount of dedication to cinematography—including the use of imprinting where human "mothers" developed a relationship with birds from birth to get closer to them—but also to sound, with bird calling and song recorded simultaneously rather than dubbed onto the film post-production. How birds fly, their peculiar appetites, exquisite plumage, types of communication, ways of courtship and mating, commitment to parenthood, and quest for survival are wonderfully narrated by the inimitable Attenborough, alongside the spectacular filming of over 300 bird species such as the kiwi, buff-breasted sandpiper, whooping crane, birds of paradise, ostrich, albatross, Nepalese honeyguide, and the show-stealing lyre bird, by some of the world's best wildlife photographers: Barrie Britton, Andrew Anderson, Mike Potts, and Justine Evans to name a few. The life of birds—of the rainforest, the desert, the ocean, wilderness, our towns, and gardens—at their charismatic best.

Top British naturalist and TV presenter Sir David Attenborough, face to face with a Golden Eagle (*Aquila chrysaetos*) in 1998 **Bottom** A male Vogelkop Bowerbird (*Amblyarnis inornata*) inspects his blooming bower hoard, shot in West Papua, Indonesia for Attenborough's *Life* (2009) **Opposite page** Camerawoman Justine Evans getting a bird's eye view of Venzeualan avian life and Sir David Attenborough for *Life of Birds* (1998)

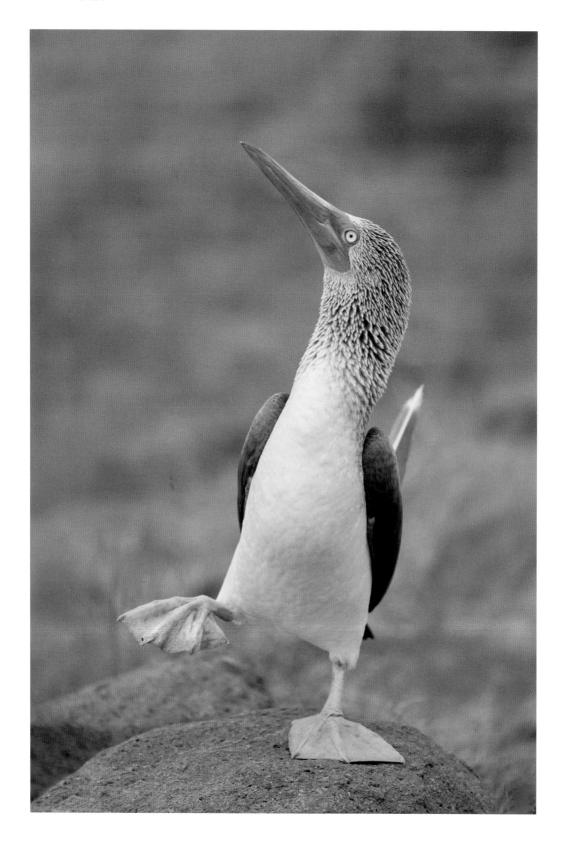

Arthur Morris

(1946-present)

ne of Canon's original alumni of their Explorers of Light program and author of the best-selling and still much pored-over pre-digital bird photography handbook *The Art of Bird Photography: The Complete Guide to Professional Field Techniques* (Amphoto Books, 1998), New York teacher turned Florida-based internationally renowned professional photographer Arthur Morris has inspired generations of bird photographers around the world. Segueing from twenty-three years as an inner-city schoolteacher to self-taught, award-winning nature photographer specializing in avian subjects, thousands of his images—noted for both their artistic design and their technical excellence—have since graced the pages of magazines and galleries from birding publications to

National Geographic to the Museum of American Bird Art at Mass Audubon. Sticking to a consistently clean, tight, and graphic style, whether shooting on film or embracing new technology, Morris's celebratory images are also packed with character and educational insight, from crisply shot perching puffins to incredibly focused soaring owls to perfectly composed feeding wildfowl. Always on hand to offer guidance, through lectures, books, or in his online Birds as Art (birdsasart.com) forum, one piece of compositional advice stands out: the background is just as important as the subject. Morris's equally stunning images of both backyard and rare birds, set against deep azure or sunset skies, verdant vegetation, or still blue water are certainly testament to that.

Opposite page Blue-footed Booby Dancing With Raised Foot in North Seymour, Galapagos Islands, and **Below** Northern Gannets in Love on Bonaventure Island, Quebec, both by American photographer Arthur Morris, www.birdsasart-blog.com

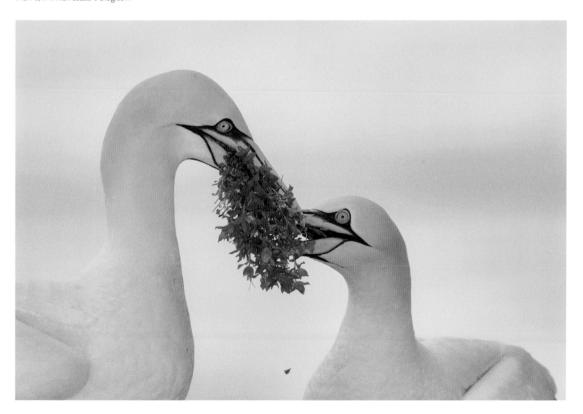

Dudley Edmondson

(1962-present)

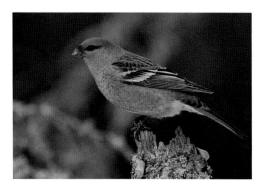

Trek up to Minnesota's Hawk Ridge on the western-most tip of Lake Superior in the United States from mid August to December and you will bear witness to one of nature's most remarkable spectacles—hundreds of migrating raptors heading south for the winter, among them American kestrels, sharp-shinned hawks, northern goshawks, peregrine falcons, and eagles. Move to the nearby lakeside city of Duluth, as avid birder and wildlife photographer Dudley Edmondson did in 1989, and you're only a short trip away from the abundant rewards of this nationally renowned bird observatory and surrounding nature reserve all year round.

Having already found respite in the outdoors as a child, looking at bugs and birds in the backyard or out on a family picnic or hike, Edmondson was inspired into more serious birdwatching by a teacher at his senior high school in Columbus, Ohio. Invited on a field trip to watch the birds of the Rio Grande Valley, raptors and birds of prey quickly became something of a highlight with photography providing a way to capture the magnificence of these soaring birds. Moving near Hawk Ridge not only brought Edmondson closer to some of his favorite birds and some of America's most spectacular natural scenery, it also allowed him to cement his career as a professional observer of wildlife. His work has since appeared in numerous birding journals and books, plus visual campaigns for clients such as The Nature Conservancy and the National Parks Service.

Several decades of birding, photography, video reportage, public speaking, and nature advocacy has taught Edmondson much about the animals, plant, and

areas of wilderness that he now engages with every day, but also the people that he meets along the way. In an endeavor to encourage more African–Americans like himself into the pursuit of nature he produced a photographically illustrated anthology of similar experiences in his 2006 book *Black and Brown Faces in America's Wild Places* (Adventure Publications), including thoughts from park rangers, world-class mountain climbers, government administrators, and fellow artists and ornithologists. He has since been on a mission to inspire more people of color and minority backgrounds to benefit from America's green spaces, whether that's in their local park or by getting out and exploring surrounding landscapes.

"Nature has been a constant in my life. Through birds, I learned about conservation and so much more in the natural world. Nature's mental and physical health benefits are much needed. As people find themselves sheltering at home, birds and gardens provide an escape from the stress and uncertainty in the world today."

Above A Pine Grosbeak (Pinicola enucleator) perches on a branch Opposite page top A female Northern Cardinal (Cardijnalis cardinalis) foraging for food Opposite page bottom A watchful Great Gray Owl (Strix nebulosa) in the snow, all by American wildlife photographer and author of Black and Brown Faces in America's Wild Places (Adventure Publications, 2006), Dudley Edmondson

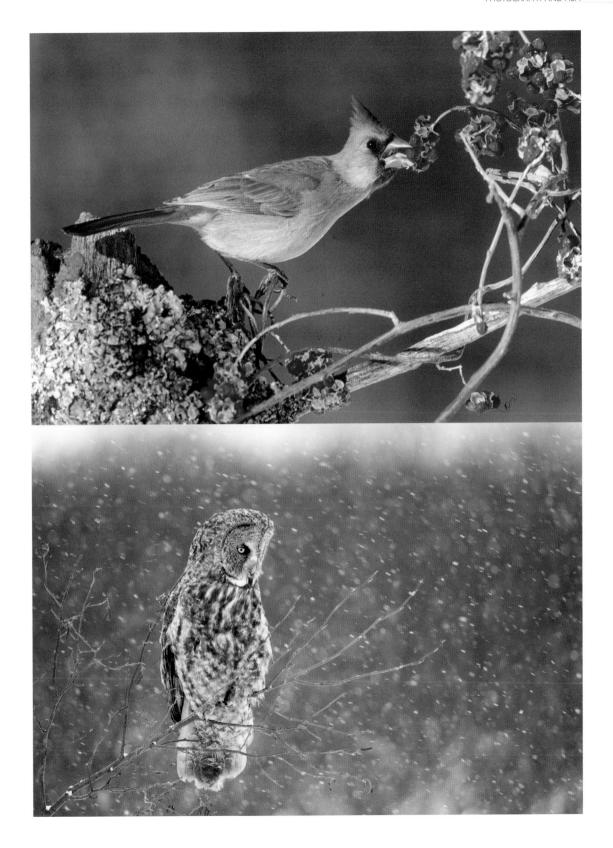

Leila Jeffreys

(1972-present)

hotographing birds up close is difficult; getting T them to pose for photographic portraits is near on impossible. Yet Australian photographic and video artist Leila Jeffreys has done just that, working alongside conservationists, ornithologists, and bird sanctuaries—and birds such as Jimmy the budgerigar, Seisa the palm cockatoo, and Pepper the southern boobook-to produce a remarkably intimate body of avian-inspired work, at once beautiful and questioning. What does it mean to be a bird? How, as humans, should we interact with them? What can we do to help wild birds through issues such as habitat loss and climate change? Jeffrey's first foray into bird documentation culminated in the muchlauded Portrait of a Budgerigar (2010), followed by Bioela Wild Cockatoos (2012), Prey (2014), Ornithurae (2017), featuring cockatoos, doves, and pigeons alongside birds in trees, and back to budgies with High Society (2019). Global exhibitions and books such as Interview with a Cockatoo (or Two) (2012) and Bird Love (Hatchette/Abrams, 2015) have also compounded Jeffrey's dedication to protecting birds as well as artistically portraying them, leading to an expedition to the Arctic Circle in 2019 on the invitation of British historian and explorer Dr. Huw Lewis-Jonesa love and compassion for our feathered friends evident throughout.

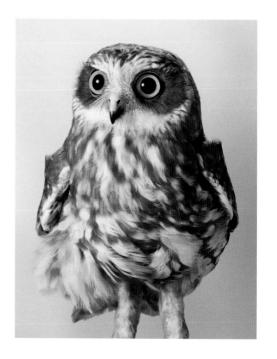

Top Bird portraits of *Pepper Southern Boobook* and **Bottom** *Seisa the Palm Cockatoo*, both by Australian photographer Leila Jeffreys, www.leilajeffreys.com

Thomas Lohr

(1980-present)

In 2015, this German fashion, portrait, and still life photographer turned his usually human-focused lens onto the avian world with the publication of his limited-edition art book *Birds* (Studio Baer). The initial idea behind the project was to produce a study on textures and colors by zooming in on feathers and plumage "to show the beauty of birds while approaching it from a different point of view." Lohr wanted to show a variety of species and an array of plumage so shot a range of birds, traveling to bird parks and menageries across Europe to establish a stunning, masterfully lit portfolio.

"Birds are inspiring creatures, but with this project I wanted to abstract things and look closer at something kind of surreal that I see when looking at birds' feathers in real detail," reflects Lohr; in most cases, the pictures only give "an idea of whether the strong, dark feathers belong to the tail or wings of a bird, or whether the pinkish fluff is found on the chest or neck of the animal."

Each abstract photo of wings, bellies, and other bird parts in the book is also beautifully juxtaposed with its scientific name, a contemplative invitation to go deeper behind the scenes of each species—the supremely tactile contrasting feather types of "Grus Monacha" (a hooded crane), the royal blue coat of "Anodorhynchus Hyacinthinus" (a hyacinth macaw), the elegant capes of "Geronticus Eremita" (a northern bald ibis) or "Pelecanus Crispus" (a Dalmatian pelican), the wispy white feathers of "Psophia Crepitans" (a gray-winged trumpeter), or the soft candy-floss pink plumes of "Phoenicopterus Roseus" (a greater flamingo)—and examine our potentially surface-level relationship with the bird world at the same time.

Top Geronticus Eremita, showing feather detail of a Northern Bald Ibis and Bottom Grus Monacha, detailing the contrasting plumage of a Hooded Crane, both by German photographer Thomas Lohr © Thomas Lohr

Bence Máté

(1985-present)

Rown as the "Invisible Wildlife Photographer," Bence Máté's love of photographing animals began in his early childhood growing up by the wetlands of the Hungarian village of Pusztaszer. At fifteen he won Hungary's Young Wildlife Photographer of the Year competition, scooped the grand title of Wildlife Photographer of the Year in 2010 for a Marvel of Ants, and won the Birds category in 2014 with Herons in Time and Space. Indeed, many of his most striking pictures are of birds: an emerald hummingbird in a standoff with a bright green snake; a gulp of great cormorants at feeding time; the time-lapse flight of a hoopoe—each composition so other-worldly, it's hard to imagine that it hasn't been

set up or retouched. The magic, however, is all through Máté's phenomenal eye for composition, immense patience, and a burning desire to get that winning shot: to the extent of inventing new forms of technology to get closer to nature, including timing and exposure devices and one-way glass photography hides. Although makeshift hide photography has been popular since Eric Hosking's time, the permanence and invisibility factor of Máté's revolutionary design allows unprecedented proximity to the remarkable behavior of species such as eagles, vultures, owls, bustards, kestrels, waterfowl, and plains-dwelling birds. A truly intimate bird's-eye view.

Below The otherworldly Herons in Time and Space Opposite page top Airscrew and Opposite page bottom Hunger, all by ground-breaking Hungarian photographer Bence Máté © Bence Máté

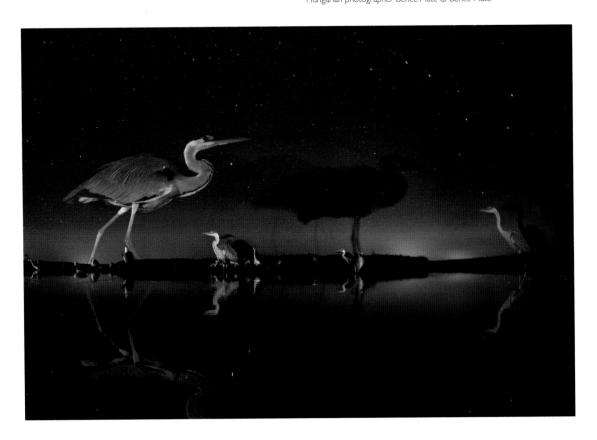

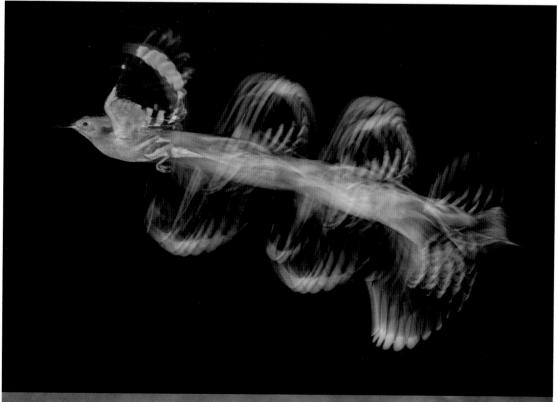

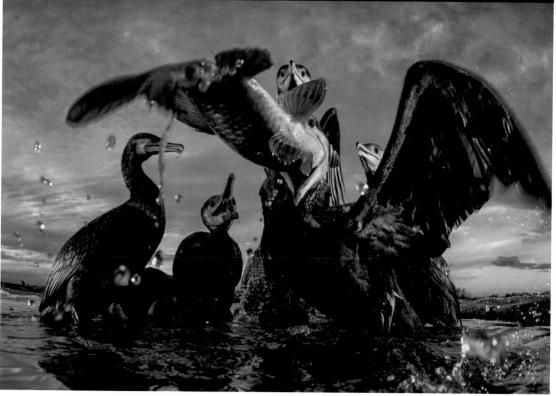

DESIGN, CRAFT, AND STYLE

Some of the most memorable and charming images of birds have been rendered through the medium of print from the woodcuts of William Morris and C.F.A. Voysey to the instantly recognizable linocuts of Robert Gillmor or highly stylized silkscreens of Charley Harper. What many of these artists share is the ability to portray the likeness or spirit of a bird in just a few simple lines or shapes, facilitated by a lifetime of observing birds at rest, in flight, and in their natural habitats. In their footsteps follow numerous designers and craftspeople, using metal, paper, ceramics, feathers, and fabric to share their celebratory visions of some of the most inspiring creatures on Earth.

Edward Lear

(1812 - 88)

est known for his nonsense poems and limericks, BEdward Lear also took a turn as an ornithological illustrator. Professing to be the twentieth child of a brood of twenty-one, he was raised and taught to draw by his oldest sister, Ann, with whom he spent hours copying out flowers, birds, and other natural forms from books and catalogs. When his family fell on hard times, a fifteen-year-old Lear advertised his artistic talents professionally, undertaking commercial commissions for "bread and cheese." In between these commissions he undertook a personal project to create a set of prints entirely devoted to parrots mainly drawn from life and including species from Australia, Africa, and America bred by leading ornithologists—culminating in the richly lithographed, uniquely taxonomic, and highly charismatic Illustrations of the Family of Psittacidae, or Parrots (1832).

Impressed by this work, the London Zoological Society eagerly commissioned him in 1832 to draw illustrations of birds for the society's taxidermist, John Gould (see page 324). He was also appointed by the naturalist Lord Edward Smith-Stanley, 13th Earl of Derby, to catalog the vast menagerie at Knowsley Hall. Lear ended up staying on the Earl's estate until 1836, working on his bird paintings, establishing a network of high-brow patrons, and entertaining the children with the curious characters and verbally inventive rhymes that would later make his name—among them, the childhood favorite, "The Owl and the Pussycat" from *Nonsense Songs, Stories, Botany, and Alphabets* (1871).

Writing in his diary in 1860, "Verily I am an odd bird," the then-itinerant wanderer and landscape painter—for which he was most known during his lifetime—continued his portrayal of his feathered friends with several sets of imaginary "colored birds" and a zoomorphic series of "nonsense birds," the character-defining color of "The Dark Blue Bird" and the strange behavior of the "The Obsequious Ornamental Ostrich, who wore Boots to keep his feet quite dry," inspiring global audiences, past and present, to engage even more fondly with the sometimes overlooked wonders of the avian world.

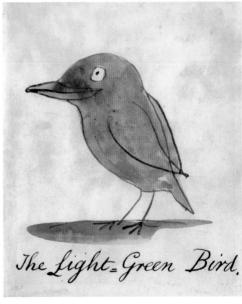

Opposite page The Dark Blue Bird from a set of 16 drawings of "Comic Birds" (1880) by poet, artist, and ornithological illustrator Edward Lear Top Psittacus autumnalis, a Red-Lored Amazon Parrot, of the bird family Psittacidae Bottom The Light Green Bird (1880), also from Lear's series of "Comic Birds"

C.F.A. Voysey

(1857 - 1941)

esigner of wallpapers, fabrics, and furnishings and architect of several country houses, Charles Francis Annesley Voysey was concerned with form and function rather than ornamental complexities, opting for "simplicity in decoration" and a limited color palette, "emphasizing outline, eliminating shading, and minimizing detail." The animal and plant kingdoms were a constant source of inspiration, juxtaposing birds and other wildlife with flowers, foliage, and fruit in designs such as "Apothecary's Garden;" the particularly pared-back "Birds and Fruit," "Blue Birds," and "Seagulls;" also "Rook and Holly," "Purple Birds," "Birds and Berries," "The Owls," and "Birds of Many Climes." Drawing inspiration from the Arts and Crafts Movement and its founder William Morris (1834–96) —who had begun to focus on writing, activism, and the production of designs such as his bird-inspired classics "Birds and Strawberry Thief" by the time the younger artist entered the scene—Voysey's elegant, quietly expressive yet often curvaceously graphic work also helped lay the foundations for the work of Czech painter Alphonse Mucha and the development of Art Nouveau. Both Voysey's and Morris's designs are now particularly celebrated by the Victoria and Albert Museum (V&A), in London, UK, who both hold a significant collection of their work, and continue to produce textiles, prints, and objects d'art inspired by their vintage and time-honored designs.

Top *Birds* with FirTree **Bottom** Parrot design, and **Opposite page** Owls All by British designer and architect C.F.A.Voysey

Charley Harper

(1922 - 2007)

"When I look at wildlife or a nature subject, I don't see the feathers in the wings, I just count the wings."

American modernist artist Charley Harper mused famously about his uniquely stylized portfolio of birds and other animals. "I see exciting shapes, color combinations, patterns, textures, fascinating behavior, and endless possibilities for making interesting pictures. I regard the picture as an ecosystem in which all the elements are interrelated, interdependent, perfectly balanced, without trimming or unutilized parts."

Now perching on everything from cups to jigsaws to children's books, Harper's bird portrayals first took flight as a series of illustrations commissioned to accompany an article about feeding station birds in Ford Times magazine—a monthly publication produced by the Ford Motor Company, whose art director was Arthur Lougee, and to which Harper would contribute hundreds of images. This first flutter into avian territory comprised eight depictions of birdlife including Feeding Station (1954) and Blue Jay Breakfast (1954), hand painted in gouache on paper shapes glued to board. Accompanying the article was the invitation to purchase serigraph (silkscreen print) editions of any illustration, hand cut and printed by Charley Harper with colors mixed by his wife Edie. Although the take up wasn't huge, the prints were sufficiently inspiring for the artist to continue producing editions of his work in this way, the perfect medium for his bold colors, clean lines, and graphic shapes.

Harper met fellow art student Edie at the Art Academy of Cincinnati, the couple swiftly marrying in 1947 after graduation and spending their honeymoon touring the American West thanks to the benevolence of the Stephen H. Wilder Traveling Scholarship. Having grown up on a farm in West Virginia and spent a great deal of his childhood roaming the Appalachian foothills in order to avoid

Opposite page top American modernist artist Charley Harper is known for his stylized yet carefully observed and wonderfully evocative illustrations of birds. Hand-pulled serigraphs include *Downy Woodpeckers* (7in/18.5cm × 5in/13cm, 1954) and **Bottom** *Red-eyed Vireos* (7in/18.5cm × 5in/13cm, 1959) Both © Charley Harper Art Studio

his chores, this officially funded sojourn was a four-month idyll where both art and nature could become one. Feeling fettered by the constraints of realism and turning back to the swift observation style and on-the-spot paintings developed during time serving with the Intelligence and Reconnaissance Platoon of the 414th Regiment in Germany during World War II, he then began "trying to simplify the great natural forms and symbolize the design underlying the surface clutter."

Birds and fish lent themselves particularly well to this new graphic style, with their "built-in functional beauty imposed by their habitats" and requiring "only a little distortion of what's there already, a thinning of lines and a simpler statement of shape." Harper's bird-inspired commissions for Ford Times become an annual affair leading to such charismatic delights as Black and White Warbler (1955), Everglade Kite (1957), Eskimo Curlew (1957), Passenger Pigeon (1957), Snowy Egret (1958), and Painted Bunting (1958), later accompanied by Harper's equally charming words.

Other notable works include illustrations for the now-coveted The Giant Golden Book of Biology: An Introduction to the Science of Life by Gerald Ames and Rose Wyler (Golden Press, 1961)—a 99-page, full-color, middle school-level introduction to biology covering everything from cells and evolution to physiology and ecosystems; he also received commissions from zoos, wildlife sanctuaries, nature centers, and national parks. Indeed, it was once said that if Harper hadn't been an artist, he probably would have been a conservationist. "Remember that I didn't start out to paint a bird—the bird already existed," advised Harper to the appreciators of his art."I started out to paint a picture of a bird, a picture which didn't exist before I came along, a picture which gives me a chance to share with you my thoughts about the bird."

Above Forest Friends (1961), one of several illustrations of ecosystems for artist and author Charley Harper's *The Giant Golden Book of Biology: An Introduction to the Science of Life* (1961), now available as a limited-edition Giclée print (12in/30cm x 4in/9.75cm, 2011) © Charley Harper Art Studio

 $\label{eq:Above Blackbird and Snowdrops, a four-color silk-screen print from the Blackbird Collection (2019) © Robert Gillmor MBE$

Robert Gillmor MBE

(1936-present)

Much inspired by his grandfather, Allen Seaby, an ornithological painter and printmaker, and Professor of Fine Art at Reading University, a young Robert Gillmor spent a great deal of time watching the older man working on his color woodcuts, as well as bird-watching around the flooded gravel pits of Reading where he grew up.

An active member of Reading Ornithological Club, Gillmor's work was first published in the longstanding British Birds magazine when he was sixteen, followed by illustrations for A Study of Blackbirds by David W. Snow (George Allen & Unwin, 1958), occasional line drawings for the RSPB (Royal Society for the Protection of Birds) and covers for their film programs. In 1965, his success was sufficient for him to embark on a full-time career as a freelance wildlife artist, receiving such laudable commissions as the original drawing of an avocet for the distinctive RSPB logo, posters for the British Birdfair, covers for the HarperCollins New Naturalist series from 1985 onward, and linocut designs for several series of feature stamps for Royal Mail's Post and Go machines—the latter flying Gillmor's birds to destinations both near and far across the globe.

Moving from Reading to Cley next the Sea in Norfolk in 1998 when his children fledged the nest meant Gillmor could be nearer to the inspiring lines of long-legged waders such as oystercatchers, herons, egrets, and those iconic avocets. Having been driven to near national extinction by Victorian hunters and egg collectors in the nineteenth century, these emblematic, piebald birds are now a common sight on the coastal wetlands of East Anglia, their long, thin upcurved bills having become a wonderful symbol of both Gillmor's huge contribution to bird conservation and his work to produce some of the most charming and collectable bird-inspired art.

RSPB

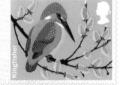

002011 5 51840 03

1st Class up to 100g

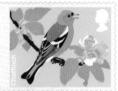

002011 1 51840 02

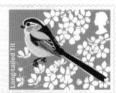

002011 1 51840 02

002010 9 51840 01

Top Robert Gillmor's original Pied Avocet (*Recurvirostra avosetta*) line drawing design for the RSPB. Reproduced by permission of RSPB, © 2020 All rights reserved. Source: RSPB **Bottom** Gillmor's beautiful linocut depictions of birds have also flown around the world via several series of Royal Mail feature stamps © Royal Mail Group Limited

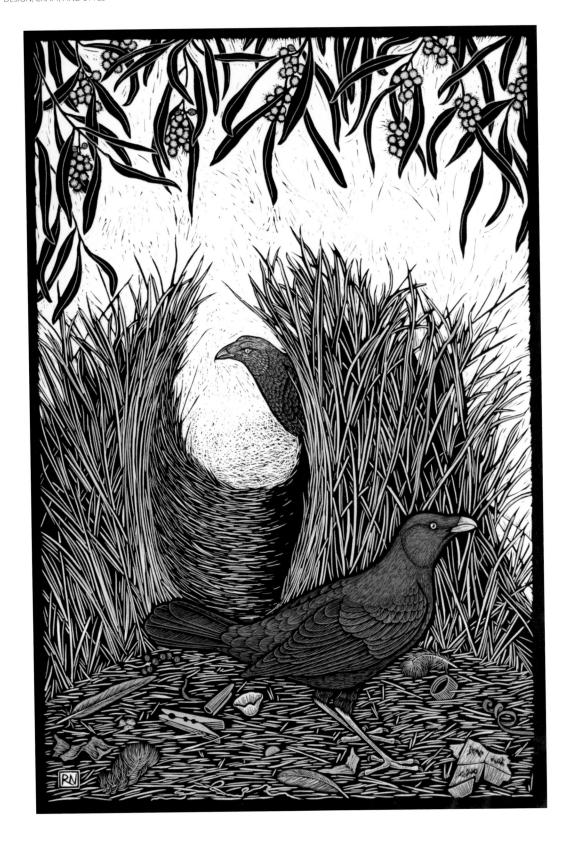

Rachel Newling

(1956-present)

s many artists through the ages have found, birds $oldsymbol{\Lambda}$ are particularly good subjects for printmaking due to their distinctive silhouettes, often graphic and colorful markings, quirky behavior, and variation of habitat. If, like British-born printmaker Rachel Newling, you live in Australia, you're also extremely well placed to observe a huge variety of birds, with one in ten of the world's around 11,000 unique bird species tracing their lineages to the "Land of the Birds," including vast numbers of parrots, pigeons, and songbirds, many of which act as vital 'ecosystem engineers' of the landscape-defining rainforests, bush, and suburbs, and the flora and fauna within. An apt celebration of all this amazing diversity, Newling's hand-colored, painterly linocuts juxtapose fan-headed Major Mitchell and red-tailed black cockatoos with a living, breathing background of beautiful red waratah blooms; male and female regent bowerbirds with vellow-flowered rainforest orchids; and little blue wrens with waterfalls of wisteria blossom. Birds also make an appearance in her Birdland series of pastel drawings, as "head and shoulder" portraits, including Osprey, Blue Faced Honeyeater, Blue Winged Kookaburra, and Rose Crowned Fruit Dove. Although many of her limited-edition works now live in homes around the world, Newling also keeps a digital version of each, as a growing record and legacy of the Australian birds that abound.

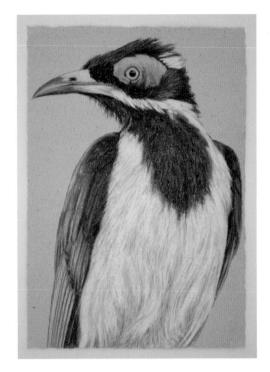

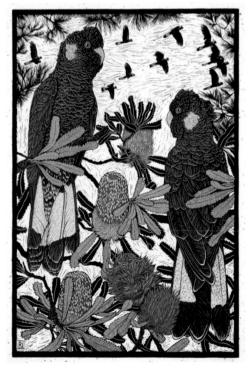

Opposite page Satin Bowerbird, a hand-colored linocut by British-born printmaker Rachel Newling (30in/74cm x 20in/50cm) Top Newlings avian oeuvre also includes pastel and paper artworks such as her Blue-faced Honeyeater (12in/30cm x 8in/21cm) Bottom A linocut celebration of flora and fauna in Yellow-tailed Black Cockatoo and Banksia (30in/75cm x 20in/50cm), all © Rachel Newling

Angela Harding

(1960-present)

 ${
m B}$ ritish backyard birds define the work of artist and printmaker Angela Harding, whose much-loved linocuts, etchings, and woodcuts have adorned numerous magazine editorials, book covers, gallery walls, and merchandise such as advent calendars and greetings cards, spanning a thirty-year career. Born in Stoke-on-Trent but now living in the aptly named village of Wing, across the ridge from the wildlifepacked Rutland Water Nature Reserve, Harding initiates her artworks through sketches and scribbles of the birds she sees in her garden, on walks through the countryside, or along the coasts of Norfolk, Suffolk, or Cornwall. Often, she will have an idea in mind for the composition of a piece from something she has read, observed, imagined, or the brief for a commissioned illustration. Her songbirds, wildfowl, and birds of prey are often positioned in an atmospheric location, habitat, or time of day or night to bring their character even further to life: Blackbirds and Berries. Curlew at Whitby, pastoral Common featuring birds in the foreground and in flight, or the monochrome Alphabet Birds. Inspired by 1930s, 40s, and 50s artists such as printmaker and landscape artist Eric Ravilious (1903-42) and Impressionistic colorist Winifred Nicholson (1893-1981), her distinctive black prints with a naturalistic color palette of deep greens, blues, and browns, and accents of deep red and sunshine yellow have a similarly traditional feel, paying a timeless homage to our most familiar birds.

For a wonderful overview of her work for bird lovers of all ages, see the fully illustrated *RSPB Birds* (Bloomsbury, 2020) in collaboration with RSPB president Miranda Krestovnikoff.

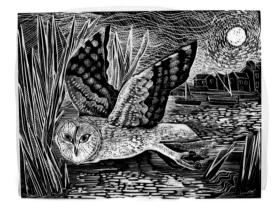

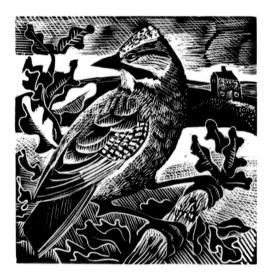

Top Marsh Owl (17in/43cm \times 14in/37cm) a lino and silkscreen print inspired by watching a Barn Owl fly over the reedbeds at Snape Maltings in evening light **Bottom** J for Jay (3in/8cm \times 3in/8cm), a wood engraving from the Alphabet Birds series **Opposite page** A charming lino and silkscreen depiction of a Blackbird Stealing Redcurrant (12in/30cm \times 13in/32cm), all by renowned British printmaker Angela Harding, www.angelaharding.co.uk

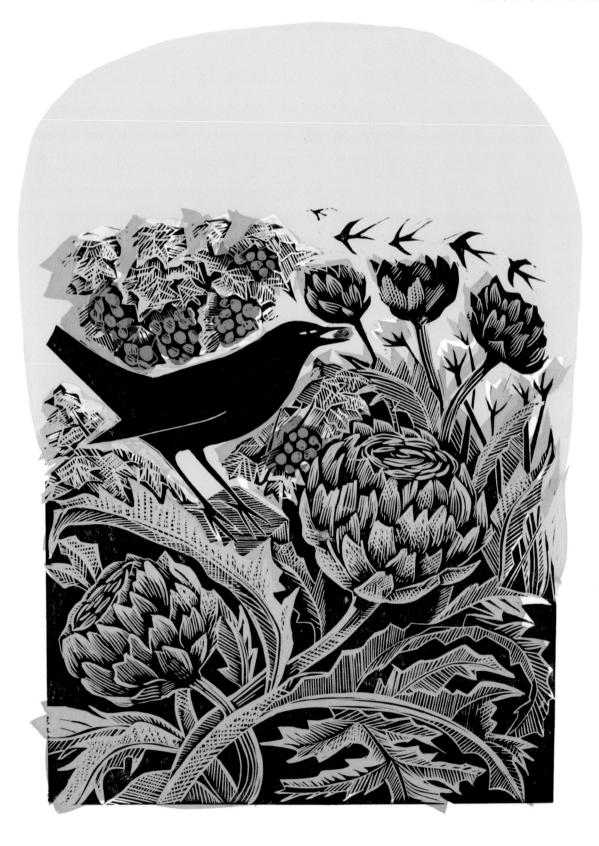

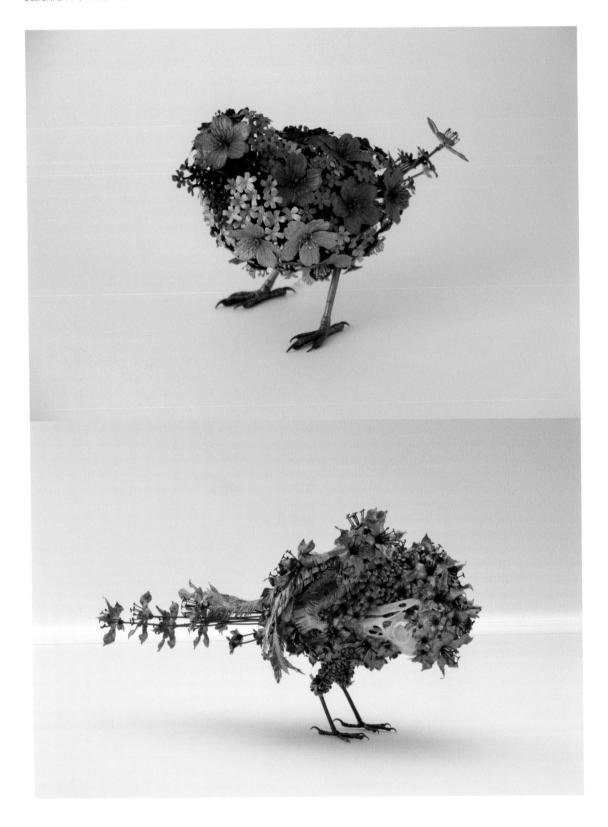

Taiichiro Yoshida

(1989-present)

The animal and plant kingdoms are fused L together in Tokyo-based artist Taiichiro Yoshida's dainty bird sculptures (among other wildlife) where wings, tails, feathers, and beaks are composed of delicate metal blooms. Created using an ancient hot metalworking technique developed in Japan around the second and third centuries BCE, each individual component is heated, carefully beaten, then formed into petals or flowers before being colored to a white, pink, pinkish-brown, or copper patina—by heating and cooling the metals at specific temperatures—and conjoined. The result is beautiful but also sometimes unsettling where bird skulls or bones peek out from within ikebana-style arrangements of naturally occurring metals such as silver, bronze, and copper as in Fire Bird (2014). For Yoshida this alludes to the continuation of life after death and the idea of nature reclaiming the body for renewal and regeneration. The use of certain flowers is also symbolic, such as the Japanese ornamental cherry blossom known as Sakura (typically Prunus serrulata). which is associated with the transient nature of life, and the Kiku or chrysanthemum (Chrysanthemum), representing longevity and rejuvenation. Such flowers are also often paired with birds in traditional Japanese art (see page 331), from Utagawa Hiroshige's Bird and Chrysanthemums (c.1830s) to Katsushika Hokusai's Bullfinch and Weeping Cherry Blossoms (1834), and Yoshida's sculptural interpretation of this intrinsic relationship between birds and flowers creates a direct flight path between present and past.

Opposite page top Japanese artist Taiichiro Yoshida fuses together delicate metal blooms and delicate bird bones to create tiny avian-inspired sculptures including Hanasuzume (4in/110mm × 3in/70mm × 6in/150mm, copper) Opposite page bottom Fire Bird (5in/120mm × 9in/230mm × 4in/100mm, copper, brass, phosphor bronze and bone of the bird) and Top Fire Bird (4in/110mm × 8in/200mm × 2in/60mm, copper, brass, phosphor bronze and bone of the bird)

Swan Song for the Birds

The art history of birds is rife with long-lost species of birds, pushed to extinction by ice ages, evolutionary changes, or human intervention, most recently in the form of climate change. As the Coronavirus pandemic has forced us to consider our own humanity, could this be the moment we pull together collectively for the planet too? Not least the 11,000-plus species of birds that still inhabit our forests, grasslands, and shores, and the often-taken-forgranted birdsong that provides a natural, hopeful soundtrack to our lives.

In 2010, film director and producer Ceri Levy—best known for his work with British pop bands Blur and Gorrillaz—put out a plea to living, bird-loving creatives, such as Sir Peter Blake, Matt Sewell (see page 329), and Gonzo artist Ralph Steadman to contribute to an exhibition about the plight of endangered birds. "Ghosts of Gone Birds" subsequently opened in late 2011 in an old East London schoolhouse. The skulking *The Extinct Guadeloupe Caracara* by Steadman and *Choiseul Crested Pigeon* by Rebecca Jewell, plus a powerful handwritten elegy to all those birds that have gone before and those currently in danger by Blake, throwing the spotlight on species which have joined or are in danger of joining the dodo, the poster bird for extinction.

Over in New York, photographer Denis Defibaugh focused on critically endangered and vanished birds, insects, and mammals in his exhibition *Afterlifes of Natural History* (2015) training his lens onto rare specimens of Labrador ducks, great Auks, and passenger pigeons found in the natural history museum of Zion National Park, Chicago's Field Museum, The Cornell Lab of Ornithology, and the Smithsonian National Museum of Natural History. Using similarly endangered Polaroid Type 55 film, the darkened images are a sobering introduction to the need to conserve our current bird life.

Art relating to "gone birds" is not only associated with the twenty-first century, however. The redocher Aboriginal bird art of a narrow rock shelter in Australia's Arnhem Land, for example, is thought to be a depiction of a large, flightless emu-like megafauna known to scientists as *Genyornis newtoni*, believed to have gone extinct an estimated 40,000 years ago. Experts think this heavily built, tiny-winged "thunder

bird" co-existed with humans for a considerable amount of time, possibly 15,000 years, and that the art was made by someone who knew the bird well, rather than through oral storytelling. While paintings of dodos by artists such as Roelant Savery (*c.*1626) are glimpses of this long-lost bird—killed to extinction by 1690 by hunting and the introduction of nonnative species.

It's not all bad news, however. In January 2020, BirdLife International (www.birdlife.org) released a new study that showed that conservation action has reduced bird extinction rates by 40 percent, although numbers also show that during the next 500 years, 471 bird species may yet go extinct, expedited by issues such as climate change. Moving forward we need to prevent low-risk species with healthy populations from becoming threatened in the first place as well as preventing critically endangered ones from being wiped out. To this effect, a new raft of conservation-aware art and books is also helping to raise awareness about the loss of avian species, such as The Book of Birds: A Field Guide to Wonder and Loss (which will be published by Hamish Hamilton in 2022) by acclaimed British nature author Robert Macfarlane and artist and writer Jackie Morris.

Written in the strange age of COVID-19, citizens of Earth are now in an unprecedented position to collectively take stock. The freedom to go about our daily lives, to be healthy, access nature, flock together, and simply exist have all been thrown under the spotlight for generations of humans like never before —well worth remembering as we think about how we treat our planet, our fellow wildlife, and the vital, glorious creatures we know as birds.

Opposite page top Detail of Edwards' Dodo (c.1626) by Dutch artist Roelant Savery (1576–1639), also thought to portray a similarly extinct Red Rail (Aphanapteryx bonasia) and the hypothetically extinct Lesser Antillean Macaw (Ara guadeloupensis) and Martinique Macaw (Ara martinicus) Below left American photographer Denis Defibaugh's haunting images of a Passenger Pigeon, RMSC. Below right Labrador Duck, Smithsonian, from Defibaugh's Afterlifes of Natural History (2015) series pay further homage to forever lost species of birds—and the vital need to conserve our avian world, and indeed all life on Earth. Both © Denis Defibaugh

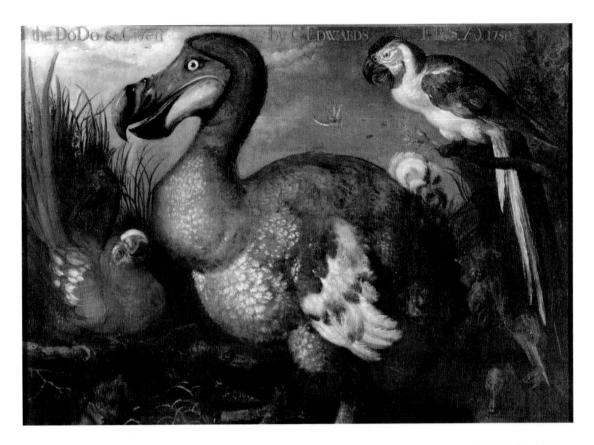

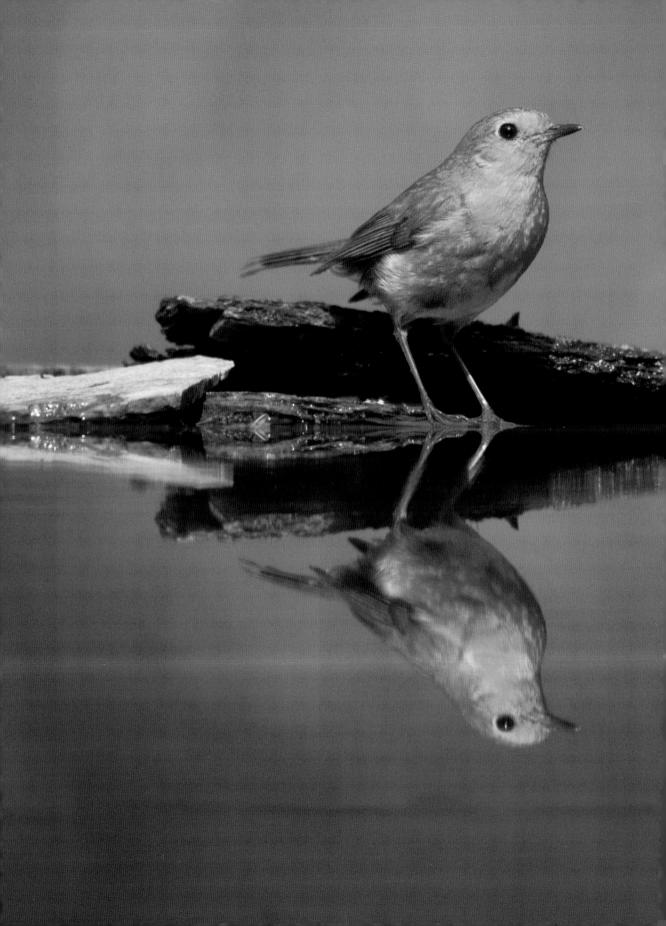

Dedicated to all the birds around the world who have provided glimpses of beauty and peace during a difficult time for humans.

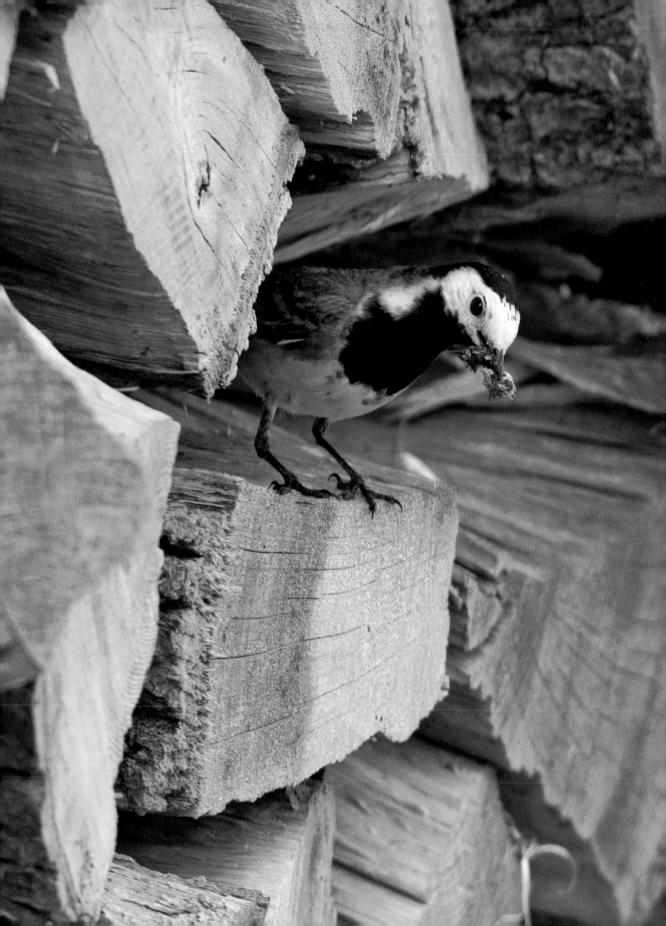

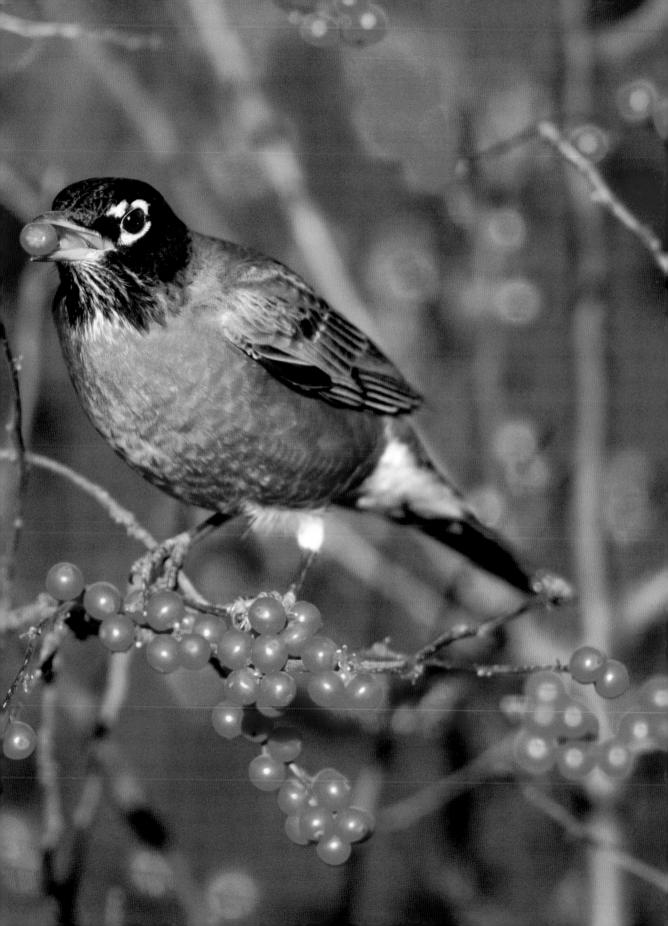

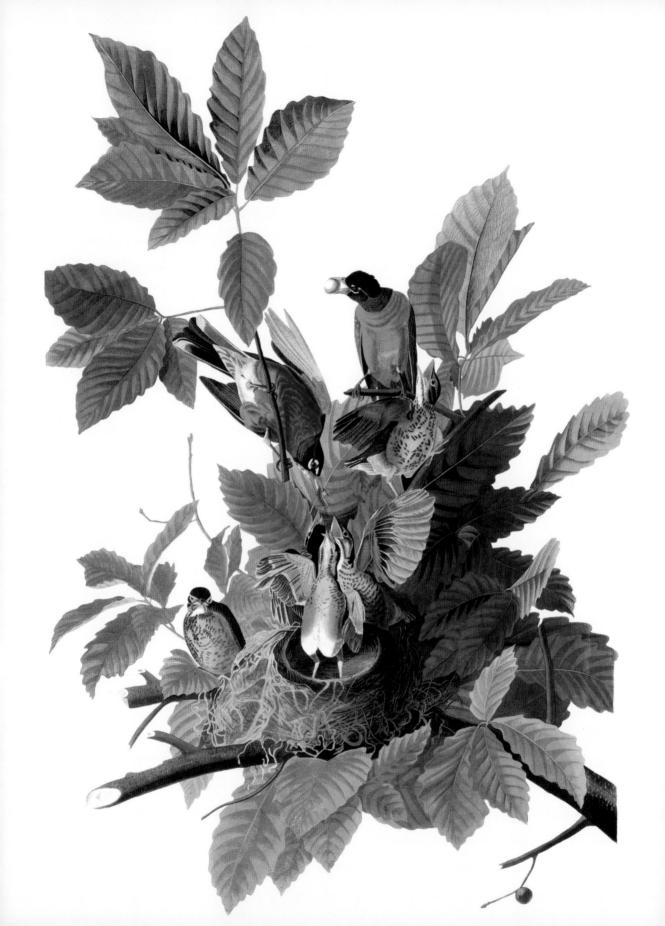

ACKNOWLEDGEMENTS

The contributors wish to thank...

Sonya Patel Ellis thanks the brilliant resources provided by ornithological and bird conservation organizations around the world, to my husband Tom Ellis for helping to turn our front garden into a bird-friendly paradise, complete with bird-attracting plants and a wildlife pond; to my children Sylvester and Iggy for turning most of their lockdown home-schooling into an avian-themed world; to Caitlin Doyle for ongoing encouragement and support; and to the birds themselves for keeping me going through the Coronavirus era with their beautiful antics and bird song. Long may they continue.

Dominic Couzens extends thanks to Caitlin Doyle for the opportunity to contribute to this book.

Paul Sterry would like to thank his friends and colleagues, Andrew Cleave, and Rob Read. If you want to help protect birds, please check out Birds on the Brink, the grant-awarding UK charity that supports bird-related conservation projects. Visit the website www.birdsonthebrink.co.uk for more information.

The publisher wishes to thank

Michael Sand at Abrams for his continued. enthusiastic collaboration on such a beautiful series: Ruth Redford for her incredible hard work on co-managing our behemoth book; Ellie Ridsdale for her beautiful design and calm; Jo Carlill for her excellent picture research and patience; Lynn Hatzius for her gorgeous illustrations; Frances Cooper, Helena Caldon and Abi Waters for their excellent editorial work; Geraldine Beare for the thorough index; Jacqui Caulton and Gareth Butterworth for their additional assistance, and Myles Archibald and Hazel Eriksson for their support. Heartfelt gratitude to Christopher Perrins, Sonya Patel Ellis, Dominic Couzens, and Paul Sterry for their wise and eloquent words. A big thank you to the families of Team Bird for your patience and understanding during this frenetic time, including Rosie, Ava, and Archie; Alba, Beth, and Saoirse. You've all been a pleasure to work with, especially in this time of global uncertainty, and thank you to each and every contributor to this wonderful collection. And finally, a skyward thank you to the bright-green, ring-necked parakeets of Southwest London, ensuring that I keep an eye ever upward.

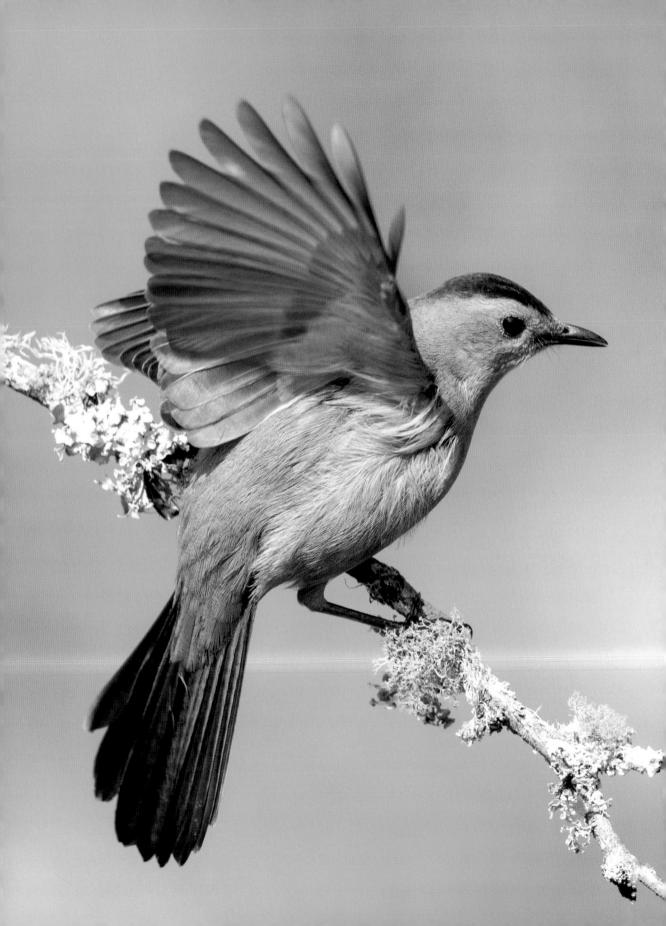

Selected books, magazines, journals and websites to help you become a better birdwatcher or birder and explore the beauty of the avian world.

Books

The Avian World

Ackerman, Jennifer, *The Genius of Birds* (Corsair, 2016).

Attenborough, David, *The Life of Birds* (BBC Books, 1998).

Avery, Mark, *Remarkable Birds* (Thames & Hudson, 2016).

Birkhead, Tim, *Bird Sense* (Bloomsbury Publishing, 2013).

Birkhead, Tim, Wimpenny, Jo, and Montgomerie, Bob, *Ten Thousand Birds: Ornithology since Darwin* (Princeton University Press, 2014).

Birds in Art

Audubon, John James, *The Birds of America* (The Natural History Museum, 2013) [US].

Elphick, Jonathan, *Birds: The Art of Ornithology* (Natural History Museum, 2014) [UK].

Harper, Charley and Oldham, Todd, Charley Harper: An Illustrated Life (AMMO Books, 2007).

Harper, Charley, Beguiled by the Wild – The Art of Charley Harper (Pomegranate Communications Inc, 2011).

Hyland, Angus and Wilson, Kendra, *The Book of the Bird: Birds in Art* (Laurence King, 2016).

Jeffreys, Leila and Graydon, Michael, *Bird Love* (Abrams, 2015).

Kim, Jane and Walker, Thayer, The Wall of Birds: One Planet, 243 Families, 375 Million Years (Harper Design, 2018). Lederer, Roger J., The Art of the Bird: The History of Ornithological Art Through Forty Artists (University of Chicago Press, 2019).

Olson, Roberta and Shelley, Marjorie, Audubon's Aviary: The Original Watercolors for The Birds of America (Skira Rizzoli, 2012).

Solinas, Francesco, Edward Lear: The Parrots (Taschen, 2018).

Attracting Birds

Adams, George, Gardening for the Birds: How to Create a Bird-Friendly Backyard (Timber Press, 2013).

Hajeski, Nancy J., Birds, Bees & Butterflies: Bringing Nature into Your Yard & Garden (National Geographic, 2016).

McKee Orsini, Michele, Handmade Birdhouses and Feeders: 35 Projects to Attract Birds into Your Garden (CICO Books, 2017).

Sorenson, Sharon, *Planting Native to Attract Birds to Your Yard* (Stackpole Books, 2018).

Birdwatching and Birding

Floyd, Ted, How to Know the Birds: The Art and Adventure of Birding (National Geographic, 2019).

Peterson, Roger Tory, Peterson Field Guide to Birds of Eastern and Central North America, 6th Edition (Houghton Mifflin Harcourt, 2010).

Sibley, David Allen, *The Sibley Guide to Birds*, 2nd Edition (Sibley Guides; Knopf, 2014).

Sibley, David Allen, What It's Like to Be a Bird (Sibley Guides; Knopf, 2020).

Sterry, Paul, Warblers and Other Songbirds of North America: A Life-Size Guide to Every Species (HarperCollins, 2017).

Children/Poetry

Lear, Edward, Edward Lear's Nonsense Birds (The Bodleian Library, 2013).

Krestovnikoff, Miranda and Harding, Angela, RSPB Birds: Explore their extraordinary world (Bloomsbury, 2020)

Macfarlane, Robert and Morris, Jackie, *The Lost Words* (Hamish Hamilton, 2017).

Macfarlane, Robert and Morris, Jackie, A Book of Birds: A Field Guide to Wonder and Loss (Hamish Hamilton, to be published in 2022).

Websites, Magazines, and Journals

Avibase – The World Bird Database https://avibase.bsc-eoc.org/avibase. jsp?lang=EN

BirdLife International/BirdLife: The Magazine

www.birdlife.org Bird Photographer of the Year www.birdpoty.co.uk

IOC World Bird List www.worldbirdnames.org

American Birding Association (ABA)/ Birding magazine www.aba.org

American Ornithological Society/ The Auk: Ornithological Advances www.americanornithology.org

Birds&Blooms magazine www.birdsandblooms.com

Bird Watching magazine (formerly Birder's World) www.birdwatchingdaily.com

National Audubon Society/Audubon magazine www.audubon.org

The Cornell Lab of Ornithology www.birds.cornell.edu/

Apps

Audubon Bird Guide

https://apps.apple.com/us/app/ audubon-bird-guide-north-america/ id333227386

BirdTrack

https://apps.apple.com/gb/app/birdtrack/id596839218

https://play.google.com/store/apps/details?id=org.bto.btapp&hl=en_GB

https://play.google.com/store/apps/details?id=com.audubon.mobile.android

Collins Bird Guide

https://apps.apple.com/gb/app/collins-bird-guide/id868827305

https://play.google.com/store/apps/details?id=com.natureguides.birdguide&hl=en_GB

Ebird from the Cornell Lab of Ornithology

https://apps.apple.com/us/app/ebird-by-cornell-lab-of-ornithology/id988799279?ign-mpt=uo%3D8

https://play.google.com/store/apps/details?id=edu.cornell.birds.ebird&hl=en

ibird pro

https://apps.apple.com/gb/app/ ibird-uk-pro-guide-to-birds/ id424729739

https://play.google.com/store/apps/details?id=com.whatbird.ukpro&hl=en_GB

Merlin Bird ID from the Cornell Lab of Ornithology

https://apps.apple.com/app/apple-store/id773457673

https://play.google.com/store/apps/details?id=com.labs.merlinbirdid.app

Organizations to Support

American Bird Conservancy https://abcbirds.org/

Bird Life International http://www.birdlife.org/

British Trust for Ornithology https://www.bto.org/

Cornell Lab of Ornithology https://www.birds.cornell.edu/

National Audubon Society https://www.audubon.org/

RSPB – The Royal Society for the Protection of Birds https://www.rspb.org.uk

INDEX

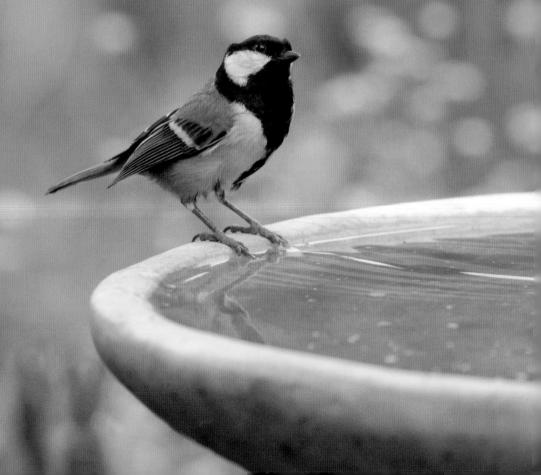

A	design, craft, and style 358-73
Abbot, John 314	history of 310-19
Acanthis flammea (Common Redpoll) 170,	ornithological art and illustration 320-31
171	painting and sculpture 332-41
Accipiter gentilis (Northern Goshawk) 342	photography and film 318-19, 342-56,
Accipiter nisus (Sparrowhawk) 224, 225	374
Accipiter striatus (Sharp-shinned Hawk) 38-9,	aster (Astereae spp.) 277, 278-9
315	Athena noctua (Little Owl) 290
Acer spp. (maple) 272	Athene cunicularia (Burrowing Owl) 52
Achillea millefolum spp. (yarrow) 298, 299	Attar, Farid ud-Din 313
Acorn Woodpecker (Melanerpes formicivorus)	Attenborough, David 319, 348, 349
75, 81, 328	Audubon, John James 9, 314, 315, 316, 320,
adult 20	321, 322, 323
Aegolius acadicus (Northern Saw-whet	Avery, Mark 343
Owl) 55	axillaries 20
Aegolius funereus (Boreal Owl) 54	
African Finfoot 331	В
Agelaius phoeniceus (Red-winged	backyards, bird-friendly 266, 268-9
Blackbird) 160	breeding and shelter 290-1
Albin, Eleazar 313–14	climbers and vines 292-3
Albin, Elizabeth 314	flowers, shrubs, grasses 277-9
Aldrovandus 313	tables, feeders, baths 282, 284-7, 288
Ali, Salim 236	trees and hedges 272, 274-5
Allen's Hummingbird (Selasphorus sasin) 69	woodpiles and compost heaps 296, 298
alliums (Allium spp.) 277	Baeolophus bicolor (Tufted Titmouse) 105, 106
Amelanchier spp. (serviceberry) 272, 274-5	Baltimore Oriole (Icterus galbula) 165
American Crow (Corvus brachyrhynchos)	Banks, Joseph 314
98, 99	Bannerman, David 317
American Goldfinch (Spinus tristis) 166, 167,	Barlow, Francis 313
209, 267	Barn Owl (Tyto alba) 15, 45, 46, 347
American Redstart (Setophaga ruticilla)	Barn Swallow (Hirundo rustica) 102, 103, 210,
140, 141	211, 212, 213, 214-15, 246, 247
American Robin (Turdus migratorius)	Barraband, Jacques 314
122, 123	Barred Owl (Strix varia) 50
American Tree Sparrow (Spizelloides	Bauer, Ferdinand 314
arborea) 148	Bearded Reedlings (or Bearded Tits) 245
Anderson, Andrew 348	bee balms/bergamot (Monarda spp.) 277
Anthocaera lunulata (Western Wattlebird) 324	beech (Fagus spp.) 272
Antillean Nighthawk 56	Belon, Pierre 313
Antrostomus carolinensis (Chuck-will's-widow)	Belted Kingfisher (Megaceryle alcyon) 72, 73
57, 59	Betula spp. (birch) 272, 274
Antrostomus vociferus (Eastern Whip-poor-	Bewick, Thomas 314
will) 58	Bewick's Wren (Thryomanes bewickii) 115
Aquila chrysaetos (Golden Eagle) 341, 348	bill/beak 20, 30-1
Aquilegia spp. (columbines) 277	binoculars 236, 256, 259
Archaeopteryx lithographica 26, 27	birch (Betula spp.) 272, 274
Archilochus alexandri (Black-chinned	bird bath 286
Hummingbird) 70	bird café, food for 289
Archilochus colubris (Ruby-throated	Bird Photographer of the Year (BPOTY)
Hummingbird) 68	342, 343, 344, 345
art of birds, the	bird table 282, 284-5

Birdfair 343	132, 273
BirdLife International 374	Book of Indian Birds, The (Salim Ali) 236
birds	borage (Borago officinalis spp.) 296, 297, 299
at-a-glance backyard birds 34-5	Boreal Chickadee 104
characteristics (skeleton, limbs, muscles) 28	Boreal Owl (Aegolius funereus) 54
feeding 30	Bouffon, Comte de 314
life cycle 33	Brancusi, Constantin 319, 338
origins 26	Braque, Georges 319, 334, 335
as special 183	breeding 290–1
swan song for 374	Brewer's Blackbird (Euphagus
topography 20–2	cyanocephalus) 161
birds of prey 36	British Trust for Ornithology 343
BirdTrack app 260	Britton, Barrie 348
birdwatching	Broad-tailed Hummingbird (Selasphorus
bird habitats 245	platycercus) 67
bird sounds 251	Brooks, Allan Cyril 318
equipment and outfitting 256, 259-60	Brown Creeper (Certhia americana) 109, 304
history 236	Brown Thrasher (Toxostoma rufum) 128, 129
immersion in 242	Bullfinch (Pyrrhula pyrrhula) 16, 17, 329
introduction 180-1, 240-1	Burrowing Owl (Athene cunicularia) 52
safe and respectful practice 18-19	Buteo jamaicensis (Red-tailed Hawk) 37,
times, weather, seasons 246	40, 41
types of birdwatchers 252-3	Buzzard 230
Black Phoebe (Sayornis nigricans) 84, 86	
Black Skimmer 344	С
Black-and-white Warbler (Mniotilta varia)	Calliope Hummingbird (Selasphorus
135, 136	calliope) 66
Black-capped Chickadee (Poecile atricapillus)	Caprimulgidae (Nightjars) 56
104, 105 , 107	Cardinalis cardinalis (Northern Cardinal)
Black-chinned Hummingbird (Archilochus	24-5, 156, 157, 353
alexandrî) 70	Carduelis carduelis (Goldfinch) 220-1,
black-eyed Susan (Rudbeckia spp). 277	282, 286
Black-headed Gull 232, 233	Carolina Chickadee (Poecile carolinensis) 105,
Black-throated Gray Warbler 244	108
blackberry (Rubus spp.) 293	Carolina Wren (Thryothorus ludovicianus) 114
Blackbird (Turdus merula) 210, 217, 218, 230,	carpal 20
291, 366, 371	Carpinus spp. (hornbeam) 272
Blackcap (Sylvia atricapilla) 213	Carwardine, Mark 343
Blackpoll Warblers 134	Catesby, Mark 314
Blake, Sir Peter 374	cedar (Cedrus spp.) 272
Bliss, William 314	Cedar Waxwing (Bombycilla cedrorum)
Blue Jay (Cyanocitta cristata) 96, 97	133, 269
Blue Tit (Cyanistes caeruleus) 219, 230, 245,	Cedrus spp. (cedar) 272
270, 282	Centaurea spp. (cornflower) 277, 278, 279
Blue-faced Honeyeater 369	Certhia americana (Brown Creeper) 109, 304
Blue-footed Booby 350	Chaetura pelagica (Chimney Swift) 62, 63
Bogdan, Jakob 313	Chaffinch (Fringilla coelebs) 195, 210, 230,
Bohemian Waxwing (Bombycilla garrulus) 132	232, 291
Bombycilla cedrorum (Cedar Waxwing) 133, 26 9	Chamaecyparis lawsoniana (Lawson cypress) 272, 274
Bombycilla garrulus (Bohemian Waxwing)	Chapman, Frank 236
. 0/	r, =

Corvus cornix (Hooded Crow) 210 Chickadees (Paridae) 104, 105 Corvus frugilegus (Rook) 230, 291 Chimney Swift (Chaetura pelagica) 62, 63 Chipping Sparrow (Spizella passerina) 149 Corvus monedula (Jackdaw) 219 Chloris chloris (Greenfinch) 220-1, 230 Corylus spp. (hazel) 272, 274 Coues, Elliott 236, 238, 318 Chordeiles minor (Common Nighthawk) coverts 20 56,60 Coward, Thomas Alfred 317 Chough 230 Chuck-will's-widow (Antrostomus carolinensis) crab apple (Malus spp.) 272, 273, 274 Crag Martin 212, 230 Crataegus spp. (hawthorn) 272 Circus pygargus (Montagu's Harrier) 347 Crawhall, Joseph 317 Clark's Crow 320 Cleave, Andrew 343 crop 31 Crotaegus crus-galli (Eurasian hawthorn) 273 cleavers (Galium aparine spp.) 296, 299 Cuckoos 181, 203, 236, 250 clematis (Clematis spp.) 293 culmen 20 Clematis vitalba (Old man's beard or traveler's Cupressus spp. (cypress) 272 joy) 294 Cupressus x leylandii (Leyland cypress) 272 clothing and footwear 260 Cyanistes caeruleus (Blue Tit) 219, 230, 245, clover (Trifolium spp.) 296 Coal Tit (Periparus ater) 245 270, 282 Cyanocitta cristata (Blue Jay) 96, 97 Coccothraustes vespertinus (Evening Grosbeak) cypress (Cupressus spp.) 272 174, 175 Colaptes aurata (Northern Flicker) 74, 76, 77 Collared Dove (Streptopelia decaocto) 218, 219, 230, 233 Dalmatian Pelican 344 Collins, William 319 dandelion (Taraxacum spp.) 299 Columba livia (Rock Pigeon/Rock Dove) 43 Dark-eved Junco (Junco hyemalis) 152, 153 Columba palumbus (Woodpigeon) 200-1 Dartford Warbler (Cettidae) 212 Darwin, Charles 219, 316 columbines (Aquilegia spp.) 277 comfrey (Symphytum spp.) 296 Daucus spp. (wild carrot) 296 Davies, Claude Gibney 317 Common Cactus Finch (Geospiza scandens) 324 Defibaugh, Denis 374 Delichon urbicum (House Martin) 213 Common Grackle (Quiscalus quiscula) 162, 163 Demoiselle Crane 230 Dendrocopos major (Great Spotted Common Gull 233 Common Nighthawk (Chordeiles minor) Woodpecker) 230, 271 Dendroica magnolia (Magnolia Warbler) 9 56,60 Common Poorwill (Phalaenoptilus nuttallii) Dion, Mark 319 Dipsacis fullonum (teasel) 277, 278 56, 57, 61 Common Redpoll (Acanthis flammea) dock (Rumex spp.) 296 170, 171 dodos 374, 375 competitions 319 dogwood (Cornus spp.) 272, 275 coneflower (Echinacea spp.) 277-8 Downy Woodpecker (Dryobates pubescens) conservation 222, 225 82, 163 Dryobates pubescens (Downy Woodpecker) 82 Cook, James 314 Cooper's Hawk (Accipiter cooperii) 37, 38-9 Dryocopus pileatus (Pileated Woodpecker) 79 Duchamp, Marcel 338 Coreopsis spp. (tickweed) 276, 279 Dumetella carolinensis (Gray Catbird) 124, 125 Cornell Lab of Ornithology, The 318, 374 cornflower (Centaurea spp.) 277, 278, 279 Ε Cornus spp. (dogwood) 272, 275 Corvus brachyrhynchos (American Crow) Eastern Bluebird (Sialia sialis) 118, 119, 291 Eastern Kingbird (Tyrannus tyrannus) 84, 91 98,99

Eastern Phoebe (Sayornis phoebe) 84, 87, 244	Fox, William Henry 338
Eastern Screech Owl (Megascops asio) 49	Frederick II 313
Eastern Whip-poor-will (Antrostomus	Fringilla coelebs (Chaffinch) 195, 230,
vociferus) 58	232, 291
Echinacea spp. (coneflower) 277–8	Fuertes, Louis Agassiz 318
Echinops spp. (globe thistle) 277, 278, 280-1	
edge effect 245	G
Edmondson, Dudley 352, 353	Galium aparine spp. (cleavers) 296
Edwards, George 312, 314	Garden Warbler 213
eggs 2002	Genyornis newtoni (large flightless bird) 374
coloration 203	Geospiza scandens (Common Cactus
interval between eggs 203	Finch) 324
size 203	Gesner, Conrad 313
elderberry (Sambucus spp.) 298, 299	Gillmor, Robert 318, 361 , 366 , 367
Empidonax minimus (Least Flycatcher) 85, 88	gizzard 31
Ennion, Eric 318	
Erithacus rubecula (Robin) 210, 217, 230, 241,	Glaucidium gnoma (Northern Pygmy Owl) 51
	globe thistle (<i>Echinops</i> spp.) 277, 278, 280–1
246, 287, 291	glossary 20–2
Erythrura gouldiae (Gouldian Finch) 325	Goldcrest (Regulus regulus) 329
Euphagus cyanocephalus (Brewer's Blackbird)	Golden Eagle (Aquila chrysaetos) 341, 348
161	Golden-crowned Kinglet (Regulus
Eurasian hawthorn (Crotaegus crus-galli) 273	satrapa) 117
Evans, Justine 348	goldenrod (Solidago spp.) 276
Evening Grosbeak (Coccothraustes vespertinus)	Goldfinch (Carduelis carduelis) 220–1, 223,
174, 175	282, 286
eye-ring 20	gorget 20
_	Gould, Elizabeth 316, 324, 325
F	Gould, John 316, 324, 325
Fagus spp. (beech) 272	Gouldian Finch (Erythrura gouldiae) 325
Fan-tailed Warbler 212	Gray Catbird (Dumetella carolinensis) 124, 125
fat ball 286	Great Auk 230, 374
field guides 259-60	Great Crested Flycatcher (Myiarchus crinitus)
Field Museum, Chicago 374	84, 85, 90
Fieldfare (Turdus pilari) 205, 264-5	Great Gray Owl (Strix nebulosa) 353
Firebird 372, 373	Great Horned Owl (Bubo virginianus) 47
Firecrest 329	Great Kiskadee 84
firethorn (Pyracantha spp.) 272, 274, 277	Great Spotted Woodpecker (Dendrocopos
first-winter 20	major) 30, 230, 271
flight 189	Great Tit (Parus major) 208, 218, 226, 230,
gliding 188	245, 292, 332
lift and drag 188	Green Woodhoopo 331
powered 188	Green Woodpecker 30
speed 191	Greenfinch (Chloris chloris) 220–1, 230
take-off and landing 190	Gray Partridge 230
turning 188, 190	Gronvold, Henrik 317
wing shapes 191	guelder rose (Viburnum spp.) 277, 279
flocks, flocking 186, 187	guerder rose (viournum spp.) 277, 279
Flycatchers (Tyrannidae) 84, 85	н
foraging and feeding 268–9, 186 , 187	Habiballah of Sava 313
forewing 20	
	habitats, North American and European 228
Fork-tailed Flycatcher 84	arrival of humans 228, 230

changes in birdlife 230	immature 20
changes in habitat 233	incubation 204
overall change and the future 233	eggshell removal 204
Haemorhous mexicanus (House Finch) 173	hatching synchrony 204
Haemorhous purpureus (Purple Finch) 172	share of sexes 204
Hairy Woodpecker (Picoides villosus) 83	Indigo Bunting (Passerina cyanea) 158, 159
Harding, Angela 319, 370, 371	ivy (Hedera spp.) 293
Harper, Charley 318, 362, 363, 364-5, 367	
Hart, William 316	J
hatchling 184, 185	Jackdaw (Corvus monedula) 219
Hawfinch 30	Jacquet, Luc 319
Hawks (Accipiter) 36	Jeffreys, Leila 319, 354
hawthorn (Crataegus spp.) 272, 275	Jewell, Rebecca 374
hazel (Corylus spp.) 272, 274	Jonston, John 313
Hedera spp. (ivy) 293	Jourdain, F.C.R. 317
hedges 272	Junco hyemalis (Dark-eyed Junco) 152, 153
Helianthus spp. (sunflower) 277	juvenal 20
Hepworth, Barbara 339	
Herons 356	K
Herrera, Diana Beltran 319	Kacho-e 333
Herring Gull 233	Kahlo, Frida 140, 319
Hiroshige, Utagawa 319, 333	Keinen, Imao 333
Hirundo rustica (Barn Swallow) 102, 103, 210,	Kestrel 230
211, 212, 213, 214–15, 246, 247	Keulemans, John Gerrard 316
HMS Discovery 314	Key to North American Birds (Coues) 236, 239
HMS Endeavour 314	Kim, Jane 318, 330, 331
HMS Investigator 314	Kingfisher (Alcedo atthis) 341
HMS Sirius 314	Kirtland's Warbler 134
Hokusai, Katsushika 319, 333	Koekkoek, Marinus Adrianus 317
Hollom, Philip 236	Koson, Ohara 332, 333
holly (Ilex spp.) 272, 275	
Holsteyn the Elder, Pieter 313	L
Hondecoeter, Melchiorde 313	Labrador ducks 374, 375
honeysuckle (Lonicera spp.) 292, 293	Lanius excubitor (Northern Shrike) 93
Hooded Crane 355	Lanius ludovicianus (Loggerhead Shrike) 94
Hooded Crow (Corvus cornix) 210	Latham, John 314
Hookpod 343	Lavandula spp. (lavender) 277, 278
hornbeam (Carpinus spp.) 272	lavender (Lavandula spp.) 277, 278
Hosking, Eric 319, 346, 347	Lawson cypress (Chamaecyparis lawsoniana)
House Finch (Haemorhous mexicanus) 173	272, 274
House Martin (Delichon urbicum) 213	Lear, Edward 316, 358, 359
House Sparrow (Passer domesticus) 176, 177,	Least Flycatcher (Empidonax minimus) 85, 88
217, 230, 241	lek 20
House Wren (Troglodytes aedon) 112, 113	Lesser Whitethroat 213, 245
Howard, Henry Eliot 317	Levaillant, François 314
Hummingbirds (Trochilidae) 64, 65	Levy, Geri 374
	Leyland cypress (Cupressus x leylandii) 272
I	Life cycle 185–207
Icterus galbula (Baltimore Oriole) 165	Lilford, Lord 317
Icterus spurius (Orchard Oriole) 164	Liljefors, Bruno 317
Ilex spp. (holly) 272, 275	Linnaeus, Carl 314

Little Owl (Athena noctua)) 290 Lodge, George Edward 317	Mniotilta varia (Black-and-white Warbler)
Loggerhead Shrike (<i>Lanius ludovicianus</i>) 94	135, 136 Monarda spp. (bee balms/bergamot) 277
Lohr, Thomas 319, 355	Montagu's Harrier (Circus pygargus) 347
Lonicera spp. (honeysuckle) 292, 293	Morris, Arthur 351, 352
lores 20	Morris, Jackie 374
Lucy's Warbler (Oreothlypis luciae) 134	Morris, William 319, 358
Luscinia megorhyncos (Nightingale) 307	Motacilla yarrellii (Pied Flycatcher) 213
Zinemin megerijines (t tightenigate) 007	mountain Ash (Sorbus spp.) 272, 274
M	Mountain Chickadee (Poecile gambeli) 300
Macfarlane, Robert 374	Mountain Pygmy Owl 45
MacGillivray, William 316, 321	Mountfort, Guy 236
Magnolia Warbler (Dendroica magnolia) 9	Mourning Dove (Zenaida macroura) 42
malar 20	moustachial stripe 21
Malus spp. (crab apple) 272, 273, 274	Muscicapa striata (Spotted Flycatcher) 213
mandibles 20	Myiarchus crinitus (Great Crested Flycatcher)
mantle 20	84, 85, 90
maple (Acer spp.) 272	0.1,00,70
Marsh Owl 370	N
Marsh Tit (Poecile palustris) 226, 245	nape 21
Martens, Karl 341	National Audubon Society 236, 321
Martinet, François 314	National Biodiversity Network 343
Masayoshi, Kitan 333	nest box 300–3
Máté, Bence 319, 356, 357	nests 198–9
Mathew, Gregory 317	nettle (<i>Urtica</i> spp.) 296, 297
Matisse, Henri 336	Newling, Rachel 319, 368 , 369
Megaceryle alcyon (Belted Kingfisher) 72, 73	nidicolous 21
Megascops asio (Eastern Screech Owl) 49	nidifuguous 21
Megascops kennicottii (Western Screech Owl)	Nightingale (Luscinia megorhyncos) 307
45 , 50	Nightjars (Caprimulgidae) 56
Megenberg, Konrad van 313	North, Marianne 316, 326
Melanerpes carolinus (Red-bellied	Northern Cardinal (Cardinalis cardinalis)
Woodpecker) 75, 80	24–5, 156, 157, 353
Melanerpes formicivorus (Acorn Woodpecker)	Northern Flicker (Colaptes aurata) 74, 76, 77
75, 81	Northern Gannet 351
Melospiza melodia (Song Sparrow) 19	Northern Goshawk (Accipiter gentilis) 342
migrants 21	Northern Hawk Owl (Surnia ulula) 53
migration 210	Northern Mockingbird (Mimus polyglottos)
distance flown in single flight 213	126, 127
ecology 212	Northern Parula (Setophaga americana)
evolution 210	138, 139
fat reserves for 213	Northern Pygmy Owl (Glaucidium gnoma) 51
numbers of migrants 213	Northern Saw-whet Owl (Aegolius
partial 210	acadicus) 55
routes 210, 212–13	Northern Shrike (<i>Lanius excubitor</i>) 93
species 210, 212	notebook 260
Mimus polyglottos (Northern Mockingbird)	Nuthatch (Sitta europaea) 244
126, 127	(Sim timping) 211
Miscanthus sinensis 277	0
Mistle Thrush (Turdus viscivorus) 206,	oak (Quercus spp.) 272
230, 241	Old man's beard (Clematis vitalba) 294
	,

Olive Warbler 134	Pipit 230
orbital ring 21	Piranga ludoviciana (Western Tanager) 143
Orchard Oriole (Icterus spurius) 164	Piranga olivacea (Scarlet Tanager) 142
Oreothlypis luciae (Lucy's Warbler) 134	Piranga rubra (Summer Tanager) 144, 145
Ortolan Bunting 213	plastics and pollutants 225, 306
Owls (Strigiformes) 16, 44, 45	Platalea ajaja (Roseate Spoonbill) 322
, 50	Pliny the Elder 313
P	Ploceidae 230
Packham, Chris 343	Poecile atricapillus (Black-capped Chickadee)
Palm Cockatoo 354	104, 105, 107
panic grass (Panicum spp.) 277, 278	Poecile carolinensis (Carolina Chickadee)
Panicum spp. (panic grass) 277, 278	105, 108
Panicum virgatum spp. (switch grass	Poecile gambeli (Mountain Chickadee) 300
"Shenandoah") 276	Poecile palustris (Marsh Tit) 226, 245
Papaver spp. (poppies) 277	poppies (Papaver spp.) 277
parental care 207	population
Paridae (Chickadees and Titmice) 104, 105	basis for evolution 219
Parkinson, Sydney 314	immigration and emigration 218
Parthenocissus quinquefolia spp. (Virginia	long-term changes 218
creeper) 293	potential of rate increase 217
Parulidae (Warblers) 134, 135	regulation 218–19
Parus major (Great Tit) 208, 218, 226, 230,	stability of numbers 217
245, 292, 332	survival rates 219
Passenger Pigeon 374, 375	Porro, Ignatio 236
Passer domesticus (House Sparrow) 176, 177,	Potts, Mike 348
217, 230, 241	primaries 21
Passer montanus (Tree Sparrow) 220-1	primary projection 21
Passerina cyanea (Indigo Bunting) 158, 159	protection 222
pelagic 21	habitats 225
Pennant, Thomas 312, 314	individuals 222
Pepper Southern Boobook 354	Prothonotory Warbler (Protonotaria citrea) 134
perching 192, 193	Protonotaria citrea (Prothonotory Warbler) 134
Periparus ater (Coal Tit) 245	Psittacus autumnalis (Red-lored Amazon
Peterson, Roger Tory 236, 318, 327	Parrot) 359
Peucedramidae (Warblers) 134, 135	Purple Finch (Haemorhous purpureus) 172
Phalaenoptilus nuttallii (Common Poorwill)	Purple Martin (Progne subis) 100, 101
56, 57, 61	Pyracantha spp. (firethorn) 272, 274, 277
Phasianus colchicus (Pheasant) 217	Pyrocephalus rubinus (Vermilion Flycatcher)
Pheasant (Phasianus colchicus) 217	84, 85, 89
Pheucticus Iudovicianus (Rose-breasted	Pyrrhula pyrrhula (Bullfinch) 16, 17, 329
Grosbeak) 154, 155	
Picasso, Pablo 319, 336, 337	Q
Picoides villosus (Hairy Woodpecker) 83	Quail 212, 230
Pied Flycatcher (Motacilla yarrellii) 213	Quercus spp. (oak) 274
Pileated Woodpecker (Dryocopus pileatus) 79	Quiscalus quiscula (Common Grackle)
Pin-tailed Wydah 331	162, 163
Pine Grosbeak (Pinicola enucleator) 352	
pine (Pinus spp.) 272	R
Pine Siskin (Spinus pinus) 168, 169	Raper, George 314
Pinicola enucleator (Pine Grosbeak) 352	Read, Rob 319
Pinus spp. (pine) 272	Red Kite 230
Tr. (L)	

Red-bellied Woodpecker (Melanerpes Sayornis nigricans (Black Phoebe) 84, 86 carolinus) 75,80 Sayornis phoebe (Eastern Phoebe) 84, 87 Red-breasted Nuthatch (Sitta canadensis) scapulars 21 111, 282 Scarlet Tanager (Piranga olivacea) 142 Red-eyed Vireo (Vireo olivaceus) 95, 163 Schan, Lukas 313 Red-lored Amazon Parrot (Psittacus Scissor-tailed Flycatcher 84 autumnalis) 359 Scops Owl 212 red-petaled sages (Salvia spp.) 277 Scott, Peter Markham 318 Red-tailed Hawk (Buteo jamaicensis) 37, Screech Owls 49-50 40,41 seabird 22 Red-throated Wagtail 212 Seaby, Allen William 318 Red-winged Blackbird (Agelaius second-winter 22 phoeniceus) 160 secondaries 22 Redstart 213 Secretary Bird 331 Regulus calendula (Ruby-crowned Kinglet) 116 Selasphorus calliope (Calliope Regulus regulus (Goldcrest) 329 Hummingbird) 66 Regulus satrapa (Golden-crowned Selasphorus platycercus (Broad-tailed Kinglet) 117 Hummingbird) 67 Rembrandt Harmenszoom van Rijn Selasphorus rufus (Rufous Hummingbird) 71 312, 313 Selasphorus sasin (Allen's Hummingbird) 69 Ring Ouzel 245 Selous, Edmund 236 Ringneck Dove 29 serviceberry (Amelanchier spp.) 272, 274-5 Robert, Leo Paul Samuel 317 Setophaga americana (Northern Parula) Robin (Erithacus rubecula) 210, 217, 230, 241, 138, 139 246, 287, 291 Setophaga petechia (Yellow Warbler) 135, Rock Pigeon/Rock Dove (Columba livia) 43 137, 250 Rook (Corvus frugilegus) 230, 291 Setophaga ruticilla (American Redstart) Rosa spp. (wild rose) 292 140, 141 Sewell, Matt 318, 329, 374 Rose-breasted Grosbeak (Pheucticus ludovicianus) 154, 155 Sharp-shinned Hawk (Accipiter striatus) Rose-throated Becard 84 38 - 9.315Roseate Spoonbill (Platalea ajaja) 322 shelter 290-1 RSPB 236, 318, 367 Shepherd, James Affleck 318 Rubus spp. (blackberry) 293 Shozaburo, Watanabe 333 Ruby-crowned Kinglet (Regulus Sialia mexicana (Western Bluebird) 120, 121 calendula) 116 Sialia sialis (Eastern Bluebird) 118, 119, 291 Ruby-throated Hummingbird (Archilochus Sibley, David Allen 318, 328 colubris) 68 Singleton, Andy 319 Rudbeckia spp. (black-eyed Susan) 277 Sitta canadensis (Red-breasted Nuthatch) rufous 21 111, 282 Rufous Hummingbird (Selasphorus rufus) 71 Sitta carolinensis (White-breasted Rumex spp. (dock) 296 Nuthatch) 110 running, hopping, walking 192, 193 Sitta europaea (Nuthatch) 244 Skylark 230 S Sloane, Sir Hans 313, 314 Salvia spp. (red-petaled sages) 277 Small, Brian E. 343 Sambucus spp. (elderberry) 298, 299 Smit, Joseph 316 Sand Martin 213, 230 Smithsonian National Museum of Natural Satin Bowerbird 368 History 374 Savery, Roelandt 313, 374 Snow Geese 18 Saxicola torquatus (Stonechat) 275 Snowy Owl (Nyctea scandiaca) 323

Snyder, Franz 311, 313	Т
Society for the Protection of Birds (later	Tachycenita bicolor (Tree Swallow) 305
RSPB) 236	Taraxacum spp. (dandelion) 299
Solander, Daniel 314	tarsus 22
Solidago spp. (goldenrod) 276	Tawny Owl (Strix aluco) 216, 230, 231, 347
song 194, 251	teasel (Dipsacis fullonum) 277, 278
Song Sparrow (Melospiza melodia) 19,	telescopes 259
146, 147	territory 197
Song Thrush (Turdus philomelos) 30, 230, 232,	establishing 196–7
241, 291	function 196
Sorbus spp. (mountain Ash) 272, 274	interspecific 196
Sozan, Ito 333	maintaining 197
Sparrowhawk (Accipiter nisus) 224, 225	proportion of year spent on 196
species 22	tertials 22
Spectacled Warbler (Sylvia conspicillata	third-winter 22
orbitalis) 12	Thorburn, Archibald 317
Sphyrapicus varius (Yellow-bellied	Thryomanes bewickii (Bewick's Wren) 115
Sapsucker) 78	Thryothorus ludovicianus (Carolina Wren) 114
Spinus pinus (Pine Siskin) 168, 169	tibia 22
Spinus tristis (American Goldfinch) 166, 167,	Ticehurst, Norman F. 318
209, 267	tickweed (Coreopsis spp.) 276, 279
Spizella passerina (Chipping Sparrow) 149	Tipling, David 343
Spizelloides arborea (American Tree	Titmice (Paridae) 104, 105
Sparrow) 148	Toxostoma rufum (Brown Thrasher) 128, 129
Spotted Flycatcher (Muscicapa striata) 213	traveler's joy (Clematis vitalba) 294
Starling, European (Sturnus vulgaris) 6, 30,	Tree Pipit 213
130, 131, 217, 230, 282	Tree Sparrow (Passer montanus) 220-1
Steadman, Ralph 374	Tree Swallow (Tachycenita bicolor) 211, 305
Stellars Jay 320	tree-creeping ivy (Hedera spp.) 304
Sterry, Paul 319	trees 272, 274–5
Stone, Sarah 314	Trifolium spp. (clover) 296
Stonechat (Saxicola torquatus) 275	Trochilidae (Hummingbirds) 64, 65
Strix aluco (Tawny Owl) 216, 230, 347	Troglodytes aedon (House Wren) 112, 113
Strix nebulosa (Great Gray Owl) 353	Trogolodytes troglodytes (Wren) 222, 245, 329
Strix varia (Barred Owl) 50	Tucker, Bernard W. 318
Sturnus vulgaris (European Starling) 6, 30,	Tufted Titmouse (Baeolophus bicolor) 105, 106
130, 131, 217, 230, 282	Tunnicliffe, Charles Frederick 318
Summer Tanager (Piranga rubra) 144, 145	Turdus merula (Blackbird) 210, 230, 291,
sunflower (Helianthus spp.) 277	366, 371
supercilium 22	Turdus migratorius (American Robin)
Surnia ulula (Northern Hawk Owl) 53	122, 123
sustainability 306	Turdus philomelos (Song Thrush) 230, 232,
Swainson, William 316	241, 291
Swaysland, Walter 317	Turdus pilari (Fieldfare) 205, 264-5
switch grass "Shenandoah" (Panicum virgatum	Turdus viscivorus (Mistle Thrush) 206,
spp.) 276	230, 241
Sylvia atricapilla (Blackcap) 213	Turtle Dove 212
Sylvia communis (Whitethroat) 213	Tyrannidae (Flycatchers) 84, 85
Sylvia conspicillata orbitalis (Spectacled	Tyrannus tyrannus (Eastern Kingbird) 84, 91
Warbler) 12	Tyrannus verticalis (Western Kingbird) 84, 92
Symphytum spp. (comfrey) 296	Tyto alba (Barn Owl) 15, 347

U wingbar 22 Wolf, Joseph 316 Ultramarine Jay 320 Urtica spp. (nettle) 296, 297 Wood Duck 328 Woodpeckers (Picidae) 74, 75 US Christmas Bird Count 236 Woodpigeon (Columba palumbus) 200-1, 230 Utamaro, Kitagawa 319, 333 World Land Trust 343 World Wildlife Fund 318 Wren (Trogolodytes troglodytes) 222, 245, 329 vent 22 Wright, Mabel 318 Vermilion Flycatcher (Pyrocephalus rubinus) Wryneck 30, 212 84, 85, 89 Viburnum spp. (guelder rose) 277, 279 Υ Vireo olivaceus (Red-eyed Vireo) 95 yarrow (Achillea millefolum spp.) 298, 299 Virginia creeper (Parthenocissus quinquefolia Yellow-billed Magpie 320 spp.) 293 Yellow Wagtail 212, 213 Vos, Paul de 313 Yellow Warbler (Setophaga petechia) 135, Voysey, C.F.A. 260, 319, 358, 361 137, 250 W Yellow-bellied Sapsucker (Sphyrapicus varius) 78 Walker, Thayer 3 Yellow-billed Oxpecker 331 Warblers (Parulidae and Peucedramidae) 30, Yellow-tailed Black Cockatoo 369 134, 135 Yoshida, Taiichiro 319, 372, 373 Watling, Thomas 314 Waxwing (Bombycilla garrulus) 273 Z Western Bluebird (Sialia mexicana) 120, 121 Western Kingbird (Tyrannus verticalis) 84, 92 Zeiss, Carl 236 Zenaida macroura (Mourning Dove) 42 Western Screech Owl (Megascops kennicottii) zinnias (Zinnia spp) 277 45, 49 Western Tanager (Piranga ludoviciana) 143 Zion National Park 374 Zonotrichia albicollis (White-throat Western Wattlebird (Anthocaera lunulata) 324 Sparrow) 150 Wheatear 213 Zonotrichia leucophrys (White-crowned Whinchat 213, 230 Whip-poor-will 57 Sparrow) 151 White Stork 218 White-breasted Nuthatch (Sitta carolinensis) 110 White-crowned Sparrow (Zonotrichia leucophrys) 151 White-necked Rockfowl 331 White-throated Sparrow (Zonotrichia albicollis) 150 Whitethroat (Sylvia communis) 213, 218 wild carrot (Daucus spp.) 296 wild rose (Rosa spp.) 292 Wilden, Jan 313 Wildfowl and Wetland Trust 318 Wildlife Worldwide 343 Wiley, Kehinde 319 Williamson, Henry E. 318 Willow Tit 245

Wilson, Alexander 314

Willow Warbler (Phylloscopus trochilus) 213

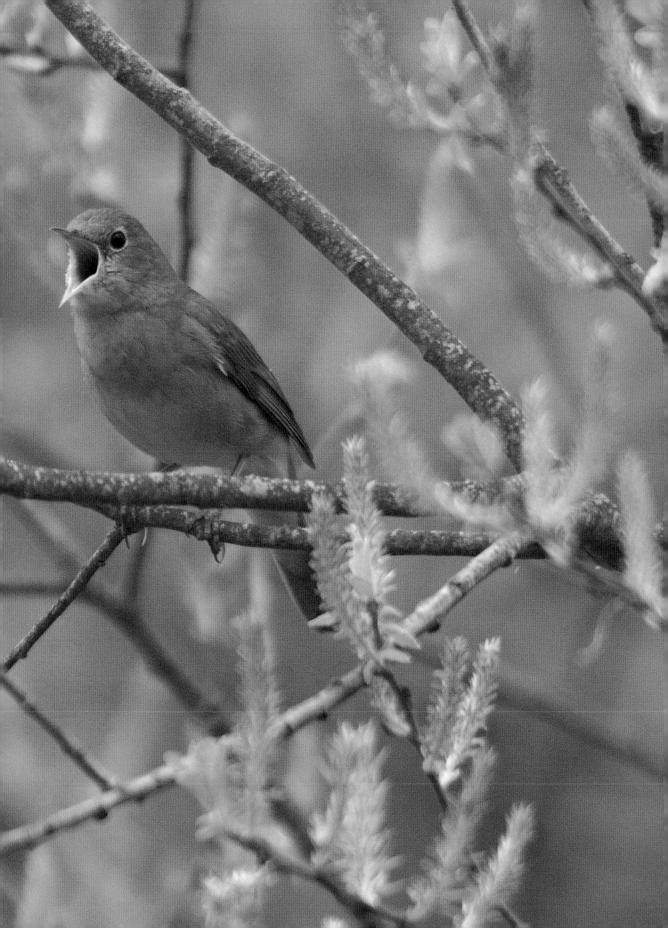

PICTURE CREDITS

All reasonable efforts have been made by the author and publishers to trace the copyright owners of the material quoted in this book and of any images reproduced in this book. In the event that the author or publishers are notified of any mistakes or omissions by copyright owners after publication, the author and publishers will endeavour to rectify the position accordingly for any subsequent printing.

For thumbnail photographs on p.34-35, please refer to the main bird identification pages.

Key: t: top, b: below, m: middle, l: left, r: right

Alamy: 18, 21t, 24-25, 27, 29, 37tl, 38b, 45tr, 45b, 49, 51, 55, 57tr, 58, 59, 61, 62, 65b, 71, 99, 112, 116b, 118t, 119, 121t, 123, 127, 130t, 169, 170,181, 185b, 186t, 186b, 189t, 189b, 190, 193t, 193bl, 193br, 196, 202mbl, 205, 209, 211t, 211b, 212, 214-215, 226, 227, 229, 232tl, 234-235, 237, 238, 240, 243t, 243bl, 243br, 247t, 247b, 248-249, 250, 251, 252, 254-255, 257, 258bl, 258br, 261, 262-263, 264-265, 267, 270, 273tl, 273b, 275, 276tl, 276tr, 280-281, 282, 283tr, 283b, 286, 287, 288, 290, 292, 297tr, 297b, 298b, 300, 304, 307, 316tl, 321, 324t, 324b, 325, 339, 379, 384, 386, 390-391, 392, 404-405, 412;

© Máté Bence, www.matebence. hu and www.bencemateshides.com: 356, 357t, 357b;

Biodiversity Heritage Library: / Smithsonian Libraries Elliott Coues, Key to North American birds, 1872, p.16 239l, p.80 239r; /National Library Board, Singapore/George Edwards (1694–1773), A Natural History of Uncommon Birds Title page 312bl, /p.32 312br; /American Museum of Natural History Library, Starling (Winter plumage), Plate 14 from Thomas Alfred Coward, The birds of the British Isles and their eggs. First series, 1919 316tr;

Bird Photographer of the Year: / © Pal Hermansen 342, / © Caron Steele 344t, / © Nikunj Patel 344b, / © Chad Larsen 345:

Bridgeman Images: Passer domesticus, house sparrow, Plate 160 from William MacGillivray's Watercolour drawings of British Animals (1831-1841) 4; Black And Yellow Warbler, Magnolia Warbler (Dendroica Magnolia) plate CXXIII from 'The Birds of America' (aquatint & engraving with hand-colouring) / Christie's Images 9; An Owl and two Eastern Bullfinches, from an album 'Birds compared in Humorous Songs, Contest of Poetry of the 100 and 1000 birds', 1791 (colour woodblock print), Utamaro, Kitagawa (1753-1806) / Private Collection of Claude Monet 16; Bullfinch and weeping cherry-tree, pub. c.1834 (colour woodblock print), Hokusai, Katsushika (1760-1849) 17; A bird's concert. Painting by Frans Snyders (1579-1657). Oil on canvas. Prado Museum, Madrid, Spain 308-309; Pal Lat 1071 Frederick II: Two horsemen with falcons, from 'De Arte Venandi cum Avibus' (vellum), Italian School, (13th century) / Vatican Library 311t; Scene of the Well: a man with a bird head and seems to fall or being pushed by a bison, Prehistoric / Caves of Lascaux, Dordogne, France 311br; Birds (pen & ink & wash on paper) (b/w photo), Rembrandt Harmensz van Rijn (1606-69) / Musee Bonnat, Bayonne, France 312tl; Accipiter striatus, sharp-shinned hawk, Plate 374 from John James Audubon's Birds of America (hand-coloured aquatint), Audubon, John James (1785-1851) / Natural History Museum 315; The Pigeon (gouache on linen), Crawhall, Joseph (1861-1913) / Art Gallery and Museum, Kelvingrove, Glasgow 316b; Five birds. Colour Illustration by Audubon; Yellow billed Magpie, Stellers Jay, Ultramarine Jay and Clark's Crow. /

British Library, London 320; Roseate Spoonbill, Platalea leucorodia, from 'The Birds of America', 1836 (colour litho), Audubon, John James (1785-1851) / Private Collection 322; Nyctea scandiaca, Snowy Owl, Plate 121 from John James Audubon's Birds of America (handcoloured aquatint), Audubon, John James (1785-1851) / Natural History Museum, London 323; Great Tit on Paulownia Branch, Koson, Ohara (1877-1945) 332; Detail of Waves and Birds, c.1825 (colour woodblock print), Hokusai, Katsushika (1760-1849) / Victoria & Albert Museum, London 333; The Birds, The Birds, Detail of Central Panel of a Ceiling in Three Parts, 1953 (oil on canvas), Braque, Georges (1882-1963) / Louvre, Paris, France. © ADAGP, Paris and DACS, London 2020 334; Frontispiece to 'The Order of Birds', a book printed for Braque's 80th Birthday, 1962 (aquatint), Braque, Georges (1882-1963) / Private Collection / The Stapleton Collection. © ADAGP, Paris and DACS, London 2020 335; Pablo Picasso (1881-1973) in his workshop in Antibes with an owl, 1946 (b/w photo) / © Michel Sima. © Succession Picasso/DACS, London 2020 336t; Dove, Picasso, Pablo (1881-1973) / Private Collection. © Succession Picasso/ DACS, London 2020 336b; Child with a Dove, 1901 (oil on canvas), Picasso, Pablo (1881-1973) / National Gallery, London. © Succession Picasso/DACS, London 2020 337; Bird in Space, 1924 (polished bronze), Brancusi, Constantin (1876-1957) / Philadelphia Museum of Art, Pennsylvania, PA. © Succession Brancusi - All rights reserved. ADAGP, Paris and DACS, London 2020 338; Self Portrait with Monkey and Parrot, 1942 (oil on masonite), Kahlo, Frida (1907-54) / Museo de Arte Latinoamericano de Buenos Aires. © Banco de México Diego Rivera Frida Kahlo Museums Trust, Mexico, D.F. / DACS 2020 340; The Dark Blue Bird, from 'Sixteen Drawings of Comic Birds' (pen & ink w/c on paper),

Lear, Edward (1812–88) / Private
Collection / The Stapleton Collection
358; Psittacus autumnalis, Linn., June
1832 (w/c on paper), Lear, Edward
(1812–88) / The Right Hon. Earl of
Derby 359t; The Light Green Bird, from
'Sixteen Drawings of Comic Birds' (pen &
ink w/c on paper), Lear, Edward (1812–
88) / Victoria & Albert Museum, London,
UK / The Stapleton Collection 359b;

Jo Carlill: 327b;

Creative Commons: 375;

- © Denis Defibaugh: Passenger Pigeon, RMSC (from Afterlifes of Natural History 375bl, Labrador Duck, Smithsonian (from Afterlifes of Natural History) 375br;
- © Dudley Edmonson: 258t, 352t, 353t, 353b;

FLPA: /JMC/Biosphoto 200-201; /Eric Hosking 327t, 346, 347t, 347bl, 347br; / Alan Murphy, BIA/Minden Pictures 19; / Paul Sawer 216; /Duncan Usher/Minden Pictures 197; /Roger Wilmshurst 195;

Getty Images: 360t, 360b, 361;

Robert Gillmor MBE: /Pinkfoot Gallery 366, RSPB original avocet line drawing. Reproduced by permission of RSPB.

© 2020 All rights reserved. Source: RSPB 367t, Stamp designs (x4) by Robert Gillmor © Royal Mail Group Limited 367b;

Angela Harding, www.angelaharding. co.uk: 370t, 370b, 371;

- © Charley Harper Art Studio: 363t, 363b, 364-365;
- © Lynne Hatzius 2020: Cover illustrations, 31, 33;
- © Leila Jeffreys, www.leilajeffreys.com, Instagram: @leilajeffreys: 354t, 354b;

Jane Kim: Photos courtesy Ink Dwell, www.inkdwell.com 330, 331t, 331b;

King's College, London: /Foyle Special Collections Library/Thomas Pennant, *British Zoology. Vol* 1, p.532 1812 Class II Birds, Div I Land. Plate LXIV: 1 Great, 2 Blue, 3 Cole, 4 Marsh Titmouse 312tr;

Library of Congress: Konrad, Von Megenberg, De Cantimpré Thomas, and Lessing J. Rosenwald Collection. https:// www.loc.gov/item/48035378/311bl;

- © Thomas Lohr: 355t, 355b;
- © Karl Martens: 341t, 341b;
- © Arthur Morris, www. BIRDSASART-Blog.com: 350, 351;

MSand: 381;

© Nature Photographers Ltd: /T.D.Bonsall 206; /Laurie Campbell 6, 185tr, 279, 297tl; /Mr & Mrs Craig (for) W.S. Paton 46; /David Osborn 52, 80t, 160t; /Richard Revels 132t, 208; /Brian E. Small cover photograph, 23b, 37b, 42, 45tl, 47, 48, 54, 57tl, 57b, 60, 65tl, 65tr, 66, 67t, 67b, 68t, 68b, 69, 70b, 72, 73, 75tl, 75tr, 75b, 76, 77, 78t, 78b, 79t, 79b, 80b, 81t, 81b, 82b, 82t, 83b, 85tl, 85tr, 85b, 86, 87, 88, 89t, 90, 91, 92, 95, 96, 100, 103, 105tl, 105tr, 105b, 106, 107, 108, 109, 110, 111t, 111b, 113, 114, 115, 116t, 117t, 117b, 118b, 120, 121b, 122, 125, 126, 129b, 132b, 133, 135t, 135b, 136t, 136b, 137t, 137b, 138, 141t, 141b, 142t, 142b, 143t, 143b, 144t, 144b, 145, 146, 147, 148, 149, 150, 151, 152b, 155, 156, 159t, 159b, 160b, 161t, 161b, 162, 163, 164t, 164b, 165t, 165b, 167t, 167b, 168, 171t, 171b, 172t, 172b, 173t, 173b, 174, 177, 244t, 244bl, 244br, 291, 410-411, 416; /Paul Sterry 21b, 22t, 43, 53, 70t, 93, 130b, 178-179, 182, 183, 198, 199, 202tl, 202tr, 202mtl, 202mtr, 202bmr, 202br, 217, 222, 223, 224, 231, 232tr, 232b, 298tl, 298tr, 406; /Roger Tidman 12, 220-221;

© naturepl.com: /Kim Taylor 185tl, /

Rob Cousins 348t, /Barrie Britton 348b, /Mike Salisbury 349;

- © Rachel Newling: 368, 369t, 369b;
- © RBG Kew: 326t, 326b;
- © Royal Mail Group Limited: Stamp designs (x4) by Robert Gillmor 367b;

RSPB: Current logo reproduced by permission of RSPB, © 2020 All rights reserved 318t, Original avocet line drawing reproduced by permission of RSPB, © 2020 All rights reserved 367t;

Science Photo Library: / Dirk Wiersma 28:

© Matt Sewell: 329t, 329bl, 329br;

Shutterstock: 15, 20, 22b, 23t, 30, 32, 37tr, 38t, 40, 41, 50, 63, 94, 97, 98, 101, 102, 124, 128, 131, 139, 140, 152t, 153, 154, 157, 158, 166, 175, 176, 219, 268, 269, 271, 273tr, 276b, 283tl, 294, 295, 305, 376-377, 380-381, 382, 403, 414-415;

© David Allen Sibley: from *The Sibley Guide to Birds* (Alfred A Knopf, 2000) 328t, 328b;

The Cornell Lab of Ornithology: © The Cornell Lab of Ornithology, Cornell University: 318b;

© Taiichiro Yoshida: 372t, 372b, 373.

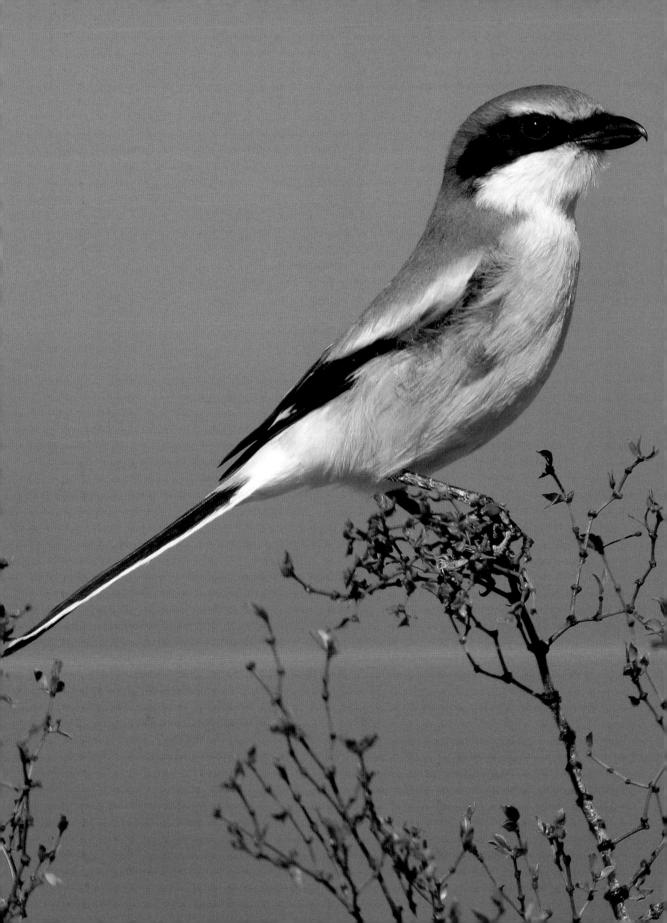

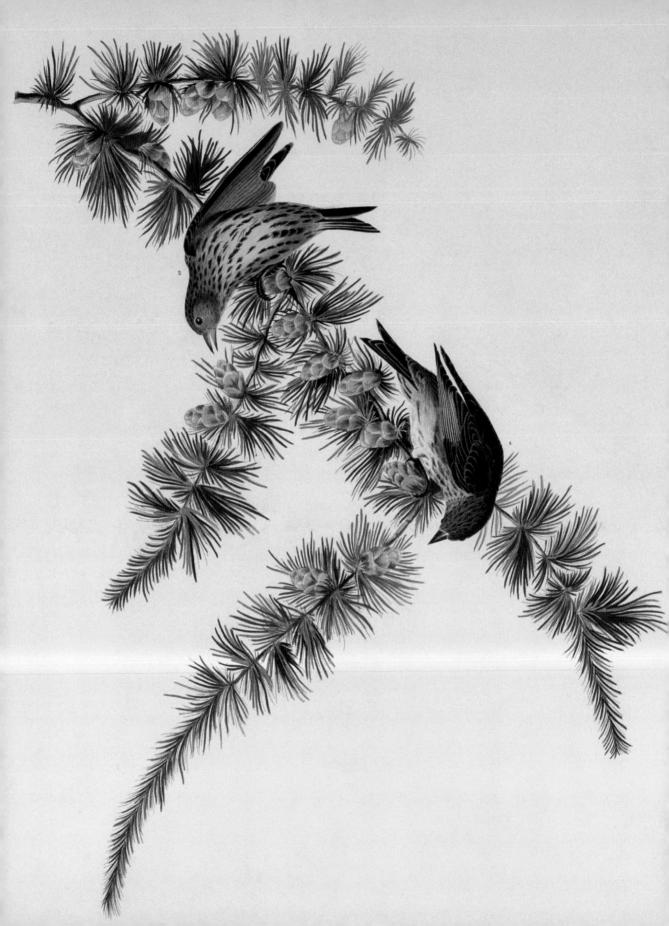

CONTRIBUTOR BIOGRAPHIES

Listed in alphabetical order

Dominic Couzens is an expert bird guide and author. He has published numerous books and articles on natural history, including for *BBC Wildlife* and *Bird Watching*, specializing in birds and mammals. His books include *Extreme Birds, Atlas of Rare Birds, The Secret Lives of Puffins*, and *Top 100 Birding Sites of the World*. He travels widely for writing and speaking, and his website is www.birdwords.co.uk.

Sonya Patel Ellis is a writer, editor and artist exploring the botanical world and the interconnectedness of nature and culture. Authored works include *The Botanical Bible*, *The Heritage Herbal*, and *Nature Tales: Encounters with Britain's Wildlife*.

See www.abotanicalworld.com.

Christopher Perrins is an Emeritus Fellow of the Edward Grey Institute of Field Ornithology at the University of Oxford, and Her Majesty's Swan Warden since 1993. He has won a number of awards for his lifelong service to ornithology, including the Royal Society for the Protection of Birds Medal and the British Ornithologists' Union Medal, and is an Honorary Life Fellow of the American Ornithologists' Union. Christopher is the author of several books, including *Collins New Generation Guide to Birds* and *The Illustrated Encyclopedia of Birds*.

Paul Sterry is the author and photographer of more than 50 natural history books, including Warblers and Other Song Birds of North America, Life-size Birds, and The Complete Guide to British Birds. Having trained as a zoologist, Paul has been a wildlife photographer, rewilding expert, and passionate conservationist for over 30 years. He is also the founding Director and coordinator of the Bird Photographer of the Year (BPOTY) Conservation Fund and co-runs Nature Photographers Photo Library with Rob Read.

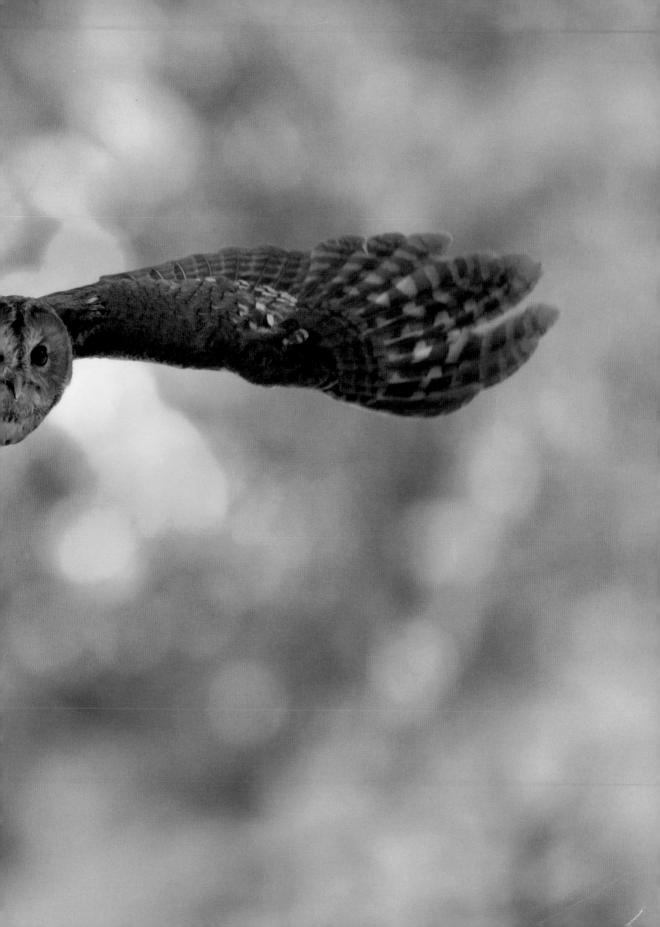

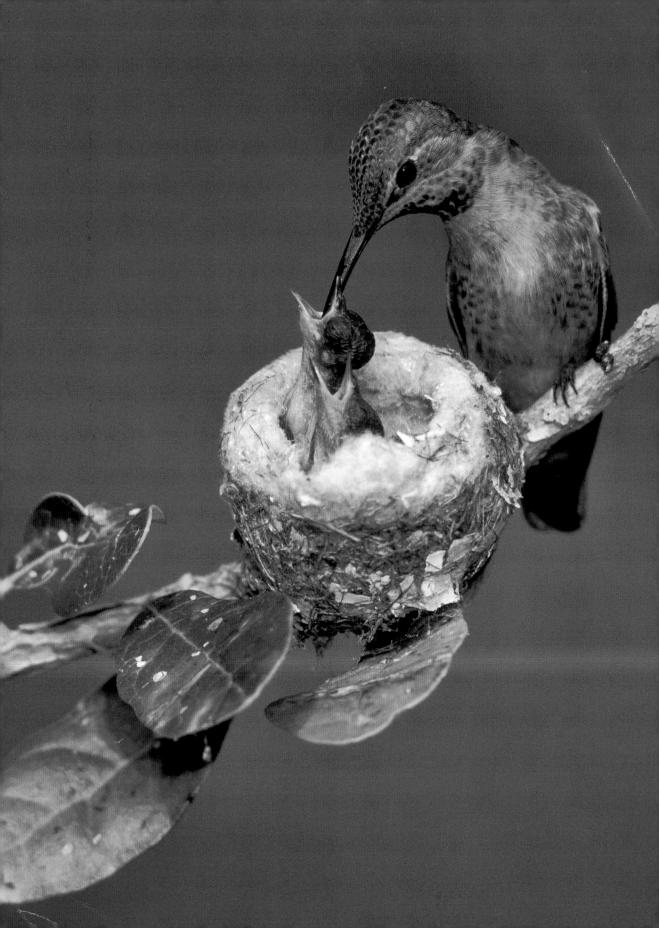